LOCATING AMERI

How does museum location shape the interpretation of an art object by critics, curators, art historians, and others? To what extent is the value of a work of art determined by its location? Providing a close examination of individual works of American art in relation to gallery and museum location, this anthology presents case studies of paintings, sculpture, photographs, and other media that explore these questions about the relationship between location and the prescribed meaning of art.

It takes an alternate perspective in that it provides in-depth analysis of works of art that are less well known than the usual American art suspects, and in locations outside of art museums in major urban cultural centers.

By doing so, the contributors to this volume reveal that such a shift in focus yields an expanded and more complex understanding of American art.

Close examinations are given to works located in small and mid-sized art museums throughout the United States, museums that generally do not benefit from the resources afforded by more powerful cultural establishments such as the Museum of Modern Art and the Metropolitan Museum of Art in New York. Works of art located at institutions other than art museums are also examined.

Although the book primarily focuses on paintings, other media created from the Colonial Period to the present are considered, including material culture and craft. The volume takes an inclusive approach to American art by featuring works created by a diverse group of artists from canonical to lesser-known ones, and provides new insights by highlighting the regional and the local.

*Cynthia Fowler is an art historian and Professor of Art
at Emmanuel College, Boston, MA, USA.*

Locating American Art

Finding Art's Meaning in Museums,
Colonial Period to the Present

Edited by Cynthia Fowler

Routledge
Taylor & Francis Group

LONDON AND NEW YORK

First published 2016 by Ashgate Publishing

2 Park Square, Milton Park, Abingdon, Oxfordshire OX14 4RN
52 Vanderbilt Avenue, New York, NY 10017

Routledge is an imprint of the Taylor & Francis Group, an informa business

First issued in paperback 2020

British Library Cataloguing in Publication Data
A catalogue record for this book is available from the British Library

The Library of Congress has cataloged the printed edition as follows:
Locating American art: finding art's meaning in museums, colonial period to the present / Edited by Cynthia Fowler.
 pages cm
 Includes bibliographical references and index.
 ISBN 978-1-4724-6799-7 (hardcover: alk. paper) 1. Art, American—Appreciation.
2. Art appreciation—United States—Regional disparities. I. Fowler, Cynthia.

N6505.L59 2015
709.73—dc23

2015024513

ISBN 978-1-4724-6799-7 (hbk)
ISBN 978-0-367-66851-8 (pbk)

Contents

List of Illustrations

Color Plates

1 Nasario López, *La Muerte en su Carreta*, late nineteenth-century. Gesso, leather, cottonwood, and pine, 51 x 24 x 32 in. Collection of Colorado Springs Fine Arts Center, Colorado Springs, CO. Gift of Alice Bemis Taylor, TM521

2 Charles Caryl Coleman, *Azaleas and Apple Blossoms*, 1879. Oil on canvas, 71 1/4 x 25 in. (181 x 63.5 cm), inscribed "Roma" and dated "1879." De Young Museum, San Francisco, CA. Museum purchase, Roscoe and Margaret Oakes Income Fund, gift of Barbro and Bernard Osher, J. Burgess and Elizabeth Jamieson Endowment Fund, and bequest of William A. Stimson

3 Philip Leslie Hale, *Deianira, Wife of Heracles, Being Carried Off by the Centaur Nessus*, c. 1897. Oil on canvas, 58 3/4 x 71 1/4 in. Danforth Art, Framingham, MA. Gift of Mr. and Mrs. William Wolfson, 1976.38

4 Raymond Jonson, *Composition Five—The Wind*, 1925. Oil on canvas, 33 x 44 in. Joslyn Art Museum, Omaha, NE. Museum purchase, 1994.20

5 Josephine Tota, *Untitled (Life Story)*, c. 1980s. Egg tempera on Masonite, 16 x 20 1/8 in. Memorial Art Gallery of University of Rochester, Rochester, NY. Gift of Rosamond Tota, 97.3

6 Edward Mitchell Bannister, *Approaching Storm*, 1886. Oil on canvas, 102 x 152.4 cm. Smithsonian American Art Museum, Washington, DC. Gift of G. William Miller, 1983.95.62

7 Frederick Arthur Bridgman, *The Funeral of a Mummy on the Nile*, 1876–77. Oil on canvas, 45 x 91 3/8 in. Collection of the Speed Art Museum, Louisville, KY. Gift of Mr. Wendell Cherry, 1990.8

8 Thomas Eakins, *Portrait of Samuel Murray*, 1889. Oil on canvas, 24 x 20 in. Cedarhurst Center for the Arts, Mount Vernon, IL. Gift of John R. and Eleanor R. Mitchell

9 Maynard Dixon, *The Forgotten Man*, 1934. Oil on canvas, 40 x 50 1/8 in. Brigham Young University Museum of Art, Provo, UT. Gift of Herald R. Clark, 1937

Black and White Figures

Acknowledgements

A few years ago, I sat outside of the American art gallery at the Worcester Art Museum in Worcester, Massachusetts, with my colleague Erika Schneider. We had just spent some time appreciating the pendant portraits of *John Freake* (c. 1671–74) and *Elizabeth Clarke Freake and Baby Mary* (c. 1671–74) on view in the gallery. We reminisced about the semester we had spent studying these and other Colonial portraits in a graduate seminar on *American Colonial Portraiture* led by Dr. Wayne Craven at the University of Delaware. As we considered these and other iconic works of American art in the Worcester Art Museum collection, I wondered aloud to Erika about the status of these objects in relation to their location in Worcester rather than a more central one like the Museum of Fine Arts in Boston. Our conversation sowed the seeds for this anthology.

A call for contributions brought forth an outstanding group of abstracts that evolved into the essays for this volume. I want to express my genuine appreciation to all of the contributors for making this book possible. It was a pleasure to work with each contributor, and it is now my honor to present their essays, all of which provide new perspectives on their selected works. In completing their essays, many of the contributors received funding and other forms of support from their home institutions. I offer my thanks to these institutions. I am also grateful to my own institution, Emmanuel College, for funding the color reproductions.

Finally, special thanks to Ashgate and its outstanding group of editors, but especially Margaret Michniewicz, for supporting this project from the start.

This anthology is dedicated to the memory of Dr. William Innes Homer (1929–2012). I and several of the contributors studied under Dr. Homer as graduate students at the University of Delaware. Beyond Dr. Homer's impact on his students, American art historians have benefited by his innovative

scholarship on American art history, particularly when the discipline was in its nascent year. Art historian Wanda Corn positions Dr. Homer among the "pioneer generation" of American art historians whom established American art history as a serious academic discipline.[1] She cites his 1975 "path-breaking exhibition" on American modern art at the Delaware Art Museum and his research on Alfred Stieglitz and his circle as some of his most important contributions to art history.[2] Dr. Homer's contributions as an art historian and as mentor to his students are too numerous to mention here. Suffice it to say that they continued into his retirement and beyond. I am personally grateful to him for supporting my own research on the embroideries of American artist Marguerite Zorach during my years as a graduate student at the University of Delaware in the 1990s. I am confident that Dr. Homer would be delighted by this anthology.

Notes

1 Wanda Corn, "Coming of Age: Historical Scholarship in American Art," *Art Bulletin* 70 (June 1988): 194.

2 Ibid., 198.

List of Contributors

Henry Adams, Ph.D., is a graduate of Harvard University and received his MA and PhD from Yale, where he received the Frances Blanshard Prize for the best doctoral dissertation in art history. He is the author of more than 350 articles in the American field, both scholarly and popular, and of 14 books, including *Eakins Revealed*, which the painter Andrew Wyeth described as "without question the most extraordinary biography I have ever read on an artist." In June 2010 he received the Lifetime Achievement Award of the Cleveland Arts Prize.

Adrienne Baxter Bell, Ph.D., is Associate Professor of Art History at Marymount Manhattan College, New York. Her scholarship focuses on nineteenth-century American art and its resonances in contemporary art. She is the author of several studies on George Inness, including *George Inness and the Visionary Landscape* (2003) and *George Inness: Writings and Reflections on Art and Philosophy* (2007). Her interest in the role of embodiment in art is reflected in her essay "Body-Nature-Paint: Embodying Experience in Gilded Age American Landscape Painting," published in *The Cultured Canvas: New Perspectives on American Landscape Painting* (2012).

Emily C. Burns, Ph.D., is Assistant Professor of Art History at Auburn University. Her research considers visual culture and transatlantic exchange between France and the United States in the late nineteenth and early twentieth centuries. She received her doctorate from Washington University in St. Louis. Her projects have been supported by the Metropolitan Museum of Art, the Smithsonian American Art Museum, the Terra Foundation for American Art, the Baird Library Society of Fellows, the Buffalo Bill Center of the West, and the Walter Read Hovey Memorial Foundation.

Sandra Cheng, Ph.D., is Assistant Professor of Art History at New York City College of Technology/City University of New York (CUNY). She has received the Metropolitan Museum of Art's Jane and Morgan Whitney Fellowship and the Swann Foundation for Caricature and Cartoon Fellowship from the Library of Congress. Her research interests include the history of collecting, caricature drawing, and studio practice; the history of monstrosity; and the history of photography. She is the daughter of Chinese immigrants who fled China during the Great Leap Forward.

Kimberlee Cloutier-Blazzard, Ph.D., is Lecturer in the Department of Art and Music at Simmons College in Boston. She also serves as Communications Manager at the Sargent House Museum. She currently serves as founding Editor and Publisher at Open Inquiry Archive, an independent, curated site for the e-publication of scholarly occasional papers. An independent scholar, she taught art history at Boston-area colleges for 15 years and has published on topics related to Northern European and American art. She received her M.A and her Ph.D. in art history from the University of Virginia.

Traci Costa completed her M.A. in art and architectural history at Roger Williams University in the spring of 2015. She received her BA in art therapy from Emmanuel College in 2010. After completing her undergraduate degree, she was an intern in art education at the Currier Museum of Art in Manchester, NH. She has held positions in public programming at the Rhode Island School of Design Museum of Art and at the Gallery Night Providence Organization. Her master's thesis focuses on the relationship between art and philosophy through the reinterpretation of works by nineteenth-century African American artist Edward Mitchell Bannister.

Constance L. Cutler is Curator for the Peru Community Schools Fine Art Gallery in Peru, Indiana. She is a graduate of Purdue University, and has worked with the collection for several years. She originated the Arts Alive! program, which uses the art collection for educational purposes for Peru Community Schools and surrounding areas.

Miguel de Baca, Ph.D., is Associate Professor of Art History and Chair of the American Studies Program at Lake Forest College. He earned his Ph.D. degree in American Studies from Harvard University in 2009, and has held research fellowships at the Smithsonian American Art Museum and Dumbarton Oaks. His scholarly interests include issues of memory, reference, and abstraction in modern and contemporary American art, and he is the author of a book on the minimalist sculptor Anne Truitt, forthcoming in 2016.

Cynthia Fowler, Ph.D., is Professor of Art at Emmanuel College in Boston. Her scholarship centers around American art in the first half of the twentieth century with a focus on textiles and women's artistic production. Her book *Hooked Rugs: Encounters in American Modern Art, Craft and Design* (Ashgate) was published in 2013. She has received fellowships from the Smithsonian Institution, the Winterthur Museum, the National Endowment for the Humanities, and the Center for Craft, Creativity and Design. She received her Ph.D. from the University of Delaware in 2002.

Herbert R. Hartel, Jr., Ph.D., is an art historian and specialist in twentieth-century American painting and sculpture. He has presented papers and published articles on Raymond Jonson, Arthur Dove, Agnes Martin, Philip Evergood, Georgia O'Keeffe, and Clyfford Still. Currently, he is Adjunct Associate Professor of Art History at Hofstra University, and John Jay College of Criminal Justice at the City University of New York (CUNY). He has also taught art history at Parsons School of Design, Baruch College, York College, Pratt Institute, and Fordham University. He received his PhD in modern and American art history from the CUNY Graduate Center.

Elizabeth Kuebler-Wolf is Assistant Professor of Art History at the University of Saint Francis in Fort Wayne, IN, where she teaches classes on modern, contemporary, and American art. She earned her PhD in art history and American studies from Indiana University, Bloomington. Her recent publications include "'Train up a child in the way he should go': The Image of Idealized Childhood in the Slavery Debate, 1850–1870," in James Marten, ed., *Children and Youth in the Civil War Era* (New York University Press, 2012) and "'The Earlier, Wilder Image': Early Artists of the American West," in Gordon Bakken, ed., *The World of the American West* (Routledge, 2011).

Lara Kuykendall, Ph.D., is Assistant Professor of Art History at Ball State University where she teaches courses on American art, the history of photography, museum studies, and art criticism and theory. She holds a Ph.D. in American art from the University of Kansas. Her research explores issues of national identity in American visual culture of the 1930s and 1940s and examines ways in which artists used heroic imagery to understand and critique the changing social and political fabric of the United States.

Jessica Marten is Curator in Charge/Curator of American Art at the Memorial Art Gallery of the University of Rochester. Her most recent project, *Art for the People: Carl W. Peters and the Rochester WPA Murals,* involved the conservation of a group of over 60 preparatory studies for WPA murals, many of which

are extant. The associated exhibition featured these studies alongside large-scale reproductions of the 13 extant murals, and was accompanied by a fully illustrated color catalogue. Her upcoming projects include an exploration of the history of the *Encyclopaedia Britannica* collection from the 1940s, and an upcoming exhibition of Josephine Tota's art.

Jessica Murphy, Ph.D., specializes in American art of the late nineteenth and early twentieth centuries. She received her Ph.D. from the University of Delaware and wrote her dissertation on American Modernism and the female artists of the Stieglitz Circle. She has worked as a research associate at the Metropolitan Museum of Art, where she contributed to the publications *Stieglitz and His Artists: Matisse to O'Keeffe* and *The American West in Bronze, 1850–1925*, and as a curatorial assistant at the Philadelphia Museum of Art. She currently works in audience engagement at the Brooklyn Museum and gives gallery lectures at the Metropolitan Museum of Art.

Sara Picard, Ph.D., is Assistant Professor of Art History at Rhode Island College. She held a Henry Luce Foundation/ACLS Dissertation Fellowship in American Art for the first critical study of antebellum New Orleans artist Jules Lion and is currently extending this research for a book on the history of mixed black and white race Americans in visual culture. Her writing has appeared in the *SECAC Review*, the *Journal of Southern History*, and *Louisiana History*.

Erika Schneider, Ph.D., is Associate Professor of Art History at Framingham State University where she teaches courses in modern, contemporary, and American art history. She received her Ph.D. from Temple University. Her dissertation, a revised version of which is under contract for publication, investigates the representation of the struggling artist in antebellum America. She has published chapters in books, including "Talisman for the Symbolist Movement: Puvis de Chavannes' *Hope*" (2009), and "Against the Tide: Paul Gauguin's Watery Women and Their Symbolist Legacy" (2010), and considers the role of American artists in the Symbolist movement. She received an inaugural Fulbright-Terra Foundation Award in the History of American Art to teach in the Netherlands in fall 2015.

Laura E. Smith, Ph.D., is an Assistant Professor of Art History at Michigan State University (MSU) and affiliated faculty with MSU's American Indian Studies Program. She teaches North American art, Native North American art, and the history of photography. Her research examines the entrenched distinctions between Indians and modernity that have largely prevented scholarly recognition of indigenous North American artists as modernists. Most recently, she published an essay "Beaded Buckskins and Bad-Girl Bobs:

Kiowa Female Identity, Industry, and Activism in Horace Poolaw's Portraits," in the catalog for the exhibition, *Photographer Horace Poolaw: The Calendar-Maker's Son*, at the National Museum of the American Indian, New York City, September 2014–February 2015. Her book *Horace Poolaw, Photographer of American Indian Modernity* (University of Nebraska Press) will be released in spring 2016.

James R. Swensen, Ph.D., is Assistant Professor of Art History and the History of Photography at Brigham Young University. He has recently completed two books on photography including *Picturing Migrants*, an investigation of the connections between John Steinbeck's *The Grapes of Wrath* and FSA photography, which will be published by the University of Oklahoma Press. His article "Focusing on the Migrant: Dorothea Lange and the John Steinbeck Committee, 1938," appears in the 2013 anthology *Ambivalent American: The Political Companion to John Steinbeck* (University of Kentucky Press).

Introduction

Artists and art historians have been providing consistent and penetrating critiques of the art museum since the 1980s.[1] Often influenced by corporate interests, art museums have been described in many critiques as bastions of cultural hegemony. Art historian Alan Wallach, one of the most outspoken critics of the art museum, explains that "art museums sacralize their contents: the art object, shown in an appropriately formal setting, becomes high art, the repository of society's loftiest ideals."[2] However, in her chapter, "Theory, Practice, and Illusion," Danielle Rice, program director of museum leadership at Drexel University, points out the limitation to critiques of the museum "as a monolithic representative of elite taste and institutional power" in that they fail to recognize the ways in which art museums actually operate in practice.[3] She observes, "Just as cultural historians and anthropologists have made clear distinctions between cultures and Culture, we need to distinguish between museums and the Museum."[4] This anthology attempts to engage this distinction by recognizing differences between museums based on geographical location and museum size. These differences have a clear effect on the collecting habits of museums and how works of art in those collections have been interpreted by art historians.

The essays in this anthology consider American artworks in museums and other institutions that span the United States and, barring a few exceptions, are located in small to midsized museums or in nonart museum settings (Appendix A). For the purposes of this anthology, I have defined small museums as those with collections under 10,000 objects and midsized museums as holding 10,000 to 50,000 objects. Location is the other important thread that connects the essays. In his analysis of the Cleveland Museum of Art, art critic and scholar David Carrier has argued for the significance of location. He states, "American public museums are heavily affected by local conditions."[5] In the majority of cases, the objects under consideration are located outside of major American cultural centers like New York, Washington, DC, and Los Angeles. Why this focus on the small and the local?

These museums often have different collecting criteria than large national museums and that different criteria translate into the preservation of works other than canonical American art. The wide geographical span of the essays brings objects to the forefront with local and regional significance that might be overlooked by larger museums more interested in national trends and narratives. In this regard, the anthology serves as a reminder that there is much to learn from art collections outside of major metropolitan areas and away from the national spotlight. The essays in the anthology that do examine works from collections in the Northeast have largely been selected for their location in alternative spaces than art museums. Clearly, small budgets that constrain museum acquisitions to so-called minor works of art are not the dream of any museum curator. That being said, small and midsized institutions with smaller budgets play a very important role in preserving works of art that hold the potential to challenge the art historical canon and provide counter narratives to dominating national ones.

Michel Foucault's writing on the museum as a heterotopia provides a useful theoretical framework for this anthology. Art historians have previously engaged Foucault to establish their critique of "the Museum."[6] As Foucault defines them, heterotopias are "counter-sites ... in which the real sites, all the other real sites that can be found within the culture, are simultaneously represented, contested, and inverted."[7] Foucault identifies the museum as a heterotopia "in which time never stops building up and topping its own summit."[8] Furthermore, he connects the museum to the modernist project "of accumulating everything, of establishing a sort of general archive, the will to enclose in one place all times, all epochs, all forms all tastes, the idea of constituting a place of all times that is itself outside of time and inaccessible to its ravages—."[9] Philosopher Beth Lord argues that using Foucault as a guide, "the museum can be seen to be a positive force ... for dismantling the very notions of historical continuity and coherence that Foucault holds in contempt."[10] She explains, "the museum functions according to an ethos of permanent critique of its own history" through "its juxtaposition of temporally discontinuous objects, its attempt to present the totality of time, and its isolation, as an entire space, from normal temporal continuity."[11] Indeed, in an effort to create a self-conscious critique of their institutions, some art museums are now arranging their works by themes rather than by historically driven art movements.[12] As the essays in this anthology will demonstrate, small and midsized art museums—and other institutions holding works of art that fall outside of the established canon— provide an important critique of the limitations of art history by offering alternative narratives to dominant national ones on the history of art. By bringing together this collection of case studies, these alternative narratives come to light.

The anthology is divided into three sections, described below, although a review of the essays will reveal some overlap. Within each section, the essays are arranged chronologically rather than by geographical location to avoid a reductive division of the United States into prescribed sections. The primary thread connecting the objects under consideration in each essay is that of location. However, it should be pointed out that the focus is not on the interior workings of the institutions in which the selected works are located. Nor is the focus on the public reception of the works, a subject that has already been addressed quite thoroughly by museum studies professionals.[13] The relationship between the public and the museum is a complicated one and beyond the scope of this anthology except to the extent that museums engage their local communities when determining their acquisitions. Harvard University Art Museums director James Cuno has called for "strengthening art museums as sites for scholarship" as a corrective to the current emphasis on their public mission.[14] These essays respond to this call in their shift away from the public response to museum collections. Specifically, the essays consider an artwork's location as a significant factor in evaluating the ways in which art historians and curators interpret and value that work. Each of the scholars included here argues for the value of their selected work in broadening our understanding of American art history. In this regard, the museums and other institutions that have housed these works have played an invaluable role in preserving them for this new consideration.

In "Art History and Museums," art historian Stephen Bann examines "the museum's alliance with art history."[15] He describes the art historical approach of arranging works by period and by schools of art as "superimposed" on art museums. Bann is particularly interested in the "disruption of the order of the museum."[16] He recognizes the "differences" that exist between museums, whether that difference be between museums from different countries or from different towns."[17] This anthology explores those differences as they relate to the locations of individual works of art. Although all art museums struggle with budgetary constraints, large art establishments like the Metropolitan Museum of Art and the Museum of Modern Art in New York have resources that encourage and support research that advances works in their collections. The essays in this anthology provide analyses of works at institutions with fewer available financial resources to encourage this type of research. As a result, these works are more easily overlooked unless there is a conscious effort by art historians to shift the lens of art historical interest away from works in large museums to those in small and midsized regional ones. These essays demonstrate that *different* art historical narratives emerge when this shift takes place.

Local History/Local Artists

In "Place Exploration: Museums, Identity, Community," museologist Peter Davis observes, "A close and permanent interaction between museums and communities rarely takes place in larger institutions, and the limitations imposed by traditional attitudes, large and historic collections, academic specialists and monumental buildings are clear. Small provincial museums ... are not bound by such strictures and have developed ways to work closer with their communities."[18] Small and midsized art museums often collect works by artists with ties to the geographical region in which the museum is located. This collecting strategy provides an opportunity for museums to engage local narratives related to their specific communities. These local narratives are significant in that they often provide an alternative to the national narratives constructed by large museums. This becomes clear in Miguel de Baca's essay on *La Muerte en su Carreta* (*Death Cart*) (c. 1860), in the collection of the art museum of the Colorado Springs Fine Arts Center. The Center's mission is decidedly regional, described on its website as "building upon our history as a unique cultural pillar of the Rocky Mountain region."[19] Based on the cultural history of the region, it is not surprising that the museum is recognized for its collection of Latin American and American Indian art. The death cart was created by the celebrated *santero* Nasario López and reflects the strong Hispanic presence in the region. The López family had roots in northern New Mexico that extend back to the sixteenth century, and López family members participated in the Penitente Brotherhood Lenten ritual that de Baca describes in his essay. An important religious object for the Penitentes, the death cart, as de Baca describes it, was a "spectral presence lingering behind" European American modernists living in the Southwest.[20] Through his examination of the death cart and its appropriation by these modernists, de Baca sheds light on the death cart's role in shaping an understanding of Hispanic culture that ultimately determined the development of American modernism. De Baca further complicates our understanding of this appropriation through an examination of the death cart's engagement with gender constructions.

Sharing the Colorado Springs Fine Arts Center's mission of collecting regional art, Danforth Art in Framingham, Massachusetts, set a curatorial goal of collecting art from New England. Painter Philip Leslie Hale matched the curatorial interests of the Danforth; he was born in Boston, studied at Boston's School of the Museum of Fine Arts and settled in Boston in 1893 after some travel abroad. Hale's work is also in the collection of Boston's Museum of Fine Arts (MFA), the Danforth's much larger neighbor.[21] Indeed, the new American Wing of the MFA houses a room dedicated to the "Boston School" of American Impressionism of which Hale is a recognized contributor. Danforth Art holds a lesser-known painting by Hale, titled *Deianira, Wife of Heracles, Being Carried Off by the Centaur Nessus* (c. 1897), which provides a very different perspective

on Hale as an artist. As Erika Schneider demonstrates in her essay, *Deianira* is best understood as an expression of American Symbolist concerns rather than those of the American Impressionists. The Danforth's acquisition of a work that does not fit neatly into the predominant perspective on Hale's oeuvre allows for the development of a refreshingly new perspective on his work.

A focus on the local can also serves to position less celebrated artists overlooked by national art museums within national narratives, providing an important corrective to exclusionary studies of canonical artists and yielding a more inclusive history of art. Herbert Hartel adds to de Baca's consideration of European American modernists in the Southwest in his analysis of Raymond Jonson's *Composition Five—The Wind* (1925). The painting, however, is not located in the Southwest but in the Midwest, among a collection of American art owned by the Joslyn Art Museum in Omaha, Nebraska. As Hartel points out, Jonson's painting stands out as the only work by the artist within several hundred miles of his birthplace in Iowa. The purchase of the painting by the Joslyn in 1994 provided the museum the opportunity to celebrate a native son. However, the purchase was also tied to the museum's curatorial goal of expanding its collection of American modern art from the first half of the twentieth century. Hartel writes: "The more that the curators could accomplish in expanding this part of the collection, the more the museum could dispel any notions of the city and state as being regionally marginalized or culturally isolated and provincial."[22] Thus, the painting serves the twofold purpose of celebrating a locally born artist and connecting the Midwest to larger national narratives about modern art.

Another way in which local history can converge with national narratives is illustrated by the 2008 purchase of Charles Caryl Coleman's *Azaleas and Apple Blossoms* (1879) by the de Young Fine Arts Museum in San Francisco. An expatriate, Coleman had no direct ties to California, but his preferred subject matter—East Asian vases—did. Several national art museums can be recognized for their Asian and Asian-influenced collections, including the Museum of Fine Arts at Boston and the Smithsonian's Freer and Sackler museums. On the West Coast, the Seattle Art Museum is another. The 2007 Guggenheim exhibition, *The Third Mind: American Artists Contemplate Asia, 1860–1989*, serves as one example of recent curatorial efforts to recognize the powerful influence of Asian culture on American art.[23] However, the de Young museum has a long-standing commitment to collecting Asian-influenced work based on the more localized cultural history of California that is defined in part by the immigration of large numbers of Asians to the Bay Area and its surroundings. These Asian-influenced works resonate in ways that are specific to California's history and Bell describes this in her essay. More broadly, her research contributes to developing scholarship on West Coast art history that provides an important corrective to the East Coast bias that has generally defined American art history.[24]

The final consideration in this section relates specifically to collecting works of art by local women artists. In her essay on artist Josephine Tota, Jessica Marten evaluates the work of an artist in all likelihood unknown to most people outside of the area of Rochester, New York. Tota had strong personal ties to the University of Rochester's Memorial Art Gallery, where several of her works are now located. She took classes at the Creative Workshop, the Gallery's community art school, and was greatly influenced by one of its instructors. Indeed, she agreed to an exhibition of her work only after the prompting of the gallery's director. Marten's own interest in Tota emerged after discovering some of her paintings in a storage room at the museum. With its long-standing commitment to Tota as an artist, it is not surprising that the Memorial Art Gallery chose to collect her work. More broadly, the acquisition reflects the museum's commitment to supporting the local Rochester art community and preserving its history. In all likelihood, Tota's paintings would be lost if not for the Gallery's specific interests. But it is important to emphasize that the preservation of her work has relevance beyond the goals of the gallery. In her analysis of Tota's *Untitled (Life Story)* (c. 1980s), Marten examines the artist's construction of female kinship networks through the imagery in the painting, a subject of great interest to feminist art historians. In her painting, Tota recounts her profound personal pain; Marten frames that pain as a "rebuttal to the powerlessness she experienced in her life" and connects Tota's experience of powerlessness to the powerlessness experienced by many women.[25] In a climate in which, even today, women artists are neglected by art museums, the preservation of works by women artists at museums like the Memorial Art Gallery is essential.[26]

Marginalized Works Reinterpreted

Essays in the previous section demonstrate that based on their commitment to supporting their local communities, small and midsized regional museums often acquire works overlooked by larger museums. This section considers works in these smaller museums that may have been overlooked in the past because they did not engage the dominating interests of art historians and curators. Frederick Bridgman's *The Funeral of a Mummy on the Nile* (c. 1877) provides the first example. Exhibited frequently in the late nineteenth century and even reproduced as prints due to its popularity during Bridgman's lifetime, this painting suffered a short-lived popularity. As Emily Burns argues, Bridgman self-consciously created a work that integrated French and American influences. As a result, his work did not align with efforts to define American art as uniquely "American," a preoccupation of many American art historians throughout the twentieth century.[27] However, as Bridgman's case reminds us, the interests of art historians shift over time. Although Bridgman

was relegated to obscurity after his death, the cosmopolitan exchange that defines his painting engages the current interest in transcultural exchange by scholars of American art history.[28] The Speed Museum's acquisition of the painting in the 1990s was timely in anticipating this art historical trend.

Maynard Dixon's painting, *The Forgotten Man* (1934), in the collection of the Brigham Young Museum of Art in Provo, Utah, documents the preservation of a work by a marginally recognized artist due to the acquisition goals of a museum with a religious mission. Dixon himself recognized that his painting would be hard to sell because of its "socially conscious" subject matter.[29] However, this was the precise reason for the interest in it by the Brigham Young University Museum of Art, operated by the Church of Jesus Christ of Latter-day Saints, which shared Dixon's interest in works that had "meaning."[30] In 1937 Dixon sold *The Forgotten Man* and three other paintings to the museum after a visit from a Brigham Young University representative presumably interested in buying them. In his essay on *The Forgotten Man*, James Swensen recounts the connection between the painting and the narrative of the downtrodden American produced by Depression Era photographers like Dorothea Lange, to whom Dixon was married at the time he created the painting. However, Swensen provides evidence that the painting runs counter to this narrative by connecting it to the successful Longshoreman's Strike of 1934, now recognized for initiating the modern labor movement in the western United States.[31] Swensen also offers a biographical reading of the work, relating the painting to marriage problems between Dixon and Lange, which ultimately resulted in their divorce.

In contrast to Bridgman and Dixon, Thomas Eakins has remained one of the most celebrated American artists. His work is the subject of much art historical scholarship and can be found in major art museums throughout the United States. Yet his *Portrait of Samuel Murray* (1889) is located at the Mitchell Museum in Mount Vernon, Illinois, a small community art center with only just over a dozen paintings by major American artists. Henry Adams observes that little scholarly consideration has been paid to this painting; in all likelihood few American art scholars have visited the museum to see it. But as Adams argues, this painting has implications for how we understand Eakins as a portraitist; it represents the beginning of a significant shift in the artist's approach to composition. Furthermore, using biography as his lens, Adams calls for a reading of the portrait as an expression of Eakins's love for his subject. Eakins scholarship has largely focused on the artist's work as an expression of national trends at the expense of considering their personal meaning for Eakins.[32] Adams's essay serves as a corrective, while the Mitchell Museum has played an important role in preserving this important work so that it may now be integrated into Eakins's entire oeuvre. Similarly, Jessica Murphy examines a largely ignored painting by Arthur Dove, one of the most highly celebrated American modernists from the first half of the twentieth

century. In her evaluation of *Carnival* (1934), located in the Montclair Art Museum in New Jersey, Murphy expands upon our understanding of Dove's work by considering the artist's representation of a popular form of entertainment in relation to the abstract depictions of nature for which Dove is best known. Perhaps due to the anomalous subject matter, *Carnival* wasn't purchased until 1969, when it was acquired by the Montclair museum.

The location of Palmer Hayden's *John Henry Series* (1944–47), examined by Lara Kuykendall in her essay, is a reminder of the long history of the marginalization of works by African American artists. Hayden's work is located in a gallery at Macy's Department Store in an historically African American section of Los Angeles. During the 1920s and 1930s, it was not unusual to see art displayed in department stores.[33] But when the Museum of African American Art was established in 1976 at Macy's by art historian and artist Samella Lewis, this practice was no longer a common one. In a collaboration that includes free museum admission and the donation of space in the store to the museum, the arrangement between Macy's and the Museum of African American Art is an intriguing model in that the museum location allows for easy access to art for the local community, a community that most art museums are still struggling to better serve. Interestingly, corporate sponsorship, a defining feature of most art museums today, is made explicit by the location. The museum's collection includes 40 paintings by Palmer Hayden, bequeathed to the museum by the artist's wife, Miriam; Hayden's *John Henry Series* was part of this bequest. As Kuykendall describes, in the series, Hayden imagines an African American man with the characteristics of any American hero—strength, courage, and moral character—to create a universal symbol of America's national heritage that could be admired by all Americans regardless of their backgrounds. At the same time, Kuydendall argues that for African Americans, the *John Henry Series* operates as both a symbol of racial pride and as an expression of the desire to be seen as integral to the country's larger national heritage. With the poor acquisitions record of many art museums when it comes to collecting works by African American artists, the establishment of alternative spaces like the African American Museum of Art at Macy's has been crucial in preserving African American art. This museum continues the precedents set earlier by historically black colleges and universities that have been essential in constructing and maintaining a history of African American art.[34]

Although this anthology focuses largely on small and midsized museums, Edward Mitchell Bannister's *Approaching Storm* (1886), in the collection of the Smithsonian American Art Museum (SAAM) in Washington, DC, is included here, as it is instructive in revealing the shifting value of works based on the variable interests of art historians. Bannister's paintings first gained recognition as a result of recuperative projects to construct a history of African American art. In the 1980s, SAAM acquired an impressive collection of more

than 100 works by Bannister. In their interpretation of these newly acquired Bannister works, art historians applied the lens of racial identity to construct arguments for their significance. However, as Traci Costa argues, this lens has been a restrictive one in that it fails to acknowledge Bannister's connection to larger movements, in his case, German Idealist philosophy. Meeting the criteria of SAAM's earlier recuperative project, Bannister's paintings were acquired by the museum. This acquisition allowed for the preservation of Bannister's work that makes Costa's revisionist interpretation possible.

Art Outside of the Art Museum

If the value of an art object can be obscured by its location at a regional art museum, what about art objects located outside of art museums? Objects in these institutions can reveal the limitations of art museums more than the inherent value of the objects themselves. Rice acknowledges that the "Q word, quality" remains a driving force in museum collecting, which she defines as the taste of "a small number of art world insiders."[35] But as Kimberlee Cloutier-Blazzard argues in her consideration of the *Portrait of Mary McIntosh Sargent* (c. 1810), located at the Sargent House Museum in Gloucester, Massachusetts, the value of a work extends beyond connoisseurship. The painting is valued by the Sargent House because it is based upon a portrait by the celebrated American portrait painter Gilbert Stuart. Indeed, Cloutier-Blazzard attributes sections of the painting to the hand of Stuart himself. But beyond this connection to a celebrated American artist that the painting documents is the relationship between McIntosh and her sister-in-law, Judith Sargent Murray, who was an outspoken advocate for women's equality and for whom the Sargent House was built. The two women had a close friendship—despite possible political differences between them—that sheds light on the strong bonds shared by women during the colonial period. Cloutier-Blazzard concludes that regardless of its pedigree, the real value of the portrait resides in its function as a document of McIntosh's life, female friendship, and eighteenth-century gender roles. Historically, large art museums have favored canonical artists, most of whom have been white men, restricted by a rigid and prescriptive form of connoisseurship. This is not to suggest that art museums should abandon their acquisition of "high quality" works, but to recognize the value of works that fall outside of that specific selection criterion.

As with the Murray portrait, a portrait of Pegeen Guggenheim painted by her husband Jean Hélion brings us to a consideration of women's lives. In their essay on *La Fille au Reflet de l'Homme (Portrait of Pegeen Guggenheim)* (1944), Elizabeth Kuebler-Wolf and Connie Cutler reflect upon this little-known portrait in relation to Pegeen's complex identity as the daughter of renown art collector Peggy Guggenheim, stepdaughter of surrealist

Max Ernst, wife of artist Hélion, and an artist in her own right. As Kuebler-Wolf and Cutler explain, this painting is rich with gender implications at the same time that it relates to specific events in Guggenheim's life. Hélion's *La Fille au Reflet de l'Homme* is currently on view in an art gallery opened in 2013 at Peru High School in Peru, Indiana. It was donated along with 137 other works by G. David Thompson, a steel magnate and collector of modern art during a period that spanned the 1940s to the 1960s. As Kuebler-Wolf and Cutler point out, the works donated to the high school had less financial value than those that Thompson gifted to large art museums, New York's Museum of Modern Art being one example. Thompson's personal connection to his former high school inspired him to donate works to the school. Similarly, a large collection of negatives by photographer Horace Poolaw (Kiowa) are located in the heart of Kiowa country, at the Nash Library of the University of Science and Arts of Oklahoma, Chickasha, as a result of Poolaw's personal connections to the Kiowa community. Laura Smith considers the complex lives of American Indian women in her analysis of Poolaw's photograph *Sindy [Sayn-Day-Mah] and Hannah Keahbone* (c. 1930), in which Native women simultaneously reveal their connections to modernity and to traditional Kiowa culture. Scholarship on Poolaw's photography is only now emerging, including Smith's forthcoming book on his work. Without the acquisition of his negatives by the Nash Library, Poolaw's photography might have been lost to scholars, which has regrettably been the case for other Native photographers.[36]

While some works of art have been marginalized due to gender and racial discrimination, the hierarchy of art that has privileged painting and sculpture over other media has marginalized the print. As Sara Picard demonstrates, this marginalization deprives art historians of important historical evidence fundamental to scholarly research. Focusing on *Le Cathedral* (1842), a lithograph by Jules Lion of the St. Louis Cathedral in New Orleans in the collection of the Louisiana State Museum, Picard examines the print as an expression of transcultural exchange between France and the United States in that it celebrates an important Louisiana landmark in a way that is typical of travel imagery from France. Just as Burns argues for the value of Bridgman's *The Funeral of a Mummy on the Nile* as evidence of French-American exchange, prints such as *Le Cathedral* add equally to this discussion of transculturalism.

Finally, the folded paper ships at the Museum of Chinese in America serve as a reminder of the limitations of art museums in collecting objects that fall outside of restrictive definitions of art. Sandra Cheng considers the position of new Chinese immigrants to the United States through an examination of *Folded Paper Ship* (1993), one of a large group of folded paper sculptures created by Chinese detainees held by the US Immigration and Naturalization Service after their 1993 effort to enter the country. It is significant that the detainees turned to the tradition of a Chinese folk craft as a means to cope with their

situation as detainees, although many of the makers were not versed in this tradition at all. As Cheng describes, these folded paper sculptures demonstrate both the detainees' personal connections to China and their hopes to establish a new home in the United States.

Threads: Tying Loose Ends

Not meant to be a comprehensive study, this anthology provides case studies that each demonstrate the fundamental importance of studying objects held at locations other than national art museums. A striking thread in the collection is the richly diverse American cultural history that is highlighted in these works. In the case of Palmer Hayden, Macy's Department Store plays a role in preserving works by an important African American artist. Horace Poolaw's negatives, preserved in an Oklahoma university library, document the contribution of American Indians to the history of American art. Similarly, through the folded paper sculptures made by Chinese refuges, the convergence of Chinese and American traditions becomes paramount. Asian American cultural history also becomes the focus in Charles Caryl Coleman's Asian-influenced paintings, particularly when considering their placement in an art museum dedicated to recognizing the role of Asian Americans in shaping California's history. Hispanic and European American cultures intersect in Nasario López's death cart, preserved due to the acquisition goals of a regional arts center. The death cart and folded paper sculptures remind us of the value of objects that fall outside of traditional definitions of art in constructing a rich and nuanced history of art. Finally, French American cultural exchange defines Frederick Bridgman's painting and the print by Jules Lion, the first located in a regional art museum and the second in a state history museum.

The emphasis of this anthology on local cultural history reflects the current cultural climate in which "the local" has been recognized as an important framework for critiquing globalization.[37] New trends in art museum strategies and in art history reflect this shift in focus to the local. The decision by the National Gallery of Art to disperse considerable portions of the Herb and Dorothy Vogel collection to art museums in each of the 50 United States is one example.[38] Similarly is the emergence of journals like *Outpost*, described on its website as a "publication of innovative art, design and community action from cities (or cities within cities) that have been traditionally underexposed beyond their local contexts."[39] This anthology's focus on the role of small and regional art museums in supporting local narratives contributes to this trend. However, more scholarship is needed. *A Love for the Beautiful: Discovering America's Hidden Art Museums* by author Susan Jaques is a rare example of related writing.[40] Taking a different approach than this anthology, Jaques's

book is a survey of lesser-known art collections rather than an examination of individual works and is directed at the general reader rather than those with more specific interests in art history. In a chapter from the book dedicated to American art, the Colby College Museum of Art, the Addison Gallery of American Art, and the Florence Griswold Museum are recognized for their American collections. For American art historians, Jaques's selections would not be surprising, as these museums have been previously acknowledged for their outstanding collections. Indeed, she quotes preeminent art historians to affirm the significance of each collection. For example, Henry Adams, whose essay on Eakins is included in this anthology, is quoted by Jaques for his perspective on the Addison Gallery of American Art, "If you had to go one place to experience American art, in some ways the Addison Gallery is the best place to go It's very small, it's very select, with great paintings."[41] As Jaques, points out, the Addison has benefited not only by its illustrious patrons, such as Museum of Modern Art cofounder Lizzie Bliss, but also by its equally illustrious alumni who have donated their works to the museum, Frank Stella being the most generous benefactor. Overall, Jaques's book provides an excellent general introduction to outstanding art collections located at a variety of art museums throughout the United States. She gets closest to the focus of this anthology in her recognition of an interesting collection of eighteenth- and nineteenth-century American portraits housed in the Portrait Gallery at the Second Bank of the United States in Philadelphia. As Jaques writes, "Viewing portraits of a young nation within a historic architectural gem is powerful and affecting."[42] Indeed, her example affirms the important role played by institutions other than art museums in the preservation of artworks.

Biography takes on particular significance in several of the essays presented in this anthology, contributing to recent efforts by art historians in "defeminizing and so upwardly revaluing those realms of experience."[43] The significance of biography applies to the Murray portrait by Thomas Eakins, tucked away at a small art center in Illinois. In the case of Maynard Dixon, biography provides us with a more complete understanding of the artist's work. Regrettably, only one work by a woman artist, Josephine Tota, is included in this anthology, although we do get a glimpse at a painting by Helen Torr in Murphy's essay on Dove and at one by Pegeen Guggenheim in the essay by Cutler and Kuebler-Wolf. But the lives of women—as feminists, as artists, as teachers, as wives—emerge from the essays dedicated to Mary McIntosh Sargent and Pegeen Guggenheim as from the essay on Tota's work. The works related to the women presented in these essays are located in such diverse locations as a university art museum, an historic house, and a high school. The role played by university art museums in preserving less celebrated works is highlighted in the case of both Tota and Dixon.

Overall, new perspectives on artists emerge by shifting the lens away from the canonical artists and their most recognized works. Our understanding

of canonical artists becomes more nuanced when we consider their less recognized works, revealed in the essays on Thomas Eakins, Philip Leslie Hale, and Arthur Dove. In all three cases, the works under consideration are in regional art museums. Lesser-known artists like Edward Mitchell Bannister and Raymond Jonson emerge as participants in the broader national discourse when included in constructions of American art history. Bannister's painting is the only work discussed in the anthology that is housed in a major art museum, but even in this case it is a museum with a specific focus on American art, not a large or encyclopedic one. Even today, American art created before the Second World War receives only cursory treatment in these larger museums. The location of Jonson's work in a Midwestern art museum reminds us that a rich history of American art exists between the east and west coasts.

Conclusion

All of the essays in this anthology warrant publication on their own merit for the new perspectives they provide on their selected works. That they are included together in this anthology allows for a consideration of location as one of many factors in how we understand them. What becomes clear through a consideration of these objects as a group is the value of small and midsized regional museums in preserving works of art. University museums, historical houses, even a high school and department store, house artworks that offer important perspectives on the history of American art. Their limited visibility— to art historians and to the wider public—has at times had a deleterious effect on their successful integration into larger discourses of American art history. The museums that chose to house these works should be acknowledged for recognizing their value and preserving them even as they were passed over by larger establishments with different collecting priorities. Fundamentally, these works operate as a form of resistance to cultural hegemony in that the ownership of cultural production is not limited to the hands of only a few powerful art institutions but to a broader, diverse group of organizations that have defined these works on their own terms and ensured their preservation for future scholarship in art history.

Notes

1 See, for example, Marcia Pointon, ed., *Art Apart: Art Institutions and Ideology across England and North America* (Manchester, UK: Manchester University Press, 1994); Carol Duncan, *Civilizing Rituals—Inside Public Art Museums* (London and New York: Routledge, 1995); Emma Barker, ed., *Contemporary Cultures of Display* (New Haven and London: Yale University Press, 1999); and Andrew McClellan, ed., *Art and Its Publics: Museum Studies at the Millennium* (Oxford: Blackwell, 2003).

2 Alan Wallach, *Exhibiting Contradiction: Essays on the Art Museum in the United States* (Amherst: University of Massachusetts Press, 1998), 3.

3 Danielle Rice, "Theory, Practice, and Illusion," in *Art and Its Public*, 78.

4 Ibid., 92.

5 David Carrier, *Museum Skepticism: A History of the Display of Art in Public Galleries* (Durham, NC: Duke University, 2006), 182.

6 See Eilean Hopper-Greenhill, *Museums and the Shaping of Knowledge* (London: Routledge, 1992); and Daniel Sherman and Irit Rogoff, eds., *Museum Culture: Histories, Discourses, Spectacles* (Minneapolis: University of Minnesota Press, 1994).

7 Michel Foucault, "Of Other Spaces: Utopias and Heterotopias," 1967 lecture, http://foucault.info/documents/heterotopia/foucault.heterotopia.en.html, accessed September 1, 2014.

8 Ibid.

9 Ibid.

10 Beth Lord, "Foucault's Museum: Difference, Representation, and Genealogy," *Museum and Society* 4, no. 1 (March 2006): 2.

11 Ibid., 3–4.

12 In summer 2014, I visited the Colby College Museum of Art in Maine, which provides but one example.

13 For the relationship between the public and the art museum, see James Cuno, ed., *Whose Muse? Art Museums and the Public Trust* (Princeton, NJ: Princeton University Press, 2004; and Andrew McClennan, ed., *Art and Its Public.*

14 James Cuno, "Money, Power, and the History of Art," in *Museums and Their Communities*, Sheila Watson, ed. (London: Routledge, 2007), 516. Cuno specifically proposes that the mission of the art museum should include "the production and distribution of scholarship" Cuno, 516. He calls for art museums themselves to support scholarship. However, Cuno's suggestion could easily result in further bias in favor of art objects in large museums, which again, with larger budgets could afford to support scholarship related to their collections in ways that smaller museums could not.

15 Stephen Bann, "Art History and Museums," in *The Subjects of Art History*, Mark Cheetham, ed. (Cambridge, UK: Cambridge University Press, 1998), 234.

16 Ibid., 232.

17 Ibid., 242.

18 Peter Davis, "'Play It Again, Sam': Reflections on a New Museology," in *Museums and Their Communities*, 71–2.

19 www.csfineartscenter.org/information.asp, accessed September 7, 2014.

20 Miguel de Baca, "Blurred Boundaries: *La Muerte en su Carreta* as Artifact and Symbol," 19.

21 The Boston Museum of Fine Arts owns more than 20 works by Hale.

22 Herbert Hartel, "Raymond Jonson: A Southwestern Modernist Alone on the Prairies," 63.

23 Alexandra Munroe et al., *The Third Mind: American Artists Contemplate Asia, 1860–1989* (New York: Guggenheim Museum, 2009). Coleman and a few other West Coast artists are mentioned in the exhibition catalog, but the catalog demonstrates a Northeast bias even for a subject so directly tied to West Coast history.

24 See, for example, Paul Karlstrom, ed., *On the Edge of America: California Modernist Art, 1900–1950* (Berkeley: University of California Press, 1999).

25 Jessica Marten, "At the Margins: The Undiscovered Art of Josephine Tota," 84.

26 For a summary of the evidence of the continued neglect of women artists by museums and galleries, see Maura Reilly, "Introduction: Toward Transnational Feminisms," in *Global Feminisms: New Directions in Contemporary Art*, Maura Reilly and Linda Nochlin, eds. (New York: Merrill, 2007).

27 For a summary of this trend, see Elizabeth Johns, "Histories of American Art: The Changing Quest," *Art Journal* 44, no. 4 (winter 1984): 338–44.

28 A popular American art history textbook is a nod to this trend. See Angela Miller et al., *American Encounters: Art, History, and Cultural Identity* (Upper Saddle, NJ: Pearson, 2008).

29 James Swensen, "Maynard Dixon and the Forgotten Man," 139.

30 Ibid, 148.

31 David Selvin, *A Terrible Anger: The 1934 Waterfront and General Strikes in San Francisco* (Detroit: Wayne State University Press, 1996). The importance of reading Depression era images as images of power rather than victimization is discussed in Lawrence Levine, "The Historian and the Icon: Photography and the History of the American People in the 1930s and 1940s," in *Modern Art and Society: An Anthology of Social and Multicultural Readings*, Maurice Berger, ed. (New York: IconEditions, 1994).

32 See, for example, Elizabeth Johns, *Thomas Eakins: The Heroism of Modern Life* (Princeton, NJ: Princeton University Press, 1983; and more recently, Alan Braddock, *Thomas Eakins and the Cultures of Modernity* (Berkeley: University of California Press, 2007).

33 Jan Whitaker, *The Department Store: History, Design, Display* (London: Thames and Hudson, 2011).

34 See Richard Powell et al., *To Conserve a Legacy: American Art from Historically Black Colleges and Universities* (Andover, MA: Addison Gallery of American Art, 1999).

35 Rice, "Theory, Practice, and Illusion," 91.

36 Native photographers like Jennie Ross Cobb (Aniyunwiya) come to mind. See Hulleah Tsinhnahjinnie and Veronica Passalacqua, *Our People, Our Land, Our Images: International Indigenous Photographers* (Berkeley: Heyday Books, 2006).

37 See Ann Cvetkovich and Douglas Kellner, eds., *Articulating the Global and the Local: Globalization and Cultural Studies* (Boulder, CO: Westview Press, 1997).

38 See press release, http://www.nga.gov/content/ngaweb/press/2008/2008-vogel50x50.html, accessed July 1, 2014.

39 www.outpostjournal.org/#about, accessed August 3, 2014.

40 Susan Jaques, *A Love for the Beautiful: Discovering America's Hidden Art Museums* (Guilford, CT: Globe Pequot Press, 2011).

41 Ibid., 18.

42 Ibid., 35.

43 Anna Chave, "Minimalism and Biography," in *Reclaiming Female Agency: Feminist Art History After Postmodernism*, Norma Broude and Mary Garrard, eds. (Berkeley: University of California Press, 2005), 398. Chave's essay is a call for the use of biography to expand upon our understanding of works by male artists and at the same time the valuing of biography as it relates to women in a way that "what is coded as feminine will not reflexively be counted as secondary" Chave, 399.

PART I
Local History/Local Artists

Blurred Boundaries:
La Muerte en su Carreta as Artifact and Symbol

Miguel de Baca

During the late nineteenth and early twentieth centuries, modern artists coming from the East Coast journeyed to the American Southwest in search of new, bracing subject matter for their work. Many of them stood captivated by the artifacts and rituals of the *Hermanos de la Fraternidad Piadosa de Nuestro Padre Jesús Nazareno* (Brothers of the Pious Fraternity of Our Father Jesus of Nazareth). These "Penitentes," as they are also known, are secretive lay-religious fraternal organizations that served the spiritual needs of Hispanic Roman Catholics in remote stretches of northern New Mexico and southern Colorado. During Lent, the Penitentes came out of secrecy to perform the Passion of Christ, which quickly became attractive to outsiders for its violence, flagellantism, and culmination in a pseudo-crucifixion. Many of the unattributed crosses and adobe chapels represented by these artists in their oeuvres, which became the hallmark of a Southwest modernist style, originated as implements and meetinghouses sacred to the furtive Penitentes.

The subject of this essay is the death cart (Plate 1), a Penitente object less frequently depicted, but one that I argue is a key spectral presence lingering behind these artists' powerful fascination with the Southwest, an analysis of which reveals a deeper understanding of the themes present in their works. Although the use of portable objects in religious plays, or *pasos*, has its roots in medieval Spain, the death cart is unique to this region and has a ritual, rather than a didactic, function. During performance, the elected Penitente brother attached the heavy chassis to his torso with a rope and dragged it from the *morada* (meetinghouse) along the path to the *calvario* (calvary site), intentionally inflicting abrasions upon his body in faith for closer union with God. The chassis supported and partially enclosed the wooden statue of *La Muerte*, presented as either denuded or dressed in women's robes. *La Muerte* is the only female body presiding in this secret fraternal ritual.

Certainly, the crucifixion was the main spectacle of the Good Friday rites, both to the Penitentes who performed it and the uninvited onlookers. But the death cart object bears the allure of an apocryphal—even transgressive—folk gospel, and crystallizes the primitive allure of the region to a generation of artists.

La Muerte en su Carreta

Although the death cart varies in its look between the artisanal studios spanning northern New Mexico and southern Colorado, the typical object is comprised of two elements: the cart, and the statue of La Muerte standing inside it. The cart is assembled of thin wooden splints adhering together to rawhide and mortice-and-tenon joints to shape the four standing sides. Bulkier wood makes up the floor, the main frame of the chassis, two rough-hewn wheels with wooden hubs, and the axle running between them. Wooden roller bearings slipped through the axle on each end brace the cart, chassis, and wheels. A shallow chair, crafted of carved wood and held together by mortice-and-tenon joints, sits inside the cart. Inside the chair, the sculpture of La Muerte provides a powerful visual. The statue is a carved wooden skeleton, unclothed or wrapped in a black woolen or silk mantilla, and striated on the torso and legs to indicate sections of bone, painted with light-colored gesso. Its skull features narrowly set eyes, sometimes inlaid with obsidian, and the wide forehead and pinched features lend an overall impression of desiccation.

Nasario López's La Muerte en su Carreta is an exquisite and unusual artifact not only because it is one of the original objects to exist in New Mexico but also because we have a clear picture of its provenance. Oral history in the Hispanic Southwest tells that López was the first to make an image of La Muerte—a distinction that reveals his reputation as a founding santero (saint-carver) in the region.[1] López's carreta is fashioned without nails, and the body of La Muerte is hand-shaped, suggesting that it was made perhaps even earlier than the date of its attribution circa 1860. Years later, in 1936, the Colorado Springs collector Harry Garnett acquired the cart from José Dolores López, the son of Nasario López, who was a key figure in the revival of the santero tradition in the early twentieth century.[2] By the time of Garnett's purchase, many liturgical artifacts from the elder López's generation were being copied for aesthetic purposes. But the death cart in the Colorado Springs collection originally belonged to a sacred morada and played a role in the Penitentes' ritual performances.[3]

The allegorical significance of La Muerte is semantically obscure. In Penitente communities, she is referred to as Nuestra comadre Sebastiana, which means "Our Godmother Sebastiana"[4] or "Our good friend Sebastiana," and Doña Sebastiana ("Lady Sebastiana"). The title comadre separates her from

la madre ("Mother"), to emphasize her connotative difference from the Holy Mother, the Virgin Mary, who avoided earthly death—according to Roman Catholic dogma, Mary's whole body and soul entered heaven at the end of her life, thus she cannot reappear as skeletal remains. The name "Sebastiana" is a feminine declension of the male Saint Sebastian, who is frequently depicted as martyred by arrows. By contrast, Doña Sebastiana carries a wooden bow strung with sinew, suggesting her agency as the archer, rather than as the victim. Taken together with her macabre appearance, one may assume that her arrows represent the arbitrariness of the moment of demise.[5]

The Penitente *La Muerte* is similar to, but distinct from, other Latin American vernacular *santos*. The skeletal personification of death has its roots in the medieval Spanish *La Parca*, a female character analogous to the Grim Reaper, which traveled with colonizers to the New World in the sixteenth century and adapted to and borrowed from local indigenous religious culture. *San La Muerte* in Argentina and Paraguay and *Rey Pascual* in Guatemala and southern Mexico are male folk saints, and their bony frames correspond in a different way to the body of Christ. *Santa Muerte*, a folk saint that is the subject of intense devotion in the borderlands region between the United States and Mexico, is closest to the Penitente *La Muerte* in her feminine appearance. A salient difference of *La Muerte* is that its devotees are all male, whereas San La Muerte, Rey Pascual, and Santa Muerte appeal to worshippers of both genders.[6]

Another important difference between *La Muerte* and these aforementioned personifications of death is its enclosure within the fugitive world of the Brotherhood. The Penitentes originated as a Franciscan Order, but their spontaneous and creative methods of worship made them unwelcome among orthodox communities of faith. While abstention and suffering are commonly invoked in Roman Catholicism, and are explicitly recommended during Lent, the Penitentes' rites remained at the fundamental extreme. Thus the Brotherhood secularized in 1833 and scattered away from its original *misiones* and the oversight of the Church.[7] As is true for many fraternal organizations, clandestine rituals not only serve to consolidate bonds among the membership but also contribute to outsiders' perceptions that such closeted rituals are illicit. Tellingly, the patron saint of the Penitente Brotherhood is San Juan Nepomuceno (St. John of Nepomuk), whose principal attribute is a finger sealing the lips, symbolic of his martyrdom for refusing to divulge the secrets of the confessional. The veneration of San Juan became increasingly relevant as the Church intensified its persecution of the Brotherhood in the mid- to late nineteenth century. Penitentes also guarded their privacy for modesty's sake, so that the extremity of their worship practices would not eclipse their regular service to the community and the public good.[8]

In Spanish and Latin American traditions, it is relatively common to see Good Friday pageants involving likenesses of venerated saints, but what sets the death cart apart is its mobilization as a form of penance. Indeed, the

live body of the worshipper became the physical target in the death cart performance, forcing his body into submission. In this performance, the penitent faced away from the erect *La Muerte*, accepting a prone position, and harnessed his torso to the chassis with a horsehair or sisal rope. Assuming the weight of the female statue, the penitent dragged it along the path to the *calvario*, causing bleeding in the tissues and skin around the neckline and shoulders. Thus the death cart literally entered the penitent's body, intensifying the sense of human mortality, which *La Muerte* also compactly signifies. Her presence potently suggests the reversal of penetrative agency in unmistakably gendered terms, and may compel us toward the further analysis of penetration as a trope of sacrifice and redemption.[9]

To understand this more fully, we must first examine the penitent's desire to open up his fleshly exterior (to "be penetrated," so to speak), as the physical proof of his interior, intangible belief. Part of this desire is clearly to suffer in sympathy with Christ's wounds, a literal interpretation of the Gospel of Luke, "If any man would come after me, let him deny himself and take up his cross daily and follow me" (9:23). But there is another aspect of this desire, which hinges on the concept of mortification. Here, the scriptural precedent is found in St. Paul's letter to the Romans: "So then, brethren, we are under obligation, not to the flesh, to live according to the flesh—for if you are living according to the flesh, you must die; but if by the Spirit you are putting to death the deeds of the body, you will live" (8:12–13). The believer "dies to the flesh," or becomes "other" to his body, through self-abnegation rituals, including the extremes of self-torture. In another passage, St. Paul was explicit about the foreignness of the body to the believer, in effect making his body "a slave" to his enlightened spiritual will (1 Corinthians 9:27). Thus the penitential Good Friday exercise signifies two desires; likeness to Jesus is implied by the virtual crucifixion, and the desire for bodily self-estrangement is literalized by the bloodied backs of the flagellants and the torso of the brother elected to carry the death cart.[10]

In the all-male atmosphere in which Brothers withstand such mortification practices, the presence of *La Muerte* points to a crisis of masculinity. The ritual customarily acts as proof of spiritual identity as an individual believer as well as the confirmation of the homosocial bonds affirmed by the Penitente community of faith (i.e., as in any secret brotherhood, these are the rites of belonging). However, the death cart admits the female as another penetrating "other" through which belief is strengthened. Such an interpretation is focused by the quiver of arrows belonging to the Doña Sebastiana, conjoining the act of penetration to male submission. Outside the space of performance, patriarchy is affirmed through the fraternal bond, which openly mirrors the single-sex male privilege of the Roman Catholic priesthood. But in the death cart performance, there is a stunning reversal. The penitent's will to enact punishment against his own body is theatricalized by his submission

to a female agent. We cannot definitively understand this entire spectacle of masochism as essentially masculine, but rather, as an example of the incoherence of masculinity—a need to obtain the usually feminized qualities of passivity and bodiliness, and the desire to become abject in the elusive quest for spiritual transcendence.

Becoming the Other

As I suggested at the opening of this essay, artists were drawn to the style and subject matter of indigenous and Spanish colonial culture in the American Southwest. The rugged landscape, distinctive architecture, and colorful Native American and Hispanic religious artifacts appealed to those who had grown weary of modern city dwelling. Such an appropriation of rural, native, and non-Western visual and material culture has always been vital for the development of modernism in the arts. This phenomenon of primitivism is based on the belief that unencumbering oneself from the complexities of contemporary urban life leads to more intuitive and innovative forms of expression.

By the 1910s, there were enough white artists living in northern New Mexico to warrant the establishment of several ateliers.[11] These men, mostly painters, presented Penitente subject matter in a literal way, focusing on the bloodiness of these secret rituals as tableaux replete with flagellants and the ominous *madero*, which is the heavy wooden cross erected at the *calvario* site. For instance, William Penhallow Henderson's *Holy Week in New Mexico— Penitente Procession* (1919) (Figure 1.1) relies on a dynamic sense of line and a bright palette to convey the exciting, exotic Good Friday exercises. The mountains and wild hills in the background conspire with an obtrusive sagebrush plant in the foreground to compress the central action into a tight central strip, which is the arduous path to the *calvario*. Such compression gives the sense of density and chaos among the participating actors, but the wide zone at the bottom edge of the painting separates the viewer from the ceremony. Henderson renders the Brothers' flesh in the same brown tone as the earth, solidifying a relationship between the Penitentes and their land of origin. Splashes of red on their bodies suggest the ubiquity of blood in the ritual.

Curiously, these paintings of Penitente processions omit the death cart; in fact, they aggressively negate the presence of the feminine altogether in favor of a hypermasculinized spectacle of violence.[12] I submit that these white painters' inability to visualize the death cart is the result of a fantasy to identify themselves as participants in an exclusive Brotherhood similar to the one they depicted—a fantasy that did not consciously imagine an assertive presence of the feminine. It is in the realm of the all-male, of "homosociality,"

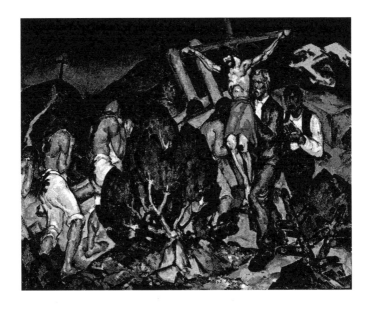

1.1 William Penhallow Henderson, *Holy Week in New Mexico—Penitente Procession*, 1919. Oil on panel, 33 x 41 in. Collection of New Mexico Museum of Art, Santa Fe, NM

that definitions of maleness are practiced and reinforced.[13] The bonds established by these artists in a presumptively alien (yet fully colonized) territory reinforced a new sense of their masculinity, one that traded on the preeminently physical model of manhood understood to be at the core of the Hispanic Brotherhood. And this new masculinity also perceived itself to be unstintingly modern. To borrow the language of Abigail Solomon-Godeau, these white, male newcomers modeled themselves into "savage artists," entertaining powerful dreams of "originality and self-creation, the heroism and pathos of cultural creation, a *telos* of avant-gardism" that was at the root of their quest into an exotic land.[14] Like the avant-garde itself, this narcissistic myth of pure and original discovery regards itself as masculine in its essence. What we, as viewers, see in these paintings is a spectacle of masculine strength corroborated by the privileged artist, who simultaneously aspires to, and is at a gentlemanly arm's length from, the gore.

The self-torture represented in these artists' interpretations of the Good Friday ritual accentuates an exclusively male volition, one that is nonetheless caught in a strange and tenuous network of desires. For in establishing the Hispanic male body as the subject of the gaze, there follows an attendant desire to identify with its audacity and stamina. And, at the same time, it follows that this desire is also directed at the debased "other" that results from the masochistic display. Despite the virility conveyed by the blood-sport aspect of the ritual, it is the sand-colored, opened-up, blood-spurting Penitente body

that best represents the presumptively primitive intensity these white artists sought to possess. The Penitentes' submissive interactions with the death cart find no salient framework because their bodies have already been subjugated to the penetrating gaze of the white artist.

By comparison, let me briefly consider Georgia O'Keeffe's abstract work, which I think further clarifies the masculine terms of these artists' primitivism. The modes of representation employed by the Taos and Santa Fe ateliers make O'Keeffe's paintings seem strikingly sparse. *Black Cross with Stars and Blue* (1929) is one of four paintings of crosses O'Keeffe painted during her first summer in Taos. The authoritative central cross shatters the painting into four uneven quadrants: two upper zones of twilight sky, and two lower ones admitting a view of sky, mountains, and the land beyond. "One evening ... we walked to the back of the *morada* toward a cross in the hills," O'Keeffe recalled of an encounter, "I was told it was a Penitente cross The cross was large enough to crucify a man. It was in the late light and the cross stood out—dark against the evening sky."[15] *Black Cross* is far more compelling than what the artist elsewhere describes as evoking the pervasive Catholicism of the region. Rather, *Black Cross* meditates deeply on the theme of fracture: it alludes to a broken, but absent, body through abstract zones permanently divided into four corners by the monolithic cruciform.

Formally speaking, the cross in O'Keeffe's painting performs the fracture that is the main gesture implied by the whole ritual. However, the cross is the hinge in O'Keeffe's painting that collapses the symbol back into an object and a compositional device, which in turn verifies the self-reflexive, modernist flatness of the canvas as a manipulated surface. The artist's words "large enough to crucify a man" reveal the painting's key omission, which is the spectacularized Hispanic male body that previously acted as the point of identification for artists wishing to establish their own initiation into the world of the "savage." As the art historian Anna Chave has pointed out, "[O'Keeffe] rejected from the first the dominant mode of invoking desire; that is, she did not depict in a literal way the site of desire itself, the human body."[16] Perhaps it was implicit in O'Keeffe's vision that the experience of extreme penance—of virtual or actual penetration—sanctioned by male actors and desired by male painters, already contained within it the key dynamic of becoming the shattered "other" to one's own self. Her sensuous imagery of inexact rectangles and undulating hills instead legitimated a feeling of intense corporeality without having to resolve the crisis of masculine control brought up by the desirable, and yet penetrated bodies, of the Penitente worshippers.[17] In this context, the artist proposed that the magnified desire for brokenness in the modernist Southwest (both literally and figuratively identified by the prominent presence of the *madero*) was already coded as bodily, male, and ethnically foreign, in turn upsetting the white masculine subject's fictive wholeness upon which his modernist "self" was fashioned.

I am not suggesting that it is necessary to know about the death cart, nor even Penitente iconography, to appreciate the formal innovations of O'Keeffe's work, but I think her work is more arresting and abundant when issued into the commonly held gendered determinations of American modernism at a critical moment in its development.

Martha Graham's *El Penitente* (1940)

Thus far I have discussed the appearance of the death cart object in Penitente rituals and the various ways it appears—or disappears—in the paintings of modern artists who came to the American Southwest in the 1920s and 1930s. The last part of this essay concerns the death cart as a prop in *El Penitente* (1940), a modern dance designed by the twentieth-century choreographer Martha Graham. *El Penitente* is a pastiche of the Good Friday ritual replete with a death cart-shaped set piece, designed by Isamu Noguchi, in which Graham substituted her own body for *La Muerte* in the original performance. Graham's substitution is decisive: here, the choreographer's female agency dictates the movement of the male bodies on stage. Her fantastical imagining of *La Muerte* as other biblical figures gravitates away from Penitente belief, but to viewers, radically recuperates the importance of its presence to the crisis of subjectivity implied in the original rites.

Graham perceived the inseparability of the physical and the visual in the Penitente ritual. Like many other artists, Graham visited New Mexico in the 1930s, and wrote about it possessing incomparable "ferocity."[18] As a dancer, it is natural that when Graham studied the Penitentes in New Mexico, she assiduously attended to the positions of the bodies in relationship to their rituals. Agnes de Mille remembers: "[Martha] ... had visited the little one-room mud churches of New Mexico. She had knelt in them ... before the *santos*, the primitive figures of Christ hanging on the cross, with raw wounds and blood painted on the ... bodies."[19] Graham put herself in the position of the worshipping body to be able to theatricalize such movements in her choreography. It is probable that Graham had direct access to Nasario López's death cart, as well. In 1936, Graham danced at the opening of the Taylor Museum in Colorado Springs, where the death cart was one of the earliest accessioned objects of Hispanic religious art.[20]

What is remarkable to me about *El Penitente* is how specifically Graham aligned her method with narrative in a way that reveals the choreographer's physical understanding of the Penitente rituals. For instance, in the first suite of the dance, the character of the Penitent enacts a physical blow to the body emulating the movement of self-flagellation. This movement is accompanied by the dancer's forceful expiration of breath, and this is more than mere theatrics: the dancer's body convulses in anguish, tied to a

solar plexus contraction routinized in the Graham method.[21] The same gesture is expressed in a later suite, when the Penitent imagines Christ watching over him, as the Christ figure indicates by pulling a fabric screen back and forth to meet the Penitent's searching eyes. As Christ thrusts his left arm outward, the Penitent aspirates again, now convulsing along the stage floor. As an early dance in her repertoire, *El Penitente* is an experiment in the movement vocabulary that later became signature choreography. Throughout *El Penitente*, Graham choreographed her dancers' bodies into right angles and extreme floor positions that extend the body to its Vitruvian proportions, modeled on movements attainable by Graham's own highly trained body, which she also demanded of her *corps*.

Graham was the first outsider to imagine the Penitente rituals through an exploration of female identity. While the other two male dancers in *El Penitente* remain stable in their characterizations of the Penitent and the imaginary Christ, Graham begins by identifying herself with *La Muerte*, changing her role to the Virgin Mary, Eve, and Mary Magdalene throughout the course of the dance. Marcia Siegel uses the term "Graham-character" to describe the reiterative exploration of female subjectivity found throughout the choreographer's oeuvre.[22] On one hand, this may be interpreted as conventional: male subjects appear as stable, and female subjects are fungible. On the other hand, Graham acknowledges through the enactment of her various roles (punisher, intercessor, temptress) a more complex, independent state of being. To borrow from the contemporary art theory of Amelia Jones, in turn of Simone de Beauvoir's theory of female "immanence":

> [The] adoption of such structures of femininity work through reiteration to unhinge them. The "bodily norm" of femininity (which instantiates the female psychic subject) is assumed by way of the (usually female) subject's identification with conventional, patriarchal, and heterosexist tropes of the feminine (in this case, women as "immanent," men as achieving "transcendence"); but it is also just such an assumption (or reiteration) that destabilizes as it produces (conventional) sexual identities.[23]

The enactment of multiple female identities is important because it operates outside of the possessive male gaze, which reduces a woman's body to that which is sexually adjunct to men. Graham's identification of *La Muerte* as the crucial first script played by the lead female dancer (indeed, in the original performance, Graham herself) recognizes the subversive agency of the figure within the signifying economy of the all-male Penitente ritual. Leading out from that position, Graham called into play various other female presences that both accept and refuse to abide by traditional interpretations. Adding to this, we remember that her unstinting choreography literally bent the bodies of her dancers into a performance of submission. In effect, as a result of her interaction with the death cart, Graham identified her own body as

the disruptive agent at the center of a highly and self-consciously gendered performance.

The death cart appears as the object of difference in Graham's work, signifying special otherness within a ritual appropriated precisely for its "ferocious" (exotic, nonwhite) appeal. But these issues must be parsed delicately, because representations of the Penitente Brotherhood are deeply entwined with colonialist expectations to find imagined bounty belonging to the "other," as we have seen in certain other artists' quarters in modernist New Mexico. Despite her sincerest hieratic affinities for the material culture of the Penitentes, Graham is not unsusceptible to bias. It should rightly seem that Graham's borrowing of *La Muerte* as one of her many masks points out her privileged position as a bourgeois, heterosexual white woman, and troublingly elides a fuller picture of the original religious culture of the Hispanic Southwest. And yet there is something also appealingly brazen about Graham's excessiveness in *El Penitente*—something plentiful in the way her body moves to the very boundary of anatomical possibility—that unbalances the patriarchal subject as the paradigm of control.

For the purposes of this study, *El Penitente* describes a fascinating reintroduction of the death cart into a modern cultural discourse that had repressed it. By visualizing the Brotherhood, white artists in the Southwest established their practice at the edge of the periphery, emulating their occult mysticism as a metaphor for the avant-garde rejection of mainstream civilization. By working to her own aesthetic, O'Keeffe resisted collapsing into the purely primitive, although *Black Cross* depends on the viewer's connection to an existing iconography in order to deflect its regular meanings. Similarly, Graham deployed Penitente rituals and objects to establish a movement vocabulary based on her own body. To all of these artists the death cart— and, indeed, the entire rich folkloric tradition of the Penitentes—represented special contingency at the limen of identity, the allure of the subversive, and the dangerous and enduring appeal of pain as a pathway to self-knowledge.

Conclusion

In this essay I have emphasized the discursive contexts of Penitente material culture for modernist artists in the Southwest. However, the circumstances of Nasario López's death cart's arrival in the collection of the Colorado Springs Fine Arts Center points out a correlated history of object transmission. Over the course of the first half of the twentieth century, the allure of New Mexico reached an expansive audience of potential visitors, many of whom came west with the desire to possess artifacts suffused with the heritage of the region. In this new marketplace, some younger *santeros* copied the liturgical art of their forefathers for white buyers, while others refused change and allowed their

studios to lapse into desuetude. But the most coveted objects had the aura of authenticity. The Colorado Springs journalist Henry Garnett had begun to amass a personal collection of Hispanic *santos* drawn from the region's renowned makers, including the López carvers. Between 1937 and 1950, the museum (as the Taylor Collection, named for the founding donor Alice Bemis Taylor) worked with Garnett to systematize its acquisitions, including the entire contents of a number of churches and *moradas*. Nasario López's death cart came to the museum via Garnett's collection early on, purchased with funds from Taylor herself.[24]

So what do we make of this admittedly uncomfortable history of appropriated cultural patrimony? In the postcolonial museum landscape, issues of sovereignty now thankfully inform decisions about collection and display. And yet, the death cart is the signifier of a religious tradition decimated by the influx of white settlers in the modernist period. There is another history of colonization still to be theorized — namely, that of the military-industrial complex that established itself in New Mexico, and claimed the state as a scientific proving ground in the Cold War. Here, the concept of decimation necessitates a much more complex, even global, perspective, to understand the social effects of this change. As a "cultural pillar" in the Southwest, the Colorado Springs Fine Arts Center is uniquely enabled to educate the public on the pressures of colonialism that historically have inflected its institutional identity, as well as the identities of the communities it serves and represents.[25] To place the death cart in a comprehensive and perhaps even oppositional history of modernism is but a step in that larger project.

Notes

1 Jonathan Batkin, "Spanish New Mexico and Colorado," in *Colorado Springs Fine Arts Center: A History and Selections from the Permanent Collections* (Colorado Springs, CO: Colorado Springs Fine Arts Center, 1986), 81–118: 91.

2 William Wroth, *Images of Penance, Images of Mercy: Southwestern Santos in the Late Nineteenth Century* (Norman, OK: University of Oklahoma Press, 1991), 152.

3 Batkin, "Spanish New Mexico," 91.

4 In Spanish, the word *madrina* most commonly refers to "godmother," however, the word *comadre* is a term parents use to refer to the godmother, or alternatively, the godparents use to refer to the birthmother; in both instances, it is a term of familiarity and intimacy.

5 Louisa R. Stark, "The Origin of the Penitente 'Death Cart,'" *Journal of American Folklore* 84, no. 333 (July–September 1971): 304–10: 305.

6 See especially chapter 1, "Brown Candle: History and Origins of the Cult," in R. Andrew Chestnut, *Devoted to Death: Santa Muerte, the Skeleton Saint* (Oxford: Oxford University Press, 2012).

7 Marta Weigle, *Brothers of Light, Brothers of Blood* (Albuquerque: University of New Mexico Press, 1976), 8–10.

8 Thomas J. Steele, S.J., *Santos and Saints: The Religious Folk Art of Hispanic New Mexico* (Santa Fe: Ancient City Press, 1994), 111–13.

9 This "reversal of penetrative agency," as I am arguing here, is further supported by the fascinating case of a nineteenth-century penitential *paso* (pageant) involving the figure of Our Lady of Sorrows. One of the principal attributes of Our Lady of Sorrows is a bleeding heart surrounded by seven daggers. In at least one Penitente *morada*, the statue of Our Lady featured two additional daggers descending from its base, such that if the penitent carrying the figure above his head were to lower it at any time during the *paso*, the staves would have stabbed into his shoulders. Stark, "Origin," 310.

10 For a greater theoretical elaboration upon penetrability and the performance of "otherness," I recommend Peggy Phelan's remarkable assessment of the figure of St. Thomas in Caravaggio's *The Incredulity of St. Thomas* (1601)—which has greatly influenced my thinking here—in chapter 2 of *Mourning Sex: Performing Public Memories* (London: Routledge, 1997).

11 Eric McCauley Lee and Rima Canaan, *The Fred Jones Jr. Museum of Art at the University of Oklahoma: Selected Works* (Norman: University of Oklahoma Press, 2004), 162.

12 Oftentimes in the Good Friday ritual, the Brothers made their way to a designated point to be joined by female auxiliaries before proceeding together to the *calvario*. However, only the men practiced corporal penance. Weigle, *Brothers of Light*, 145.

13 Michael Hatt, "'Making a Man of Him': Masculinity and the Black Body in Mid-Nineteenth Century American Sculpture," *Oxford Art Journal* 15, no. 1 (1992): 21–35: 24.

14 Abigail Solomon-Godeau, "Going Native," *Art in America* 77, no. 7 (July 1989): 119–61: 120.

15 Georgia O'Keeffe, *Georgia O'Keeffe* (New York: Viking Press, 1976), n.p.

16 Anna C. Chave, "O'Keeffe and the Masculine Gaze," in *Reading American Art*, ed. Marianne Doezema and Elizabeth Milroy (New Haven: Yale University Press, 1998): 350–70: 354.

17 Chave, "O'Keeffe," 356.

18 Agnes de Mille, *Martha* (New York: Random House, 1956), 175.

19 De Mille, *Martha*, 177.

20 Marshall Sprague, "Colorado Springs Fine Arts Center: Its Formative Years," in *Colorado Springs Fine Arts Center: A History and Selections from the Permanent Collections* (Colorado Springs, CO: Colorado Springs Fine Arts Center, 1986), 11–24: 19.

21 Marian Horosko, *Martha Graham: The Evolution of Her Dance Theory and Training, 1926–1991* (Chicago: A Cappella Books, 1991), 43.

22 Marcia Siegel, *The Shapes of Change: Images of American Dance* (Boston: Houghton Mifflin Co., 1979), 151.

23 Amelia Jones, *Body Art: Performing the Subject* (Minneapolis: University of Minnesota Press, 1998), 179; in Beauvoir's original: "It is male activity that in creating values has made of existence itself a value; this activity has ... subdued Nature and Woman [Woman is defined] as *flesh* ... doomed to *immanence* ... [t]he *Other* [who is] particularly defined according to the particular manner in which the *One* chooses to set himself up. Every man asserts his freedom and transcendence." Simone de Beauvoir, *The Second Sex* (1949), trans. H.M. Parshley (New York: Knopf, 1952), xvi, 60, 233.

24 Jonathan Batkin, "The Taylor Museum: A Tribute to Folk Culture," in *Colorado Springs Fine Arts Center: A History and Selections from the Permanent Collections* (Colorado Springs, CO: Colorado Springs Fine Arts Center, 1986), 43–51: 47.

25 The museum's mission statement is "To provide innovative, educational and multidisciplinary arts experiences, building upon our history as a unique cultural pillar of the Rocky Mountain region," as published on its website: http://www.csfineartscenter.org/information.asp#general.

Echoes of the East, Echoes of the Past:
Charles Caryl Coleman's *Azaleas and Apple Blossoms*

Adrienne Baxter Bell

> I wish I could be in London to show you a few houses and a few men and women, but I will be in Japan, sitting under an almond tree, drinking amber-coloured tea out of a blue and white cup, and contemplating a decorative landscape.
>
> Oscar Wilde, 1882[1]

Since the mid-nineteenth century, California has served as a cynosure for Chinese and Japanese culture in the United States. Spurred by trade and by immigrants who arrived in the Pacific Northwest as laborers and miners, cities from San Diego to San Francisco gradually assimilated East Asian religious ideas and artistic principles into their social fabric. By the late nineteenth century, when Oscar Wilde visited San Francisco on his lecture tour, devotion to East Asian aesthetics had spread deeply into the cultural landscapes of America and Europe. California's prescient appreciation of East Asian culture remains visible today and can be seen in the recent (2008) acquisition of a little-known painting by the de Young Museum in San Francisco: *Azaleas and Apple Blossoms* (1879) (Plate 2) by the American expatriate artist Charles Caryl Coleman (1840–1928). A summary glance at the painting imparts little more than a lovely, flowering plant. However, closer examination of the work within the context of its acquisition by the de Young reveals its multifaceted identity. By situating *Azaleas and Apple Blossoms* within its prestigious collection of American paintings, sculpture, and decorative art, the de Young achieves three important goals. First, it sheds light on Coleman, an accomplished but overlooked American artist, and an unacknowledged leader of the international aesthetic movement that helped to define American and European culture during the Gilded Age. Given the explicit references to Chinese and Japanese aesthetics in the painting, the

acquisition also illuminates and celebrates the long-standing appreciation of East Asian culture in California. Finally, the acquisition reminds us that artists whose work fails to accord with certain constructed aesthetic norms can become unfairly and inappropriately marginalized. Those norms must be periodically reconsidered and revised.

Charles Caryl Coleman: The Road to Rome

By 1879, the year he painted *Azaleas and Apple Blossoms*, Coleman had lived in Rome for more than a decade. Visitors regularly stopped by his studio on the top floor of 33 Via Margutta. "Rome was the Mecca of American Artists," the artist and US Consul David Maitland Armstrong noted at the time, "and there was a large colony of them, many of whom were successful, as American Art was then the fashion."[2] Coleman had received only scattered training in the arts. Born in Buffalo, New York, he had briefly studied painting with William Holbrook Beard and the lesser-known Andrew Andrews. Fully aware of his need for more progressive education, he traveled to Paris to study with Thomas Couture.[3] Coleman's early landscapes and genre scenes reveal his debt to Couture's teaching, which valued the effect of the sketch, or *premier pensée*.[4] While Coleman would engage his keen sense of design in his paintings—particularly in *Azaleas and Apple Blossoms*—he never abandoned his love of the expressive potential of the sketch.

In Paris, Coleman had the good fortune of meeting Elihu Vedder (1836–1923), who would become a lifelong friend. In 1860, after nearly three years of training and ready to test himself as an independent artist, Coleman joined Vedder in Florence, where they entered the circle of the Macchiaioli artists, who favored plein air painting and exaggerated chiaroscuro. The years 1862–66 marked Coleman's brief return to America, during which he served in the Civil War, was honorably discharged, maintained a studio in New York, and began to show his work in exhibitions at the Boston Athenaeum, the Brooklyn Art Academy, and the National Academy of Design (NAD). He was elected Associate at the NAD in 1865; much to his chagrin, he never became a full member.[5] Eager to return to Italy and to continue his friendship with Vedder, Coleman left America in May 1866. Rome served as his headquarters for the next 20 years. Vedder's Roman studio, at 53 Via Margutta, was located only a few steps from Coleman's. (In 1901, Vedder followed Coleman to Capri, where he designed and resided in the Villa Torre Quattro Venti.) In all, Coleman quickly found his place within what Henry James memorably termed "the immensely poetic affair" that was Rome.[6]

Coleman's *Azaleas and Apple Blossoms*

During the late 1870s and 1880s, Coleman painted at least 15 large-scale, exquisitely detailed still life panels. Measuring 71 1/4 inches high by 25 inches wide, *Azaleas and Apple Blossoms* commands attention for its striking scale and proportions. These formal features originate in two sources: first, the unusually elongated horizontal format of Macchiaioli paintings, which Coleman rotated vertically, and, perhaps more conspicuously, in the structure of the hanging scroll, one of the many systems of displaying East Asian painting and calligraphy. Hanging scrolls are displayed in the alcove of a room; as integral parts of Chinese and Japanese interiors, they accord with Coleman's desire to create works of art that seamlessly integrate with their environment. This space, which is designed for the display of prized objects and often includes seasonal flower arrangements, can only be entered to change the display. Coleman alludes to the sacrality of these principles in the elongated format and floral subjects of his decorative panels.

To American eyes, accustomed to the courtly magnolias of Martin Johnson Heade or the stealthy still life arrangements of John Frederick Peto, the character of the flowers in *Azaleas and Apple Blossoms* may seem somewhat improbable; the branches of azaleas are so magnificently attenuated as to defy gravity. In nature, such spindly branches could not sustain their verticality unassisted. Here, by contrast, they wend their way to the apex in a simulacrum of their growth pattern, periodically bursting into dramatic white blossoms. As with many aesthetic movement artists, Coleman sacrificed the exigencies of naturalism for the pleasures of artifice. Meticulously and gingerly, and at key locations, he intersected branch with branch, and blossom with branch, and blossom over blossom to balance dense passages—passages of visual weight—with lighter ones. To counterbalance the painting's verticality, he created three focal points on its horizontal axis. The first—the deep red of the Japanese repoussé bronze jardinière—anchors the structure. The triangular cluster of flowers just north of the painting's midpoint represents the second. The last appears in the lavish clusters of azaleas at the apex. These three intermissions on the branches' vertical escalade generate a nearly Chinese dichotomous structure of contrary, interconnected, and complementary forces in the natural world—dark and light, density and fragility, substance and transmutation—that here undergirds a dynamic aesthetic system in which the whole is greater than the sum of its parts.

In *Azaleas and Apple Blossoms*, four sprigs of pink apple blossoms spill from a blue-and-white pear-shaped bottle vase. The vase plays both historical and autobiographical roles. Fully developed in China during the fourteenth century, blue-and-white pottery production reached its apex during the reign of the Kangxi emperor of the Qing Dynasty (1661–1772); it became enormously

popular in Europe and America when "Chinamania" proliferated in London in the 1870s and famously incarnated in James McNeill Whistler's "Peacock Room" (1876–77). The leaping deer motif, seen on the front of the vase, is an established symbol in Chinese art of strength, agility, and longevity; it counterbalances the azalea, which symbolizes the ephemeral qualities of temperance, fragility, gratitude, and passion.[7] The vase and the adjacent jardinière also signal Coleman's identity as a voracious collector and art dealer. Indeed, Coleman purchased and displayed in his studios many of the objects featured in his decorative panels.

Coleman extended allusions to East Asian symbolism in the ledge's patterned cream-colored cloth, which evokes the characteristic mounting (*heri*) of a Japanese hanging scroll. Each irregularly placed roundel features three interlocking circles in a larger circle; as a group, they call to mind (but do not officially reproduce) Coleman's characteristic interlocked, triple-C monogram.[8] The inscription "Roma" and the date "1879" in the lower-right roundel together stand in for the signature. This form of roundel and the fragments of larger, paler floral roundels that overlap on the slightly darker, mushroom-colored backdrop recall Japanese *mon*—that is, decorative emblems, akin to coats of arms or crests, often displayed separately or printed onto formal attire. Somewhat surprisingly, a fragment of a darker roundel appears in the upper-left corner of the painting. In this asymmetrical state and position, it engages the viewer's curiosity, echoes the fragile nature of the floral subject matter, and recalls the asymmetry favored in East Asian aesthetics. Coleman rehearses the theme of circularity in concave rosettes that mark each of the four corners of the painting's Cassetta frame. In so doing, he unifies the work and conveys his understanding of the entire composition—painting and frame—as an arena for aesthetic engagement.

The City of Rome and the Stratification of History

The rediscovery of Coleman's art—a form of historical excavation—evokes the type of archaeological excavation for which Rome is famous. In this space, the stratification of history remains omnipresent; modern structures are often built directly over ancient ruins. Some medieval churches in Rome (e.g. the Church of San Lorenzo in Lucina, Santa Maria in Trastevere, and San Lorenzo Fuori le Mura) even bear indisputable physical evidence of their long genealogy—pagan or early Christian inscriptions, found onsite—embedded into their façades. Visitors to these sites cannot help but acknowledge the depth of history on which the city of Rome is physically and sociologically constructed.[9] Given his presence in Rome from the late 1860s until the mid-1880s, Coleman would have regularly been exposed to this form of historical pastiche; it is likely, moreover, that it served as one of his primary

sources of inspiration, particularly in the case of the decorative panels, in which he often meticulously juxtaposed objects and symbols from a wide range of historical periods and cultures.[10]

Coleman's Roman Studio

The character of Rome, with its historical stratifications, infiltrated and shaped the character of Coleman's Roman studio. Together, city and studio functioned as more than physical locations for the artist; they housed motifs and galvanized his imagination. To reconstitute a sense of the importance of the Roman studio, we turn to an illustrated report written by an anonymous journalist in 1884 and published in *The Decorator and Furnisher*. It presents us with a paradigmatic aesthetic movement space of vast, high-ceilinged rooms filled with countless objets d'art. The illustrations (by George R. Halm, art director for the magazine) (Figure 2.1) show walls covered with Ottoman and Indian fabrics that set the stage for large cabinets, which Coleman inset with his own decorative panels and topped with small vases, flowers, and

2.1 Illustration by George R. Halm, in "A Roman Studio," *Decorator and Furnisher* (December 1884): 87

decorative plates. A lute propped against a bench vies for attention with an elaborate still life of fruit, wine bottles, an artist's palette, and small book (of poetry?)—the makings of an impressive pastoral concert. Printed fabrics that artfully cover chairs and tables, and that serve as flirtatious curtains between rooms, heighten the aura of luxury and invention. While William Merritt Chase's renowned Tenth Street studio—the 1895 painting of which hangs near Coleman's *Azaleas and Apple Blossoms* at the de Young—also embodied "art atmosphere" for its "dazzling array of beautiful, exotic, and curious objects, decontextualized and massed for maximum visual effect,"[11] it seems nearly Spartan by comparison to Coleman's Roman studio.

As studios often serve as catalysts for the imagination, Coleman mined the contents of his Roman studio for pictorial imagery. When designing *Still Life with Peach Blossoms* (1877; Michael Altman F/A and Advisory Services, LLC), he used the ogival-patterned, brocaded wall covering, perhaps of sixteenth-century Ottoman origin, as a backdrop for the still life; the peony-patterned Indian patka seen above this fabric in the Roman studio later covered the ledge on which the still life rests in the painting. The journalist who visited Coleman in 1884 intuitively understood the catalytic identity of the studio setting. After introducing Coleman to his readers as "a charming gentleman, and above all, one of our best artists," he responded to the invitation to peruse the studio as follows:

> Will I walk in? Yes, indeed. As I pass from the outer to the inner room amid pictures, bric-a-brac, *roba di Roma*, more truly *di mondo*, I am bewildered with their beauty and quaintness. On one side stands an iron crane, a curious bit of hammered work from the home of Titian, near by a lute that Romeo might have played upon, and a poison-bearing poniard that Caesar Borgia might have owned, yes and used. On the other side of the room stands a grotesquely-carved chest, the last resting place of the fair but hapless bride, who in the wantonness of joy on her fatal wedding night hid herself from her too fond lover; yes, there is the old lock that snapped the cord of her young life forever … .

… and so on and so on.[12] The effect is nearly hypnagogic: the journalist—a stranger to Coleman's life and work—nevertheless cannot help but invent stories around each of the objects in the studio; that is, he cannot help but let his own imagination run wild. The vivid reactions were no accident; inspired by the essence of Rome, Coleman collected and fancifully juxtaposed historical objects in his studio with his paintings to create his own vital, oneiric art environment.

Many years later, Coleman would have his photograph taken in a way that embodies the somewhat otherworldly tenor of his studio (Figure 2.2). Dressed in a richly patterned and multilayered floor-length surcoat, he rests in a high-backed leather chair. To his right, a gradual is propped beside a bronze candle-stand. These accoutrements entice the viewer's gaze, yet Coleman

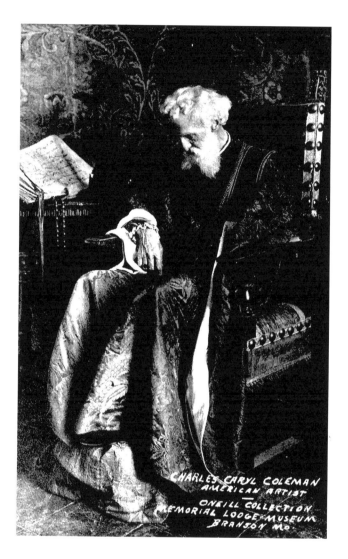

2.2 Photograph of Charles Caryl Coleman, c. 1900. Collection of the author

does not meet the photographer's lens. Instead, with his head bent and eyes closed, he has slipped into a dream, or into the world of his imagination. Unlike American expatriate sculptors, who needed Rome for its plentiful supply of marble and marble copyists, Coleman might easily have remained in New York. Or, he might have visited Italy and returned home, as did many American artists before and after him. And yet, he stayed; he abandoned the ties that bound him to his American genealogy and to American values. In their place, Italy provided him with a flood of inspiration through the

international aesthetic movement. In this fluid, fertile space, disencumbered by prosaic personal history, he could become a Renaissance prince, as seen in the photograph, and invent images that transcended the exigencies of science, time, and historical coherence.

Azaleas and Apple Blossoms in California

The de Young's acquisition of Coleman's *Azaleas and Apple Blossoms*, a painting rich with East Asian associations, suits the museum's long-standing recognition of the Japanese and Chinese presence in America. That presence began during the California Gold Rush (1848–55). Preceding it, there were perhaps only 50 native Chinese in the United States; just a few decades later, there were more than 100,000 and nearly every town in the West could claim a Chinatown of its own.[13] During the nineteenth century, Chinese immigrants worked as laborers; they were largely responsible for developing the mining industry and building the transcontinental railroad. Tragically, their presence generated widespread racism and discrimination. In 1882, state and federal legislatures passed ordinances, collectively known as The Chinese Exclusion Act, that curtailed the entry of Chinese laborers into the country. The 1924 Immigration Act restricted immigration further by excluding all Chinese, thereby "condemning the Chinese American population already in the States to slow suffocation."[14] It was finally repealed by the Magnuson Act on December 17, 1943. The 2000 US Census reported that 49 percent of all Asian Americans lived in the West, with the greatest concentration in the San Francisco Bay Area.[15]

Japonisme and Chinoiserie—terms used to describe the widespread desire to purchase and copy works of art from Japan and China, respectively— in part counteracted efforts to minimize the Chinese presence in America through restrictive immigration laws. Japonisme began when Japanese ports reopened to trade with the West after 1853. For the next 50 years, objects from East Asia flooded European and American markets. European and American collectors purchased bric-a-brac, including prints, fans, lacquers, bronzes, swords, and silks, while artists, including Coleman, incorporated East Asian motifs into their work. Nurturing this continuous flow of trade was a sense that the Japanese "lived a life in harmony with nature, with art and beauty overriding material considerations."[16] As the Chinese population grew in California, so too did the collecting of East Asian art. Today, California hosts 16 major collections of Asian art; together they represent slightly more than 30 percent of the 52 collections in the United States, with three of the top five located in California.[17] The acquisition of *Azaleas and Apple Blossoms* by the de Young and the painting's East Asian motifs and format together advance

this tradition by subtly alluding to the widespread acceptance of Chinese and Japanese culture in California during the past 150 years.

Rediscovering Coleman's Art

Coleman has not been entirely overlooked in the modern era. A few curators have included his paintings in their exhibitions and several American museums purchased his decorative panels. For example, the Museum of Fine Arts, Boston, may have responded to their city's own long-standing appreciation of East Asian culture by purchasing an earlier version of *Azaleas and Apple Blossoms* (1877). However, no museum or gallery has yet given the artist a solo exhibition, and there is no complete published list of his work.[18]

To what causes can we attribute this oversight? First, Coleman almost certainly slipped into obscurity because of the duration of his expatriation; once he left America in 1866, he returned only briefly to meet with friends or to supervise small exhibitions of his work. Italy became his home. This initial decision, especially its tenor of dissatisfaction with the American status quo, excluded him from traditional histories of American art, which favored artists who worked on American soil and who upheld American values, such as nationalism and pragmatism, or who reflected the idea of the sacrality of America in their landscape paintings.

Second, Coleman spent the last 40 years of his life not in Rome—not in the company of fellow American expatriates, who received visits from art-buying American tourists and career-boosting American critics—but, instead, on the island of Capri. While Capri is, of course, accessible, it is nevertheless an island and, therefore, off the beaten path of patrons and critics who might have served as advocates. And yet, the isolation of Capri is precisely what Coleman desired; it distanced him from pedestrian life and, at the same time, nourished his imagination.

Seen from an historical perspective, Coleman's expatriation to Capri hindered him in another way in that, even today, Capri remains weighted with presumptions of wealth and lethargy. How could art history single out a cutting-edge painter from such an indolent setting? Sadly, these stereotypes have long eclipsed the island's virtues, including its prehistoric origins, its rich geological and cultural landmarks, and its physical beauty, all of which have inspired such artists as Albert Bierstadt, Sanford Gifford, and William Stanley Haseltine, and the writers Norman Douglas, Compton Mackenzie, W. Somerset Maugham, Graham Greene, Rainer Maria Rilke, and others. Coleman deeply valued Capri's attributes; for them, he traded the possibilities of wealth and social affluence that might have come from collectors, critics, and art dealers in New York. Had he shared closer physical proximity with

his friend Stanford White, for example, more of his paintings might have joined the distinguished art collections of White's wealthy clients.

Third, the trajectory of Coleman's work diverged from the prevailing trends of nineteenth-century and early twentieth-century American art. When expressivity entered into the American painter's vocabulary through the Barbizon School and emerged as late nineteenth-century Tonalism, Coleman continued to paint meticulously, as evidenced by *Azaleas and Apple Blossoms*. Moreover, he never favored the popular American art forms of portraiture, trompe l'oeil, and cityscapes, which might have gained him recognition and approval. Although his "Songs of Vesuvius" pastels and watercolors (c. 1906) explored the pleasures of abstraction, they bear no signs of influence from European modernism. And while Coleman's preoccupation here with a single motif—Mount Vesuvius, which he could see from his studio in Capri— bears much in common with Cézanne's devotion to Mont Saint-Victoire, we have no evidence that Coleman was inspired by or even saw the works of the French painter. Ironically, histories of art tend to exclude outlying artists.

Finally, while Coleman was an accomplished artist, the genre scenes that he painted in Capri align with more conservative trends in Gilded Age and modern art. He painted what he saw in his environment: local harvesters carrying jugs of wine or oil and baskets of local produce, families working the wine and olive oil presses, and children basking in the island's opulent sunshine. In other works, he conjured Capri's ancient history, envisioning chiton-clad women dancing or lounging in the gardens of Roman villas. To be sure, selected paintings are, like some of their Pre-Raphaelite cousins, "wistfully saccharine" and easy to dismiss as "escapist fantasy."[19] Still, many retain the geniality that attracted their original, intended audiences. In short, tastes change and we need not judge every work of art against contemporary paradigms.

Conclusion

Coleman's neglect is not unusual in the history of art, which is filled with examples of artists resurrected from obscurity. Mark Roskill drew attention to the case of Georges de La Tour (1593–1652), who received his first solo exhibition only in 1972.[20] As with Coleman in Capri, La Tour worked outside of the center of the art world—for him, Paris—painting for most of his life in Lorraine; he remained cut off from its "sophistication" and "up-to-dateness." Both Coleman and La Tour were inspired by earlier art—Coleman by Japanese and Chinese art and Greek sculpture, La Tour by the art of Caravaggio. La Tour's art also failed to accord with the aesthetics of Louis XIV, the Sun King, who countenanced scenes glorifying monarchs and historical subjects, neither of which interested La Tour. "How could it happen in the history of art," Roskill

asks, "that an artist who was so important and successful in his time could be so completely forgotten in this way? And how did he come to be rediscovered again, entirely within [the twentieth] century, so that we now have a sizable number of paintings by him, and he is now recognized as one of the truly outstanding artists of the seventeenth century?"[21] While we may never have full answers to these questions, they surely involve twentieth-century scholars who researched and wrote about La Tour, and who exhibited his work.

Roskill's questions suit the case of Charles Caryl Coleman. The acquisition of Coleman's *Azaleas and Apple Blossoms* by the de Young advances his rediscovery. It was, moreover, entirely fitting, given the close rapport between the painting's subject matter and the museum's location in California, a state renowned for both its receptivity to East Asian immigration and its long-standing admiration for East Asian aesthetics. Now, visitors can, in the spirit of Oscar Wilde, contemplate a decorative scene from the Far East, created by an American artist, and reconsider the aesthetic norms that eclipsed it for so many years.

Notes

I would like to thank Timothy Anglin Burgard, the Ednah Root Curator of American Art and Curator-in-Charge, American Art Department, at the de Young Museum for his thoughtful and very helpful comments on an earlier draft of this essay. Many thanks, also, to Dr. Adriana Proser, John H. Foster Senior Curator of Traditional Asian Art at the Asia Society, and Dr. John Carpenter, Curator of Japanese Art, Department of Asian Art, Metropolitan Museum of Art, for their counsel on East Asian art. Finally, I am grateful to Dr. Cynthia Fowler for selecting this topic for inclusion in this anthology and for shepherding the project with skill and enthusiasm.

1 Letter from Wilde to Frances Richards, c. May 16, 1882, in Rupert Hart-Davis, ed., *The Letters of Oscar Wilde* (London: Rupert Hart-Davis, Ltd., 1962), 119. Wilde was unable in person to introduce Richards to his friend James McNeill Whistler. The comment about Japan was wishful thinking, as Wilde never visited the country.

2 Quoted in Regina Soria, *Elihu Vedder: American Visionary Artist in Rome (1836–1923)* (Rutherford, NJ: Fairleigh Dickinson University Press, 1970), 66.

3 Marchal Landgren, *American Pupils of Thomas Couture* (Baltimore: University of Maryland Art Gallery, 1970), 26–7.

4 Albert Boime, "Thomas Couture and the Evolution of Painting in Nineteenth-Century France," *College Art Bulletin* 51 (1969): 48.

5 On September 9, 1862, Coleman joined Buffalo's Company K, One Hundredth Regiment, and headed for the Southern battlefields. He later volunteered as Second Lieutenant and, on December 23, 1862, was commissioned First Lieutenant. On May 18, 1863, while on duty on Folly Island, SC, he was wounded fairly seriously in the jaw from the accidentally discharged revolver

of a brother officer. See Regina Soria, *Dictionary of Nineteenth-Century American Artists in Italy, 1760–1914* (East Brunswick, NJ: Associated University Presses, Inc., 1982), 91; see also Coleman's entry in *The National Cyclopaedia of American Biography* (New York, 1931), vol. 21, 233. In a letter written three years before he died, Coleman expressed his resentment for what he considered to be a snub by the academy: "I hoped when I sent the 'Return from the Crucifixion' that it might make me a full member of the Academy, but alas! no such good luck. My painting days were finished some years since after having been an A.N.A. for more than half a century." Letter from Charles Caryl Coleman to Edwin Blashfield, February 24, 1925, Edwin Blashfield Correspondence, Box A-F, Mss Collection, New-York Historical Society.

6 Henry James, *The Italian Hours* (1909; reprint New York: Grove Press, 1959), 166.

7 Patricia Bjaaland Welch, *Chinese Art: A Guide to Motifs and Visual Imagery* (Boston: Tuttle Publishing, 2012), 117. On botanical taxonomy, see Alfred Byrd Graf, *Hortica* (East Rutherford, NJ: Roehrs Company, Publishers, 1992). Graf's definitions confirm that the white flowers in the painting are azaleas that resemble the rhododendron "Polar Bear" ("a 'Beltsville' hardy evergreen type azalea suitable for late blooming") (p. 1158) and that the pink flowers stem from the apple tree (*malus pumila* [*domestica*]) (p. 1098). The kinds of flowering fruit tree blossoms that Coleman painted in his decorative panels—apple, quince, cherry, plum, and almond—are all common to the Province of Rome, in which Coleman lived and worked.

8 Coleman may have viewed the form of three circles, or triquetra, in its spiritual light. Known in the field of sacred geometry as the Tripod of Life, it represents the second day of Creation. Within Christianity, it represents the Trinity. Kindred forms, such as the multicircled Flower of Life, have been found in the Ancient Near East and Egypt and date to the seventh century BCE. See Roger Cook, *The Tree of Life: Symbolism of the Centre* (London: Thames & Hudson, 1974). I thank Dr. Ken Ching, Associate Professor of Mathematics at Marymount Manhattan College, for his guidance on this subject.

9 See Ann Marie Yasin, "Displaying the Sacred Past: Ancient Christian Inscriptions in Early Modern Rome," *International Journal of the Classical Tradition* 7, no. 1 (Summer 2000): 39–57.

10 For more on the theme of pastiche in Coleman's work, see Adrienne Baxter Bell, "Utopian Pastiche: The Still Life Paintings of Charles Caryl Coleman," in *A Seamless Web: Transatlantic Art in the Nineteenth Century*, Cheryll May and Marian Wardle, eds. (Newcastle upon Tyne: Cambridge Scholars Publishing, 2014), 147–62.

11 Sarah Burns, *Inventing the Modern Artist: Art and Culture in Gilded Age America* (New Haven and London: Yale University Press, 1996), 49, 50.

12 "A Roman Studio," *The Decorator and Furnisher* (December 1884): 86–7. [No author is given in the original article.]

13 Samir S. Patel, "America's Chinatowns: Dozens of Digs and Collections Are Revealing the Culture, Diversity, and Challenges of the First Chinese Americans," *Archaeology* (May/June 2014): 39. See also Gordon H. Chang, "Chinese Painting Comes to America: Zhang Shuqi and the Diplomacy of Art," in *East-West Interchanges in American Art: A Long and Tumultuous Relationship* (Washington, DC: Smithsonian Institution Scholarly Press, 2012), 127–41.

14 Anthony Lee, "Crooning Kings and Dancing Queens: San Francisco's Chinatown and the Forbidden City Theatre," in *Reading California: Art, Image, and Identity, 1900–2000* (Los Angeles County Museum of Art, 2000), 218.

15 See "Asian American," in *Calisphere*, University of California, at www.calisphere. universityofcalifornia.edu/calcultures/ethnic_groups/ethnic2.html.

16 Christine Guth, "Japonisme," in *The Cult of Beauty: The Victorian Avant-Garde, 1860–1900* (London: V&A Publishing, 2011), 110.

17 California museums with outstanding collections of Asian art include the Asian Art Museum of San Francisco, the Japanese American National Museum in Los Angeles, and the Pacific Asia Museum in Pasadena. For a useful collection of essays on this topic, see Gordon H. Chang, ed., *Asian American Art, 1850–1970* (Stanford, CA: Stanford University Press, 2008).

18 See Alice Cooney Frelinghuysen, et al., *In Pursuit of Beauty: Americans and the Aesthetic Movement* (New York: Metropolitan Museum of Art, 1987), 320–21, 329, 333. The volume also contains a very helpful biographical and bibliographical entry on Coleman by Catherine Hoover Voorsanger (pp. 410–11). More recently, two of Coleman's paintings were included in Regina Soria, with Gabriele Borghini and Elena di Majo, *Viaggiatori Appassionati: Elihu Vedder e Altri Paesaggisti Americani Dell'Ottocento in Italia* (Comune di San Gimignano, 2002). For a complete list and critical examination of Coleman's work, see Adrienne Baxter Bell, *Transnational Expatriates: Coleman, Vedder, and the Aesthetic Movement in Gilded Age Italy* (forthcoming).

19 Ken Johnson, "Pining for a Burnished Time, Long Ago and Far Away," *New York Times,* June 6, 2014, C23.

20 See Jacques Thuillier, et al., *Georges de La Tour* (Paris: Réunion des Musées Nationaux, 1972). The exhibition in the Orangerie des Tuileries was organized by Michel Laclotte, Pierre Rosenberg, and Jacques Thuillier.

21 Mark Roskill, *What Is Art History?* (London: Thames and Hudson, 1976), 124.

Shot through the Heart, the Woman Is to Blame: Philip Leslie Hale Performs a Symbolist Game

Erika Schneider

Boston-based artist and teacher Philip Leslie Hale (1865–1931), while known for his popular Impressionist-style paintings, also explored the more controversial Symbolist style. His *Deianira, Wife of Heracles, Being Carried Off by the Centaur Nessus* (c. 1897) (Plate 3) at Danforth Art in Framingham, Massachusetts, represents an unusual example of this experimentation. Mentioned briefly in his biography by the artist's daughter, the painting diverges from Hale's oeuvre in its exploration of sexuality and betrayal. How the work and its preparatory drawings came to this small suburban museum as well as the recondite meaning behind the subject form the basis of this study.

Danforth Art Museum

Danforth Art, called the Danforth Art Museum when it was founded, has a focus on American art and the New England region and started as a small local effort without any assistance from a Danforth family. In 1975, a group of residents composed of business people, professors, and art enthusiasts decided the Boston suburb needed an art museum of its own. Framingham, which is about 20 miles west of Boston, has a current population of more than 68,000 people and boasts a history dating from before the American Revolution. Framingham State University, founded in 1837, anchors the center of the town, and members from the college were instrumental in the museum's formation.

One of the original board members, Paul Marks, proposed to name the museum after Thomas Danforth (1623–99), the Deputy Governor of Massachusetts Bay, to convey the regional mission of the new art institute.

Danforth's family, as friends of King Charles of England, received a royal grant of land in the wilderness to the west of Boston in the early seventeenth century. Thus, he owned much of the land that now constitutes Framingham and the surrounding towns.[1] As a staunch critic of the Salem Witch Trials, Danforth also later donated part of his land to one of the accused and her family. Many local sites in Framingham bear the Danforth name, included a park, street, and gymnasium.

Danforth Art's collection today consists of more than 3,000 works with a concentration in American art from the eighteenth century to the present. The collection includes works by well-known artists such as Albert Bierstadt, Meta Warrick Fuller, Charles Sprague Pearce, Jaune Quick-to-See Smith, Faith Ringgold, Gilbert Stuart, and James McNeill Whistler. Most of the pieces, including the Hale works, came into the Danforth in 1970s, but the museum has been steadily collecting, primarily through donations and gifts. As the mission has been clarified, the collection policy has shifted slightly. For example, Boston Expressionism, a mid-twentieth-century movement known for gestural and emotional works, now forms a major component to the museum's collection with around 300 related works.[2] In the 1970s, the mission was to collect American art with a focus on New England artists such as the Boston School of which Hale was a part.

Between 1975 and 1976, William and Evelyn Wolfson donated eight Hale works to the fledgling museum, where their children took art lessons, to support the local institution. Although William Wolfson saw the Hale works mainly as a financial investment, his wife appreciated their colors, subjects, and mood and has maintained a large number of the original group.[3] The donated works included *Deianira, Wife of Heracles, Being Carried Off by the Centaur Nessus* and two preparatory works, a drawing of his wife Lillian Westcott Hale, two oil paintings, titled *Ninon* and *Glitter*, and an oil and study for the work *Riders on the Beach* (1890s).[4]

Hale's Career

After passing qualifying exams at Harvard University to appease his Unitarian minister father and patrician family, Philip Leslie Hale received art training in America and abroad. He attended the Museum School in Boston and the New York Art Students League before going to Paris to study at the Académie Julian and École des Beaux Arts. He showed in Paris, Boston, New York, Philadelphia, and Chicago and began teaching at the Museum School in 1893 while spending his summers in Giverny, France, in the artist community that developed around Claude Monet. These early years represented an influential time for him.

Throughout his career, Hale's style demonstrated aspects of Impressionism and post Impressionism, particularly the work of the Nabis and Symbolists. His brushstroke never had the fluidity of the French Impressionists, the artist preferring a more academic structure and modeling of form as did most of his Boston School colleagues such as Edmund C. Tarbell and William Paxton. However, his colors and compositions favored the more experimental work of Post Impressionism. The tendency for high-keyed colors manifested itself in his teaching. Beginning in 1898, he taught summer classes in Matunuck, Rhode Island, humorously commenting, "Students are advised to bring ... plenty of chrome yellow no. 1. It is well to anticipate the yellow fever."[5] This popular nineteenth-century lead-based yellow dominates many of his landscape works such as *Girls in Sunlight* (1895), now in the Museum of Fine Arts, Boston. His more simplified *Landscape* (c. 1890), also in Boston's collection, demonstrates his movement toward modernist tendencies related to *Les Nabis* in the "flatness of the design and the primacy of surface pattern."[6] The painting at Danforth Art falls into the time period when Hale was still traveling to France and before he married fellow artist Lilian Westcott Hale and settled in Dedham, Massachusetts.

Centaur and Nude

Although *Deianira, Wife of Heracles, Being Carried Off by the Centaur Nessus* is the title of Hale's painting, the subject is far from clear. The work's alternate titles suggest the multiple interpretations the painting has undergone in its more than one hundred-year history. According to Ovid's *Metamorphoses*, Heracles allows Nessus to ferry his wife across the raging river Evenus only to shoot the centaur when he abducts her. In the preparatory sketches, the work appears as *Centaur and Nude* or *Flight of the Night*. Both titles imply a mythological or allegorical subject, but they lack the precision and more salacious aspects of the later title. Creating a more specific narrative not present in the drawings and pastel, Hale introduced the archer only in the final oil painting. Furthermore, in the painting the centaur has wings, which are not part of the original myth. The large size of the painting—at 48 x 76 inches—suggests he had higher exhibition aspirations for the piece than relegating it to his studio where it languished until his death. Throughout all stages and variations, the focus remains on the two ascending figures.

In the painting, the central figures are the centaur and nude, whose anatomy Hale tightly rendered as was typical of his style. The centaur is identified by his body of a black horse and the torso of a muscular man.[7] The eroticism of the painting derives from the female figure. Across his chest and thrown over his right shoulder lies the prone body of a fair-skinned nude woman who languidly drapes her left arm over his other shoulder. Her legs hang

evocatively between the centaur's reared front legs. Both of their bodies arch backwards as her auburn hair flows into his crimson wings whose feathers burst out with blue and green tips and burnt sienna shadows. The imaginative colors and deviance from the classic myth demonstrate Hale's ability to create suggestive variations of traditional themes.

The details in the faces indicate less abduction than willing acceptance. Deianira sensuously parts her lips and seems to nestle her head under the centaur's chin, which is thrust upward as he receives the fatal blow from Heracles's arrow.[8] The sexual abandon of Deianira is unusual in the myth because her cries for help are what alert Heracles to her abduction. She is supposed to fear or resist Nessus. Instead in Hale's painting she surrenders to her erotic desires in a type of rape fantasy, thereby expressing her own forbidden yearning. Hale minimizes the damsel's peril while heightening her sensuality.

Heracles and Nessus

The prurient details of the Heracles and Nessus myth intrigued Symbolists. As a legendary randy centaur, Nessus could not resist the young woman's beauty. Ovid recounted the fatal attraction:

> But you, ferocious Nessus, who were struck
> with love for Deianira, lost your life:
> a flying arrow pierced you through the spine."[9]

When Nessus tries to ravage Deianira, Heracles shoots him with a Hydra-poisoned arrow, warning him first:

> Nessus, to thee I call (aloud he cries)
> Vain is thy trust in flight, be timely wise:
> Thou monster double-shap'd, my right set free;
> If thou no rev'rence owe my fame and me,
> Yet kindred should thy lawless lust deny;
> Think not, perfidious wretch, from me to fly,
> Tho' wing'd with horse's speed; wounds shall pursue;[10]

While these passages by Ovid affirm the prurient nature of the myth, Hale's variation has much more drama as the sky frames the flying figures high above the land.

The rest of the story, not pictured in Hale's work, concludes in tragedy. With his dying breath, Nessus deceitfully entices Deianira to make a purported love potion from his blood to ensure Heracles's faithfulness. The toxic concoction eventually leads her unwittingly to kill her husband when she suspects him

of betraying her. After she anoints his cloak with the potion, she gives it to his faithful servant Lichas to deliver. When Heracles puts it on, it burns and adheres to his flesh. When he tries to remove the poisonous garment, he tears his own skin down to the bone. In his anguish, he throws himself on a funeral pyre. Thus Deianira, whose name means "man-destroyer" or "destroyer of her husband," becomes an unintentional femme fatale who kills the demigod. She then commits suicide.

The story of Deianira and Nessus focuses on violence, sexuality, and tragedy. These themes are not usually in Hale's repertoire but they are typical of Symbolist artists. In contrast, most of Hale's works consist of light-filled landscapes or domestic interiors with pensive female figures. Although he often sketched from the nude, his finished compositions rarely included nudity. His symbolist exceptions warrant further examination because they redefine his position in the history of American art. For example, Swiss Arnold Böcklin (1827–1901) and German Franz von Stuck (1863–1928) also explored the mythological story of Heracles and Nessus. Although these other adaptations most likely postdate Hale's work, and it is unlikely that Hale saw the works, their examination demonstrates how Hale's American version of Symbolism lacks the violence of the European Symbolists, but shares their interests in sexuality.

In Böcklin's *Nessus and Deianira*, he pushed the action to the foreground with burly figures who barely remain within the picture frame.[11] With hoofs clearly planted on the ground, the dark-skinned, wide-eyed centaur looks more beast than man. His human torso has as much fur as his horse body, and the hair from his head, beard, and mane intermingle. The kneeling and partially exposed Deianira grasps Nessus's beard while trying to remove his hand from her covered breast. Nessus gasps with surprise, and Deianira grimaces with disgust. Unlike Hale's female protagonist, this Deianira protests fiercely. Behind the muscular wrestling figures appears an aged Heracles in the lower right, who strategically aims a spear, not the traditional Hydra-poisoned arrow, between the centaur's legs, but he is a minor character in the lustful conflict. In Stuck's versions of the story, *Heracles and Nessus* from 1899 and 1927, he also emphasized the figures but Heracles plays a more active role in the composition.[12] Clad only in the Nimean lion skin wrapped around his head and loins, he has just released the lethal arrow into Nessus's back, which is covered by his ponytail mane. Caught mid-leap, the centaur rears up while holding a clothed Deianira across his front. She looks back at us in terror, wide-eyed and open-mouthed. Her protest is more helpless than Böcklin's muscular Amazon's. Despite the difference in Heracles's role, the erotic charge of the painting remains in all three images.

Defining Symbolism

Symbolists championed the need to express mood and feeling over static representation, sentiments that led more conservative critics to label this movement's adherents as decadent. Such charges served only to make this important post-Impressionist movement a seductive alternative to the status quo because it gave artists the freedom to break away from the confines of artistic formalism while still acknowledging the classical references and moralizing allegories that dominated academic art during the nineteenth century. Both Böcklin and Stuck embraced these elements in their careers and in their representation of Heracles and Nessus. As an American, Hale may have avoided the more blatant characteristics in a way that would have played to American tastes. By investigating themes of sexuality and betrayal through the classicizing lens of mythology, Hale examined subjects that were widely contested in nineteenth-century America.[13] Consequently, American patrons were hesitant to support the style.

Hale's Symbolist Game

Hale's daughter recalled that the artist painted unpopular allegories toward the end of his life. In her 1957 biography of the lives of her artist parents, Nancy Hale described three unnamed paintings in the studio as among these unpopular allegories: *Riders on the Beach, Heracles and Nessus* (1897), and *Moonlit Pool (Flowers in the Moonlight)* (1919).[14] Although she does not use the Heracles and Nessus title, she clearly describes the painting at the Danforth: "One was of a winged centaur, fabulous, soaring against a crimson-streaked dark sky while, far below on earth, stands the tiny relentless figure of the archer who has loosed the arrow that has struck the centaur's flank to bring him down."[15] By neglecting to mention the nude female figure in the composition, she avoids the blatant sexuality of the work, and this is the main point of the painting. The debate among American audiences about sexuality often led to the disapproval of the sexuality in Symbolist works, particularly when coupled with violence. Hale's luscious treatment of flesh, both of the woman and the centaur's torso, increases the work's sensuality but guarantees its rejection as well.

Other Hale works engage a Symbolist mood, such as the aforementioned *Moonlit Pool*, but also *Spirit of the Night* (c. 1920), *Girl with Gulls* (c. 1920), and *Fenway Studio* (1922). All of these works ended up in the Hale attic and then at a 1966 Vose Galleries exhibition of Hale's work. In all these works, enigma replaces subject. *Moonlit Pool* (Figure 3.1) features a supple nude woman floating in a blue lake. Her blonde tresses spill out behind her as her arched body sinks beneath the translucent water. With her arms spread wide, she

seems to surrender to the pool, much like Hamlet's Ophelia. Nancy Hale mused, "[S]he is, perhaps, dead."[16] Yet the only flowers here are water lilies reminiscent more of Monet's Giverny than the Shakespearian heroine's watery grave. Furthermore, the clandestine setting coupled with the figure's nudity suggests a sylvan sprite or water nymph more than a mere mortal. Without further details, the narrative remains enigmatic. This layering of possibilities and meanings situates the painting within the Symbolist aesthetic. After conceding that it won neither prize nor recognition at the National Academy of Design, a *Hearst's Magazine* critic wrote, "'Flowers in Moonlight' presents to our admiration a veritable poem in paint … . Never before has an artist depicted with such success a form down in the mysteriousness of the water's depth, a figure just visible, not by a trick but by a consummate artistry."[17] The writer continues to use lyrical descriptions without concerning himself with narrative or content, praising its mystery where others did not.

The *Hearst's Magazine* article also highlighted another Symbolist work by Hale through a photograph of Hale in front of his unfinished life-sized *Spirit of the Night*.[18] The painting features two figures, one diaphanously clothed and one nude. The draped figure serenely opens her arms and veil to envelope protectively the vulnerable nude who leans onto her shoulder. A double-branched tree behind them echoes the lines of their legs in reverse. The sky is sapphire and sprinkled with stars. The dreamy mood, contrast between nude

3.1 Philip Leslie Hale, *Moonlit Pool*, 1919. Oil on board, 37 1/2 x 72 in. Private collection

and clothed figures, and lack of specific mythological identification makes for an unusual allegorical night subject. *Girl with Gulls* (Figure 3.2) (shown as *Aphrodite of the Sea Gulls*) offers an even more bizarre experiment. A nude stands on frothy waves as she combs her hands through her long locks over her head and lets them cascade down past her hips. Like an academic birth of Venus, the figure has idealized proportions and a mesmerizing gaze that extends beyond the viewer. Instead of mythological zephyrs carrying her to shore, white seagulls proliferate below and behind her, seeming to emerge from the waves and her hair. The figure's frontality and over life-size large scale (84 x 47 1/2 inches) add to the oddness of the work. She could be a modern goddess, but her confrontational nudity and the plethora of seagulls modernizes a purely mythological reading. Shown at the National Academy of Design and the Museum of Fine Arts, Boston, it found no buyer like his other Symbolist works.

Stylistically, *Fenway Studio* stands out for its Whistlerian mood in its muted tones, loose brushstrokes, and geometric framing. Standing on the stairs of Hale's Boston studio, a woman in white passes a bouquet to another woman above who leans over the railing. The strong diagonal of the stairs counterbalances the multiple rectangular frames, and the bouquets of flowers on the landings soften the angularity. The Asian-inspired screen, ikebana flower arrangement, and cropped composition reveal the influence of Japonisme, prevalent in France when Hale studied there. The lack of narrative and harmonious arrangements of forms aligns the work with the Aesthetic Movement with its "art for art's sake" credo that closely parallels tenets of Symbolism.

Unsellable Allegories

Hale failed to gain recognition for his painting, Symbolist or other styles. Some art historians have attributed the artist's neglect to his extremes in style or the enemies he made during his lifetime.[19] For example, he critiqued the *New York Tribune*'s esteemed, albeit conservative, art editor Royal Cortissoz when he defended fellow Boston artist Paxton. He also criticized progressive New York painters, such as the members of The Eight for what he perceived as their technical deficiencies.[20] And although he won numerous prizes and showed two works at the landmark International Exhibition of Modern Art, or Armory Show, in 1913, he never became a full academician at the National Academy of Design and remained an associate member only. Even after his death, Hale did not have a resurgence in popularity.

Rather than dwell on the sensational details or try to explain the enigmatic narratives of the forgotten Symbolist works, Hale's daughter attributed the

3.2 Philip Leslie Hale, *Girl with Gulls*, c. 1920. Oil on board, 84 x 48 in. Private collection

negative response to the allegorical nature of the works. She explained their forgotten status:

> Such pictures will always be unsaleable. They belied, moreover, every tenet of painting in which my father believed—being of imaginary subjects, not painted from the model, nor demonstrating the composition of light. They lacked everything except meaning, secret and protean meaning: the meanings of a literary mind, to which, in the end, he must have been driven.[21]

Unlike Hale's Impressionist works that used the model and considered the nuances of color and light, these works eschewed those aspects. Although his daughter found the works to be too imaginative, she recognized that the intangible was the appeal for her father. In her biography, she noted that her father was perpetually sad, which she based on his lack of artistic success in comparison to her mother who made a robust living from her portrait commissions. As Hale himself once bitterly declaimed, "But don't forget this little paradox, that the more talent a man has, the more trouble he's likely to have in making a living, and the worse he paints (provided his stuff is passable) the more immediate success he will have."[22] If one applies this credo to the artist, Hale claims that an excess of talent has led to his own failure. On the other hand, his daughter failed to recognize the importance of the "allegories."

In 1963, three years after her mother's death, Nancy Hale ostensibly sold her father's remaining 70 works to increase his recognition. She explained in a 1988 interview, "My mother had been hoarding his pictures in the attic for years because she wanted them to appreciate in value, but I didn't think they were going to—just left them with nobody seeing them. I thought they ought to get out into the world and be shown."[23] The treasure trove included sketches, silverpoints, oils, and watercolors. Hale's *Heracles and Nessus* works were among them. Although the large scale of the final oil indicates the artist intended to exhibit the work, he abandoned the work in his studio. His early death precluded further reexamination, and his wife removed this painting along with other "unsaleable" Symbolist works from public view. Businessman Franklin Folts spearheaded the purchases for Danforth Art along with his brother and three other investors, one of whom was Danforth Art donor William Wolfson who received 24 percent of the collection, the second largest percentage after Folts. When the works resurfaced, American art, let alone Symbolism, remained in its infancy in collecting and scholarship.[24] Without the Danforth Art Museum's community outreach and art classes coupled with the neglect of American art, *Heracles and Nessus* could have easily ended up in the storage of a larger New England collection or auctioned out of the region altogether.

The campaign to bring Hale to an esteemed place in American art began in fervor after this purchase. In his 1966 introductory essay for the Vose

Galleries exhibition, Folts predicted the forgotten artist's resurgence. Citing Hale's numerous lifetime awards along with national and international museum representation, Folts acknowledged the artist's lack of commercial success. As a major investor, he had much at stake in increasing the value of the works. In the Vose Galleries press release Folts avowed, "Hale has all the proper credentials—fabulous family, prizes and awards, education, exhibits (like Durand-Ruel)—that seem to be necessary for a guy to possess before people can make appropriate judgments regarding the worth of his work. He's also been dead the magic number of years."[25] Despite Folts's predictions, most critics did not value Hale's works in the twentieth century. Even a 1979 appearance of *Moonlit Pool* on the cover of Charles Eldredge's pivotal book, *American Imagination and Symbolist Painting*, did not change the Hale market. As Robert Hale Ives Gammel, a former student of Hale, wistfully explained in his posthumously published 1986 book on the Boston School, "His paintings enjoyed very moderate success in his lifetime and they are not likely to be regarded as more than period curiosities in the future."[26] Instead, Hale appeared as a coda in the history of American Impressionism or as a source of inspiration to his more popular wife. Hale's Symbolist works did not start to appreciate until the twenty-first century. In 2004, *Girl with Gulls* sold for $62,000, twice the estimated value.[27]

Conclusion: Hale and American Symbolism

American Symbolism remains an underappreciated transitional movement linking academic styles to more avant-garde tendencies. Hale provides a pivotal example of this transitional link. Hale responded to French modernist trends when he experimented with light, color, and composition. He expanded upon these elements when he chose subjects outside the traditional Impressionist scenes of everyday life. By combining an interest in the technical and the modern, he created a new type of Symbolist art. The painting *Deianira, Wife of Heracles, Being Carried Off by the Centaur Nessus* gives us a glimpse into this experimentation. Examining Hale's painting within the context of an American Symbolist movement repositions Hale in a new art historical context outside his narrow definition as a Boston School Impressionist. Doing so is central to understanding a crucial period in American art history, a period that in many ways set the stage for the subsequent arrival of modernism in the United States during the early twentieth century. The Danforth Art's choice to accession this and other paintings by Hale, paintings that would not have been of interest to museums that understood Hale only within the context of the Boston School, allows us to reconsider Hale from this broader context.

Notes

1 Paul Rosenberg, "History of the Danforth Museum," unpublished essay (2000), e-mail from Rosenberg to author, June 25, 2014.

2 E-mails from assistant curator Jessica Roscio to author, June 13, 14, and 17, 2014; e-mail from registrar Kristina Wilson to author, June 12, 2014.

3 In-person interview with Evelyn Wolfson (Wayland, MA), June 17, 2014.

4 In the late 1970s, the Danforth Museum de-accessioned the studies for *Riders on the Beach*.

5 Philip Leslie Hale, quoted in Trevor Fairbrother, *The Bostonians: Painters of an Elegant Age, 1870–1930* (Boston: Museum of Fine Arts, 1986), 211.

6 See the description on the MFA, Boston's website: http://www.mfa.org/collections/object/landscape-34732. Accessed June 26, 2014.

7 The wings appear only in the color compositions—a preparatory pastel, not in the Danforth collection, and the Danforth oil sketch and oil painting.

8 In the drawing, the woman closes her eyes and appears submissive, even turning her head toward the centaur's face.

9 Ovid, *Metamorphoses*, trans. Sir Samuel Garth, John Dryden (1717): Book Nine, lines 98ff.

10 Ibid. The wings on Hale's centaur may originate with Ovid's description, though translations differ among authors.

11 As an early Symbolist, Böcklin often combined mythological and fantastical subjects. Arnold Böcklin, *Böcklin* (Munich: F. Bruckmann, 1975).

12 Bram Dijkstra, *Idols of Perversity: Fantasies of Feminine Evil in Fin-de-Siècle Culture* (New York: Oxford University Press, 1986), 280. An admirer of Böcklin and a founding member of the Munich Secession, Stuck focused on seductive female nudes from mythology.

13 For a discussion of sexuality in nineteenth-century America, see Helen Lefkowitz Horowitz, *Rereading Sex: Battles Over Sexual Knowledge and Suppression in Nineteenth-Century America* (New York: Knopf, 2002).

14 Nancy Hale, *The Life in the Studio* (Boston: Little, Brown and Company, 1957), 204. Despite Nancy Hale's recollection of these being late works, only *Moonlit Pool* dates from the twentieth century; the other two were late nineteenth-century works that also never found buyers.

15 Ibid.

16 Nancy Hale, *The Life in the Studio*, 205.

17 Gardner Teall, "As in a Steel Sword: True Refinement in Art," *Hearst's Magazine* 37, no. 2 (March 1920): 40, 69. The painting won the Popular Prize in 1919 at the Pennsylvania Academy of the Fine Arts where Hale taught.

18 One of the titles used for *Heracles and Nessus* included *Return of the Night*, linking the subject of the two paintings.

19 Fairbrother, 59, 211. R.H. Ives Gammell, *The Boston Painters, 1900–1930* (Orleans, MA: Parnassus Imprints, 1986), 129–30. Hale is not even mentioned in American art history survey textbooks today though his sister Ellen Day Hale appears frequently.

20 Gammell, ibid.

21 Nancy Hale, *The Life in the Studio*, 205.

22 Philip Leslie Hale, quoted in Franklin Folts, *Paintings and Drawings by Philip Leslie Hale, 1865–1931* (Boston: Vose Galleries of Boston, 1966), 1.

23 Nancy Hale, quoted in *Philip Leslie Hale, A.N.A. (1865–1931)* (Boston: Vose Galleries of Boston, 1988), 19.

24 Wanda Corn, "Coming of Age: Historical Scholarship in American Art," *Art Bulletin* 70, no. 2, (June 1988): 188–207.

25 "One of the 'Lost Collections' Turns Up in Boston; Hale Goes on Exhibit," News Release, Vose Galleries of Boston, September 15, 1966.

26 Gammell, *The Boston Painters*, 124.

27 It was sold on August 5, 2004, by Eldred's Auctioneers, East Dennis, MA. On September 28, 2010, it sold again for $37,500 at Christie's New York, reflecting the overall downturn of the art market. See Blouin Art Sales Index: http://artsalesindex.artinfo.com/asi/lots/4094837. Accessed June 5, 2014.

Raymond Jonson:
A Southwestern Modernist Alone on the Prairies

Herbert R. Hartel, Jr.

Trying to Paint the Blowing of the Wind

Composition Five–The Wind (1925) (Plate 4) is an oil on canvas painted by Raymond Jonson in 1925, at a crucial point in his life and career. It is one of the first paintings Jonson made once he settled permanently in New Mexico and one of several works integral to his profound stylistic transformation in the mid-1920s, as diverse influences from modern art, modern theater, and the western landscape melded to achieve a compelling personal style and mode of expression. In this painting, the artist attempted to visualize the wind using recent stylistic developments in modern art. This concern was as particular to the West as it was universal; the Futurists were interested in speed and motion, the cubists sought to dismantle the solid, tangible world and present it conceptually, and many abstract artists such as Constantin Brancusi and Arthur Dove were exploring the immaterial powers and forces in nature. Jonson's painting is one of the few examples of American modernism to be seen at the Joslyn Art Museum in Omaha, Nebraska, and it is the Joslyn's best painting by an American artist who came of age in the first half of the twentieth century in the West. Its acquisition by the Joslyn is a fine demonstration of knowledgeable and visionary curatorship and of making selections with care, wisdom, and foresight. The Joslyn's painting is the only work by Jonson known to be in a museum within a few hundred miles of Omaha and the artist's birthplace in Iowa. In a way, the acquisition of this painting by the Joslyn was like a part of the artist returning home.

The Joslyn Art Museum and Its Collection

Omaha, Nebraska, is known for insurance and steaks. Famous natives and one-time residents of the city include Gerald Ford, Fred Astaire, Henry Fonda, Marlon Brando, Malcolm X, and Warren Buffett. It was the setting for the critically acclaimed dark comedy *About Schmidt* (2002), a film starring Jack Nicholson about a newly retired and suddenly widowed insurance actuary who must reevaluate his life at a major turning point. It is certainly not famous for its art. Yet the Joslyn Art Museum in Omaha is undoubtedly the best art museum in Nebraska, with the largest and most impressive permanent collection in the state. It is in a handsome building at 2200 Dodge Street, on the outskirts of downtown and across the street from Central High School. It is an unassuming gem of an art museum in the heart of the Great Plains, founded in 1928 by Sarah H. Joslyn, the widow of George A. Joslyn, a wealthy publisher who was born in Omaha and grew his business there.[1] The Joslyn Art Museum was founded on the ethical and didactic bases that were common among the art museums established across the United States in the decades spanning the Civil War and the Roaring Twenties: to preserve great works of art and make them available to the general public in order to enlighten, educate and enrich the lives of visitors. The Joslyn opened in 1931 in a brand new art deco building on the site it still occupies, but it has expanded over the years to include additional gallery spaces, a sculpture court, and a huge outdoor garden.

Over the years, the Joslyn's collection has grown and diversified. The highlights of its collection of European paintings include works by Jules Breton, William-Adolphe Bouguereau, Gustave Courbet, Claude Monet, Titian, Veronese, El Greco, and Rembrandt.[2] The collection of American art is even larger and features paintings by George Caleb Bingham, William Sidney Mount, Thomas Cole, Winslow Homer, Mary Cassatt, and John Singer Sargent.[3] Not surprisingly, the Joslyn has an extensive collection of works by artists who depicted the American West, including George Catlin, Karl Bodmer, Alfred Jacob Miller, Albert Bierstadt, Charles Marion Russell, and Thomas Moran.[4] Its rich collection of Native American art includes paintings and designed objects from the Sioux, Lakota, Navajo, and Omaha tribes, and more recent works by artists Allan Hauser, Oscar Howe, and Roxanne Swentzell.

Modern and contemporary art at the Joslyn is a curious matter. This portion of its collection favors post–World War II American painting and sculpture. The Joslyn's two greatest works from this era are Jackson Pollock's *Galaxy* (1947) and Martin Puryear's *Self* (1978). Not surprisingly, since it is in Nebraska, it has a significant collection of regionalism, the highlights of which include Thomas Hart Benton's *Hailstorm* (1940) and Grant Wood's *Stone City, Iowa* (1930).[5] However, its collection of early twentieth-century American art,

with several works by John Sloan, George Bellows, Stuart Davis, Manierre Dawson, George Ault, Raymond Jonson, and Emil Bisttram, is comparatively small with few works that stand out. In broadening the museum's collection of modernist art and adding works of great quality and importance, and in bringing new awareness and excitement to its collection of the art of the West, the acquisition of *Composition Five–The Wind* proved invaluable.

Acquiring *Composition Five–The Wind*

The acquisition in 1994 of Raymond Jonson's *Composition Five–The Wind* by the Joslyn Art Museum was a watershed event for its efforts to expand its collection of early modern art from Europe and North America in order to help the local population and regular visitors to the museum better understand and appreciate the great stylistic and aesthetic variety in the art of the past 150 years. It had long been a concern among the Joslyn's curators that this was an area of the collection that needed to be developed and expanded, but the limited amount of money available for acquisitions and the high prices for early modern art, especially by famous European masters, were perpetually frustrating obstacles. The more that the curators could accomplish in expanding this part of the collection, the more the museum could dispel any notions of the city and state as being regionally marginalized or culturally isolated and provincial. One aspect of this concern was an acute awareness of the need to expand the collection of modernist Western art, of broadening the museum's perspective of recent avant-garde developments in American art that were not clustered in the Northeast, Chicago, or California.[6] This would provide a richer, more thorough, and more balanced view of Western American art by paying more attention to the twentieth century. *Composition Five–The Wind* is one of the only works that the Joslyn has acquired over the past 30 years that help achieve this curatorial goal. It has served dual purposes in the collection as an example of modern art and American art, particularly modernist art that flourished in the West. This was a crucial aspect of the work that singled it out for the curators as a prime choice for acquisition. Although no one artwork should be expected to do so much, Jonson's painting became quite successful in simultaneously representing international modern art, American modernism, and modern art in the Western United States.

The decision to acquire *Composition Five–The Wind* for the Joslyn was made by Janet Farber, who was then associate curator of twentieth-century art, and was supported by Marsha Gallagher, who was then chief curator and director of western studies. At its meeting on September 12, 1994, the Joslyn's acquisitions committee approved the purchase of the painting for $100,000 from Hirschl and Adler Galleries in New York City, who handled the sale for an anonymous owner.[7] This price was an impressive, unprecedented

amount for a work by Jonson up to that time. Even to this day, it is among the highest recorded prices ever paid for a Jonson. The Joslyn was able to raise the money for this purchase from the sale of numerous artworks and other historical objects it considered to be of lesser importance. The purchase of *Composition Five–The Wind* was made as part of the 1994 "Grand Opening and Celebratory Year," during which the Joslyn celebrated its new wing designed by British architect Norman Foster. As a result, *Composition Five–The Wind*, which is seminal in Jonson's oeuvre and one of his greatest accomplishments, became an almost singular icon at the Joslyn of modernist painting produced in the West by a native of the West. Twenty years after it was acquired, it is still proudly exhibited in the museum and featured on its website. Yet it seems strangely isolated from the rest of the collection; it is a singular painting that stands out from the works around it. Even the Joslyn's painting by Emil Bisttram, a Western abstract painter who cofounded the Transcendental Painting Group with Jonson in New Mexico in 1938, provides it with little company. Bisttram's *Taos* of 1934 is a fairly early painting by the artist, a work on paper depicting a panoramic view of the town that shows how far regionalism had spread in the 1930s. Since Bisttram's most important works are his purely abstract paintings that he started a few years later, the Joslyn's Bisttram is a fine work but not a good example of his greatest innovations. Farber and Gallagher saw Jonson's *Composition Five–The Wind* as a particularly valuable addition to the collection because they considered it important to both American modernism and international modern art in that it straddled these two curatorial areas. Most scholars of modern art would still doubt that it is that significant to global modernism. However, scholars of American art would certainly consider it important, although the limited scholarship on Jonson up to the time of its acquisition would have left most of them flustered in explaining why.[8] Ironically, financial constraints balanced with the opportunity to obtain a great work by a lesser-known artist made these curators impressively prescient. Although the importance of American modernism within global modern art is still being reexamined, it has not yet received the respect it is due and has not been fully integrated into mainstream historical accounts. Even recent historical surveys of American art that are determined to broaden our perspectives pay little attention to Jonson and his fellow modernists in the West.

My Personal Appreciation of *Composition Five–The Wind*

It was the news of the historic sale of this painting at auction in 1989 that introduced me to the work of Raymond Jonson. The sale was not only a watershed event in the marketplace for Jonson's work but a clarion alerting scholars, dealers, and collectors of American art that modernist painting and

sculpture in the United States was more diverse, complex, and underexplored than they realized. It certainly was an eye-opening shock for me. *Composition Five–The Wind* sold at Skinner's Auction House in Bolton, Massachusetts, on September 8, 1989, for $70,400.[9] The auction price was about 25 times greater than the high end of the estimated auction price. It was about 10 times the previous record for a work by Jonson at auction. *Composition Five–The Wind* had for years belonged to Margaret Naumburg, an important educator and psychologist who was a pioneer of art therapy.[10] She was the ex-wife of Waldo Frank, the writer and art critic who wrote extensively in the 1910s to 1940s. Jonson met Naumburg in 1931 when he was traveling to Chicago and New York (with his wife Vera back home in Santa Fe) and they began some sort of sexual relationship that was brief and may have never become truly physical. Jonson had conceived of something akin to a ménage à trois involving Naumburg, his wife, and himself, but it never came to be, probably because Naumburg grew less interested in Jonson while Jonson also had lingering mixed emotions about this extramarital relationship and never stopped loving his wife. Jonson seems to have been convinced, for a short while at least, that this unusual arrangement would have been an emotionally, spiritually wonderful experience for all three of them.[11] At some point, Jonson sold or gave *Composition Five–The Wind* to Naumburg, who owned it until she died in Boston in 1983. It was eventually auctioned at Skinner's, where it was sold for a record price to an anonymous buyer. This auction price held the record for a work by Jonson for almost 20 years, when *Composition Eleven–Rain (Opus for Vera)* of 1931 sold for $108,000 at Bonham's in Los Angeles in 2008.[12] The 1989 sale price for *Composition Five–The Wind* was such a surprise that it led to article-length reports in *Southwest Art* and *ARTnews* in late 1989, and it was then that I first heard of this artist and saw this painting. At the time, Jonson was unfamiliar or only vaguely familiar to most collectors, dealers, admirers, and scholars of American art. I remember looking at the color reproduction in *ARTnews* and wondering who was this artist whose work was so captivating and intriguing and yet so different from what I knew about American art of the 1920s, which for me at this time meant Georgia O'Keeffe, Charles Demuth, Stuart Davis, Charles Burchfield, and Edward Hopper.

My interest in Jonson began with his sudden, brief fame in the art world and it never ended. About five years later, Raymond Jonson, Emil Bisttram, Agnes Pelton, and the Transcendental Painting Group were discussed in a seminar on American art of the 1930s that I took at the Graduate Center of the City University of New York with Professor Marlene S. Park. Once again, my curiosity about Jonson was rekindled. When I was considering topics for my dissertation, the beauty and mystery of Jonson's paintings and the paucity of scholarship on him drew my interest. I quickly settled on my dissertation topic, a full-length monographic study of Jonson, and in Dr. Park I had an enthusiastic advisor. In pursuit of Jonson's works near and far, in tracking

down major and minor works in museums, galleries, and private collections, I traveled across the United States. My voyages eventually took me to the Joslyn to see *Composition Five–The Wind*. It was a great pleasure, an awe-inspiring occasion, and the fulfillment of a personal and professional goal that would probably not make much sense to most people, but I had finally seen in person the artwork that had influenced the direction of my graduate school career like no other.

The Significance of *Composition Five–The Wind*

Composition Five–The Wind is a highly abstracted composition of wind blowing over wide open spaces. It consists of various tones of blue, purple, and gray. In its use of blue as a dominant color, the painting is similar to Jonson's many landscapes from the 1910s and 1920s, but most of these earlier works feature overtly recognizable images of nature, usually of the Southwest, and are characterized by more saturated, brighter hues, in particular ultramarine. *Composition Five–The Wind* is dominated by a long triangular form painted with a smoothly shaded cerulean that projects into the picture from the left, almost like a metallic object, and ends near the center of the canvas. Behind and above this triangle are numerous smaller cerulean triangular forms schematically shaded from dark to light and arranged so their points face right. Another large triangular form comes to its apex near the center of the composition, at the same point where the more solid, metallic-looking triangle ends. By placing this point of convergence off-center, Jonson made the composition more dynamic. To the right of where these triangles meet is a series of almost concentrically placed bubble-forms that suggest floating clouds. Many of these forms appear to be partially covered by a transparent layer of blue that overlaps most of the lower-right of the painting. This overlapping layer of cerulean has a clearly defined contour that runs up the center of the painting in a sweeping arc and then sharply turns and heads straight to the right edge of the canvas. In the process, it darkens all the forms behind it. Such lively, dramatic effects of spotlighting occurred often in Jonson's paintings from the late 1910s through the 1930s and were influenced by his exposure to the simple stage movement in modern theater and his designs for the Chicago Little Theatre, for which he worked in 1912–17.[13] Several meandering black lines streak across the composition. In the bottom right, there are several closely spaced blue and green curving forms indicative of hills or mountains. The maze of rectangular blocks in the lower left painted with muted violet suggests the steep, windblown mesas of the Southwest. Our viewpoint in this painting is from the sky above a vast expanse of land.

Jonson went through a great stylistic epiphany in the mid-1920s and *Composition Five–The Wind* was crucial to it. This was when Jonson finally discovered his own expressive identity and completely absorbed the tenets of modernism that he had been studying for 15 years. The painting itself is an imaginative visualization of the intangible, unseen forces of nature that combines diverse aspects of modernist painting, including symbolism, cubism, and futurism. It facilitated Jonson's pursuit of complete abstraction, which was a slow, analytical, and introspective process of gradually liberating his paintings from all references and suggestions of physical things. This was the goal he established for his painting at least by 1921 if not earlier, for it was in Chicago in 1921 that he first became fascinated with Wassily Kandinsky, but pure abstraction was something he did not achieve in his own work until the late 1930s.

After living across the West as a child and spending his teenage years in Portland, Oregon, Jonson lived in Chicago for 14 years, where he studied the technical aspects of his craft, saw some of the latest in modern art, created stage sets, costumes, and lighting for the Chicago Little Theatre, and became a vocal proponent of modernism in the Midwest. However, as the years in Chicago passed, he became increasingly bothered by urban problems of overcrowding, noise, dirt, and the high cost of living. In 1924 he and his wife Vera moved to New Mexico after a momentous 1922 trip to the Southwest convinced him that its terrain and light would rejuvenate his art and the lower cost of living would ease his problems of financial survival.[14] The move required much scrimping and saving by Jonson and Vera to pay off their debts in Chicago and purchase land for a home near Santa Fe. During this period of relocation and the early years in New Mexico, Jonson battled serious depression that seems to have been caused by his financial struggles, lack of critical attention, and uncertainty that relocating to the Southwest would solve his problems. *Composition Five–The Wind* was one of the first paintings he did once he had settled in Santa Fe in 1924. It was immediately preceded by *Earth Rhythms Nos. 1* to *3* and *Composition Four–Melancholia (Space Moods)* and followed by *Composition Six–Agony* and *Earth Rhythms Nos. 4, 5,* and *6.* It belongs to his series of *Compositions,* a group of 10 paintings and one drawing that he produced from 1922 to 1931 that attempt to visualize natural phenomena that are essentially intangible, such as wind, rain, and fire. Some of these works also express the artist's personal, psychological, and spiritual experiences and problems during these years.[15]

Jonson's goal in his *Compositions* was to visualize the invisible or intangible, to find pictorial means for comprehending fleeting essences of nature and common experience. This impulse is related to the concerns of many early twentieth-century artists and scientific, technological, and philosophical developments of the time. The viewpoint of this painting would have been almost inconceivable without the lofty heights of the Rocky Mountains or the

unprecedented aerial views made possible by the airplane (although Jonson is not known to have ever flown in an airplane). It was done less than 20 years after Orville and Wilbur Wright built the first working airplane and only two years before Charles Lindbergh's first successful solo flight across the Atlantic Ocean. It may not be coincidental that Jonson did this painting two years after Constantin Brancusi made his first version of *Bird in Space*. The concern for visualizing motion, speed, and energy that led to Jonson's *Compositions* and some of Brancusi's most famous sculptures also influenced many other artists in Europe and the United States. It was fundamental to futurism, which began in Italy in 1909 and flourished before World War I.

Composition Five–The Wind was not the first painting by Jonson to explore this theme. In *Rhythm of the Wind* (Figure 4.1) of 1917, the subject is the same but wind is depicted in a more literal manner by showing how it affects tangible forms. By 1925, Jonson had found the means to convey the idea or experience of this natural phenomenon in abstract terms. *Composition Five–The Wind* also involves expressive content, as the tonal orchestration of blues and analogous hues, broad sweeping lines, and the contrast of dramatic geometric forms and more delicate, curvilinear ones evoke mood and emotion. In *Composition Five–The Wind*, one senses mystery, excitement, confusion, and awe. Arthur Johnson, Raymond's younger brother, cautioned him to be prepared for an endless struggle for acceptance and understanding by the public when exhibiting works like this one:

> Frankly, you will never live to see the day when an average American can look at your "The Wind" and, without the kindly assistance of a guide, get anything out of it. Color! Composition! Technique! Drama! Action! Form? Poetry?–not [sic] a thing. To him the wind means and for a long time is going to mean, leaves blown down the street, trees bending over, waves tossing on the sea, and so on, and so on.[16]

In conveying the sensations of the rapid movement of air high above land, *Composition Five–The Wind* utilizes aspects of the formal vocabulary of futurism in visualizing intangible and abstract forces, processes, and phenomena. Jonson accomplished this by using various triangular forms all pointing to the right. These visual devices are adaptations of such futurist methods for conveying movement and speed as force lines. *Composition Five–The Wind* is quite similar to Giacomo Balla's *Street Lamp* of 1909 and *Swifts: Paths of Movement + Dynamic Sequences* of 1913. In *Street Lamp*, Balla expressed glowing yellow light emanating from its source with densely packed, short, quick strokes of white, yellow, red, and green paint. *Swifts: Paths of Movement + Dynamic Sequences* is a mostly abstract painting that suggests rapid movement with force lines described as glistening grays and yellows organized in swirling bunches. It is not known exactly when and how Jonson first became familiar with futurism, but by the 1920s he certainly knew of it

4.1 Raymond, Jonson, *The Rhythm of the Wind*, 1917. Oil on canvas, 42 x 45 in. Gift of Learn Art, Inc., Savannah, GA, to the Raymond Jonson Collection, University of New Mexico Art Museum, Albuquerque

through numerous exhibitions and publications. Throughout his career, a few critics apparently considered Jonson related to futurism, probably because he used terms such as "dynamic" or "dynamism" to describe and title a few works, such as *City Dynamism* of 1932. Jonson and Arthur did not feel Jonson's paintings were futurist, but they understood why Jonson might be mistaken as a futurist. Arthur explained this when he wrote in a 1936 letter: "I've been thinking about that word 'dynamism' which you use in some of your titles. It is a word which, rightly or wrongly, has certain connotations with the 'Futurists' … of Italy. I think you are not a 'futurist.' But the 'F.' were fond of using that word 'dynamism' in *their* titles … . Jonson says 'City Dynamism' [a painting Jonson did in 1932] therefore he must be a 'Futurist.'—this without reference to the work itself. However, the term remains a good one."[17] Arthur admitted that *Composition Five–The Wind* "does have a superficial resemblance to some of those Futurist paintings such as 'Dynamism of an Automobile,'

'Dynamism of an Engine,' et al.," and he liked the term *dynamism* but claimed that the similarities between Jonson's painting and futurism were minimal and superficial.[18] In the 1920s and 1930s American art critics often referred to futurism when interpreting or criticizing modern artworks that they found difficult to comprehend.

A Great Painting is Still Blowing in the Wind

Jonson's *Composition Five–The Wind* is one of the artist's greatest works and it is displayed proudly in a museum that has no other works by him and few works by the artists most closely associated with him. The Joslyn is hundreds of miles from the several places that Jonson considered his home at one time or another—central Iowa, Chicago, Portland, and New Mexico. The largest collection of Jonson's works is his bequest to the University of New Mexico at Albuquerque, which has hundreds of his paintings and sketches plus his personal papers and effects. For 30 years after his death, Jonson's works and property were kept in the house and studio that was built for him in 1950 on the northern edge of the campus by the University of New Mexico and which was his home for the last 32 years of his life. At any time, numerous works would be on view. In 2010, Jonson's works, papers, and property were moved from the Jonson Gallery to the university's main building on campus.[19] The building is still there but is now used by another administrative branch of the university. This relocation was done because of environmental conditions and preservation, security, administrative costs, larger exhibition space, and so on. However, no matter what the reasons, the loss of the Jonson Gallery led to the end of a permanent exhibition space for Jonson's work that was directly connected to the artist. The New Mexico Museum of Art in Santa Fe, the Smithsonian American Art Museum, and the Portland Art Museum each own several works. Several important works are in private collections in New Mexico, California, New York, New Jersey, and Oregon. Unlike most American artists of historical significance, Jonson is underrepresented in museums in the Northeast. Thus it is all the more fortunate that some of Jonson's greatest works are dispersed across the country for viewers from all over to see them. It is even more important that museums like the Joslyn have managed to acquire fine singular examples of an artist still getting his due appreciation. There is some poetic irony that Jonson's painting of wind is now displayed in a museum on the Great Plains, a vast expanse of land known for the power of wind. Since Jonson was born near Chariton, Iowa, about 200 hundred miles east of Omaha, he was a child of the Great Plains, and of all the museums that own works by him, the Joslyn is the closest to his place of birth. Jonson's *Composition Five–The Wind* may seem alone in this museum on the Great Plains, but it is at home there.

Notes

1 www.joslyn.org/about/history. Retrieved April 18, 2014.

2 www.joslyn.org/collections-and-exhibitions/permanent-collections/european. Retrieved May 14, 2014.

3 Ibid.

4 Ibid.

5 Ibid.

6 Brooke Masek, executive assistant to the director of the Joslyn Art Museum, e-mail to the author, June 10, 2014; Brandon Ruud, former curator of modern and American art at the Joslyn Art Museum, telephone interview with the author, October 11, 2013.

7 Brooke Masek, executive assistant to the director of the Joslyn Art Museum, e-mails to the author, June 4 and 17, 2014.

8 By the early 1990s, the most important scholarship on Jonson included Sharyn Udall, *Modernist Painting in New Mexico, 1913–1935* (Albuquerque: University of New Mexico Press, 1984); Van Deren Coke and Ed Garman, *Raymond Jonson: A Retrospective Exhibition* (Albuquerque: University of New Mexico Press, 1964); Ed Garman, *The Art of Raymond Jonson, Painter* (Albuquerque: University of New Mexico Press, 1976); Elizabeth McCauley, *Raymond Jonson: The Early Years* (Albuquerque: Jonson Gallery of the Art Museum of the University of New Mexico, 1980); Sue Ann Prince, ed., *The Old Guard and the Avant-Garde: Modernism in Chicago, 1910–1940* (Chicago: University of Chicago Press, 1990); MaLin Wilson, *Raymond Jonson: Cityscapes* (Albuquerque: Jonson Gallery of the Art Museum of the University of New Mexico, 1989). Most of these are small exhibition catalogs with a limited number of illustrations.

9 Bonnie Barrett Stretch, "A Modernist Surprise," *ARTnews* 88 (November 1989): 45–46; Jacqueline M. Pontello, "Southwest No Longer Stigma," *Southwest Art* 19 (December 1989): 23–4.

10 Brooke Masek, e-mail to the author, June 17, 2014.

11 MaLin Wilson, *Raymond Jonson: Cityscapes*: n.p.; Herbert R. Hartel, Jr., *The Art and Life of Raymond Jonson: Concerning the Spiritual in American Abstract Art* (PhD diss., Graduate School and University Center of the City University of New York, 2002): 201–5. Jonson discussed his sexual interest in Margaret Naumburg and his desire for a relationship that involved Margaret, Vera, and him in several letters he wrote to Vera during his 1931–32 trip to Chicago and New York and letters from the same time that he wrote to his friend, the professor and philosopher Charles W. Morris, Jr.

12 Jonson's *Composition Eleven—Rain (Opus to Vera)*, 1931, oil on canvas was sold at Bonham's in Los Angeles on August 5, 2008, for $108,000 (including premium), auction 16104, lot 269. http://www.bonhams.com/auctions/16104/lot/269. Retrieved June 12, 2014.

13 Herbert R. Hartel, Jr., "Raymond Jonson and the Chicago Little Theatre,
 1912–1917: The Influence of the Simple Stage Aesthetic on an American Modernist
 Painter," *Journal of the Illinois State Historical Society* 104, no. 3 (Fall 2011): 199–222.

14 "'The Land of Sunshine and Color and Tragedy': The Early Paintings of
 Raymond Jonson and the Lure of the Southwest," *Journal of the American Studies
 Association of Texas* 36 (2005): 69–91.

15 Herbert R. Hartel, Jr., *The Art and Life of Raymond Jonson*, 143–5.

16 Arthur to Vera, March 1, 1928, Raymond Jonson Papers, Archives of American
 Art (hereafter referred to as RJP/AAA), reel RJ 1: 284.

17 Arthur to Jonson, June 8, 1933 RJP/AAA, RJ 1: 418.

18 Arthur to Jonson, June 9, 1936 RJP/AAA, RJ 1: 472.

19 http://catalog.unm.edu/catalogs/2012–2013/general-information.html. Retrieved
 29 May 2014.

At the Margins:
The Art of Josephine Tota

Jessica Marten

Working quietly in her Rochester home, painter Josephine Tota (1911–96) spent the later years of her life embarking on a creative journey of exorcism and acceptance. Her paintings exhibit surrealist tendencies toward dreamscapes, multiple narratives, destabilized identities, contradiction, and fairy tales. Her irrepressible artistic impulse and obsessive imagery also link her with artists in the contested category of outsider art. Despite straddling these two realms, Tota's trajectory was her own. The complications that arise from positioning her within an art historical framework both clarify and challenge the artist's marginalization.

For a previously undiscovered artist like Tota, an understanding of the circumstances of her life and creativity must come first; an introduction of sorts. Her life story provides an essential key to unlocking the otherwise impenetrable personal iconography in her paintings.[1] After decades of painting as a hobby, her awakening to intensely personal subject matter and her discovery of the medium of egg tempera as a septuagenarian enabled her to fully tap into the stream of her creative, obsessive energy. Tota's late paintings sprang from the deep well of her memories and dreams, and she reflected upon her life the only way she could, in paint and pictures.

Untitled (Life Story) (Plate 5) is one of 14 paintings by Josephine Tota in the collection of the Memorial Art Gallery of the University of Rochester; the remainder of her paintings and painted ceramics are held by family members and friends. Tota did not title her work, nor did she offer insight into their meaning. She was a woman of few words, in general—no papers or letters exist—our knowledge of her life comes primarily from the personal accounts of family members.[2]

The density of *Untitled (Life Story)*, one that requires patient and repeated viewing, is typical of Tota's style. It features a complex, richly allegorical scene

full of personal symbols, the precise meanings of which are largely unknown to us now. Despite the appeal of her bright palette, multiple temporalities and narratives hopscotch around a shifting space in which no zone feels safe. Many of Tota's motifs are in evidence here: anxious women, ambiguous spaces, masks, tears of blood, clothing, needles, and threads. Like a trip down Alice's rabbit hole, the wild and fantastical world of Tota's late paintings encompasses a dizzying depth and wonder that delights and confounds viewers. *Untitled (Life Story)* is well suited to serve as a lens through which to view the artist's life and work. Like so many threads, the images weave together a portrait of one woman's alienation, anxiety, and frustration; an artist at the margins.

Biography and Inspiration

Josephine Tota felt a deep and abiding connection with the spirituality and mystery of the natural world. In her art she followed the essential impulse that drove her: to understand, express, and control the relationship between seen and unseen worlds.[3] As a young girl, she spent her time in the company of fairies who lived under a rock near her family's home. As an artist in her seventies, this sensibility found expression in her depictions of human/plant hybrid creatures that grow in the ground, occupying both the visible realm of the surface and the mysterious world of nature and spirit below.

Born in Corato, Italy, in 1911, Tota recalled her childhood with fondness; she spent long hours absorbed by her imagination in communion with the natural world on her family's farm. In addition to keeping company with fairies, her other early memories included drawing pictures on the slats of wooden crates and lying in the grass to watch the clouds float through the sky. As a deeply sensitive and unusually bright and outspoken child, Tota often felt alienated from her four siblings and parents. Even within her own family she was an outsider.[4] These feelings of isolation and marginalization were reinforced by the circumstances of her life, including early experiences of childhood poverty and the trauma of immigrating to the United States.

Tota was nine years old in 1920 when her family emigrated from Italy. Arriving in Rochester in Upstate New York, where a relative was working as a tailor, the Tota family struggled with the harsh climate, debilitating poverty, and language barrier. During this period, Rochester attracted many skilled laborers and tailors from Italy who provided 40 percent of the workforce for the city's booming clothing industry.[5] The Tota family—consisting of father, mother, four daughters, and one son—would have been subjected to the conflicting influences of Rochester's sizable Italian immigrant community and the Americanization of public schools and settlement houses.[6] Tota, on the cusp of her own seismic developmental shift of puberty, had to navigate

this wholly new cultural environment. Similar to other immigrant women who have struggled with the duality of their home and adopted cultures, Tota described feeling torn and of having a fractured sense of herself.[7] This sensation would take visible form, more than 60 years later, in her paintings.

By the time Tota was 16, she had left school to contribute to the family's income. In the 1927 Rochester City Directory, she is listed, along with her mother Isabella, as an employee at the tailor shop of the National Clothing Company, a department store in downtown Rochester.[8] When she turned 19, her family arranged her marriage to her cousin Frank Tota, thereby keeping her maiden name. After moving to the Bronx in 1930, where she did not work or attend school, Tota struggled with the lack of companionship and creative stimuli. Her isolation was exacerbated by several devastating miscarriages that led to a period of deep depression.

After moving back to Rochester, Josephine and Frank's only surviving child, Rosamond, was born in 1940. Throughout much of Rosamond's life, her mother worked at the National Clothing Company where her creative, intuitive personality was frustrated and depleted by her monotonous work as a seamstress. She sought to alleviate the drudgery of tailoring clothes with artistic activities. During her lunch breaks she would visit the public library to pore voraciously over books on art from all periods. By the late 1940s, she began taking weekly art classes, painting representational landscapes and still lifes in oil paint on canvas. Creating art became a source of great joy and release for her.

In 1967 Tota's life changed dramatically. The year brought a series of tragedies including the deaths of her mother and husband, the diagnosis of her sister with cancer, and her own diagnosis of uterine cancer. Tota received radiation treatment that resulted in chronic neuropathic pain that she likened to having the lower half of her torso stuck with needles, or set on fire.[9] This storm of personal tragedies led to her retirement from the National Clothing Company, as well as a severe depression for which she was hospitalized and subjected to ECT treatments or shock therapy.

After her recovery, Tota again turned to her creative impulse by taking painting and ceramics classes at the Memorial Art Gallery's community art school, the Creative Workshop. She blossomed under the tutelage of Fritz Trautmann (1882–1971), a legendary colorist and instructor at the Creative Workshop.[10] Earlier in the century, Trautmann had joined his close friend, the artist/architect Claude Bragdon, in explorations of color, sound, and philosophy. Trautmann's mystical leaning, his emphasis on the power of color, and his desire to bring out each student's "unique and precious individuality" certainly nurtured Tota's path towards her later iconography and style.[11]

Tota's voracious appetite for art was also fed on trips to visit her adult daughter, Rosamond, in Manhattan, where she spent days absorbing the city's

galleries and museums. Tota was as equally engrossed by contemporary, abstract art as she was spending hours mesmerized by the medieval paintings at the Metropolitan Museum of Art. Thanks to her natural inclination, further honed by decades of art classes and careful looking at any and all art available to her, Tota developed a sophisticated and independent eye.

In the early 1980s, after decades of working in a representational style, Tota had a transformative breakthrough while painting a still life. Losing herself thoroughly to the creative experience, Tota later realized she had painted an abstracted image of a disembodied bird head in the background of the composition. This creative step, one made without conscious choice, was a revelation for her. Now in her early seventies, this new freedom led Tota into the depths of her imagination as a source for imagery and creative inspiration.

Inspired by her love of medieval paintings, Tota took the next step closer to her personal, surreal style when she sought out the help of an artist friend to teach her the demanding technique of painting in egg tempera. The medium of medieval panel paintings, egg tempera had been adopted earlier in the twentieth century by Surrealist artists like Leonora Carrington, Sylvia Fein, and Remedios Varo. Beyond the medium's functional desirability for its luminous, high-key tonalities, artists appreciated the symbolic value of the egg's potent associations with mysticism, reproduction, and domesticity.[12] For Tota, the obsessive technique—grinding the pigments, mixing the paints, building up the image with multiple, small brushstrokes—complemented her creative temperament.[13] The first time she painted with tempera, she described feeling as though she had done it before. The meticulous process provided a highly controlled environment in which she could exorcise the chaotic fears and traumatic events represented in her paintings.

Now in her seventies, largely freed from the obligations of work, marriage, and motherhood, Tota found her artistic license; she was ready to jump down her rabbit hole. With the bright colors, tempera paint, elaborate compositions, and intense emotions, the influence of her beloved medieval paintings is clear, but the content had no source other than Tota's dreams and memories. Throughout the 1980s, Tota spent countless hours in her home filling her small jewel-like paintings with the richness of her strange imagination.

Public Recognition

Larry Merrill, former director of the Creative Workshop, recalls that by the time he joined the Memorial Art Gallery staff in 1986, Tota had abandoned her painting classes and was only actively enrolled in ceramics classes. Given the intensely personal nature of her two-dimensional work, it is not surprising

that Tota chose not to continue to make her paintings in a classroom setting. Yet having seen her work, Merrill began to make frequent appeals to Tota to exhibit her paintings and some of her equally colorful, though less narrative, ceramics at the Creative Workshop's faculty and student exhibit space, the Lucy Burne Gallery. Only after much persuasion did he convince Tota to show the public the paintings she had produced in the privacy of her home over the previous decade.[14]

When the exhibition opened in January of 1990, Tota was 78 years old. The show was accompanied by a brochure in which Merrill wrote how Tota's "frightening images of women gripped by doubt, fear and pain paradoxically calm her but spook the viewer."[15] In the *Democrat and Chronicle* newspaper, critic Ron Netsky described her "mysterious allegorical narratives" and their "expressive, 'primitive' quality despite years of training."[16] For an introverted woman who had lived her life feeling ostracized, the anxiety of exposing herself through her art must have been intense, yet from all accounts, the positive response to her paintings provided Tota with a welcome affirmation of her talent.

Given her insular tendencies, it is unsurprising that the public's experience of Tota's work ended here. The possibility of growth and exposure beyond this exhibition was further thwarted by Tota's diagnosis of progressive dementia. Yet, her powerful creative impulse continued to assert itself, as evidenced by a sketchbook filled with drawings made in the last year of her life. Like a visual document of an artist all too aware of her decline, in the sketchbook Tota revisited potent images and symbols: trees, gazing faces, and her signature, "Tota," written again and again.[17]

Josephine Tota died on December 29, 1996, from complications of vascular dementia. Soon after, the Memorial Art Gallery accepted the gift of *Untitled (Life Story)* from her daughter, Rosamond Tota, from whom a small self-portrait by the artist was also purchased. In 2011, after discovering the two Tota paintings in MAG's art storage rooms, I began planning for a small installation to highlight Tota's work.[18] These plans led to contact with Tota's daughter, Rosamond Tota, and her niece, Lisa Rosica. Over the course of many conversations in person and via e-mail, a clearer picture of the artist came into view. Soon after, Rosamond Tota expressed her interest in giving more of her mother's work, at which time the museum selected 12 additional paintings from her collection.[19] Because of Tota's singular vision and her strong Rochester connections, MAG sought a greater depth of representation than most midsized museums with an encyclopedic collection would normally seek for an individual artist's work. With Tota's artistic legacy secured within the museum's walls, the next challenge is to situate her work within the wider art historical framework.[20]

Categorizing Tota's Work: Surrealism's Descendent

In 2012 the Los Angeles County Museum of Art mounted the exhibition, *In Wonderland: The Surrealist Adventures of Women Artists in Mexico and the United States*, which examined the surrealist qualities of Lewis Carroll's story of Alice's adventures and their influence on and inspiration for women surrealists and subsequent generations of artists.[21] Like Alice's Wonderland, Josephine Tota's painted world is equal parts delightful dreamland and menacing realm of teacups, playing cards, dizzying shifts in scale, and hybrid creatures. Tota counted Lewis Carroll as an influence.[22] Indeed, her images share many Carrollesque qualities: inscrutable scenes played out by hybrid creatures where domestic spaces, normally the domain of female power, are disrupted and threatened. Just as Alice had to renegotiate space in her shifts in scale, Tota and the female surrealists earlier in the century renegotiated their shifting identities of artist, woman, wife, and mother.

In *Untitled (Life Story)*, Tota populated the scene with images and symbols of herself at different points in her life. On the left, an interior scene is dominated by a large standing figure in a black dress, likely Tota's younger self with her characteristic downturned eyes. She gazes out at the viewer with a mournful look as she pulls a wedding dress out of a box from which a bouquet has tumbled. Higher on the wall another bouquet hovers, this one with withered flowers and a blackened ribbon. Oversized threaded needles surround her on the walls, as if contained within the fabric of the house. These ominous presences point at the young Tota's head and torso, their coiling threads like serpents about to strike. All of the tools and accoutrements of a seamstress—needle, thread, fabric, clothing—oppress or threaten to injure the occupants of this domestic scene. Occupying the same plane as the needles are the head and arms of a distraught woman with gray hair, again likely Tota. She holds a handkerchief to her open mouth as though consuming it against her will. Almost 20 years after having retired from her working life, Tota is made to consume her trade, or it may consume her.

The trio at the center of Tota's personal life occupies the center of the painting, a tumultuous, tilting zone where the private meets the public sphere. Below two trees that grow tortured faces, a table is set for a Mad Hatter's tea party and a metaphysical family reunion. The three chairs at the table—pink, yellow, and blue—likely represent mother, wife, and artist Josephine, daughter Rosamond, and husband Frank, respectively. The curved line that divides the green-and-blue tablecloth continues in the line where the floor meets the grass. Divided precisely by gender roles, Tota's pink chair sits in the private sphere of the home, while Frank's blue chair is planted firmly in the public sphere of the outdoors. Made up of equal parts mother and father, Rosamond's yellow chair straddles the two spheres.

If our bodies are vessels, teacups are an appropriately delicate surrogate. Rosamond's teacup sits directly in front of her well-placed yellow chair: upright, viable, and open to life's experiences. In contrast, Tota's pink chair sits awkwardly at the corner of the table and her cup is pushed to the other end of the green tablecloth, just slightly out of reach and noticeably inverted in its saucer. This vessel is no longer performing its intended function. Frank's cup and saucer have fallen to the floor where they remain shattered; a tragic symbol of his early death. Similar to the female surrealists, like Frida Kahlo and Leonora Carrington, Tota's paintings feature women as the active agents who play aggressor and victim, subject and object; men and boys make occasional appearances. In this painting of Tota's life story, her husband's greatest presence is his absence.

Josephine Tota is a descendent of the female surrealists when placed within what scholar Whitney Chadwick described as their "production of iconographies of the feminine unconscious."[23] Tota often described feeling "torn" or fractured, and included multiple representations of herself in many of her paintings.[24] This tendency toward a fractured sense of self is one that has been observed in female surrealists and is sometimes associated with balancing the demands of a creative drive alongside those of marriage and motherhood.[25] Multiplicity and duality reflected Tota's unique personality and her life experiences, forming the iconography of her "feminine unconscious." Indeed, *Untitled (Life Story)* is dominated by dualities: female/male, absence/presence, old/young, black/white, mother/daughter, wild/domesticated, interior/exterior, day/night, past/present.

The dichotomous mother/daughter relationship figures prominently in this painting. Along a path that cuts diagonally across the lower right corner, a woman and a young girl gather nuts into a yellow bag. In the grass nearby, four large dandelions with aggressively reaching leaves crane up and out of the ground. A curious, comical pink squirrel watches. Rosamond Tota recalls childhood memories of collecting horse chestnuts with her mother from a neighborhood tree. The ritual involved bringing the nuts back to their house to be placed in the front yard for the squirrels to eat. Only as an adult did Rosamond discover that the nuts disappeared because her father retrieved them during the night in order to maintain the child's illusion.[26]

This little vignette is like a poetic memory of that parental impulse to weave magic and fantasy into children's lives. Both mother and daughter have their eyes closed; behind them, two heads that correspond with the figures below sprout from the top of the house and watch with brows furrowed (possibly Josephine and Rosamond years later). Are the closed eyes of the young mother and daughter symbolic of Tota's memory of their unself-conscious rapport, or do they depict the figures' inability to see things as they really are? As an intensely visual person, Tota understood and negotiated her place within the world through her eyes. When debilitating cataracts threatened to

take her sight in the midst of her most fruitful, inspired artistic period in the mid-1980s, the artist was traumatized. Ultimately, she regained her ability to see, but she never got over the threat to her vision and the difficulties of her medical treatment. For Tota, her sight, her gaze, was the source of her greatest power; representing the figures with closed eyes connoted a loss.

Tota's surrealist impulses toward dream imagery, ambiguous domestic spaces and relationships, fractured self-images, and dualities are captured within the framework of Chadwick's "iconographies of the feminine unconscious." While she was clearly aware of the work of the surrealists, counting Salvador Dali and Frida Kahlo among her favorite artists, her eclectic tastes encompassed a love for the work of Wassily Kandinsky, Georgia O'Keeffe, and Frank Stella, among others.[27] More than 50 years after the golden age of the surrealist movement, Tota began her fertile yet solitary artistic journey. She played her own muse, confronting her demons through her obsessive mythology. That similarities are evident between Tota's work and the surrealists illuminates that movement's interest in the pure and unmediated expression of Tota's other artistic ancestors, so-called outsider or visionary artists.

Outsider Artist

Before we can position Josephine Tota's work in relation to outsider art, we must first acknowledge the changeable nature of this category and the problems that result from applying to it methodologies developed around mainstream art. An ever-growing body of literature on the subject exists in which the boundary lines are drawn and redrawn.[28] New names and descriptors are introduced and discarded in an effort to define the indefinable. Visionary, primitive, nonacademic, naive, and self-taught: none are fully satisfactory. The very qualities that comprise the category—individuality, singular vision, little or no artistic training—make a universally applicable title or definition impossible. A reductive understanding, one that is continually being rewritten, is the belief that outsider artists are individuals often lacking art training who, with little thought to its reception, find themselves compelled to create art.

As is true for many so-called outsider artists, Josephine Tota's creative process allowed her to revisit and revision painful life experiences from a safe distance. The characteristic *horror vacui* and obsessive patterning employed by many such artists to impose order and control are evident in Tota's sophisticated compositions. The highly decorative, painted border framing *Untitled (Life Story)* contains the scene and establishes a boundary between the content and the viewer (presumably Tota). In reframing her painful memories, Tota gained control over them with a power and agency not afforded her in life.

Beyond its cathartic value, the therapeutic effects of Tota's art making were multilayered. When she was deeply engaged with consuming or producing art, Tota described falling into transcendent states in which her physical and emotional pain and losses lifted. During even the longest painting sessions for which she stood at her easel, her lifelong affliction of foot pain due to fallen arches was alleviated.[29] Her expression served its purpose in the therapeutic and exorcising value of the creative process, not in its reception; a point further illustrated by her disinterest in titling or discussing her art.

While she did sign many of her paintings, (often, mysteriously, with a copyright symbol, "TOTA©") indicating her understanding of her role as their creator and of an audience other than herself, Larry Merrill recalls the artist's great reluctance to exhibit her work or to have her photo taken.[30] Only after significant persuasion did she permit the photo and Merrill's resulting portrait (Figure 5.1) captured Tota's quiet presence. Sitting in her home surrounded by her art, the room and the artist are brightly illuminated by sunlight. With no apparent pride or excitement in this moment of recognition, Tota sits slightly hunched with her hands folded on her lap, as though trying to take up as little space as possible. Other than the art that surrounds her, nowhere in her presence is any indication of the artistic force within. Tota's conflicted feelings about her public role as an artist are evident.

5.1 Josephine Tota in her home surrounded by her paintings and ceramics, c. 1990. Photograph by Larry Merrill

The term "compulsive visionary" may come closest to capturing the qualities of Josephine Tota's art. First used in the Los Angeles County Museum of Art's 1992 exhibition, *Parallel Visions: Modern Artists and Outsider Art*, curator Maurice Tuchman described its unifying qualities:

> A distinct compulsiveness, a visionary tone, a fusion of edgy uncertainty and anxiety with a firm certitude, a sense of exorcism, and the need and intent to get it out and place it down … . Such expressiveness verges on the hallucinogenic; it grapples with the unknowable.[31]

The tone, compulsion, and subject matter Tuchman describes capture Tota's feverish visions. For a woman who was uncomfortable as the subject of another's gaze, Tota's oeuvre indicates a heightened interest in the power of sight and the human eye. Due to her visual nature and the threat she experienced to her sight during her cataract scare in the mid-1980s, the omnipresent eyes in Tota's paintings are laden with emotional weight and meaning. The night sky of *Untitled (Life Story)* is dotted with bubbles containing totemic eyes that cry blood. After the trauma of her cataract surgery during which complications arose that threatened her eyesight, Tota's use of the bloody eye motif may have provided her with Tuchman's "sense of exorcism, and the need and intent to get it out and place it down."

Tota also harnessed the psychological power of the gaze with figures who look at each other and directly at the viewer with curiosity, concern, fear, or despair. The faces that occupy the two trees in the center of the composition look out at the viewer, at the mourning figure in black, and off into the distance. They cry blood, grasp their head in alarm or horror, and furrow their brows in dismay. The agonized figure at the top of the tree that clutches its head and opens its mouth in a primal scream may be the source of the plea written across the sky, "why?" Are these family trees broadcasting ancestral warnings? Are they spirit guides with revelations from another dimension? Viewers of Tota's paintings are interlopers in the private communications between the artist and herself in which she "grapples with the unknowable"; no answers are forthcoming.

Although Tota's work embodies the compulsive, edgy, and hallucinogenic qualities Tuchman outlines for "compulsive visionary" art, she does not fit in with their sites of training and production as isolated from "the galleries, museums, and universities with which mainstream artists are regularly associated."[32] While Tota's singular style and personal iconography developed mainly in the quiet isolation of her home, it grew out of decades of consuming and creating art within the art world infrastructure. These inspired, vivid depictions of her interior life were made possible because of her artistic training, not in spite of it.

The period of time studying under Fritz Trautmann at the Creative Workshop certainly influenced her work as student and instructor shared

beliefs in the symbolic and expressive power of color. Tota employed color as a compositional device to keep the viewer's eye zigzagging around complex scenes and to link figures and objects in meaningful, symbolic ways. In *Untitled (Life Story)*, the yellow of Rosamond's chair is echoed in the bag in which she collects her nuts, the four dandelions in the grass, and the five dandelions in the sky. With an unmistakably anthropomorphic quality, the dandelions, like the trees, exist in the visible, known world aboveground and serve as conduits with the spiritual, unseen realm underground. Where dandelion yellow is used throughout the scene, it is linked repeatedly with her living daughter and may also reference those children Tota lost to miscarriage while living in the Bronx and later in Rochester.

The pink of Josephine's chair is repeated throughout the scene as well, in the sash of the wedding dress, the bouquets, the squirrel, and in a pink hand and the symbol of the spade in the tree. Positioned directly over the head of the artist as she collects nuts, the pink hand is splayed open. Ultimately, it was through Tota's agency—her hand—that she made her art. The hand may be an assertion of Tota's role as the artist or it may represent an activating agent from the beyond that has imbued her with the mysterious power of creation. That Tota seems to have pondered the source of her creative drive posits an understanding of her as a wonderfully sophisticated and self-aware artist.

Conclusion

Like her chair in *Untitled (Life Story)*, awkwardly and inconveniently placed, Josephine Tota's place within the history of art is not an easy fit. In some ways, her life and art share many similarities with the fiercely independent Florine Stettheimer and her late-in-life career, singular vision, and crowded compositions inspired by medieval paintings.[33] Yet, again, this association is not perfect; similarities between the two women are offset by indisputable differences between their access to economic and cultural resources. Neither "surrealism's descendent" nor "outsider artist" can comfortably contain her. "Compulsive visionary" comes closest, yet fails in essential ways as well. In death as in life, Josephine Tota exists on the margins.

Tota reflected upon life and death in her art. In *Untitled (Life Story)*—a small detail perhaps, but a good example of the richness of her paintings that can only be absorbed with repeated viewings—is the single spade in the tree on the right. This is not an unusual detail; Tota's oeuvre is sprinkled with playing card symbolism (another link to *Alice's Adventures in Wonderland*). Despite a historical association with bad omens, the ace of spades or "death card" can also symbolize the death of something old and the birth of something new. Love and devotion often lead to pain and loss; bonds

forged are later bonds broken. Knowing Tota's penchant for dichotomous thinking, it seems possible she intended the more complicated interpretation: life is change.

Today, more and more voices are calling for change to the art historical framework; for dissolution of the insider/outsider duality and the integration and institutional sanctioning of artwork by outsiders. Amidst such movements as Occupy Museums, institutions seek more inclusive ways to represent the history of art. Interest in traditionally marginalized art forms and makers, in particular outsider art, has reached a fever pitch in the art world and in the media. Roberta Smith of the *New York Times* described the year 2013 as a "breakout moment for outsider art," with an "increasing infiltration or dissolution of the mainstream."[34] That year saw major exhibitions featuring outsider art including, *"Great and Mighty Things": Outsider Art from the Jill and Sheldon Bonovitz Collection* at the Philadelphia Museum of Art; the resurgence of the Outsider Art Fair in New York City; and Massimiliano Gioni's integration of insider and outsider art in the *Encyclopedic Palace* exhibition at the Venice Biennial. Critic Jerry Saltz, not the first to say it but perhaps the first to say it so emphatically, issued a clarion call to museums to stop segregating outsider art from the mainstream canon, to "Change—or wither with your prejudices and die a slow death."[35] This paradigm shift toward boundary dissolution may work to Tota's advantage.

With the acquisition of 12 Josephine Tota paintings in 2011 by gift from Rosamond Tota, the Memorial Art Gallery has made a commitment to the artist's work. Tota's singular style and compelling vision, her historic connection with the museum, and her unique perspective on the immigrant experience have secured her legacy in Rochester. While Tota's indefinable qualities make categorization challenging, the psychic urgency of her images—a rebuttal to the powerlessness she experienced in her life—has universal appeal. Her Technicolor palette and dense, disturbing imagery make for a viewing experience both vertiginous and sublime. A retrospective exhibition exploring further the intersections between the artist and her influences and her place within the art historical framework would no doubt find a rapt audience in Rochester and beyond.

Notes

1 To read more about the challenges of writing about women artists, see *Singular Women: Writing the Artist,* ed. Kristen Frederickson and Sarah E. Webb (Berkeley: University of California Press, 2003), in particular see Barbara J. Bloemink's essay "Florine Stettheimer: Becoming Herself," in which she wrote of her biographical approach, "Without such understanding, we risk misreading and possibly dismissing," 127. For an assessment of the complexities of biographical modes of inquiry for outsider artists in American art, see Lynne Cooke,

"Orthodoxies Undermined," in *Great and Mighty Things": Outsider Art from the Jill and Sheldon Bonovitz Collection*, ed. Ann Percy with Cara Zimmerman, exh. cat. (Philadelphia: Philadelphia Museum of Art; New Haven: Yale University Press, 2013), 204–14.

2 I want to thank the artist's daughter, Rosamond Tota, and niece, Lisa Rosica, who have generously shared with me their rich understanding of Josephine Tota's life and art. Conversation between Rosica and author, September 24, 2010; e-mail from Rosica to author, September 25, 2010; e-mail from R. Tota, November 21, 2010; conversation with Rosica and author, October 4, 2012; conversation with Rosica and R. Tota, October 5, 2013; e-mail from Rosica to author, July 23, 2014; e-mail from R. Tota to author, July 27, 2014.

3 R. Tota and Rosica conversation, October 5, 2013.

4 Rosica e-mail, September 25, 2010.

5 Frank A. Salamone, *Italians in Rochester, New York, 1900–1940* (Lewiston, NY: Edwin Mellen Press, 2000), 19.

6 Salamone, 59.

7 Rosica conversation, October 4, 2012. For more on the duality experienced by immigrant women, see Roni Berger, *Immigrant Women Tell Their Stories* (New York: Routledge, 2011).

8 Rochester, New York, City Directory, 1927.

9 Rosica and R. Tota conversation, October 4, 2013.

10 "Gallery Exhibit Showcases Works by Tota, Williams," *Brighton-Pittsford Post*, February 1990.

11 Fritz Trautmann letter to Marlene Phillips, August 1961, Memorial Art Gallery archives, Rochester, NY.

12 For more on Carrington's ideas about egg tempera, see "The Alchemical Kitchen: Domestic Space as Sacred Space," in Susan L. Aberth, *Leonora Carrington: Surrealism, Alchemy and Art* (London: Lund Humphries, 2004), 57–96.

13 Larry Merrill's notes, November 28, 1989, exhibition file for *Inside Out*, MAG archives.

14 Merrill e-mail to author, June 19, 2014. Thanks to Larry Merrill, Josephine Tota's legacy exists at the MAG.

15 Exhibition pamphlet, *Inside Out,* January 26–March 3, 1990, Lucy Burne Gallery of the Creative Workshop, MAG archives.

16 Ron Netsky, "Two Artists: Naive by Design," for the *Democrat and Chronicle* Arts section, February 11, 1990, 3D. Another notice of the exhibition, more descriptive than analytical, "Gallery Exhibit Showcases Works by Tota, Williams," *Brighton-Pittsford Post*, February 1990.

17 This sketchbook is in the collection of Lisa Rosica.

18 The installation was on view in the museum from January 12–April 3, 2011.

19 R. Tota e-mail, March 30, 2011.

20 More information on Tota and images of her work can be found at www.mag. rochester.edu.

21 Ilene Susan Fort, Tere Arcq, and Terri Geis, eds., *In Wonderland: The Surrealist Adventures of Women Artists in Mexico and the United States*, exh. cat. (Los Angeles: Los Angeles County Museum of Art, 2012).

22 Rosica e-mail, July 23, 2014.

23 Whitney Chadwick in "Prologue," to Fort, Arcq, and Geis, 16.

24 Rosica, October 4, 2012.

25 This sense of a fractured self and the need to resolve or represent it in their art finds an earlier example in Frida Kahlo, as Salomon Grimberg addressed in "Frida Kahlo: The Self as an End," *Mirror Images: Women, Surrealism, and Self-Representation*, Whitney Chadwick, ed. (Cambridge: MIT Press, 1998), 83–104.

26 Rosica and R. Tota conversation, October 5, 2013.

27 Rosica e-mail, July 23, 2014; Tota e-mail, July 27, 2014.

28 In addition to related sources on outsider art listed in other footnotes, see Roger Cardinal, *Outsider Art* (New York: Praeger Publishers, 1972); Vera L. Zolberg and Joni Maya Cherbo, eds., *Outsider Art: Contesting Boundaries in Contemporary Culture*, (Cambridge: Cambridge University Press, 1997); Gary Allen Fine, *Everyday Genius: Self-Taught Art and the Culture of Authenticity* (Chicago: University of Chicago Press, 2004); James Elkins, "Naïfs, Faux-naïfs, Faux-faux naïfs, Would-be Faux-naïfs: There Is No Such Thing as Outsider Art," in *Inner Worlds Outside*, exh. cat., ed. John Thompson (Dublin: Irish Museum of Modern Art, 2006), 71–9.

29 R. Tota and Rosica conversation, October 5, 2013.

30 Larry Merrill e-mail to author, June 19, 2014.

31 Maurice Tuchman, introduction to *Parallel Visions: Modern Artists and Outsider Art*, ed. Maurice Tuchman and Carol S. Eliel, exh. cat. (Los Angeles: Los Angeles County Museum of Art, 1992), 10.

32 Ibid.

33 For more on Stettheimer, see Barbara J. Bloemink, *The Life and Art of Florine Stettheimer* (New Haven: Yale University Press, 1995).

34 Roberta Smith, "No More on the Outside Looking In," *New York Times*, April 11, 2013.

35 Jerry Saltz, "Jerry Saltz on the Outsider Art Fair—and Why There's No Such Thing as 'Outsider' Art," *Vulture.com*, February 1, 2013.

PART II
Marginalized Works Reinterpreted

Edward Mitchell Bannister and the Aesthetics of Idealism

Traci Costa

Edward Mitchell Bannister (1828–1901)—a Canadian-born black painter who enjoyed a 30-year career in Providence, Rhode Island—was subjected to racial discrimination throughout his life, as was his legacy in the aftermath of his death. Persistent prejudice has resulted in Bannister's exclusion from mainstream accounts of American art history and created a lack of urgency to preserve his artwork, thus minimizing his significance beyond the state of Rhode Island.[1] Consequently, art historians have focused on compiling a coherent biographical account of Bannister's life, with critical interpretation of his artwork as a secondary concern. The presently reductive understanding of his artwork—particularly in the case of his large body of landscape paintings—is a direct result of this. Because he endured the racism that defined nineteenth-century America, art historians continually presume that Bannister's race was the driving force behind his artistic expression.[2] This approach effectually positions his artwork within the political and social movements of his era but fails to capture the nuances of his individual perspective as a freeborn, freethinking, black artist.[3] This limited interpretive lens has oversimplified Bannister's legacy, leading art historians to identify his landscapes as reactions against his sociopolitical standing or expressions of his basic admiration for nature.[4] Past accounts of Bannister's career have merely remedied his omission from historical discourse, in turn diminishing his significance as an autonomous artist.

This paper places Bannister's artwork within the framework of German Idealism, a philosophical system prevalent in nineteenth-century New England and America in general. Several sources evidence Bannister's connection to Idealist philosophy. Most notable is his unpublished manuscript, *The Artist and His Critics* (1886), written during the height of his career.[5] A profoundly neglected resource, this document offers valuable insight into his philosophy of artistic expression and criticism. With this

manuscript as my focus, I will identify the relationship of Bannister's writing to the basic principles of German Idealism, associated with Georg Wilhelm Friedrich Hegel (1770–1831) and Friedrich Wilhelm Joseph Schelling (1775–1854). To evidence this connection further, I will explore Bannister's exposure to German Idealism through influential nineteenth-century authors, Ralph Waldo Emerson and Washington Allston. Upon establishing this influence, I will evaluate his dynamic landscape painting, *Approaching Storm* (Plate 6), completed concomitantly with his manuscript. I will also analyze *Hay Gatherers* (c. 1893) (Figure 6.1), a later landscape believed to convey explicit racial themes. Together, these analyses illustrate the abundance of Idealist techniques, themes, and symbols embedded in Bannister's compositions. While no direct link exists between Bannister and German Idealists, this evidence sufficiently demonstrates his affinity toward their philosophy.

Today, Bannister's work survives in local institutions connected to the artist's career in Rhode Island. These include the Providence Art Club, the library at Brown University, and the Museum of Art at the Rhode Island School of Design.[6] Committed to the preservation of American art, the National Museum of American Art in Washington, DC, also holds a collection of his works. Without the specific and vested interests of these institutions—in local art and in art of the United States—these important works by Bannister may have been lost to history.

An Overview on Bannister

The first African American nationally recognized in the arts, Bannister is renowned for winning the first-place medal in painting at the Philadelphia Centennial Exhibition of 1876 for his landscape, *Under the Oaks.*[7] Living in Providence at the time, he was the only New England artist honored at the exhibition, lending prestige to his and Providence's reputations alike.[8] He later became a founder and board member of the Providence Art Club and the Rhode Island School of Design, two institutions that were essential to the development of Providence as a notable arts center.[9] A celebrated activist, Bannister was a fixture among antislavery organizations throughout his lifetime, participating in an array of capacities from fundraising to advocacy.[10] Today, his work survives in such places as the Providence Art Club, the library at Brown University, the Museum of Art at the Rhode Island School of Design, and the National Museum of American Art in Washington, DC.[11]

Bannister derived artistic influence from the French Barbizon school, whose serene landscapes and idealized representations of the working class

6.1 Edward Mitchell Bannister, *Hay Gatherers*, 1893. Tempera on panel, 45.72 x 60.96 cm.
Private collection

aligned with his own harmonious renderings of nature.[12] He encountered
this style in Boston, where he moved in 1850 from his birthplace, New
Brunswick, Canada, to begin his career.[13] He became acquainted with the
Barbizon style through William Morris Hunt, upon Hunt's return from
France where he had developed a friendship with French Barbizon school
leader, Jean-François Millet.[14] Though the details of Bannister relationship
to Hunt's are unknown, it is likely that they crossed paths at the Studio
Building in Boston where each artist rented studio space.[15] Additionally,
both men actively exhibited work in Boston during the 1860s, giving
Bannister ample exposure to French Barbizon sensibilities through Hunt's
artwork.[16] Bannister also studied anatomical drawing under William
Rimmer at the Lowell Institute during this time, allowing him to develop
his technical skill and to network with other Barbizon artists.[17] Bannister's
Barbizon connection continued when he moved to Providence between
1869 and 1870.[18] By the time of his arrival, Providence's artistic taste was
predominantly Barbizon due to the influence of art dealer Seth Vose, who
had been importing European Barbizon paintings into New England since
the 1850s.[19] Like many nineteenth-century landscape artists, Bannister
sought to evoke God's presence in nature and to communicate spiritual and
moral sentiments in his paintings.[20]

German Idealism

Art history emerged as a formal discipline in Germany during the late eighteenth and early nineteenth centuries, coinciding with the scientific and historic thinking of the Enlightenment.[21] This era introduced the theory of "aesthetics" associated with Immanuel Kant, who recognized sensory knowledge as a universal mode of cognition.[22] Hegel and Schelling proceeded from this Kantian understanding, offering their own philosophies of mind, spirit, and art. While Kant considered aesthetics a type of knowing, Hegel and Schelling used the term to refer simply to art itself.[23] For them, aesthetics were a product of knowledge, a tangible intellection of spirit.[24] Their philosophy was the first to account for changes in artistic production over time, regarding art as an historical, evolutionary, and theological reflection of man's concept of divinity.[25] The metaphysical premise of German Idealism fundamentally countered British empiricism and materialism, making it an attractive philosophy to American Transcendentalists—particularly New England theologians—during the nineteenth century.[26]

Hegel and Schelling belong to the school of Transcendental Idealists, a branch of German philosophers who believed that one could transcend the physical world through the apprehension of its underlying concepts.[27] Hegel's philosophy of mind and spirit is concerned with the role of perception in the development of self-consciousness, or the dichotomous relationship of "the self" and "the other," where nature, as the manifestation of the "Absolute Spirit," embodies the other.[28] Hegel's Absolute Spirit is akin to God, the metaphysical basis of the physical world.[29] The fixed antithesis of mind (intellectual) and form (sensible) is the premise of Hegel's *Phenomenology of Spirit* (1807) and *Philosophy of Mind* (1830), which informed his *Introductory Lectures on Aesthetics* (1835–38) and *The Philosophy of Fine Art* (1886).[30] For Hegel, art synthesizes mind with form, allowing the Absolute Spirit to transcend the ideal realm and find expression in the real.[31] He favored the "Romantic arts"—such as painting—believing this medium reveals the Absolute most clearly.[32] Beauty in art derives from the artist's ability to reconcile mind, or spirit, with form.[33] As an intrinsically moral and didactic tool, art awakens man's spirituality and inspires him to contemplate the duality of his own being.[34]

Schelling published *The Philosophy of Art* in 1859, affirming Hegel's belief that art illustrates the negotiation between ideal and real.[35] Schelling also recognized art's ability to make philosophy—a direct representation of the divine—objective.[36] Like Hegel, Schelling identified the Absolute Idea as the immediate cause of all things.[37] He shared Hegel's "double-view" of the universe, characterized by the dialectical relationship between the absolute and the particular.[38] Both philosophers believed the artist's aim is to express

the Absolute Idea through the real.[39] Schelling defined beauty in art as "an absolute synthesis or mutual interpretation of freedom and necessity."[40] Like Hegel, he regards painting as the ideal art form, as it is the furthest removed from reality given its two-dimensionality.[41] Taking Hegel's philosophies of mind and spirit further, Schelling uses these ideas to codify Idealist aesthetic guidelines, identifying a number of elements that make the Absolute objective in painting—namely, light, color, contrast, the human figure, and variations of line and shape.[42]

For Schelling, light is the element of the ideal revealed in nature.[43] Light synthesizes with the body through color, which differentiates figures from their environment.[44] Color should derive from nature and operate in a self-enclosed system, organized around the contrast of warm and cool tones.[45] Corresponding colors, like green and purple, are harmonious and pleasing to the eye.[46] For Schelling, the worthiest form of artistic depiction is the human figure, given its capacity to mirror the Absolute when shown at peace or rest.[47] As with all forms, the artist must show what is necessary of the figure, eliminating anything superfluous to its essence.[48] Perspective becomes integral to this, revealing only what is necessary of the whole.[49]

Schelling believed certain geometries possessed a greater capacity to symbolize the Absolute Idea, particularly the ellipse, triangle and bent line.[50] He favored elliptical forms for their ability to express variety and difference within identity.[51] Conversely, recurring shapes—such as circles, squares, right angles and parallel lines—reinforce monotony, appearing the same regardless of vantage point and permitting the least variance of form.[52] The triangle is thus most favorable, given its unequal angles and absence of parallel lines.[53] Addressing line quality, he states, "One cannot deny that for the eye, too, the straight line is the symbol of hardness, of inflexible dimensions, just as the bent line is a symbol of flexibility the elliptical one—placed horizontally—gentleness and transiency, the wavy line of life, and so on."[54]

Schelling also noted the importance of symmetry, grouping, and chiaroscuro to the symbolic capacity of composition.[55] The first of these—symmetry and grouping—are the main components of painting.[56] Symmetry refers to two halves of a painting in relative balance, a disturbance in which yields a suspension of identity.[57] These halves defer to a middle ground where the essential element in painting falls.[58] Grouping relates individual parts in proper depth through a larger system, ideally proceeding from multiples of three in a pyramidal arrangement to allow the whole to precede parts in perception.[59] Considered last is chiaroscuro, the mutual effect that light and dark colors have on one another when juxtaposed.[60] The magical element of painting, chiaroscuro produces a range of lighting effects, intensifies illusion, reinforces perspective, and allows the artist to place his light source within the canvas itself.[61]

Bannister's Manuscript

The Artist and His Critics, held at the Rhode Island Historical Society, is the only surviving record of Bannister's philosophy on artistic production and criticism. Bannister delivered this 31-page manuscript in a speech to the Ann-Eliza Club, a subset of the Providence Art Club dedicated to cultural and philosophical discourse.[62] Despite being well preserved and easily accessible, this resource remains entirely underutilized as a means to understand Bannister's artwork. Art historians who address this manuscript—such as Lynda Roscoe Hartigan, Juanita Marie Holland, Corrine Jennings, Kenneth Rodgers, Sharon F. Patton, Romare Bearden, and Harry Henderson—do so summarily, presenting this essay as evidence of his status as an exceptional and intellectual African American or his connection to Barbizon sensibilities.[63] Upon closer inspection, his manuscript echoes a number of German Idealist concepts—namely, the "Absolute Idea," "universal law of limitations," "finite mind," "Spiritual Idea," and "perfect harmony."[64] Furthermore, his ideas regarding art's content and purpose mirror Schelling and Hegel's philosophies of mind, spirit, and art, as well as the fundamentals of Transcendental Idealism.

Bannister seemingly references the Enlightenment in the opening of his manuscript, addressing his era as "between the period of knowing nothing of Art and an awakening appreciation of its value as a teacher, and its importance as a means toward lifting us out of the low atmosphere of sordid gain and narrow selfish ambition into one more ethereal and spiritual."[65] In asserting the didactic function and moral power of art, Bannister positions his ideas among those of German philosophers like Schelling, who asserted that art was a reflection of philosophical ideas (the divine), and Hegel, who believed that art served an instructive and moral purpose in bringing spiritual content before man's consciousness. The previous excerpt from Bannister's manuscript resonates closely with the following quote from Hegel's *Introductory Lectures on Aesthetics*:

> Of course, we may often hear those favourite phrases about man's duty being to remain in immediate oneness with nature, but such oneness in its abstraction is simply and solely coarseness and savage and art, in the very process of dissolving this oneness for man, is raising him with gentle hand above and away from mere sunkenness in nature.[66]

Strengthening his apparent connection to Idealism, Bannister defines the artist as an interpreter of the "infinite, subtle qualities of the spiritual idea, centering in all created things, expounding for us the laws of beauty and so far as the finite mind and executive ability can, revealing to us glimpses of the absolute idea of perfect harmony."[67] This excerpt evokes the basic dichotomies of Idealism—infinite and finite, universal and particular, spiritual and physical, freedom and necessity. Articulating himself in undeniably Idealist

rhetoric throughout his manuscript, Bannister borrows both the philosophical leanings and vocabulary of Hegel and Schelling.

Bannister also stresses the importance of responsible critique in his writing, which to him entails the analysis of an artist's "underlying motives," "the social, religious and political conditions under which they labored," and their "dependence on the character of their time."[68] In his explanation of appropriate criticism, Bannister hints at the spirit or zeitgeist of a culture that informs artistic expression, a concept embraced and promoted by German Idealists. In doing so, Bannister stresses that the meaning and feeling of the artist are as deserving of criticism as their technical ability.[69] He notes that critics of his day tend toward "according errors," an indiscriminate approach that is ultimately a disservice to art, artists, and the public alike.[70] In his definition of the artist's role, the function of art, and his prescription for proper art criticism, Bannister reinforces the metaphysical basis of art and the philosophy of mind and spirit described by Idealism.

Bannister, the American Transcendentalists, and Their Connection to German Idealism

In his manuscript, Bannister embraces the Transcendentalist concept of the artist as a "spiritual conduit" and art as the reflection of the Absolute Spirit, supporting the conclusion of art historians that he was familiar with Transcendentalism through Emerson. Bannister likely encountered Emerson in Boston, where Emerson often lectured on art and abolitionism.[71] Art historian Barbara Novak describes Emerson's extensive engagement with German philosophy as well as the Transcendentalist affinity toward Idealism in general.[72] Henry A. Pochmann also acknowledges this connection, identifying a strong Idealist tradition in America that characterized the seventeenth through twentieth centuries.[73] Among the German philosophers that Emerson consulted (a list including Kant, Coleridge, Carlyle, Böhme, Oken, Fichte, and Hegel) he was most impressed with Schelling.[74] Emerson had a complex relationship with Idealism, expressing simultaneous appreciation and mistrust for Schelling and Hegel.[75] He found Schelling's fundamentals appealing—namely, the identification between subject and object, the notion of the "world-soul," and the belief that nature is the art of God.[76] He appreciated Hegel's historic theory and concept of nature as the "Idea in its otherness."[77] He also respected Hegel's dialectics and logic, accepting the synthesis of something and nothing as the basic "paradox of being."[78] Emerson integrated Idealist ideas into his writing to the extent that they confirmed his preexisting views.[79] German philosophy validated the beliefs of many Transcendentalists who treated its theories similarly, parsing out ideas to retain the most favorable.[80]

Despite finding Hegel challenging, Emerson embraced his fundamentals.[81] R.A. Yoder and W.T. Harris attest to this, noting a recurring dialectical structure in Emerson's prose.[82] Harris argues that Emerson's first book, *Nature*, boasts a dialectical system of logic and acknowledges the "over-soul" that is revealed to man through nature, while presiding over both.[83] It is clear that Idealist ideas were impressed upon Emerson and that he ultimately sympathized with the philosophy's foundation.[84] Novak refers to Emerson as the "unofficial spokesman for American landscapists," articulating the influential position that he held in nineteenth-century American culture and his ability to shape artistic taste and theory through his writing.[85]

Author and painter Washington Allston was among those artists influenced by Transcendentalism. Among Allston's personal and professional affiliations, his connection to philosopher S.T. Coleridge is of particular interest. Italian scholar Regina Soria has argued that Coleridge validated Allston's beliefs about faith and spirituality, spurring his interest in Schelling among other German philosophers.[86] Though Allston was not a self-proclaimed Idealist, he openly incorporated their principles into his writing.[87] C.P. Seabrook Wilkinson describes Allston's *Lectures on Art* (1850) as a "swansong of eighteenth century aesthetic theory" and Allston as the "Laureate of the Ideal."[88] As the first to publish an art treatise in English and the only to promote an Idealist based art theory in nineteenth-century America, Allston profoundly influenced artistic theory in and beyond New England.[89] Bannister became familiar with Allston's treatise while living in Boston, later referencing this work in *The Artist and His Critics*.[90] Allston's ideas also surfaced in Emerson's writing, a close friend and admirer who wielded Allston's philosophy to confirm and differentiate his own perspective.[91] Together, these men informed Bannister's concept of artistic expression and introduced him to the principles of German Idealism embraced by American Transcendentalist thinkers. Considering Allston and Emerson's demonstrable connection to German Idealist philosophers and Bannister's affinity toward these influential writers, it is plausible that Bannister, too, engaged critically with Idealist concepts. In turn, it is equally plausible that these concepts informed his art-making process and surfaced in his work.

An Analysis of *Approaching Storm* and *Hay Gatherers:* A German Idealist Perspective

In subject, theme, and title, *Approaching Storm* evokes Hegel and Schelling's worldview: the dialectical relationship between the universal (nature) and the particular (man). This work conveys the negotiation between self (particular) and other (universal), where nature is the manifestation of the Universal Idea or Absolute. In this painting, Bannister glimpses the precise moment when

these two opposing forces meet, bringing them into an ideal relation where neither overpowers nor subdues the other, but rather reaffirms each other's being. Bannister's centrally placed figure resonates with Schelling's assertions that man is the worthiest subject in art and that a composition's essential element occupies the midpoint.[92] The figure is thus the essential element in this painting, emphasizing the subjective experience and finitude of man as he confronts the objectivity and infinitude of nature. Bannister renders only what is essential of his subjects. This is consistent with the Idealist aesthetic, in which beauty requires the elimination of superfluous detail.[93] He clusters his composition into elliptical masses, as seen in the clouds, trees, rocks, and shrubs. Placed horizontally, Banister's ellipses recall Schelling's perception of this shape as an indicator of impermanence. This symbolism is appropriate in this instance, conveying the unlimited power of nature and the transitory condition of its effects. Overall, this painting is free of straight lines, regular shapes, and right angles—all symbols of rigidity and monotony for Schelling. Instead, Bannister employs bent and curved lines (as in the bowed footpath that cuts across the canvas) to reflect the landscape's variable nature.

Bannister's tertiary palette creates distinct relationships within a harmonious system of corresponding colors. This occurs between the bluish-gray and purple sky and the lush landscape of yellows and greens below. These two planes accentuate one another—the greens pulling out the purples in the sky and the yellow of the fields drawing out the blues above. Bannister organizes his picture plane by color temperature. The canvas's lower half, rendered in warm variations of yellow and green, contrasts with the sky's cool gray, blue, and purple tones. The landscape becomes progressively cooler as you move from bottom to top, lending an atmospheric quality to the clouded sky. This balanced system of color epitomizes Schelling's aesthetic principles, which demand that colors proceed from nature, operate in harmony, and organize around the polarity of warm and cool tones.[94] Beyond this, the color relationships in this painting establish balance and symmetry among the canvas's halves, conveying a stable sense of identity and belonging.

The last topic of concern in this canvas is light, an element intrinsic to the artists understanding of chiaroscuro. Upon initial impressions, *Approaching Storm* is strikingly dim. The clouded sky shadows the landscape, defining space with contrasts in color versus pools of light. The sky is seemingly backlit, indicated by openings in the clouds located above the figure, on the right and in the distance. Light—a symbol of the Absolute Spirit in art—is an underlying presence in this work that asserts itself through the material density of clouds. The relationship between the sunlight and the natural world is thus illustrative of the relationship between the Absolute Spirit or Idea and the material realm described in Idealism. One can surmise that the light source is located within the composition itself, an effect of chiaroscuro that also reinforces depth and perspective. Bannister's treatment of form,

composition, color, and light, serve as a catechism for Idealist philosophy, making its principles concrete and tangible to the viewer.

Painted circa 1893, *Hay Gatherers* has received the most critical attention from art historians given its inclusion of African American subjects. Gwendolyn Dubois Shaw carefully considers the racial context of religious symbols embedded in Bannister's composition. For Shaw, this image elevates the labor of working-class African Americans while subtly referencing Rhode Island's participation in the slave-trade industry.[95] Relating this scene to a biblical narrative, she likens Bannister's figures to the Israelites who, within the reach of the system that enslaved their ancestors, traversed the wilderness in pursuit of the Promised Land.[96] Consideration of this painting in the context of Idealist aesthetics only reinforces Shaw's interpretation of *Hay Gatherers* as an exploration of racial oppression in a post-emancipation world. Combining these lenses yields the clearest insight into Bannister's artistic intentions for this image.

Bannister's approach to symmetry, geometry, and grouping in this work epitomizes Idealist aesthetics. He divides his picture-plane into imbalanced halves; the left populated by trees and underbrush, the right dotted with trees and people. According to Shaw, the figures in this canvas vacillate between spaces of labor (signified by the hay bale) and leisure (signified by the open pastures in the foreground).[97] For Schelling, compositional asymmetry results in the suspension of identity. This understanding of asymmetry enhances Shaw's assessment of these figures as caught between the promises of the future and reminders of a painful past. If the right of the canvas symbolizes labor and Rhode Island's plantation history, the left represents the future for African Americans post-emancipation. A density of shrubs and trees, the left offers an impeded view, disallowing apprehension of the horizon beyond. This obstructed sightline symbolizes the uncertainty felt by former slaves and their descendants who were navigating new issues of class and race. An overlooked detail on the right further substantiates the identification of this half with the past. Magnifying the rightmost edge reveals two additional figures, facing one another in pause. Bannister renders these figures in minimal detail; their only distinguishing feature being the white apron worn by the woman to the right. The progressive abstraction of figures from foreground to background symbolizes the fading traces of plantation history, a meaning that Shaw inferred based upon subject matter alone. An understanding of Idealist aesthetics adds depth to her interpretation, suggesting the means by which Bannister evoked these ideas.

Bannister's landscape is broken down into a series of triangles, each oriented with their apex to the sky and their bases parallel to the ground. This shape defines the treetops and shrubs, creating a compositional rhythm that leads the eye from foreground to background. He treats his figures similarly, breaking them into two groups related through pyramidal arrangements.

The first group is in the middle distance, gathered around the bale of hay. Two figures stand in front while one sits atop the bale, glancing downward. The second group includes the figure to the right of the hay, the women in the foreground and the women in the right distance of the canvas. Shaw neglects these rightmost women, identifying distant trees as the apex of this pyramidal group. As Schelling suggests, triangular grouping indicates an interconnectedness among figures while allowing the whole to precede parts in perception.

Beyond evoking harmony, Bannister's employment of the triangle evades monotony. This is particularly relevant to Shaw's understanding of *Hay Gatherers* as an image that elevates African American, middle-class labor. In avoiding recurring geometries (as in the circle or square), Bannister lifts the viewer out of the monotonous rituals of everyday life by emphasizing variety and harmony among God's creations. As in the lot of his landscape scenes and in keeping with the Idealist aesthetic, the human figure occupies the approximate midpoint of the composition. The midpoint of *Hay Gatherers* contains three figures and two cows, gathered around a bale of hay situated below a cluster of trees. From their integration, one could infer that the harmonious relation between man and nature is the essential element in this work. Focusing on the figures alone, the solidarity of the group comes to the forefront, suggesting the necessity of unity among African Americans during this time.

The sky in *Hay Gatherers* consists of light blues, purples, and whites versus the ominous grays of *Approaching Storm*. Once again, the light source is within the image itself, symbolizing the relationship of the Absolute, or Ideal, to the physical, or real. As with *Approaching Storm*, *Hay Gatherers* proceeds from an enclosed system of tertiary colors. The upper half of the image is predominantly light purple while the lower half dissolves into shades of green. There is an array of tertiary tones within the lower half of the composition that, when juxtaposed, establish depth and space within the picture plane. Where Bannister employs a yellow-green, a bluish-green or reddish-purple is nearby. This correspondence occurs above as well, evidenced in the subtle interchanging of violet and orange tones that define the puffs of clouds.

Shaw addresses the landscape as a means of transcendence for the artist, an idyllic and contemplative retreat. This understanding mirrors Hegel's belief in the moral purpose and aim of art to lift the viewer out of sunken identification with the physical realm toward the contemplation of universal concepts. Bannister brings the dialectics or contradictions of his reality into ideal relation on the canvas, directly engaging Idealist philosophy. As Bannister navigates issues of race and class, he addresses the dichotomy of African American identity, suspended between reminders of a trying past and the signs of hopeful future. The result is an unequivocally Idealist representation of the African American experience during this time.

Conclusion

In his 1914 article, "Reminiscences of Providence Artists," George W. Whittaker dubbed Bannister "The Idealist."[98] He expands upon this in an undated article, likely written before the artist's death:

> He is as purely an ideal painter as any we have among as—his ideals are realities ... he gives us what his "mind's eye" beholds, and in facing nature he first gets his "picture" by twisting and turning objects in his composition to suit his fancy, digesting well what he appropriates, thus obtaining the best results. The idealist sees most with closed eyes, and our friend is an active member of this class.[99]

Whittaker returns to this connection between Bannister and Idealism throughout his writings on the artist, presenting his insights in a more assertive than suggestive manner.[100] Although Whittaker is one of the most cited sources for information regarding Bannister, historians have entirely overlooked this element of his writing. In their seminal book, *A History of African-American Artists*, Bearden and Henderson described Bannister as an artist who painted what he knew personally, injecting his own poetic sentiments into his renderings of nature.[101] They also suggest that *Approaching Storm* expresses Bannister's interest in nature's accidental, conflicting effects. However, their description of Bannister's work is only cursory due to the nature of the book as a survey of African American art. *Edward Mitchell Bannister*, an exhibition catalog for the 1992 show of Bannister's work by Holland and Jennings, is a much more comprehensive examination of the artist. This text moves beyond a racially based reading to account for Bannister's interests and beliefs, which reflect "a philosophy that had much in common with Transcendentalism."[102] Here, they briefly discuss Bannister's manuscript and philosophical influences, but avoid any definitive connections beyond his engagement with Emerson and Allston. Though they describe Bannister as an "artist-thinker" who used his paintings to clarify his philosophical and religious perspective, the biographical aim of this text takes ultimate precedence over the analysis of his artistic motivations.[103] While their writing offers some of the most critical assessments of Bannister's work, suggesting an underlying geometry to his compositions and the presence of metaphor in his work, their interpretation is brief at best, skimming the surface of what one can glean from his paintings.[104] In a 1997 exhibition catalog, *Edward Mitchell Bannister: American Landscape Artist*, Holland and Rodgers acknowledge Bannister's art as a vehicle for God's ideas and a record of "natures force and his own feeling about it."[105] They address his omission of the superfluous in his style, his brilliant application of light and his ability to synthesize figure and nature.[106] In this way, previous scholarship on Bannister's painting has indirectly connected his work to German Idealism, stopping short of naming it as such. In describing the

effects of his work, these art historians approach Idealist concepts without any philosophical specificity. Instead, Bannister's racial identity provides the ultimate framework for historical interest in his artwork, subverting his unique contribution to American art in order to emphasize the overarching narrative of African American history. Consequently, Bannister becomes a trope for the exceptional black artist. It is time to move beyond this limited interpretive lens to one more multifaceted; one that considers Bannister in the context of broader issues and ideas related to nineteenth-century American art.

Considering Bannister's reiteration of Idealist concepts in his manuscript, the circulation of German Idealism in nineteenth-century New England, and the various encounters that Bannister had with this philosophy, it is plausible to argue that Idealist philosophy surfaced in his paintings. Application of the Idealist lens only enhances past interpretations of his artwork, allowing for substantive evaluation of his artistic forms and intentions. According to Bannister, the critic who fails to consider an artist's motive within the character of his time grasps neither the character nor accomplishment of the artist's work.[107] Consideration of these factors situates Bannister within the larger philosophical dialogue of his era, lending necessary definition to his career by distinguishing his legacy from the general narrative of African American life in the nineteenth century.

Notes

1 Nearly all art historians who contemplate Bannister's life and artwork acknowledge the problematic exclusion and marginalization of African Americans from mainstream art historical accounts. See Juanita Marie Holland and Corrine Jennings, *Edward Mitchell Bannister, 1828–1901* (New York: Kenkeleba House and Whitney Museum of Art, 1992), 9; Romare Bearden and Harry Henderson, *A History of African-American Artists: From 1792 to the Present* (New York: Pantheon, 1993), xvii–xiii, 51; Gwendolyn DuBois Shaw, "Landscapes of Labor: Race Religion and Rhode Island in the Painting of Edward Mitchell Bannister," in *Post-Bellum, Pre-Harlem: African American Literature and Culture, 1877–1919*, ed. Barbara McCaskill and Caroline Gebhard (New York: New York University Press, 2006), 70–71; Lowery S. Sims and Jonathan P. Binstock, "Edward Mitchell Bannister," in *African American Art: 200 Years* (New York: Michael Rosenfeld Gallery, 2008), 38; Sharon F. Patton, "Edward Mitchell Bannister (1826/7–1901)," in *African-American Art* (Oxford: Oxford University Press, 1998), 11, 13; and Juanita Marie Holland and Kenneth Rodgers, *Edward Mitchell Bannister: American Landscape Artist* (Durham, NC: North Carolina Central University Art Museum, 1997), 14.

2 Lynda Roscoe Hartigan, "Edward Mitchell Bannister," in *Sharing Traditions: 5 Black Artists in 19th Century America* (Washington, DC: Smithsonian Institution Press, 1985), 82; Edward Bannister, *Edward Mitchell Bannister, 1828–1901, Providence Artist: An Exhibition Organized by the Museum of Art, Rhode Island*

School of Design for the Museum of African Art, Frederick Douglass Institute (Washington, DC: Museum of African Art, 1966), n.p.; Holland and Jennings, *Edward Mitchell Bannister*, 11–13, 17, 21; Shaw, "Landscapes of Labor," 59–63, 66–70; and Holland and Rodgers, *Edward Mitchell Bannister*, 2, 6, 9.

3 Growing up in New Brunswick, Canada, where the British abolished slavery shortly after his birth, Bannister enjoyed access to a quality education, better than that of his peers in the United States who struggled against pervasive racial oppression. William Wells Brown. *The Black Man, His Antecedents, His Genius, and His Achievements,* 2nd ed. (New York: T. Hamilton, 1863), 214; Bearden and Henderson, *A History of African American Artists*, 41.

4 For examples of art historical interpretations that emphasize Bannister's race or appreciation for nature, see Anne Prentice Wagner, "Newspaper Boy" (*Smithsonian American Art Museum*, last modified January 2012), n.p.; Hartigan, "Edward Mitchell Bannister," 75–8; Bearden and Henderson, *A History of African American Artists*, 49–50; Holland and Jennings, *Edward Mitchell Bannister*, 13, 18; Patton, "Edward Mitchell Bannister, 89; Shaw, "Landscapes of Labor," 59–73; and Holland and Rodgers, *Edward Mitchell Bannister*, 13–14.

5 Edward Bannister, *The Artist and His Critics*, Ann-Eliza Club Manuscript Division, MSS# 26, Box 1, Folder 25 (Rhode Island Historical Society, Providence, RI, 1886).

6 Bearden and Henderson, *A History of African-American Artists*, 40.

7 Hartigan, "Edward Mitchell Bannister," 69–70; Shaw, "Landscapes of Labor," 69–70; Samella Lewis, *African American Art and Artists* (Berkeley: University of California Press, 2003), 31; Bearden and Henderson, *A History of African–American Artists*, xii, 44; Bannister, *Edward Mitchell Bannister*, n.p.; Holland and Rodgers, *Edward Mitchell Bannister*, 6; Holland and Jennings, *Edward Mitchell Bannister*, 29; Sims and Binstock, "Edward Mitchell Bannister," 38; Patton, "Edward Mitchell Bannister," 87–8.

8 Holland and Rodgers, *Edward Mitchell Bannister*, 12; Hartigan, "Edward Mitchell Bannister," 67, 75; Bannister Gallery (Rhode Island College) and Rhode Island Black Heritage Society, *4 From Providence: Bannister, Prophet, Alston, Jennings: Black Artists in the Rhode Island Social Landscape* (Providence: Rhode Island College, 1978), n.p.; Bannister, Edward Mitchell Bannister, n.p.

9 Bearden and Henderson, *A History of African-American Artists*, 40; Bannister Gallery (Rhode Island College) and Rhode Island Black Heritage Society, *4 From Providence*, n.p.; Holland and Jennings, *Edward Mitchell Bannister*, 45.

10 Holland and Jennings, *Edward Mitchell Bannister,* 21. Bannister actively participated in the Colored Citizens of Boston, the Crispus Attucks Choir, and the African-American Histrionic Club.

11 Bearden and Henderson, *A History of African-American Artists*, 40.

12 Paul F. Thompson, *Edward Mitchell Bannister: The Barbizon School in Providence.* Biographical Files, Edward Bannister Box (Providence Art Club Archives, Providence, RI, 1965), 1–3; Terry Gips, "Foreword," in *Narratives of African American Art and Identity: The David C. Driskell Collection* (College Park: University of Maryland Press, 1998), 26; Joan M. Marter, ed., "Bannister, Edward Mitchell (1833)," *The Grove Encyclopedia of American Art* no. 2 (2011):

199; Holland and Jennings, *Edward Mitchell Bannister*, 40; Holland and Rodgers, *Edward Mitchell Bannister*, 3; Sims and Binstock, "Edward Mitchell Bannister," 38; Bearden and Henderson, *A History of African-American Artists*, xi–xii, 40–51; Patton, "Edward Mitchell Bannister," 89.

13 Holland and Rodgers, *Edward Mitchell Bannister*, 6; Hartigan, "Edward Mitchell Bannister," 71; Bearden and Henderson, *A History of African-American Artists*, 41; Holland and Jennings, *Edward Mitchell Bannister*, 17; Shaw, "Landscapes of Labor," 59; Lewis, *African American Art and Artists*, 29; Patton, "Edward Mitchell Bannister," 56. There is a consensus that Bannister moved to Boston in 1850, though Hartigan, Holland, and Rodgers place him there in 1848 and Bearden and Henderson place him there in the 1840s.

14 Bearden and Henderson, *A History of African-American Artists*, 43.

15 Holland and Jennings, *Edward Mitchell Bannister, 1828–1901*, 25.

16 Bannister Gallery (Rhode Island College) and Rhode Island Black Heritage Society. *4 From Providence*, n.p.

17 Hartigan, "Edward Mitchell Bannister," 72.

18 Hartigan, ibid., 74; Holland and Jennings, *Edward Mitchell Bannister*, 25; Sims and Binstock, "Edward Mitchell Bannister," 38; Patton, "Edward Mitchell Bannister," 86; Bearden and Henderson, *A History of African-American Artists*, 43; Lewis, *African American Art and* Artists, 31; Holland and Rodgers, *Edward Mitchell Bannister*, 12.

19 Holland and Jennings, *Edward Mitchell Bannister*, 39; Hartigan, "Edward Mitchell Bannister," 75. By 1870, Barbizon works dominated Providence's local collections and profoundly influenced landscape painting. Bannister's career coincided with the city's growing taste for pastoral, harmonic landscapes. Though his primary market was in Boston, Vose made an indelible mark on the taste of Rhode Island artists through his large-scale importation of European works.

20 Bearden and Henderson address this trend in landscape painting in *A History of African-American Artists*, 49. For more information on the American landscape tradition, see Barbara Novak, *Nature and Culture: American Landscape and Painting, 1825–1875* (1980; reprint, New York: Oxford University Press, 2007), 195–231; Angela Miller, *The Empire of the Eye: Landscape Representation and American Cultural Politics, 1825–1875* (New York: Cornell University Press, 1993) 1–20, 209–88.

21 John Hendrix, *Aesthetics and the Philosophy of Spirit: From Plotinus to Schelling and Hegel* (New York: Peter Lang, 2005), 8–9, 206; Michael Hatt and Charlotte Klonk, *Art History: A Critical Introduction to Its Methods* (New York: Manchester University Press, 2006), 21–2; Donald Preziosi, ed., *The Art of Art History: A Critical Anthology* (New York: Oxford University Press, 2009), 55.

22 Preziosi, *The Art of Art History*, 2, 55–8.

23 Ibid., 58.

24 Hatt and Klonk, *Art History*, 3; Hendrix, *Aesthetics and the Philosophy of Spirit*, 1; Preziosi, *The Art of Art History*, 58.

25 Preziosi, *The Art of Art History*; Hendrix, *Aesthetics and the Philosophy of Spirit*, 9–10; Hatt and Klonk, *Art History,* 22–5.

26 Renee Welleck, "Emerson and German Philosophy," *New England Quarterly* 16, no. 1 (March 1943), 60–61; Renee Welleck, "The Minor Transcendentalists and German Philosophy," *New England Quarterly* 15, no. 4 (December 1942), 652; Henry A. Pochmann, *German Culture in America: Philosophical and Literary Influences, 1600–1900* (Madison: University of Wisconsin Press, 1957), 79–85, 153–98; Henry A. Pochmann, *New England Transcendentalism and St. Louis Hegelianism: Phases in the History of American Idealism* (Philadelphia: Carl Schurz Memorial Foundation, 1948); Novak, *Nature and Culture,* 226–31.

27 Hendrix, *Aesthetics and the Philosophy of Spirit*, 4–9, 40–41, 205.

28 Ibid., 3–4, 198.

29 Ibid., 7; Hatt and Klonk, *Art History*, 25.

30 Hendrix, *Aesthetics and the Philosophy of Spirit*, 197.

31 Ibid., 176–94; Hatt and Klonk, *Art History,* 25.

32 Hendrix, *Aesthetics and the Philosophy of Spirit*, 203.

33 Ibid., 163–4.

34 G.W.F. Hegel, *Introductory Lecture on Aesthetics*, ed. Michael Inwood, trans. Bernard Bosanquet (London: Penguin Books, 1993), 56–60.

35 Hendrix, *Aesthetics and the Philosophy of Spirit*, 45–50.

36 F.W.J. Schelling, *The Philosophy of Art*, ed. and trans. Douglas W. Scott (reprint; Minneapolis: University of Minnesota Press, 1989), 26–30.

37 Schelling, *The Philosophy of Art*, 23–32.

38 Ibid., 34–7.

39 Hendrix, *Aesthetics and the Philosophy of Spirit*, 37–45; Hegel, *Introductory Lecture on Aesthetics*, 51.

40 Schelling, *The Philosophy of Art*, 30.

41 Ibid., 128.

42 Ibid.

43 Ibid., 119–20.

44 Ibid., 121–2.

45 Ibid., 124.

46 Ibid., 126.

47 Ibid., 130–54.

48 Ibid., 133.

49 Ibid., 130.

50 Ibid., 131.

51 Ibid., 130–31.

52 Ibid.

53 Ibid.

54 Ibid.

55 Ibid., 134–6.

56 Ibid., 134.

57 Ibid.

58 Ibid.

59 Schelling adds, "Even though one is free to compose them from both even and uneven numbers, the double even ones, for example, 4, 8, 12, and so on, are excluded; only those composed of uneven ones are tolerable, for example 6, 10, 14, and so on, even though the uneven ones are always the most appropriate." Schelling, ibid., 134–5.

60 Ibid., 137.

61 Ibid.

62 Bannister was an important member of the A&E Club, dubbed "Artist Laureate" by his cohorts for his intellectual and artistic contributions to the group. See Hartigan, "Edward Mitchell Bannister," 75; Holland and Rodgers, *Edward Mitchell Bannister*, 12; Holland and Jennings, *Edward Mitchell Bannister*, 49; Bearden and Henderson, *A History of African-American Artists*, 47.

63 Hartigan, "Edward Mitchell Bannister," 82; Holland and Rodgers, *Edward Mitchell Bannister*, 12; Holland and Jennings, *Edward Mitchell Bannister*, 39; Patton, "Edward Mitchell Bannister," 89; Bearden and Henderson, *A History of African-American Artists*, 47.

64 Bannister,*The Artist and His Critics*, 1–31.

65 Ibid., 1.

66 Hegel, *Introductory Lectures on Aesthetics*, 55.

67 Bannister, *The Artist and His Critics*, 4–5; Holland and Jennings, *Edward Mitchell Bannister,* 39.

68 Bannister, *The Artist and His Critics*, 11, 13, 19.

69 Bannister uses the artistic criticism of Jean Francois Millet to exemplify this point, asserting that his works are "unjustly accused of endeavoring to ferment strife, of insulting national pride." For Bannister this attribution neglects the artist's motive and feeling, the tender, sympathetic, and deeply religiousness that is the true artistic nature. Bannister, ibid., 6–20.

70 Ibid., 16, 24.

71 Ibid., 4–5; Holland and Jennings, *Edward Mitchell Bannister*, 39; Bearden and Henderson, *A History of African-American Artists*, 43.

72 Novak, *Nature and Culture*, 218–31. Novak notes that American transcendentalists were exposed to German philosophy early on. Comparisons of their philosophies indicate a plethora of congruent ideas, such as the erasure of the ego, the entry into the infinite, and the search for universal quietism.

73 For an extensive history of German thought in America, consult Pochmann, *New England Transcendentalism*, and Pochmann, *German Culture in America*.

74 Renee Welleck, "Emerson and German Philosophy," *New England Quarterly* 16, no. 1 (March 1943): 41–52.

75 Emerson's wrote in a letter to his student, John F. Heath, "To hear Schelling might well tempt the firmest rooted philosopher from his home and I confess to more curiosity in respect of Schelling's opinions than to those of any living psychologist. There is grandeur in the attempt to unite natural and moral philosophy which makes him a sort of hero." Welleck, ibid., 50.

76 Ibid., 52–3.

77 Ibid., 56–7.

78 Ibid., 57–8.

79 Novak, *Nature and Culture*, 226–7; Welleck, "Emerson and German Philosophy," 53–60.

80 Welleck, "Emerson and German Philosophy," 61.

81 Pochmann, *New England Transcendentalism*, 54–64.

82 R.A. Yoder, "Emerson's Dialectic," *Criticism* 11, no. 4 (Fall 1969): 314–15; W.T. Harris, "The Dialectic Unity in Emerson's Prose," *Journal of Speculative Philosophy* 18, no. 2 (1884): 200–201.

83 Novak, *Nature and Culture,* 227–31; Harris, "The Dialectic Unity in Emerson's Prose," 200–201.

84 Welleck, "Emerson and German Philosophy," 62.

85 Novak, *Nature and Culture*, 227.

86 Regina Soria, "Washington Allston's Lectures on Art: The First American Art Treatise," *Journal of Aesthetics and Art Criticism* 18, no. 3 (March 1960): 331–2.

87 Ibid., 338.

88 C.P. Seabrook Wilkinson, "Emerson and the Eminent Painter," *New England Quarterly* 71, no. 1 (March 1998): 122, 126.

89 Soria, "Washington Allston's Lectures on Art," 338.

90 Holland and Jennings, *Edward Mitchell Bannister*, 39.

91 Soria, "Washington Allston's Lectures on Art," 329; Wilkinson, "Emerson and the Eminent Painter," 121, 125–6.

92 Schelling, *The Philosophy of Art*, 130–34.

93 Ibid., 133.

94 Ibid., 124.

95 Shaw, "Landscapes of Labor," 59–73.

96 Ibid.

97 Ibid.

98 Whittaker, "Reminiscences of Providence Artists," *Providence Magazine: The Board of Trade Journal* (March 1914): 138.

99 George W. Whittaker, "Edward Mitchell Bannister," Edward Mitchell Bannister Papers, Archives of American Art, Washington, DC, Smithsonian Institution, n.p.

100 He writes in an undated article, "Our friend was a spiritually minded man and from the beginning of his art career to its close he felt deeply that the Ideal was the real. This ideality obtains in all his canvases making them poems of peace. … He draws us from the hard realities of life, and by his deep interpretation, touches the soul, clearly representing the invisible in the visible." George W. Whittaker, "Edward M. Bannister," 6. In another undated article he writes, "Yet when we get at the proper distance we find that the hand seemed to have not been wholly guided by the sight, but by a deeper sense—a magical power. He shapes his forms out of the nature within, and raises the beholder into the realms of ideas. He does not minister wholly to intellect, which is but a gateway, but to the feeling within." George W. Whittaker, "Edward Mitchell Bannister," n.p.

101 Bearden and Henderson, *A History of African-American Artists*, 47–8.

102 Holland and Jennings, *Edward Mitchell Bannister*, 39.

103 Ibid.

104 Ibid., 13–14.

105 Ibid., 14.

106 Ibid., 10, 11, 13, 17.

107 Bannister, *The Artist and His Critics*, 11.

Wandering Pictures:
Locating Cosmopolitanism in Frederick A. Bridgman's
The Funeral of a Mummy on the Nile

Emily Burns

The panoramic painting, *The Funeral of a Mummy on the Nile* (Plate 7), completed in 1877 by American expatriate painter Frederick Arthur Bridgman (1847–1928), depicts an imagined ceremony of transporting the mummified remains of an Egyptian pharaoh encased in a glittering gold sarcophagus across the Nile from the city of Thebes (present-day Luxor; unseen at the right) to the mortuary complex across the river at the left of the composition. Although monumental, the painting has eluded careful study because it was buried in a private collection when the two main art historical books on American art in fin-de-siècle France were published, so the authors discussed its significance by coupling critical reviews with a black-and-white period illustration.[1] In addition, scholars have overlooked the American art galleries at the Paris Universal Exposition of 1878 as a subject of study, so the central role of this painting in this exhibition has not been discussed. Hospital chain owner Wendell Cherry (1935–91) purchased the painting from a Sotheby's auction in 1990, and donated it to the Speed Art Museum in Louisville, Kentucky. Now that the painting is on public view, its role in the history of American art and transnational art of the nineteenth century can be reassessed.

An analysis of *The Funeral of a Mummy on the Nile* in its historical and critical context reveals the tightly interwoven relationship between iconography, style, and national identity within Franco-American artistic exchange. The many locations within and implied by the picture in its many iterations construct its meaning. Bridgman's drawing together of multiple painting styles, his iconography, and the painting's exhibition venues heightened his engagement with ideas of cosmopolitanism in the period. Its twentieth-century movements also reengage concerns of cosmopolitan mobility of its day, traced from the artist's origins in Tuskegee, Alabama, to Paris, Egypt,

London, New York, Boston, and Philadelphia, and to the painting's current home in Kentucky.

In the 1870s, the term *cosmopolitan* highlighted the possibility of coalescing many diverse cultures and characters.[2] Many art critics in France, Britain, and the United States responded to the rise of "cosmopolitan painting" during this decade. In the period after the US Civil War and in the early years of the French Third Republic, the Parisian art schools became a central destination for artists from around the world.[3] This attraction incited the proliferation of French academic painting styles as art students adopted the techniques of their instructors. Philip Gilbert Hamerton (1834–94), a British artist and critic, announced anonymously in an article about the English and American paintings on view in Paris at the Universal Exposition of 1878 that "the cosmopolitan style of painting is becoming more and more prevalent throughout the world."

Hamerton partly attributes a transnational rise of academic painting to the World Fairs of the late nineteenth century, in which many nations submitted art for international reception and competition. But he also relates "cosmopolitan painting" to French artistic and political hegemony, noting "the style which I call cosmopolitan first developed itself in France, and then invaded the neighboring European countries."[4] Hamerton expresses hesitation about this practice because it "has subdued the native art of those countries" to result in "sameness."[5] Furthermore, Hamerton maligns the market-driven nature of the transnational embrace of French art:

> How many French artists live by selling their pictures in England and America, where they interfere with the professional success of native painters! The whole world is becoming a gigantic mart for artistic products, and pictures are sent everywhere to find buyers ... Pictures go wandering all over the civilized world till they find buyers, and then their repose is only temporary, for as soon as the collection is brought to the hammer they go wandering again.[6]

Hamerton's critique of cosmopolitan painting is cynical and scathing, but other critics embraced the open transnational artistic community that Paris represented during this period and the cultural exchange that resulted from the wide circulation of paintings. Bridgman in particular found currency in ideas of cosmopolitan mobility that he used to structure *The Funeral of a Mummy on the Nile*.

Bridgman's cosmopolitanism is registered through the style of the painting, the location of his iconography, and its dissemination to a wide international market. Indeed, his was one of the "cosmopolitan paintings" that Hamerton mentioned in his survey of American paintings at the Paris Exposition in 1878.[7] In *The Funeral of a Mummy on the Nile*, the artist sought to produce the kind of marketable painting that could "wander" from place to place because it drew so many diverse referents together. With cosmopolitan mobility, Bridgman turned Hamerton's anxieties about "wandering pictures" and the market into

an asset. The artist subtly tailored the painting to his transnational audiences and connected many different cultures simultaneously.

While Bridgman's case shows a global receptivity to place and diverse cultures as a priority of the 1870s, this very cosmopolitan character led to the painting's fall into obscurity just 20 years after it was first exhibited. As American critic Maria van Rensselaer wrote in 1890, Bridgman's "work shows with exceptional clearness the effect of cosmopolitan influence. None could be less experimental, less provincial" because of these transnational cues in the artist's style and subject.[8] Thus the painting epitomizes an art historical moment that celebrated cosmopolitan connections across time and space. Its later reception, however, reveals a retrenchment in nationalism by the 1890s, when critics preferred art that seemed "provincial" as a stand-in for the nation.

Cosmopolitan Styles

The Funeral of a Mummy on the Nile depicts an imaginary Ancient Egypt, but through its style, contemporary viewers recognized the painting as French. Bridgman's painting functioned as an homage to his French instructor, Jean-Léon Gérôme (1824–1904), but also as an attempt to surpass the latter's mastery.[9] The artist carefully designed the painting to stage his stylistic emulation and his artistic invention. When the painting was exhibited, critical adulation was almost universal, but reviewers tended to highlight different elements of the piece along national lines. Some French critics celebrated the technical prowess of *The Funeral of a Mummy on the Nile*, noting approvingly that Gérôme could have signed his own name to the canvas.[10] In accord with Orientalist imagery of this period, for which Gérôme was well known, Bridgman's representations of the figures and the boats are carefully built out of many smaller academic sketches.[11] This style emphasized Bridgman's absorption of French academic models, a feature that some American writers echoed proudly.[12] Yet some US critics derided this apparent influence. For example, American sculptor William Wetmore Story (1819–95) wrote that the painting was "entirely of the school of M. Gérôme." Story went on, "Interesting and full of merit as it is, one cannot but help wishing it had more of Mr. Bridgman's own individuality and less of M. Gérôme's."[13] Other US critics accepted this influence as a natural stepping-stone toward innovation by arguing that the progression should be "Imitation first, then originality."[14]

Yet not every American critic saw Bridgman's painting as exclusively emulative of Gérôme's style. Bridgman's loosening of his brushstrokes on the background and "the opalescent lustre of the sky" suggest his calculated engagement with newer styles on view in 1870s Paris, such as impressionism.[15] The painting was shown at the Salon of 1877, concurrent with the Third Impressionist Exhibition.[16] One French reviewer of this Salon noted the

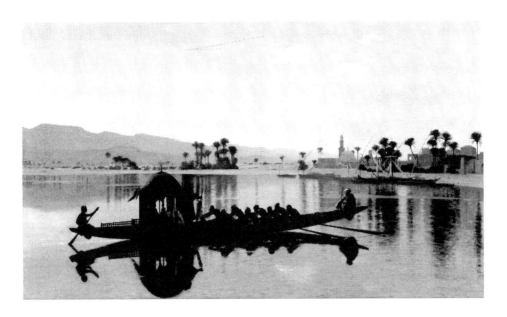

7.1 Jean-Léon Gérôme, *The Excursion of the Harem*, 1869. Oil on canvas, 31 x 53 in. Chrysler Museum of Art, Norfolk, VA

appearance of impressionism alongside academic painting, but few French writers noted Bridgman's handling of light until the turn of the century.[17] As compared with Gérôme's tightly painted *Excursion of the Harem* (Figure 7.1), which art historians have noted was an important model for Bridgman's *The Funeral of a Mummy on the Nile*, Bridgman's approach to depicting the setting is radically different from his teacher's.[18] In the glaring light of midday, Gérôme pales out the colors of the background, and the reflection of the boat in the water is perfected as a mirror. Bridgman sets the stage for his painting at a more dramatic time of day and captures all of the subtleties of the brightly colored scene. Furthermore, in the reflection of the boat on the water, he creates wavering ripples that break the perfect reflection with subtle touches of impasto, especially in the dotted flowers that float alongside the boat. While Gérôme activates motion through the dramatic rowing of the figures, the motion in Bridgman's picture comes more through the loose brushstrokes in the water beneath the solemn, tranquil boats. *The Funeral of a Mummy on the Nile* could never be considered an impressionist painting because of the way it combines so many observations and studies into a single scene and with its tight brushwork on the figures. The landscape, however, engages with a more open brushstroke and atmospheric effects that draw from this new style.[19] Bridgman's painting, then, was Parisian in two ways—as academic and as impressionistic.

His engagement with disparate artistic styles in the same painting highlights its cosmopolitan nature, as he combines more traditional and newer styles in France. In this, he developed a place among the *juste milieu*, or artists who painted within the academic tradition but selectively drew from more avant-garde practices.[20] While both of these styles originated in France, artists in the rest of Europe and the United States engaged with them during this period. American artist and critic Earl Shinn (1838–86) in particular celebrated Bridgman's adaptation to a cosmopolitan style; rather than "insisting on his foreign accent" and producing merely "dialect art," Bridgman participated in the transnational art network.[21]

Not surprisingly in the context of international artistic competition, Bridgman's US critics in particular drew out distinctions between master and pupil. In an attempt to summarize Bridgman's career in 1899, critic W.G. Bowdoin wrote that Bridgman was versatile and flexible in his attempts to draw on many stylistic options at will.[22] A reviewer of an 1881 exhibition of Bridgman's work in New York insisted that the artist's "original position in art" resulted from his "combining some of the best qualities of a number of schools in his paintings."[23] American critics such as Shinn argued that any influence on Bridgman's art by others was mitigated; he insisted, "In a perfectly independent way, Bridgman occasionally suggests other painters."[24] Shinn went so far as to say that Bridgman "completely distances Gérôme by placing behind his carefully calculated scheme of figures a landscape of almost divine purity and beauty, completely impossible to the older artist."[25] He also declared, "In enveloping [the figures] with harmonious light and air, this young genius excels his master."[26] In response to the celebration of this more atmospheric aspect of his work in the American press, Bridgman specifically included many of his studies and sketches for *The Funeral of a Mummy on the Nile* in a large exhibition of his work held in 1881 in New York City.[27] This eclectic display provoked critical reaction that saw Bridgman as versatile, and therefore not beholden to any models. After that exhibition, Shinn used these sketches as evidence to proclaim, "My artist,—and this is his secret—is at will an impressionist, and a glorious impressionist."[28] While his French critics celebrated his academic technique, his US observers highlighted the ways in which he challenged those models.

Orientalism, Egyptology, Tourism, and Cosmopolitanism

Bridgman's *The Funeral of a Mummy on the Nile* brings together not only a range of painting styles but also many places and many times in the history of the world. The artist participated in the transnational language of Orientalism, which had favor in France and Britain, as well as in the United States at the end of the nineteenth century.[29] British critics favored Bridgman's combination

of technique and iconography; one wrote, "All the details of costume and accessories are thoroughly studied, and the drawing and painting are deserving of high commendation."[30] The artist made contact with British and French Egyptologists as he prepared his painting and consulted objects in European and US museum collections, thus giving his piece an intellectual air that participated in international scholarship in the period.[31] Many reviewers noted the carefully studied iconography and style of the material culture imagined in the picture as well as the ritual that Bridgman reconstructs. One French critic celebrated, "For this real and lasting impression which comes to us in this rare work, we judge that Bridgman's knowledge is truly accurate and that both this surprising world and these wonderful sites represent the classical land where Pharaohs regenerate."[32] French critic Paul Lefort also described Bridgman's *The Funeral of a Mummy on the Nile* as exhibiting the "dual expertise of being an archaeologist and a colorist."[33]

Yet, Bridgman also tailored his Orientalist scene to American viewers. While the artist includes the requisite titillating bare-breasted women through the mourners on the boat, they are relatively minor within the compositional frame. In this, as one scholar has suggested, Bridgman's work becomes more about archaeological accuracy than about the hypersexualized representations of large-scale figures often foregrounded in Orientalist paintings in Europe.[34] Bridgman's figures are also much less prominent in the setting than within the paintings of a Victorian painter with whom Bridgman was often compared: Lawrence Alma-Tadema (1836–1912).[35] While Bridgman's work seemed in dialogue with this artist for its interest in Ancient Egypt, Bridgman may have minimized the figures within the compositional scale for some American audiences, who had already challenged what they had seen as inappropriate nudity in his work.[36] Bridgman's careful selection of Orientalist elements alongside archaeological study and intellectualism lends his painting accessibility to a wide number of audiences through an iconographic language that privileged an in-depth engagement with faraway cultures.

The contemporary place of Egypt, though, was on the minds of many European and American observers in 1878. The Suez Canal, which opened in 1869, allowed for foreign tourism to prosper in this region, and Mark Twain's *Innocents Abroad*, published in that same year, included a large segment on travel to Egyptian ruins.[37] As a result of this cultural conversation around travel to Egypt, Bridgman's iconography registered with the contemporary interest in tourism to North Africa. The viewer's experience of *The Funeral of a Mummy on the Nile* heightens the notion of travel between places; the painting is panoramic and horizontally structured so that the viewer must walk along the 7 1/2 foot work, following the motion implied within it. As one takes in additional details, as invited by its archaeological accuracy, one continues to move before the picture. Furthermore, because the boats move from right to left, the painting thwarts expectation, and encourages the viewer to cycle

back along it to understand the flow of the scene. In its representation of the physical voyage across the Nile and a metaphorical voyage into an afterlife, the iconography of the picture mimics the artist who travels.

Bridgman developed a reputation for himself as a "great traveler" who made art in response to place as he traveled between Europe and the United States, and to North Africa.[38] Even in the early 1870s, the press kept track of his travels.[39] The artist visited Egypt from the winter of 1873 to the spring of 1874, and joined a group of British tourists on a Nile cruise that took him as far south as the Second Cataract (in present-day Sudan).[40] Bridgman collected hundreds of objects during his travels, which he used to decorate his Paris studio at 146 Boulevard Malesherbes. In 1904, he recalled that after his trip to Egypt, "I brought back to Paris a very large collection of the trappings and ornaments. My time from now on was spent in reproducing on canvas the multitude of impressions I had received in these lands of langour and sunshine."[41]

While his compatriot William Merritt Chase (1849–1916) made paintings of his bric-a-brac within his studio spaces, Bridgman used these objects with "erudition" to create a greater sense of historical accuracy within his narrative painting.[42] Visitors to his studio commented on his insistence in keeping all of the different historical styles separate, so that the Ancient Near Eastern material was kept in a different room from that of Ancient Egypt, and a visitor could have an immersive experience in each. Bridgman's cosmopolitan studio enhanced the cohesion of many foreign cultures into a single Parisian space. The photograph printed in *Art Amateur* in 1899 (Figure 7.2) suggests that Bridgman maintained these associations with Ancient Egypt throughout his career. The visitor to his studio described, "Nothing in its kind can exceed the beauty of this entrance, with its clustered columns, flanked by statues of Horus and Isis placed against the latticed windows, the lotus-bud decorations of its pilasters, and the agricultural scene portrayed upon its frieze. … The interior is filled with his collection and studies of ancient Egyptian art."[43] Another visitor to his studio noted that the objects from his travels "have been supplemented by friezes, furniture and ornaments designed by the artist in keeping with his idea of giving each room a complete and distinct individuality. This character note is especially dominant in the Egyptian room, with its painted and gilded cedar wood chairs and its bas-reliefs of Egyptian life. The coloring is dark blue, relieved by gilding in the decorations and hieroglyphics, and lighted by electric lotus flowers."[44] Bridgman's stylized spaces offered his intellectual and artistic homage to these historical epochs.

Bridgman also used costume to transform his contemporary Parisian space into a collection of other times and places simultaneously; this same reviewer read his performative costume as indicative of the accuracy of Bridgman's studies: "The costume worn by the artist testifies to the care taken by him in restoring life and reality to antiquity."[45] Yet this costume and the caption,

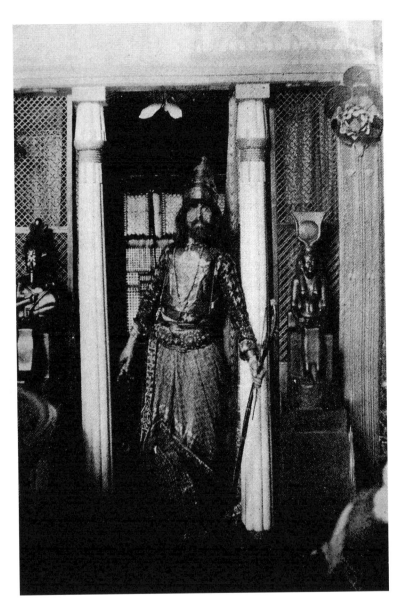

7.2 *Mr. Frederick Bridgman in the Costume of an Assyrian King at the Entrance to the Ancient Egyptian Room in his Paris Studios*, in "Frederick Arthur Bridgman," *Art Amateur* 40, no. 4 (March 1899): 76. University of Delaware Library. Photograph courtesy of Amy Torbert

which combine Assyria, Egypt, and Paris, reveal the very cosmopolitan mixing that *The Funeral of a Mummy on the Nile* highlights. The artist dresses as an Assyrian king as he beckons the viewer into the Egyptian room with the doorway framed behind him. His gesture intensifies his performativity around his collection of artifacts. His carefully designed space and his iconographic choices marked his self-aware participation in a cosmopolitan network by trading in cultures and objects.

Cosmopolitanism and "Wandering Pictures"

In the circulation of *The Funeral of a Mummy on the Nile* to France, England, and the United States for exhibition, the painting is entrenched in its contemporary moment of cosmopolitan art making. In 1877, Bridgman first showed the painting in his Paris studio at 75 Boulevard Clichy, in an open house that was advertised in the American presses in Paris, such as the *American Register*.[46] His teacher, Gérôme, visited the painting to offer celebration of the piece.[47] In the spring, *The Funeral of a Mummy on the Nile* hung on the line at the Paris Salon to critical acclaim and to a third-class medal. American James Gordon Bennett (1841–1918), who owned the *New York Herald*, purchased the painting for the enormous sum of $5,000.[48] The following year Bennett lent the work to the American art galleries of the Paris Universal Exposition of 1878, where it also won an award, and the artist received the French Legion of Honor. With the same massive painting being exhibited two years in a row in Paris, it raised public awareness of Bridgman's work and marked a pivotal point of his early career.

In 1880, *The Funeral of a Mummy on the Nile* traveled across the Atlantic to the galleries of Samuel P. Avery in New York and of William & Merritt in Boston with his two other major archaeological paintings, *The Entertainment of an Assyrian King* (private collection) and *The Procession of the Bull* (private collection).[49] In late 1880, the painting was exhibited in Philadelphia at the Philadelphia Society of Artists show, and in 1881, it traveled to the American Art Gallery in New York City and to Boston for a large exhibition of Bridgman's work.[50] One visitor to the exhibition, George Ferras, responded in the form of a romantic poem, which was published in *Lippincott's Magazine* and *Art Interchange*.[51] The exhibition also included many of the artist's sketches for the painting, which found a ready market among American visitors who appreciated their "broad, free manner."[52]

The painting may also have been shown in London at the Royal Academy in 1881 under the title *The Funeral Rites of the Mummy on the Nile*.[53] Bridgman avidly exhibited paintings in England as in the United States, and found collectors for his work in both countries.[54] Even though *The Funeral of a Mummy on the Nile* found a buyer the year it was first exhibited, its travels

constructed a market for the artist. It became an international calling card for Bridgman's work, and even appeared in an American short story as a cosmopolitan testament of "the richness and stateliness of a far-off age" that simultaneously "seemed to strike a common chord of humanity."[55] For the rest of Bridgman's career, he exhibited his work in transnational spaces: the Paris Salon and *salonnets*, such as the Cercle de l'Union artistique, American and British academic exhibition spaces, and in galleries in all three locations.[56]

Reproductive engravings of *The Funeral of a Mummy on the Nile* enhanced its wanderings. By developing a close relationship with Adolphe Goupil (1806–93), whom he probably met through Gérôme, Bridgman participated in the modern picture industry.[57] Indeed, his painting traveled through reproductions in books and journals that moved around Europe and the United States. This circulation brought his picture in the form of black-and-white engravings into people's homes and induced armchair travel of those who did not otherwise make the trip. Engravings appeared in *Les Chef d'oeuvre de la Exposition 1878*, an issue of *L'Art* in France, and the US edition of *Art Journal*.[58] In looking at the depiction of Ancient Egypt, viewers in Europe and the United States could travel in time and in place, as the artist himself had done in 1873. Furthermore, the reproduction enhanced the painting's "wandering" to many places, so viewer and image together participated in a constructed cosmopolitan experience.

The painting occupied a range of unexpected places simultaneously. Through participation in a range of transnational exhibition spaces, from the large-scale Paris Salon and the Fine Arts Society of London to the smaller scale New York City art galleries, Bridgman's *The Funeral of a Mummy on the Nile* embodied the kind of "wandering" of pictures wrought by a cosmopolitan world in the 1870s and early 1880s.[59] But Bridgman's cosmopolitan moment was short-lived. That *The Funeral of a Mummy on the Nile* had been "produced abroad" based on the artist's distant travels was an asset in the late 1870s.[60] It was one of the first American paintings to receive large-scale international attention, and it paved the way for an increase in the French government's patronage of American paintings at the Paris Salon.[61] Even during that period, though, some US critics, such as Van Rensselaer, who championed a national art school, thought that Bridgman's engagement with French styles meant that "he will scarcely be enumerated in the future among those who are now ... laying the foundations of a distinctively American school."[62] By the 1890s, Van Rensselaer's prediction proved portentous; critics treated Bridgman's cosmopolitanism as a liability in its combination of so many foreign spaces and styles into a single work of art.

The "cosmopolite" that Bridgman represented became "typical," while "the thorough-paced American" became "exceptional."[63] A *New York Times* review of an exhibition of Bridgman's paintings in 1890 complained, "By method or subject or character expressed in paint he is not American at all ... he is an

example of a foreigner who goes to France and, while losing all the distinctive characteristics of his native land, has never gained the characteristics of the land he has adopted." The reviewer concluded that Bridgman would forever produce diluted "pupil's work" and never be registered as "an outcome of national ideas and character." As a result, the critic predicted, Bridgman's art would not have lasting resonance: "A century hence, who will care to see Algiers through the eyes of an American wearing French spectacles."[64] Members of Bridgman's artistic generation came to his defense; Chase, Augustus St. Gaudens (1848–1907), and others complained to the *New York Times* about its reviewer's attack on Bridgman's exhibition.[65] Younger generations, however, scorned the stronghold he and several of his expatriate colleagues held on the art market, particularly in his native United States.[66] Bridgman lived and continued to paint in Paris until his death in 1928, but he fell into greater obscurity in American esteem. Meanwhile, French writers consistently wrote about his work and claimed him as "almost a Frenchman."[67] As H. Barbara Weinberg and other art historians have discussed, critics who sought to find a nationalist narrative of American painting deliberately excluded Bridgman from the canon of what Shinn had delicately described as "dialect art."[68] It is due to this cultural shift that the provenance of this painting between its announced purchase by Bennett in 1877 and its resurfacing on the art market in a 1990 Sotheby's auction remains unknown.

Notes

Thanks to Lisa Parrott-Rolfe, Speed Art Museum, and Régine Bigorne, Musée Goupil, for their assistance with research, and to Cynthia Fowler, Corey Dzenko, Chloë Courtney, and Anna Dobbins for their feedback. Thanks to Miranda and François Fontaine for offering the perfect space to write this essay.

1 H. Barbara Weinberg, *The Lure of Paris: Nineteenth-Century American Painters and Their French Teachers* (New York: Abbeville Press Publishers, 1991), and Lois Marie Fink, *American Art at the Nineteenth-Century Paris Salons* (Washington, DC: National Museum of American Art, Smithsonian Institution, 1990). Bridgman was born in Tuskegee, Alabama, and studied art in New York City and at the Brooklyn Art Association while working as an engraver at the American Banknote Company until he went to Paris in 1866 to continue his art training. The most complete biography of Bridgman is Ilene Susan Fort, "Frederick Arthur Bridgman and the American Fascination with the Exotic Near East" (PhD diss., City University of New York, 1990). The painting measures almost four feet in height and over 7 1/2 feet in length.

2 This definition should be differentiated from the twenty-first century use of the term that emphasizes the ethics of an interconnected world. On defining cosmopolitanism, see Zlatko Skrbis, Gavin Kendall, and Ian Woodward, "Locating Cosmopolitanism: Between Humanist Ideal and Grounded Social Category," *Theory, Culture & Society* 21, no. 6 (2004): 123.

3 See Patrice Higonnet, *Paris: Capital of the World* (Cambridge, MA, and London: Belknap Press of Harvard University Press, 2002); Albert Boime, *The Academy and French Painting in the Nineteenth Century* (London: Phaidon, 1971); Karen L. Carter and Susan Waller, eds., *Foreign Artists and Communities in Modern Paris, 1870–1914: Strangers in Paradise* (Farnham: Ashgate, 2015). On American artists in Paris, see also Kathleen Adler, Erica E. Hirshler, and Weinberg et al., *Americans in Paris, 1860–1900* (London: National Gallery, 2006).

4 [Philip Gilbert Hamerton], "English and American Painting at Paris in 1878, II," *International Review*, May 1879, 553.

5 Ibid., 553–54. Hamerton argued, however, that British artists had maintained their unique identity.

6 Ibid., 560.

7 Ibid., 556. Hamerton offered only restrained compliments about the piece.

8 Mrs. Schuyler van Rensselaer, "Frederick Arthur Bridgman," *Frank Leslie's Popular Monthly* 29, no. 6 (June 1890): 3.

9 On the American interest in Gérôme, see Mary Morton, "Gérôme en Amérique," in *Jean-Léon Gérôme (1824–1904): l'histoire et spectacle* (Paris: Musée d'Orsay and Skira, 2009), 183–95; Weinberg, *The American Pupils of Jean-Léon Gérôme* (Fort Worth, TX: Amon Carter Museum, 1984); Fort, "Frederick Arthur Bridgman," 4, 25–35, 197–8; and F.A. Bridgman, "Working Under Great Masters, II: Gérôme, The Painter," *Youth's Companion* 3500 (June 21, 1894): 290.

10 "pourraient être signées par la maître." Albert Wolff, "Le Salon de 1877," *Figaro*, May 4, 1877, 1, col. 3. See also Victor Champier, *L'année artistique: année 1878* (Paris: A. Quantin, Imprimeur-Éditeur, 1879), who wrote that "Bridgman … rappellent clairement son maître" (229); Emile Bergerat, "Salon de 1877 (10e article)," *Journal Officiel de la Republique Française* 9, no. 171 (June 24, 1877): 4747; and Paul Mantz, "Exposition Universelle: Les Écoles Étrangères, IX. Etats-Unis, Suisse, Danemark, Swéde, et Norvége," *Les Temps*, November 6, 1878, 3.

11 On this training, see Weinberg, "Nineteenth-Century American Painters at the École Des Beaux-Arts," *American Art Journal* 13, no. 4 (1981): 66–84.

12 Outremer, "Art Echoes from Paris—II," *Aldine* 9, no. 4 (July 1, 1879): 115; and Lucy H. Hooper, "American Art in Paris," *Art Journal* n.s., no. 4 (1878): 90.

13 William Wetmore Story, "The Fine Arts," *Reports of the United Commissioners to the Paris Universal Exposition, 1878*, vol. 2 (Washington, DC: Government Printing Office, 1880), 111–12.

14 "American Painters—Winslow Homer and F.A. Bridgman," *Art Journal* n.s., no. 4 (1878): 229.

15 Ibid., 229.

16 Richard Brettell, "The 'First' Exhibition of Impressionist Painters," in *The New Painting: Impressionism, 1874–1886*, ed. Charles S. Moffett (San Francisco: Fine Arts Museums of San Francisco, 1986), 189–202.

17 A. Descubes, "Le Salon de 1877," *Gazette des lettres des science & des arts* 19 (June 1, 1877): 251; Eugène Hoffman, "Exposition Bridgman," *Journal des Artistes* 17, no. 3 (January 16, 1898): 2150.

18 Weinberg, *American Pupils*, 49–51; and Fort, "Frederick Arthur Bridgman," 158–9.

19 Bridgman later wrote a scathing critique of impressionism. See *L'Anarchie dans l'art* (Paris: Société Française d'Editions d'Art, L. Henry May, 1898).

20 Michael Marrinan, *Painting Politics for Louis-Philippe: Art and Ideology in Orléanist France, 1830–1848* (New Haven and London: Yale University Press, 1988), 206–15; Robert Jensen, *Marketing Modernism in Fin-de-Siècle* Europe (Princeton: Princeton University Press, 1994), 138–66; and Fort, "Frederick Arthur Bridgman," 332.

21 Edward Strahan [Earl Shinn], "Frederick A. Bridgman," *Harper's Monthly* 63, no. 377 (October 1881): 694–5.

22 W.G. Bowdoin, "A Versatile Figure in Art," *Art Interchange* 42, no. 2 (April 1899): 87.

23 "The F.A. Bridgman Pictures at the American Art Gallery," *Brooklyn Daily Eagle*, February 3, 1881, 1, col. 8.

24 Strahan, "The Art Gallery: Frederick A. Bridgman," *Art Amateur* 4, no. 4 (March 1881): 71. See also Van Rensselaer, "Frederick Arthur Bridgman," 6.

25 Strahan, "Art Gallery," 71.

26 Strahan, "Exhibition of the Philadelphia Society of Artists," *Art Amateur* 4, no. 1 (December 1880): 4.

27 "A Prosperous Painter," *Harper's Bazaar* 14, no. 17 (April 23, 1881): 2; Lucy H. Hooper, "The Paris Salon of 1877. III," *Art Journal* n.s., 3 (September 1877): 283; and Fort, "Frederick Arthur Bridgman," 324–8.

28 Shinn, "F-A. Bridgman," in *The Great Modern Painters: English, French, German, etc.* (Paris: Goupil & Co., 1884–86), 95.

29 On Orientalism in nineteenth-century art, see Jill Beaulieu and Mary Roberts, eds., *Orientalism's Interlocutors: Painting, Architecture, Photography. Objects/ Histories* (Durham, NC: Duke University Press, 2002); Roger Benjamin, *Orientalist Aesthetics: Art, Colonialism, and French North Africa, 1880–1930* (Berkeley: University of California Press, 2003); Holly Edwards et al., *Noble Dreams, Wicked Pleasures: Orientalism in American Art, 1870–1930* (Princeton, NJ: Princeton University Press, 2000); and Gerald Ackerman, *American Orientalism* (Paris: ACR Edition Internationale, 1994).

30 Quoted in "American Painters—Winslow Homer and F.A. Bridgman," 229.

31 "Frederick Arthur Bridgman," *Art Amateur* 40, no. 4 (March 1899): 76.

32 "Par l'impression réelle et durable qui nous vient de cette œuvre rare, nous jugeons que l'érudition de M. Bridgman est, alle aussi, fort réelle et que ce monde étonnant et que ces sites merveilleux sont bien le monde et les sites du pays classique où régènerent les Pharaons." Mario Proth, *Voyage au pays des peintres salon de 1877* (Paris: Henri Vatan Librairie, 1877), 130. Thanks to Agathe Cabau for her help with this translation.

33 "sa double science d'archéologue et de coloriste." Paul Lefort, "Les Écoles étrangères de peinture," *Gazette des Beaux-Arts* ser. 2, 8, no. 4 (October 1878): 484. Thanks to Agathe Cabau for her help with this translation.

34 Jennifer Danielle Patterson, "Beyond Orientalism: Nineteenth-Century Egyptomania and Frederick Arthur Bridgman's 'The Funeral of a Mummy'" (MA thesis, University of Louisville, 2002).

35 Edward Strahan [Earl Shinn], ed., *The Chefs-d'oeuvre d'art of the International Exhibition, 1878* (Philadelphia: Gebbie & Barrie Publishers, 1878), 60–61. See also Fort, "Frederick Arthur Bridgman, 143–4, 177–9; and Brian T. Allen, "The Garments of Instruction from the Wardrobe of Pleasure': American Orientalist Painting in the 1870s and 1880s," in Edwards et al., *Noble Dreams, Wicked Pleasures*, 70–72.

36 Outremer, "Art Echoes from Paris, II," 115. See also Fort, "Frederick Arthur Bridgman," 212–13.

37 Mark Twain, *The Innocents Abroad: Or, the New Pilgrim's Progress: Being Some Account of the Steamship Quaker's City's Pleasure Excursion to Europe and the Holy Land: With Descriptions of Countries, Nations, Incidents, and Adventures as They Appeared to the Author* (Hartford, CT: American Publishing Company, 1869). On the cultural significance of the Suez Canal, see Zachary Karabell, *Parting the Desert: The Creation of the Suez Canal* (New York: A.A. Knopf, 2003); and Darcy Grigsby, *Colossal: Engineering the Suez Canal, Statue of Liberty, Eiffel Tower, and Panama Canal: Transcontinental Ambition in France and the United States during the Long Nineteenth Century* (Pittsburgh, PA: Periscope, 2012).

38 "Frederick Arthur Bridgman," *Art Amateur*, 76.

39 Fort, "Frederick Arthur Bridgman," 111.

40 On Bridgman's travels in Egypt, see Fort, "Frederick Arthur Bridgman," 115–27; and Patterson, "Beyond Orientalism," 28–31.

41 Hayden Talbot, "Frederic A. Bridgman and Some of His Paintings," *New York Times*, April 24, 1904, SM5.

42 Proth, *Voyage au pays*, 130.

43 "Frederick Arthur Bridgman," *Art Amateur*, 76.

44 Lillian Kendrick Byrn, "Frederick A. Bridgman," *Taylor-Trotwood Magazine* 4, no. 5 (February 1907): 491.

45 "Frederick Arthur Bridgman," *Art Amateur*, 76. On Bridgman's studio, see also Benjamin Tupper Newman, "Two Americans in Paris: 1885," *Archives of American Art Journal* 12, no. 4 (1972): 23–4; and Bowdoin, "Versatile Figure in Art," 86.

46 "American Art at the Coming Salon," *American Register*, March 25, 1877, 4, col. 7, as cited in Fort, "Frederick Arthur Bridgman," 143.

47 Fort, "Frederick Arthur Bridgman," 36.

48 Outremer, "Art Echoes from Paris. I.," *Aldine* 9, no. 3 (May 1, 1878): 96. On Bennett, See J.C.P. Gourvennec, *Un Journal Américain à Paris: James Gordon Bennett et le New York Herald, 1887–1918* (Paris: Musée d'Orsay, 1990).

49 Fort, "Frederick Arthur Bridgman," 154, 295; Montzeuma [Montague Marks], "My Note Book," *Art Amateur* 2, no. 5 (April 1880): 91; "American Art News," *Art Interchange* 4, no. 7 (March 31, 1880); 59; and Van Rensselaer, "Spring Exhibitions and Picture-Sales in New York, II," *American Architect and Building News* 7, no. 228 (May 8, 1880): 200. The latter two paintings also found US patrons.

50 Strahan, "Exhibition of the Philadelphia Society," 4–5; Van Rensselaer, "The Philadelphia Exhibition, I," *American Architect and Building News* 8, no. 259 (December 11, 1880): 280; and Fort, "Frederick Arthur Bridgman," 302–3. On the New York exhibition, see Strahan, "Art Gallery," 67, 70-71; and Fort, "Frederick Arthur Bridgman," 294–300.

51 George Ferrars, "Burial of an Egyptian Mummy," *Art Interchange* 6, no. 6 (March 17, 1881): 58.

52 "F.A. Bridgman Pictures at the American Art Gallery," 1.

53 Fort, "Frederick Arthur Bridgman," 465.

54 In 1887, the Fine Arts Society of London hosted an exhibition of Bridgman's paintings that included Egyptian sketches. See Wilfrid Meynell, *A Glimpse of the East: Two hundred and thirty Sketches and Studies by F.A. Bridgman in Egypt and Algeria* (London: Fine Art Society, 1887).

55 Edith Robinson, "The Portrait by Hunt," *Outing, an Illustrated Monthly Magazine of Recreation* 21, no. 2 (November 1892): 128.

56 On the *salonnets*, see Marc Simpson, "Sargent and His Critics," in *Uncanny Spectacle: The Public Career of the Young John Singer Sargent*, exh. cat. (New Haven and London: Yale University Press, 1997), 34–5; and Fae Brauer, *Rivals and Conspirators: The Paris Salons and the Modern Art Centre* (Newcastle upon Tyne: Cambridge Scholars Publishing, 2013), 2.

57 The Getty stockbooks (Getty Research Institute) list prints of paintings by Bridgman, and the Musée Goupil, in the Musée Aquitaine in Bordeaux, includes photographs of paintings for reproduction and prints after works by Bridgman. On Goupil and art marketing, see Hélène Lafont-Courturier, *Gérôme and Goupil: Art and Enterprise* (Paris: Réunion des musées nationaux, 2000); and DeCourcy McIntosh, "Goupil's Album: Marketing Salon Painting in the Late Nineteenth Century," in *Twenty-First-Century Perspectives on Nineteenth-Century Art: Essays in Honor of Gabriel P. Weisberg*, ed. Petra ten-Doesschate and Laurinda S. Dixon (Newark: University of Delaware Press, 2008), 77–84.

58 Strahan, *Chefs-d'oeuvre*, 60–62; "L'Art," *Scribner's Monthly* 17, no. 5 (March 1879): 762; "American Painters.-Winslow Homer and F.A. Bridgman," 228. It was also reproduced in George William Sheldon, *Recent Ideals of American Art: One Hundred and Seventy-five Oil Paintings and Water Colors in the Galleries of Private Collectors, Reproduced in Paris on Copper Plates by the Goupil Photogravure and Typogravure Processes* (New York and London: D. Appleton and Co., 1888).

59 Hamerton, "English and American Painting," 260.

60 D. Maitland Armstrong, *Reports of the United States Commissioners to the Paris Universal Exposition, 1878*, vol. 1 (Washington, DC: Government Printing Office, 1880), 85.

61 Susan Grant, "Whistler's Mother Was Not Alone: French Government Acquisitions of American Paintings, 1871–1900," *Archives of American Art Journal* 32, no. 2 (1992): 2–15; and Véronique Wiesinger, "La politique d'acquisition de l'État français sous la Troisième République en matière d'art étranger contemporain: l'exemple américain (1870–1940)," *Bulletin de la Société de l'Histoire de l'Art français* (1993): 263–99.

62 Van Rensselaer, "Spring Exhibitions," 202.

63 Van Rensselaer, "Frederick Arthur Bridgman," 3.

64 "Pictures of Algiers," *New York Times*, April 14, 1890, 4.

65 F.D. Millet, "Mr. Bridgman's Pictures," *New York Times*, April 17, 1890; W.M. Chase, "Mr. Bridgman's Pictures," *New York Times*, April 18, 1890, 4; and Augustus St. Gaudens, "The Bridgman Exhibition," *New York Times*, April 20, 1890, 4.

66 "American Artists at War in Paris," *New York Times*, December 1, 1907, C3.

67 "est presque un Français." O.F., "Petites Expositions: Tableaux et Études de M. Bridgman," *La Chronique des arts et de la curiosité* 2 (January 8, 1898): 10. See also Frédéric Viborel, "Le peintre Frédéric A. Bridgman," *La revue des lettres et des arts* (May 1, 1909): 310–13.

68 Weinberg, *Lure of Paris*, 8; and Strahan, "Frederick A. Bridgman," 694–5.

"The One I Most Love"—Thomas Eakins's Portrait of Samuel Murray

Henry Adams

Thomas Eakins's portrait of Samuel Murray in the Mitchell Museum belongs to a sort of painting within his oeuvre that is not well understood, and it stands out as one of the most significant and one of the most mysterious instances of this type (Plate 8). Dimly lit, in a fashion somewhat reminiscent of Rembrandt, it has precisely the moody, psychologically mysterious qualities that give Eakins's late portraits an emotional resonance more powerful and haunting than those of any other nineteenth-century American painter. What makes the likeness particularly fascinating, however, is its biographical significance, for it records the figure in his life with whom Eakins apparently had the closest and deepest emotional ties: the constant companion of his later years, with whom he shared a studio, went on cycling, camping, and nude swimming expeditions, who may well have been his lover, and with whom he appears to have been more intimate than he was with his legal wife. For example, during Eakins's final illness, Murray spent the last two week of his life, night and day, by his bedside holding his hand, and allegedly Eakins would allow no one else to feed him, refusing food that was offered to him by his wife, Susan. Whole bodies of Eakins's later work are directly indebted to his relationship with Murray. We know, for example, that it was Murray who introduced Eakins to wrestlers and boxers as an artistic subject and thus provided the impetus for the largest and most ambitious paintings of his later career.[1]

Despite its significance for our understanding of Eakins's life, the portrait of Murray has been reproduced only infrequently. Though documented in the "catalogue of works" at the back of Lloyd Goodrich's 1933 monograph, it was not reproduced in the literature on Eakins until Sylvan Schendler's study on Eakins of 1967, and so far as I can discover it has been included in only one major exhibition, the mammoth gathering of some 250 oil paintings, watercolors, drawings, and photographs by Eakins organized by

the Philadelphia Museum of Art in 2002, where it was almost lost amidst the profusion of material.[2] Oddly, it was not included in the exhibition of Eakins's likenesses that John Wilmerding organized in 1993 for the National Portrait Gallery in London, although this exhibition was largely devoted to late portraits very similar in their general format.[3]

I will suggest some possible reasons for this in my conclusion, but no doubt the obscure location of the painting largely explains this neglect, for it is housed in a museum few scholars in the American field have actually visited: the Mitchell Museum in Mount Vernon, Illinois, a small community art center in the southwest corner of the state, closer to Saint Louis than Chicago, at the juncture of two crossing highways. Its collection contains just over a dozen paintings by major American masters, acquired by the museum's founders John and Eleanor Mitchell—globe-trotting big game hunters who began collecting art shortly after the discovery of oil on their land brought them sudden wealth. The paintings vary widely in style and quality and don't seem to reflect any consistent principle of selection. The most celebrated and widely reproduced painting in the collection is *Mrs. T. in Wine Silk* (1919) by George Bellows, a bravura display of brilliant brushwork, but arguably the much more sober Eakins painting of Murray contributes even more significantly to our understanding of its creator and his achievement. Judged by this criterion it is surely the museum's most intriguing work. Intriguingly, the portrait of Murray was the first major art acquisition consummated by the Mitchells, since their one earlier attempt at art purchase, a painting ascribed to Sir Henry Raeburn, was returned to the dealer when it became apparent that it was spurious.[4]

A New Type of Portraiture

Before he was fired from the Pennsylvania Academy in 1886, Eakins's portraits were notable for their careful rendition of the sitter's environment. For example, in his portrait of *Benjamin Rand* (1874), the clutter of meticulously rendered objects on the desk—including a microscope, beam balance, test tubes, a rose, a woman's shawl, and even a black cat—threatens to draw attention away from the sitter's face, which is rather roughly painted and half obscured by shadow. After he was fired, however, Eakins began producing portraits in a new format, different from that of his early work, of which the portrait of Murray is a prime example: close-up studies of heads, somberly lit, with little if any background, most often on canvases that are identical in size—20 by 24 inches. In many regards it's an inversion of the approach he had pursued earlier. In other words, there's virtually no attempt, such as we usually expect in formal portraiture, to indicate the sitter's profession or social station. Instead, we view the sitter's head alone, in close-up, as if we were

seated a few inches from them. Setting and context are largely eliminated, resulting in a mode of expression that, paradoxically, is extremely intimate and extremely cryptic. Indeed, there's a notable tension in these paintings between the implied intimacy with the sitter and the abrupt way in which Eakins wrests them away from any identifiable context. While the parallel is not absolutely exact, these paintings seem to stand apart from Eakins's other portraits rather in the way that a personal snapshot differs from a posed studio photograph.

Goodrich's catalog of Eakins's work lists upward of 70 paintings in this format and of these exact dimensions.[5] The painting of Murray, which he signed and inscribed 1889, appears to be the earliest dated example, and Eakins continued to make paintings of this sort up to 1910, the date of three signed paintings of Dr. Gilbert Lafayette Parker, his wife, and son—in other words, right up to the time of the stroke in 1910 that ended his career as an active painter.[6] During his late years, it appears, works of this type accounted for about half of Eakins's total production. They might even be considered, as a group, as the major project of Eakins's later career.[7]

Biography and Meaning

To grasp Eakins's intentions in making the Murray portrait, it's helpful to place it in the context of what Eakins was going through in this time. In February of 1886 Eakins received a career setback from which he never fully recovered when he was fired from his position as "Head of Schools" at the Pennsylvania Academy of the Fine Arts. Eakins's first biographer, Lloyd Goodrich, portrayed this as the result of complaints "from a few women," but the recent discovery of new documents has revealed a very different story. The principal opposition came from his teaching assistants and members of his own family, particularly his sister Caroline and her husband, Frank Stevens, and included numerous accusations of exhibitionism and sexually inappropriate behavior, including even the claim that he had engaged in incest with his sister Margaret. The conflict simmered on for years, since after Eakins was removed from the academy, action was taken to expel him from two Philadelphia art clubs. The event marked a turning point in Eakins's life, from holding the most important art position in Philadelphia to being jobless and viewed by many as a social pariah. And it's hardly surprising that the event also marked a significant shift in the character of his artistic work.[8]

After being expelled from the academy, Eakins established an art school of his own, the Philadelphia Art Students League, with the support of a group of dissident students, where he taught without pay. But within a few months enrollment dwindled from about 40 or 50 to about half a dozen students, and then to just two or three. While it existed in name for six or seven years,

changing its location roughly once a year, regular classes seem to have ceased around 1889, at which point what had supposedly been a school became simply a small cluster of hangers-on who frequented Eakins's studio. During this period Eakins sought medical help for depression and went through what might loosely be described as a "nervous breakdown," and in the summer of 1887, on the advice of his doctor, S. Weir Mitchell, he took a "rest cure" at a ranch in South Dakota, returning after two months with a pony and a collection of cowboy costumes that provided the basis for several subsequent paintings.

In general, this was a period of major setbacks; but in 1889 Eakins received his first bit of positive news on the professional front when he was commissioned by three classes of the Pennsylvania School of Medicine to paint a portrait of the surgeon Dr. D. Hayes Agnew—a gift in honor of his retirement. By any standards it was a major commission; but surely one particularly welcome for a figure who had been largely ostracized from polite Philadelphia society after the academy scandal. Eakins on his own initiative, and for the original fee, agreed to expand the commission from a portrait of Agnew alone to one that showed Agnew conducting a surgical demonstration in his clinic—a decision that entailed adding another 37 figures and portrait heads to the painting—along with some additional hands and feet of figures not fully visible. Producing the portrait by the deadline was a mammoth undertaking. The painting—6 by 11 feet, the largest canvas of Eakins's career—had to be completed in just three months to be ready by commencement day, May 1, 1889. Too large to fit on an easel, the painting rested on the floor of Eakins's studio, and Eakins worked on the lower portions sitting on the floor, rather than in the usual standing position. Somehow, Eakins completed the project on schedule by working night and day, apparently sometimes falling asleep on the floor in front of the painting.[9]

After his firing at the Pennsylvania Academy, the Agnew commission was surely a welcome opportunity to attempt a comeback. But in addition, it provided a sort of vindication for a still earlier slight. In 1876 Eakins had put roughly a year of work into a major painting of a medical operation, *The Gross Clinic*, which he clearly hoped would bring him national attention, but which instead was rejected from the art display of the Philadelphia Centennial Exhibition and exiled to a medical pavilion, where it was displayed alongside catheters and bedpans. The commission for the Agnew Clinic shows that many people admired the earlier painting, despite the controversy it inspired. In short, the Agnew Clinic represented a sort of triumph over the two most bitter moments of Eakins's professional career—and at the same time, reawakened memories of what he had gone through.

Murray first connected with Eakins during this troubled period, in November of 1886, when Eakins was 42 and Murray just 17—a difference in age of exactly 25 years. As Murray later recalled, Eakins discovered him one

day sketching in Woodlawn Cemetery, and invited him to come to study with him. Of poor Irish background, Murray was the eleventh of 12 children of a stonecutter employed by the cemetery. Within a year or so, Murray had graduated from being merely a student and had begun to work with Eakins in his Chestnut Street studio, first as an assistant and then as a sculptor in his own right. They soon became inseparable, and from that point onward, Eakins appears to have gone on most of his excursions and conducted most of his social activities with Murray. Because of his father's wealth, Eakins did not have to work for a living, and in fact their pairing fell into a pattern not uncommon in homosexual relationships: the attraction of an elderly man of means for a much younger man of working-class background.[10]

During this period, however, Eakins continued to be involved with women, although in ways that suggest some sort of psychological confusion or emotional tension. Eakins had married Susan MacDowell in 1884, two years after the death of his sister Margaret, who had served up to that time as his secretary and housekeeper. From various accounts, including those of Charles Bregler and Lucy Langdon Wilson, we know that Eakins treated Susan harshly, in rather the fashion of a master to a domestic servant, with a seeming absence of normal gestures of affection. The marriage was childless and in 1884 Eakins executed a distinctly unflattering portrait of his Susan with his setter dog, which was reproduced shortly after it was completed by Marianna Van Rensselaer in her *Book of American Figure Painters*. Interestingly, Eakins later reworked this painting to make her look even more haggard and careworn: this reworking seems to date from 1889, the very year of the portrait of Murray at the Mitchell Museum.[11]

In this period, Eakins was also personally and socially engaged with other women, including several relationships that had tragic outcomes. For example, one of his students, Lillian Hammitt, was discovered walking the streets of Philadelphia in a bathing suit, claiming that she was married to Eakins, and was arrested and placed in an asylum. Another, his niece Ella Crowell, committed suicide after telling her parents that Eakins had sexually molested her. While Eakins's photographs of nude young men have often been interpreted as homoerotic, it's notable that during his later years he was obsessed with viewing women naked as well, and he consistently pressured women who posed for him to undress, even in cases where their age or social station made this an odd request. Far from abandoning woman as a subject, he continued to make paintings of women, including many renderings of women in *dishabille* that some writers have described as titillating or erotic. Art critic Peter Schjeldahl, for example, has described Eakins's 1895 likeness of Maud Cook as "one of the most erotically charged pictures I have ever seen."[12]

Samuel Murray

Murray remained unmarried for most of his life, although in the 1890s he became engaged to an art teacher at the Philadelphia School of Design for women, three years older than himself, Jennie Dean Kershaw. They remained engaged for some 20 years, finally marrying in March of 1916, just three months before Eakins's death, when Eakins was helpless and bedridden and Murray was 46. The marriage was childless. Eakins executed an unfinished portrait of Kershaw (c. 1897) that makes her look nervous and birdlike. At least one viewer, Sylvan Schendler, has noted that she looks on the verge of hysteria and has suggested that she and Eakins were in competition for Murray's affection.[13]

With Eakins's encouragement, Murray became a sculptor rather than a painter, and he enjoyed some degree of local success. In his lifetime, Murray was arguably more successful than Eakins. Starting in 1892 he showed in nearly every annual exhibition of the Pennsylvania Academy, and in 1894 his bust of Benjamin Eakins won the Gold Medal of the Philadelphia Art Club. He also exhibited nationally and internationally, although he never received a major commission outside of Philadelphia. Much of his work was portraiture, and at least 40 of his portraits were of men and women whom Eakins painted. They were usually done about the same time, though not at the same sittings. Today he is best remembered for is portraits of the Eakins family, including a statuette of Eakins, a bust of his father, and a small bronze statuette of Susan Eakins.

Everything he did was produced in close collaboration with Eakins, and not surprisingly, his work meets a very high technical standard, although it lacks the peculiar quality that makes Eakins's work stand out as so memorable. It's notable that even today there's no substantial study of his work, and only one of his statuettes, a likeness of Eakins sitting on the floor painting, is widely reproduced, and this more because of its significance as a document of Eakins than for its intrinsic artistic value. Nonetheless, on several occasions Eakins made seemingly extravagant claims about Murray's artistic ability, declaring of one of his portrait busts that "no better work in my judgment has ever been done in America," and of one of his statues (of Commodore Barry) that "artistically the statue is I believe the best in the country."[14]

By the time Lloyd Goodrich encountered Murray, around 1930, he was old and hard of hearing but he was still very talkative, and regaled him with stories about his friendship with Eakins and the excursions they went on together. Lloyd Goodrich recalled,

> When I visited him several times in 1931 he was in his sixties and almost completely deaf, but he enjoyed talking about Eakins and everything that had to do with him. Frank, with a keen sense of humor, he was full of stories about

the people they had known and the experiences they had shared. (Some of his stories, I came to realize, were embroidered, for he had an Irish imagination.)

In talks with me he must have felt that I was getting from others too sad a picture of his master, for he kept emphasizing the good times they had had. Both active bicyclists, they would go on long cycling trips, sometimes putting their machines on the train to Washington, then riding south, "eating Virginia ham and waffles." They often visited the boathouse on the Cohansey and went swimming there. They enjoyed the Italian sections of Philadelphia, and sometimes went to New York when Eakins went there to lecture. On one trip to New York, the hotel porter took them for a couple of hicks, so they entered to the spirit of the occasion; Eakins pointed to the folding beds and asked what those things were, and Murray played his part by trying to blow out the gas.[15]

Intimate Companions: Eakins and Samuel Murray

Significantly, as Lloyd Goodrich has recorded, on the basis of his conversations with Murray, Eakins's portrait of Murray was directly associated with the Agnew project. Murray directly participated in the creation of the Agnew painting, not only the physical preparations, such as stretching the canvas, but also some of the artistic aspects, such as working out the perspective of the benches and filling in some of the background and lesser parts of the painting with a big brush. No doubt Eakins was also grateful for his company during late hours while he worked on the project. In gratitude, Eakins produced a portrait of Murray shortly afterward, which he inscribed and gave to him. It seems clear that Eakins conceived quite specifically to memorialize their companionship during the creation of the Agnew painting. It also seems quite likely that the painting expresses sentiments that were addressed to Murray rather than to the public at large. As it happens, Murray's best-known work was also associated with Eakins's Agnew commission. It's a small statuette of Eakins sitting on the floor, working on the painting.

The question of whether Eakins was homosexual has produced markedly different responses since the first writings on Eakins. For Goodrich, a major aspect of the appeal of Eakins was a manliness that he believed to be free of homosexual or even sensual undercurrents—a quality of ruggedness that he saw as integral to the American character. To Goodrich, Eakins's manliness contrasted with the overly "feminine" qualities he discerned in the work of such figures as Whistler, Sargent, or La Farge, which to his mind, while "technically brilliant," was not "robust," and lacked "formal power.[16] The climactic concluding passages of Goodrich's 1933 monograph on Eakins, which clearly had a sexual subtext, contrasted the "manliness" of Eakins with the "queerness" of more aesthetic-minded painters. A central element of this position was the conviction that heterosexual art was "manly" and

homosexual art was "feminine," an idea that he directly addressed in his expanded monograph on Eakins of 1982, in which he declared,

> It does seem to me that in modern times (not Greece or the Renaissance) the art of homosexuals tends to show certain qualities that are conspicuously absent in Eakins's: sophistication, wit, elegance, fantasy, satire, decorative values. And specifically, an attraction toward the male more than the female, and a tendency to idealize the male face and figure. I do not perceive any of these characteristics in Eakins's work.[17]

Interestingly, however, during the same period that Goodrich was championing Eakins because he was "not queer," in homosexual circles a conviction seems to have developed that Eakins was indeed gay, and that along with Walt Whitman—with whom he briefly associated—he was a pioneer of a modern, openly gay lifestyle. Tracing the emergence of this view is complicated because during much of the twentieth century, homosexuality has been illegal, so statements alluding to gay qualities in Eakins's work were phrased through innuendo. Three forms of evidence have been put forward that Eakins was gay: his friendship with Whitman, his preoccupation with photographs of the nude male figure, and most centrally, his painting *Swimming*, also known as *The Swimming Hole* (1886), which displays a profusion of nude male buttocks unparalleled in nineteenth-century American art. The writings of F.O. Matthiessen (1941) and Lincoln Kirstein (1972), both of whom were homosexual, clearly viewed Eakins's work in this light, and in 1972, three writers, Gordon Hendricks, Donelson Hoopes, and William Gerdts, specifically raised this possibility. By the 1990s for many writers it was simply a given that Eakins was homosexual—although interestingly, other writers denied this belief with equal certitude. In 1994, for example, Adam Gopnik declared that "The homoerotic content of Eakins's work is evident," and in 2002 John Esten published a book of photographs of young men by Eakins, with the titled *Eakins: The Absolute Male*, with the clear marketing goal of appealing to a homosexual audience.[18] In 1995 the gay composer Ned Rorem wrote regretfully that he came into the world too late to become sexually engaged with Eakins. As he wrote,

> I can never meet and sniff and love, say, Thomas Eakins. Not his painting, but the finite trembling man. I long for his flesh, which was gone before I was born.[19]

Recently, in fact, a biographer of Eakins, William McFeely, has discovered a document that seems to resolve this question, establishing without much doubt that Eakins was homosexual—or at least was seriously in love with a young man. Among the Bregler Papers, in Eakins's hand, is a sort of Whitmanesque prose-poem which reads in part,

The one I love most lay sleeping by me under the same cover on the cool night. In the stillness as the autumn moon beams his face was inclined toward me and his arm lies light around my breast—and that night I was happy.[20]

Oddly, McFeely does not attempt to identify "the one I love," but the passage seems to refer quite unmistakably to Samuel Murray, who we know slept regularly with Eakins at a boathouse in Cohansey, as well as when they went camping together.[21] From all accounts, Eakins's affection for Murray made a striking contrast with his treatment of his wife, who did not usually accompany her husband on his excursions but stayed at home, did the housekeeping and housecleaning, and "was kinda killed" when she married Eakins according to several informants.[22]

Yet while the creation of the Agnew painting was a triumphant moment for Eakins, the mood of his portrait of Murray is anything but celebratory. It's apprehensive, in a way that hints of something painful or tragic. Indeed, what's surprising is that Eakins's portrait provides a picture of Murray that's so different from what we know from other sources about his character. As Lloyd Goodrich's memories make clear, Murray was a compulsive raconteur and something of a jokester. Even the photographs of him bathing nude with Eakins or cavorting with him often have an atmosphere of high jinks. Eakins was clearly depressive by temperament, and his friendship with Murray seems to have been motivated in part because Murray lured him out of his tendency toward despondence and lethargy. The single photograph of Eakins that shows him smiling seems to have been a response to Murray making silly faces at him from behind the camera.

The Murray Portrait

Why then did Eakins portray Murray looking serious and perhaps even sorrowful? As in other paintings of this period, Eakins seems to catch the sitter at an unguarded moment, when the public facade drops away and the sitter appears vulnerable and uncertain. Murray looks off to the left with unfocused eyes, as if lost in self-reflection. His face looks pale; his coat fades into the dark background; his flamboyant purple tie, which was distinctly "artistic" by the standards of the period, has a flamboyance that seems at odds with the pallor of his face and his solemn expression. For that matter, why the flamboyant tie? Murray was of working-class background and none of the photographs that survive show him in such attire. Eakins continually made disparaging remarks about anything that smacked of artistic affectation. Why insist on this element in a portrait of one of his closest companions?

Words are not very adequate for describing a facial expression, in part because what seems like a single expression often contains ambiguities as well as subtly conflicting elements. But at some level Murray's expression is one of pain—perhaps his own pain, perhaps his identification with the pain that he sees in Eakins. In this regard, one way of reading the painting is as a record of Eakins's own feeling of inner pain and hurt, and of a very brief moment when he shares that with another human being. Whatever the expression, surely it seems to capture Murray at a moment when his jokester qualities have been momentarily suspended.[23]

If Eakins did have a sexual relationship with Murray—though as I've indicated, the evidence is somewhat ambiguous—surely it started around 1889, the moment at which they became constant companions. Thus, Eakins's portrait of Murray is certainly a key document for resolving this question. What's curious is that the painting withholds information about Murray's physique, though contemporary photographs of him in the nude show that he was a muscular, strikingly vigorous young man (Figure 8.1). Indeed, rather than emphasizing Murray's good looks, the painting emphasizes his uncertainty and pallor, and one might even propose makes him look physically weak. In significant ways, the portrait is quite different from what we would expect in a painting of a lover. But then, it's also true that as a rendering of Murray's personality the painting is also highly peculiar, since, as has been noted, it seems to disregard all the fun-loving qualities that were the most notable aspect of his personality. Sylvan Schendler, one of the few writers to directly describe the portrait, has even proposed that its underlying message is critical rather than romantic, and that it records Murray's "softness" and "lack of intellectuality."[24] Whether or not this is true, surely the qualities of the painting are not erotic or romantic in conventional terms. At its deepest level the painting feels profoundly uncertain, hesitant, and unsure. Surely the likeness does not flatter a quite good-looking young man, who was then at the height of his physical attractiveness.

Indeed, it seems quite possible that something about Eakins's love relationship with men was emotionally blocked, as is suggested when we carefully study Eakins's painting *Swimming*, which has always been recognized as the work in which he most directly confronted the subject of the nude male figure. Certainly, the profusion of male nudity is unparalleled in nineteenth-century American art—and yet in significant ways the painting is not so much erotic as repressed. Each of the figures is somehow contorted so that the genitals are discretely hidden, the composition is strangely stiff, and the color harmonies are jarring. Identifying the figures in the painting reveals that while some were unattached young men, others were married. About half the figures in the painting sided with Eakins at the time he was dismissed from the academy; but the other half sided against him. In other words, the painting does not record a celebration of kindred spirits but something much

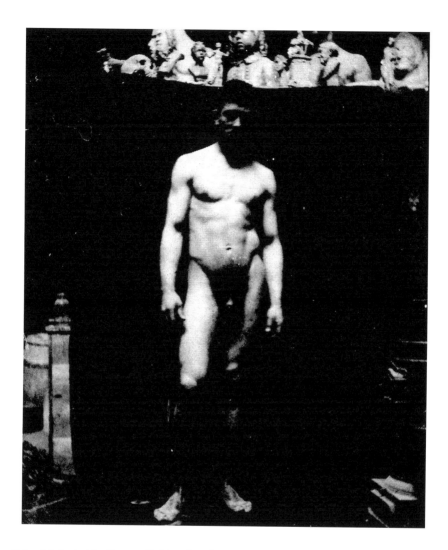

8.1 Attributed to Thomas Eakins, *Standing Nude (Samuel Murray),* c. 1890–92.
Cyanotype on paper, 4 3/8 x 3 11/16 in. Hirshhorn Museum and Sculpture Garden,
Smithsonian Institution, Washington, DC. Gift of Joseph H. Hirshhorn, 1966.
Photograph by Lee Stalsworth

more ambiguous, divisive, and uneasy. Eakins's photographs of nude figures,
also, while extraordinarily numerous in a way that suggests an obsession of
some sort, are hardly erotic in the usual sense. Indeed, there's often a sense of
something awkward in the stance and position of the figures; and as Elizabeth
Johns has noted, a very frequent element is the presence of an onlooker of
some sort, and of intrusive elements in the setting, in a way that seems to
dispel any mood of erotic fantasy.[25] For that matter, like so many of the

documents in Eakins's life, his prose poem to "the one I love" is open to more than one reading. While clearly an expression of love for a young man, it stops just short of being sexual, since his companion is asleep. What's more, at the very period of his relationship with Murray, Eakins continued to engage in actions toward women that stirred up scandal and that, at some level, surely contained a sexual undercurrent.

What's interesting is how the portrait seems to deny the readings we would like to impose on it based on the stories, legends, and even myths that have grown up around Eakins, and around his relationship with Murray. When we review Eakins's paintings in this format, it's striking that the ones that have become most popular and widely reproduced are the ones that are easily reducible to a completely conventional meaning—such as his paintings *The Veteran* or *The Bohemian*, which portray stock types of popular fiction—the soldier ruminating on his war experiences, like some character in a story by Ambrose Bierce, or an impoverished artistic type, of the sort celebrated by writers such as Henri Burger. But the modernity of Eakins's work is even more apparent in portraits such as that of Samuel Murray, which aren't so easily reduced to a clear narrative or neat summation of character—and in the case of the portrait of Murray even seem to contradict what we can glean about the sitter from other sources.

Undoubtedly, for Eakins himself, this painting had a very special significance in ways that are difficult for an outsider to entirely grasp. As has been hinted, in some way this is surely associated with the many scandals that surrounded Eakins, and that his emotional and sexual needs did not conform to traditional patterns. Hence he chose to communicate in a cryptic manner, in a sort of secret code. Indeed, at some level Eakins seems to express himself through contradiction.

Conclusion

In many regards Eakins's portrait of Murray is an annoying riddle, a frustrating enigma.[26] But Murray's extraordinary significance in Eakins's later life makes this a work of paramount importance to decode. If nothing else, it admonishes us that Eakins's artistic intention should not be reduced to simplistic formulations, of the sort found in articles in *Reader's Digest*, but requires more sensitive and nuanced analysis. If we are ever to make real contact with what is most modern about Eakins's work, its extraordinary complexity and ambiguity, its quality of mysterious and tragic depths of feeling, its qualities of emotional and sexual repression, its curious mixture of confession and concealment, surely this is a work that should not be overlooked—that in fact deserves a central place.

Notes

1 Henry Adams, *Eakins Revealed* (Oxford: Oxford University Press, 2005), 40; Lloyd Goodrich, *Thomas Eakins*, vol. II (Cambridge: Harvard University Press, 1982), 109.

2 Sylvan Schedler, *Eakins* (Boston: Little, Brown and Company, 1967), 114; Darrell Sewell et al., *Thomas Eakins* (Philadelphia: Philadelphia Museum of Art, 2001), 208, plate 73.

3 John Wilmerding, *Thomas Eakins* (London: National Portrait Gallery, 1993).

4 The history of the collection at the Mitchell Museum is documented in an excellent catalog by Kevin Sharp, with contributions by Sharon Bradham, Adam Thomas, Julie Novarese Pierotti, and Amy Roadarmel, *Cedarhurst: The Museum and Its Collection* (Mount Vernon, IL: Cedarhurst Center of the Arts, 2008).

5 Lloyd Goodrich, *Thomas Eakins: His Life and Work* (New York: Whitney Museum of American Art, 1933), 161–209. Just one painting earlier than 1889, *The Veteran* (c. 1884) seems to belong to this same essential type, although it's slightly different in dimensions.

6 Goodrich catalog numbers 238, 469, 470, and 471. Eakins's portraits of Frank Macdowell, Douglass Norman Hall, and Lillian Hammitt (Goodrich catalog nos. 219, 220, 233, and 234) may possibly be earlier than the Murray portrait, but aren't dated.

7 The paintings of these dimensions tend to portray people who were part of Eakins's intimate circle, such as family members or students. Even in his late years, when Eakins sought out a person to paint because something about their appearance or profession or life-achievement interested him, he tended to use a slightly larger canvas and to show more of their body.

8 See Adams, *Eakins Revealed*, 49–67; Amy Werbel, *Thomas Eakins: Art, Medicine and Sexuality in Nineteenth-Century Philadelphia* (New Haven: Yale University Press, 2007), 131.

9 For an account of the commission, see Goodrich, *Thomas Eakins*, vol. II, 39–51.

10 Ibid., 99–110.

11 Adams, *Eakins Revealed*, 326–31.

12 Peter Schjeldahl, "The Surgeon," *New Yorker*, October 22, 2001, 79.

13 Schendler, *Eakins*, 145.

14 Goodrich, *Thomas Eakins*, 107.

15 Ibid., 101.

16 Gooddrich, *Thomas Eakins: His Life and Work*, 155. It's often stated that Eakins was not accused of homosexuality in his lifetime, but in fact, at least three of Goodrich's informants stated or strongly implied that Eakins was homosexual, and this seems also to have been an aspect of the accusation recorded by Susan Eakins, that her husband was accused of behavior "in the manner of Oscar Wilde." Nonetheless, Goodrich went to his grave insisting that the relationship between Eakins and Murray was purely platonic—"like father and son."

17 Goodrich, *Thomas Eakins*, 110.

18 Adam Gopnik, "Eakins in the Wilderness," *New Yorker*, December 26, 1994, 87; John Esten, *Thomas Eakins: The Absolute Male* (New York: Universe Publishing, 2002). For a full discussion of this material, see Adams, *Eakins Revealed*, 307.

19 Ned Rorem, *Lies: A Diary, 1986–1999* (Washington, DC: Counterpoint, 2000), 265.

20 William S. McFelly, *Portrait: The Life of Thomas Eakins* (New York: W.W. Norton & Company, 2006), 103.

21 Although McFeely does raise this question later in his account, where he states, "'Love' is a word often sneaking into descriptions of the relationship of the two men. Clothed or naked, Murray was dazzlingly handsome and Eakins, into his sixties, was still a striking man. Even those writers who believe that the men slept together tend to downplay the sexual act, equating it to bike rides or fishing expeditions. But to be true to the Eakins story, the possibility has to be taken into account." Ibid., 173–4.

22 Henry Adams, "Despite Its Twist on Tradition, Portrait of Painter Thomas Eakins Is Blemished," review of William S. McFeely, *Portrait: The Life of Thomas Eakins*, in the *Chicago Tribune*, November 26, 2006, Living/Books.

23 See Schendler, *Eakins*, 111.

24 Ibid.

25 Of course, it could be argued that in Eakins's lifetime an overt visual expression of homosexual desire would not have been acceptable, but to a large degree I think the reverse is the case. Since homosexuality did not "exist" in this period, homosexual messages that seem obvious today don't seem to have been visible to the general public, or at least were not discussed or attacked. To cite a slightly later instance, it's striking that the public controversy that revolved around Paul Cadmus's painting *Fleet's In!* when it was removed from an exhibition at the Corcoran Gallery in 1934 revolved around the presence of female prostitutes, and the homosexual pick-up taking place in the painting was never mentioned. See Anthony J. Morris, "The Censored Paintings of Paul Cadmus" (PhD diss., Case Western Reserve University, 2010).

26 Of course, also, to fully understand it, we should analyze Eakins's portrait of Murray alongside other portraits of his intimates in this period, including those of his wife, Ella Crowell, Lillian Hammitt, and other male students, such as Douglass Norman Hall.

Maynard Dixon and *The Forgotten Man*

James Swensen

More than a half century after his death, the California artist Maynard Dixon is best remembered for his sweeping western vistas and his interest in the abstract qualities of rock and sky. Living in San Francisco during the Great Depression, however, forced the painter to confront the hardscrabble world outside his studio. In the face of strikes and turmoil, he turned to grittier, urban scenes of violence and the outcast. While many scholars have difficulty placing this work—seeing it as a temporary aside—Dixon's turn to socially engaged material should be seen within his larger pursuit of the "West of Then and Now."[1] In the 1930s there was simply no escaping the harsh realities of the present.

Created in a moment of economic turmoil and personal crisis, Dixon's 1934 painting, *The Forgotten Man* (Plate 9), is emblematic of his socially conscious work. It is a direct response to the traumatic events occurring on San Francisco's streets and to one of the era's most important themes— the forgotten man. Furthermore, it reflects a low point in Dixon's life both professionally and personally. As chaos ensued around him, few were buying his paintings, and his wife, the photographer Dorothea Lange, was to leave him for another man.

In the 1930s Dixon's painting was known across the United States and seen as a reflection of the hardships of the day. In 1937 Dixon sold *The Forgotten Man* and several other works to Brigham Young University (BYU) in hope that they would continue to be seen. Being located in the West, however, has limited the *The Forgotten Man*'s exposure. While not known in broader circles, it has been embraced in unique ways at BYU, which is operated by the Church of Jesus Christ of Latter-day Saints, or the Mormons. This essay explores the context of Dixon's painting and follows the history of a work that is an important, but forgotten image of the Great Depression.

The Forgotten Man

During the Great Depression, the phrase—"the forgotten man"—became shorthand for the fallen and down-and-out. Just prior to the Depression, however, the phrase carried a different connotation. In 1883 Yale sociologist William Graham Sumner posited that "the forgotten man" was the simple, self-supporting laborer.[2] He was, moreover, the man in the middle of the economic pyramid, the backbone of the American economy, and "the man who is never thought of."[3] At the same time, he was the victim of "the reformer, social speculator, and philanthropist," who supported social programs and economic policies that did not directly aid his well-being.[4] In other words, the forgotten man was marginalized in favor of the "poor and the weak."[5] "He works, he votes, generally he prays," Sumner insisted, "but he always pays—yes, above all, he pays."[6]

In the early 1930s Sumner's usage of the term was still in circulation. The "forgotten man" was seen as the invisible, average citizen.[7] He was the "middle-class citizen" and hidden taxpayer who was "roped into a system that seemed to help everyone except themselves."[8] Who is the "forgotten man" an editorial in Muncie, Indiana, queried. "He is the fellow that is trying to get along without public relief and has been attempting the same thing since the depression that cracked down on him."[9]

There was, at the time, a competing connotation of the phrase that was gaining traction. In a nationally broadcast address on April 7, 1932, then New York Governor Franklin Delano Roosevelt evoked "the forgotten man at the bottom of the economic pyramid" to marshal support for new ideas and programs aimed at those affected by the Depression.[10] In the face of economic collapse, Roosevelt's reorientation toward the lowest third of a nation resonated with voters who swept him into the presidency later that year.

Aiding the "forgotten man" became a core component of Roosevelt's administration and the policies of his New Deal. This was not lost on Roosevelt's supporters. Shortly after his election a cartoon in *New York Daily News* showed a worker with a pickax, shaking the hand of an erect Roosevelt (Figure 9.1). The accompanying caption read, "Yes, You Remembered Me." All across the nation "the forgotten" were sought out in order to aid. For Farm Security Administration photographer Russell Lee, the destitute sharecroppers in Oklahoma "rightfully claimed the title, Forgotten Men."[11] Others found him in factories, in mines, or on the street.

Shocked and Panicky

In 1934 there were many reasons to feel forgotten. In comparison to the two previous years—the nadir of the Depression—1934 was slightly better,

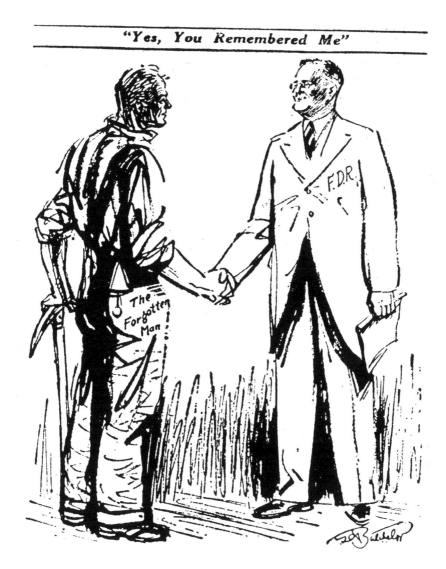

"Yes, You Remembered Me"

9.1 Clarence Batchelor, "Yes, You Remembered Me." *New York Daily News* (October 11, 1936). © Daily News, L.P. (New York). Used with permission

but recovery was slow. National unemployment hovered at 21 percent and protests mounted across the United States.[12] California, the "Golden State," was not spared hardship. With 20 percent on public relief, poverty had never been so visible in the state. Indeed, conditions were so dire that Upton Sinclair's radical End Poverty in California (EPIC) gubernatorial campaign actually gained traction. EPIC ultimately failed, but not before it put the state's economic woes on a national stage.

A poet and painter, Maynard Dixon was keenly aware of the turmoil that surrounded him in San Francisco. Born in Fresno in 1875, Dixon began as an illustrator in California and New York City. Uncomfortable in the artistic hothouse of the city, he eventually moved back to his home state and became well known for his modernist paintings of the western landscape, his cowboy attire, and eccentric ways. In 1920 he married Dorothea Lange, his second wife. Their first son, Daniel, was born five years later, followed by John, who was born in 1929.[13]

The Depression greatly impacted Dixon and his family. In the early 1930s he was at the height of his powers as a painter, but with mounting economic woes few patrons bought his work. In 1932 the family moved to Taos, New Mexico, as a temporary reprieve from the hardship. When they returned to San Francisco, they were "confronted by the terrors of the depression."[14] Lange remembered that everyone was "shocked and panicky."[15] Unable to sustain a family, they boarded their young sons and moved into their separate studios on Montgomery Street. The following year the family again turned to the desert for relief this time heading to southern Utah. Upon their return the family rented a small home on Gough Street. They may have been together but their finances were strained; none of Dixon's canvases of Utah's dramatic scenery sold.

While Dixon considered this time to be a "dark period," it was a moment of insight and liberation for Lange.[16] From her studio she watched as vagabonds flooded the city. Turning away from the wealthy clientele of her photography studio, Lange took her camera to the streets not knowing what she would do with pictures of the poor. According to her friend John Collier, Jr., once Lange left her studio she figuratively never came back.[17] Her 1932 photograph *White Angel Breadline* is representative of Lange's new focus. With his tattered hat pulled low and hands clutching an empty tin cup, the image's primary figure represents those left hollow by the Depression. Referencing Lange's new subject matter, Dixon recorded in his diary, "Dorothea begins work photographing Forgotten Man." Then he added, "No paintings of this subject."[18]

The year 1934 was difficult, but it began with some hope for the beleaguered painter. In April Dixon accepted an assignment with the Works Progress Administration to paint the construction of Boulder Dam. He spent several weeks documenting the enormous project. It was demanding work but yielded several paintings depicting Lilliputian workers against massive cliffs. The theme that dominated this series was man against nature or, as he stated, "flesh-and-blood men oppose[d] to immutable rock."[19] In one of the most telling, Dixon painted a truckload of workers slumped over and beaten, returning home after an exhausting day of labor.

When Dixon returned he found a city in chaos. Tensions along the western seaboard between dockworkers and shipping companies had been building

for months prior to Dixon's arrival. On May 9 San Francisco's longshoremen joined the picket lines. The Waterfront Strike silenced Bay Area's ports at a cost of $100,000 a day.[20] During the tension police used tear gas and heavy clubs to maintain order.[21] The strike turned deadly on July 5, "Bloody Thursday," when police fired on protestors. Two of the three deaths occurred near Dixon's studio. San Francisco was a blue-collar town and growing sympathy with the longshoremen led to a general strike on July 17. Forty thousand workers walked off the job and for four days the strike paralyzed the city. As Paul Taylor wrote, the events of July "surprised, bewildered, gratified, or terrified and maddened the average citizen."[22]

Dixon and Lange were clearly moved by the events circling their lives. Years later Collier insisted that Dixon was Lange's guide to the streets. Yet it is clear that during the commotion it was Lange who threw herself into the fray. From her home she drove the family's old Ford to the waterfront to document what was occurring. At first Dixon hesitated to go to the streets, but was urged by Lange and friends like the composer Ernest Bloch, who insisted that he "take responsibility for social causes."[23] Ansel Adams, another friend, remembered that Lange eventually "prevailed upon him to subjugate his art to the demands of politics and social criticism."[24] It is understandable that Dixon balked. He was leery of political ideologies and causes and wary of the streets.[25] This was Lange's new terrain, not his. Despite his initial reluctance, Dixon ventured to the waterfront during evenings to survey the turbulence.[26] "Like other artists," he justified, "[I] had dodged the responsibility of facing social conditions. The depression woke [me] up to the fact that [I] had a part in this as an artist."[27]

Once his forays onto San Francisco's streets began, Dixon sketched what he observed. Like Lange he became an astute witness to the people and events of the summer. Not surprisingly, Adams argued that photography, not painting, was better suited for this purpose.[28] Yet as Daniel Dixon argued, no one captured the essence of the moment better, in either medium, than his parents.[29] Both, as Therese Heyman observed, "reached for visual embodiment of the period at the same time." And yet, Heyman concluded, "For Dixon it was a temporary by-pass; for Lange the beginning of a dominant theme."[30]

Force and Futility

Dixon's response to the turmoil took shape in two series, which began in the tumult of 1934 and continued until 1939. Like his work from Boulder, the central theme of his series was man pitted against forces beyond his control. Likewise, they dealt with "concealed force and ultimate futility."[31] A growing pessimism emerged in his painting and his poetry. His poem, "1934" reflects his mood. "To feel the perfect buildings of our pride," the poem ends,

clean-cut and small, tilted off-balance,
reel toward darkness;
and in the torn gap myriads of people,
puny and helpless,
struggling like maggots in a wound;
and clear above
a pitiless cold blade of cosmic light—
ah horrible![32]

Dixon's initial response to the events of 1934 was his Strike series. In *Keep Moving* (Figure 9.2) he captured the events of early July when pickets and police were drawn in "lines of battle" along the streets and shuttered corrugated-steel doors of the Embarcadero.[33] Dixon's evening visits to the waterfront provided the feel and backdrop for the darkest paintings of the series. *Picket* depicts strikers ominously peering into the darkness, their caps pulled low. In other nocturnes the pent-up power of these figures is unleashed. In *Law and Disorder* faceless longshoremen corner and beat an overwhelmed policeman. Like John Steinbeck's strike novel *In Dubious Battle* (1935) neither side of the struggle is heroic or victorious; both are debased and violent.

At the same time that Dixon explored the darker side of the strikes and human nature, he began his Forgotten Man series. Earlier, he watched as Lange photographed the forgotten of the streets. In 1934 he was ready to respond.[34] While the Strike series is bellicose and outward-focused, Dixon's second series reflects the psychological toll of the Depression. The figures in these paintings are solitary, crestfallen players in the overarching turbulence of the time and not in specific events. Painted in late summer or early fall, *The Forgotten Man* is a key image that links the streets of San Francisco with the vagabonds flooding into California from all over the nation. It is a work that is not only central to Dixon's socially conscious turn, but deserves to be seen as one of the more important paintings of his career.

The Cipher

In preparation for *The Forgotten Man*, Dixon created at least two sketches during the summer. The first, possibly drawn on his evening explorations, depicts a balding, elderly man sitting on a curb with his left leg thrust into the street. The second sketch followed the basic composition of the first but provided additional details that would appear in the final work. Through a more erect pose, Dixon outlined the distinctive features of a man who is younger, but not youthful, with sagging jowls and weathered hands clinched in his lap. The man's clothing provides further details of his predicament. The visible sole is worn through and he wears the crumpled jacket of a man

9.2 Maynard Dixon, *Keep Moving*, 1934. Oil on canvas, 30 1/4 x 40 1/8 in. Brigham Young University Museum of Art

who is accustomed to sleeping in his clothes. The second sketch was dated August 1934. With the strikes over and life returning to normal, San Francisco was again full of movement. For Dixon, however, the moment was better represented by the cipher rather than forward progress.

In the finished painting Dixon continued with the same basic composition and details he explored in the sketches. His central figure exhibits the same defeated pose and rumpled clothing. Hatless, he wears nothing to block the midday sun that darkens his features. Even in shadow it is possible to see the man's downcast eyes, frowning expression, and angular face, which is more anguished and expressive than the sketches. The once-cradled hands fall haplessly toward the ground. The painting adds further details including the bold blue of his jacket with faded seams and a blaze of reddened hair. Other choices and details provide further information and greater visual impact.

In the painting Dixon's subject sits on a broadened, stone curb that has the appearance of a gaping precipice. Despite the gap, Dixon's use of a low vantage point focuses the viewer's attention squarely on the solitary figure.

The forgotten tend to be invisible, yet in this work Dixon wanted people to see the individual and to contemplate how the Depression brought men low.

As Lange was quick to exploit, women and children were typically seen as the "deserving poor."[35] Men were less sympathetic figures. If destitute or out of work they were expected to pick themselves up, learn from their mistakes, and move forward. "Hardship never hurts anyone who has the stuff in him" was the popular wisdom.[36] Dixon's painting, however, suggests that this was not that simple. The sight of white, homeless men was distressing for the artist.[37] For him *they* were the symbol of the Depression.

Dixon's inclusion of striding figures in the painting's background also enhanced the notion of the forgotten man. Heedless, headless, and divided almost evenly between men and women, none slow their gait to inquire or help. Their active feet are a foil to "man's" stagnant pose and worn shoes. As the eight pedestrians move forward, he goes nowhere. The noonday sun further implies he has no place to go. The men wear slacks and the women are fashionably dressed in long skirts. One carries a closed purse. The most distinct of the group is the man in the background who is dressed in spats and gray striped trousers. Once a common accessory, spats were nearly out of fashion by 1934, but were increasingly seen as a symbol of wealth and excess. *Monopoly*'s Rich Uncle Pennybags, for example, donned spats when he appeared on the board game in 1936. Dixon's figure, therefore, could represent San Francisco's moneyed class. Despite Dixon and Lange's deep connections with wealthy patrons, Dixon was suspicious of business types.[38] He must have felt they could do more. Tellingly, he is the individual furthest from the man in need.

In a real way the only thing that provides proximity to the forgotten man is the quiet fire hydrant, which seems to be more human than those marching by. There might be an additional meaning in the simple form. This distinctive, blue-capped hydrant places this scene in the lower district of San Francisco near Dixon's studio where he was "surrounded by evidences of the Depression."[39] In other words, this was not a foreign or distant scene; the forgotten man was part of Dixon's world.

Tragic Interlude

In his personal life Dixon increasingly felt as if he, too, was the "Forgotten Man." By 1931 Dixon's marriage to Lange was fraying. The excursions to Taos and Utah, and living as a family patched their differences temporarily, but by 1934 it was clear that their marriage was over. Ironically, as their subject matter aligned, they grew increasingly apart. That summer Lange met the Berkeley economist Paul Taylor and they began working together in the field. Soon they were contemplating marriage. With Dixon, 20 years her senior,

Lange professed that she never shared the "depths of his life"; with Taylor she shared everything.[40] The same age, they shared a united passion in using their abundant talents to aid those in need.[41] Dixon quickly realized that he could not match Taylor's accomplishments and attraction.[42] The 60-year-old Dixon, furthermore, was in poor health and depleted of energy. The divorce in December 1935 left him shattered.[43] In his diary Dixon recorded, "Beginning of break-up of family … Tragic interlude: Divorce. Return to S.F. [B]egin bachelor life in studio."[44]

While Dixon adopted formal elements in his work, he rejected other tenets of modernism. In particular, he was skeptical of artists espousing surrealism's pursuit of "inner significance" and the search for reality in the subconscious.[45] *The Forgotten Man*, however, not only responds to outward events but Dixon's own sublimated angst. Dixon was not a faithful husband, yet his divorce left him feeling abandoned by the woman who provided stability for 15 years. In *The Forgotten Man* these feelings may be seen in the woman's foot that metaphorically kicks Dixon's subject in the side. Over the next few years, Dixon's health and mental state continued to decline. Emphysema robbed him of his vitality and he suffered a nervous breakdown in 1937. His marriage to the artist Edith Hamlin ultimately supported and sustained the aging painter until his death in 1946.

Hot Cargo

In October 1934 Dixon displayed his Strike paintings and *The Forgotten Man* in an exhibition titled *Pictures of Today* at the Artist's Cooperative Gallery in San Francisco. This was the first time they were seen in public and his peers must have recognized the extent of Dixon's departure. In his essay for the exhibition, he insisted that the works were full of "purpose—not propaganda."[46] A critic for the San Francisco *News* believed that the work was indeed propaganda but similar to the religious art of the past that now finds "its honored place in all museums."[47] Two years later the New York–based *Art Digest* praised Dixon's urban paintings and his "perfectly frank expression of conditions observed and experienced."[48]

Dixon's work was shown in the *St. Louis Dispatch* in 1937 and featured in the progressive journal *Survey Graphic.* Under the headline "Maynard Dixon Looks at Social Conflict," several paintings, including *The Forgotten Man*, were showcased in a multipage spread that again brought his work to a national audience. For the editors Dixon's work was a "real find" in the way it reflected the ongoing Depression.[49] They praised his unbiased approach that lifted "each scene from the topical and imbue[d] it with wider significance."[50] "Here is our country today," the brief introduction concluded.

While Dixon continued to show images from his two series in diverse formats, he did not expect to sell them to the typical buyer.[51] Borrowing a strike term, he called the paintings "hot cargo" that were "never intended for homes."[52] Owning these works, he believed, came with a responsibility.[53] "[I] can't see how anyone would want to buy them except to give to a museum," Dixon frankly acknowledged.[54] It did not take long for this to happen. In 1937 Dixon received an unannounced visit from Harold Clark, dean of the College of Commerce at Brigham Young University (BYU). Like many in the West, Clark was drawn to Dixon's landscapes, but the economist's real interest was in his scenes of the Great Depression.[55] For him, these paintings had "meaning."[56] Clark personally arranged the sale of 85 paintings, sketches, and drawings to BYU for $3,700. Dixon could have obtained a significantly higher sum elsewhere but was content placing his work within an institution where, he believed, they would "function."[57]

Included in BYU's large purchase were nearly all of the Strike and Forgotten Man series including the title painting, which was listed in the inventory at around $300.[58] While out of his possession, the two series were still important to Dixon and he asked for permission to exhibit the paintings if the need arose. Writing Clark, he explained, "that their fate, their possible mission, was not yet determined," and "that they must 'function' as human works."[59] Dixon never recalled his work and they remained permanently at BYU.

BYU's Work

In their new home in Provo, Utah, Dixon's paintings were a key and sizable addition to the university's budding art collection. In 1937 Clark informed Dixon of their warm reception, noting that "Your paintings are going to do a grand job of things here as time slips by."[60] Decades after *The Forgotten Man*'s arrival at BYU, it remains one of the university's most popular works of art. In a collection that tilts toward American landscape painting, it is a uniquely personal work that, it has been said, still "speaks" to students.[61]

Art always takes on new connotations when removed from its original context. That was particularly true with Dixon's series, which clearly function differently in their new setting. Frankly, strikers in San Francisco have little to do with saints in Provo. At the time of their arrival, however, Dixon's socially conscious paintings resonated in a state that knew the hardships of the Great Depression. Clark's purchase came at a time when the Church of Jesus Christ of Latter-day Saints (LDS) was pulling its members away from the New Deal, which its leaders saw as an ensnaring dole. Rather than look to Washington, the church decided to care for its own through its newly formed welfare program and a renewed emphasis on pioneer values and cooperation.

As such, Dixon's *The Forgotten Man* had more to do with lifting the downtrodden in Utah than Roosevelt and his programs.

Dixon was not a religious man and although he saw these works as sermons, he undoubtedly did not envision them in a religious context.[62] Over time his painting continued to be enveloped in BYU and its affairs. Indeed, any institution leaves its mark on the works of art it possesses. At the religiously oriented school, *The Forgotten Man* was grafted into a Christian framework. In this light, the main figure could easily be seen as the lost sheep and the soul in need of rescue. Prior to the opening of the university's Museum of Art in 1993, the art collection was dispersed among buildings across campus. *The Forgotten Man* eventually hung in the office of university president Dallin H. Oaks. When Oaks completed his tenure, he had a copy of the painting made and took it with him when he became an apostle of the LDS faith. Thus, the painting continued to be about "my brother's keeper." Dixon knew and respected Mormons, but would probably be surprised at the ease in which his painting became part of BYU's religious life.

The Forgotten Man became part of not only the university's faith, but its politics as well. While campuses across the United States became more liberal in the second half of the twentieth century, BYU remained conservative to the extent that it continues to rank among the most conservative universities in the nation. In 2010 John McNaughton, a graduate of BYU, painted *The Forgotten Man*, a work that was influenced by Dixon's painting, but inspired and driven by his opposition to President Barack Obama and his programs.[63] Even though McNaughton, the so-called Tea Party's Painter, distanced himself from BYU, claiming that its art faculty and even its bookstore were too liberal, his work resonates with diverse audiences.[64] In his version, the forgotten man sits on a park bench in front of the White House surrounded by the 44 presidents, who gesticulate and argue while President Obama defiantly stands on the U.S. Constitution. Each detail espouses the artist's argument that the federal government has brought the nation to the "precipice of disaster.[65] While overly didactic and inflammatory, McNaughton's belief that his subject represents every American brings the forgotten man full circle to Sumner's original usage.

If nothing else McNaughton's painting demonstrates the malleability and enduring quality of the forgotten man theme. More than 75 years earlier, Maynard Dixon painted the forlorn figure at the bottom of the economic pyramid. His painting made visible what others failed to see. Not widely known beyond its current setting at BYU, and better known in its own day than now, his painting deserves to be seen more broadly as a symbol of the Great Depression and the ongoing effort to remember the forgotten man.

Notes

1 Maynard Dixon, quoted in Robert Taft, *Artists and Illustrators of the Old West, 1850–1900* (New York: Charles Scribner's Sons, 1969), 241.

2 See William Graham Sumner, *The Forgotten Man, and Other Essays* (New Haven: Yale University Press, 1919), 465–95.

3 Ibid., 466.

4 Ibid.

5 Ibid., 475.

6 Ibid., 491.

7 Amity Shlaes, *The Forgotten Man: A New History of the Great Depression* (New York: Harper Collins, 2007), 128.

8 Shlaes, *The Forgotten Man*, 12; Bruce Barton, "Commentary on 'The Forgotten Man,'" in *Sumner Today: Selected Essays of William Graham Sumner with Comments by American Leaders* (New Haven: Yale University Press, 1940), 29.

9 Quoted in Shlaes, *The Forgotten Man*, 13.

10 Shlaes, *The Forgotten Man*, 12.

11 Jean Lee and Russell Lee, "Tenant Farmers in Oklahoma," "Ancillary to General Caption no. 20," Farm Security Administration Archives, Library of Congress, Washington, DC.

12 David F. Selvin, *A Terrible Anger: The 1934 Waterfront and General Strikes in San Francisco* (Detroit: Wayne State University Press, 1996), 11.

13 For more on Dixon, see Donald J. Hagerty, *Desert Dreams: The Art and Life of Maynard Dixon* (Salt Lake City: Gibbs Smith, 1998).

14 Dorothea Lange, *The Making of a Documentary Photographer*, an interview by Suzanne B. Riess (Berkeley: Regional Oral History Office, Bancroft Library, University of California, 1968), 141.

15 Ibid.

16 Milton Meltzer, *Dorothea Lange: A Photographer's Life* (New York: Farrar, Straus, Giroux, 1978), 70–72.

17 Linda Gordon, *Dorothea Lange: A Life Beyond Limits* (London: W.W. Norton, 2009), 115.

18 Dixon quoted in Meltzer, *Dorothea Lange*, 73.

19 Grant Wallace, "Maynard Dixon: Painter and Poet of the Far West," in *California Art Research* 8, ed. Gene Hailey (San Francisco: Works Progress Administration [Project 2874], 1937), 78.

20 Samuel Yellen, *American Labor Struggles* (New York: S.A. Russell, 1936), 335.

21 Kevin Starr, *Endangered Dreams: The Great Depression in California* (New York: Oxford University Press, 1996), 97.

22 Paul S. Taylor and Norman Leon Gold, "San Francisco and the General Strike," *Survey Graphic* 23, no. 9 (September 1934): 405.

23 Gordon, *Dorothea Lange*, 130.

24 Meltzer, *Dorothea Lange*, 81; Ansel Adams, "Maynard Dixon: An Artist, A Friend," in *Maynard Dixon: Images of the Native American* (San Francisco: California Academy of Sciences, 1981), 60.

25 See Lange, *The Making of a Documentary Photographer*, 151–2; *The Thunderbird Remembered: Maynard Dixon, the Man and the Artist / Sketched from Memory by His Wife, Dorothea Lange, His Last Wife Edith Hamlin, and His Two Sons Daniel and John* (Los Angeles: University of Washington Press, 1994), 61.

26 Wesley M. Burnside, *Maynard Dixon, Artist of the West* (Provo: Brigham Young University Press, 1974), 114.

27 Wallace, "Maynard Dixon: Painter and Poet of the Far West," 82.

28 Ansel Adams, "Free Man in a Free Country: The West of Maynard Dixon," *American West* 6 (November 1969): 45.

29 *Thunderbird Remembered*, 61.

30 Therese Thau Heyman, *Celebrating the Collection: The Work of Dorothea Lange* (Oakland, CA: Oakland Museum, 1978), 52.

31 Dixon quoted in Wallace, "Maynard Dixon: Painter and Poet of the Far West," 77.

32 Maynard Dixon, *Rim-Rock and Sage: The Collected Poems of Maynard Dixon* (San Francisco: California Historical Society, 1977), 112–13.

33 Taylor and Gold, "San Francisco and the General Strike," 405.

34 See Wallace, "Maynard Dixon: Painter and Poet of the Far West," 72.

35 John E. Tropman, *American Values and Social Welfare: Cultural Contradictions in the Welfare State* (Englewood Cliffs, NJ: Prentice Hall, 1989), 54.

36 See Robert Lynd and Helen Lynd, *Middletown in Transition: A Study in Cultural Conflicts* (New York: Hartcourt Brace, 1937), 406.

37 Erica Doss, "Between Modernity and 'The Real Thing': Maynard Dixon's Mural for the Bureau of Indian Affairs," *American Art* 18, no. 3 (Fall 2004): 23.

38 See ibid., 17.

39 Lange, *The Making of a Documentary Photographer*, 144. San Francisco's Auxiliary Water Supply System was constructed in 1909 following the 1906 earthquake and fire. Blue-capped hydrants were located in the downtown area and could pump sea water from the bay if necessary.

40 Ibid., 123.

41 William Stott, "Introduction to a Never-Published Book of Dorothea Lange's Best Photographs of Depression America," *Exposure* 22, no. 3 (Fall 1984): 25.

42 Anne Loftis, *Witness to the Struggle: Imaging the 1930s California Labor Movement* (Reno: University of Nevada Press, 1998), 129.

43 See *The Thunderbird Remembered*, 58.

44 Dixon quoted in Gordon, *Dorothea Lange*, 470.

45 Maynard Dixon, "Letter to Editor," n.d. (c. 1935), Maynard Dixon Papers, Archives of American Art, Washington, DC. Hereafter cited as MD AAA.

46 Hagerty, *Desert Dreams*, 201.

47 Emilia Hodel quoted in "Dixon Portrays the Waterfront Strike," *Art Digest* 11 (October 15, 1936): 14.

48 "Dixon Portrays the Waterfront Strike," *Art Digest* 11 (October 15, 1936): 14.

49 Florence Loeb Kellogg to Maynard Dixon, letter, July 31, 1936, MD AAA.

50 *Survey Graphic* 26, no. 2 (February 1937): 83–5.

51 *The Heart of Maynard Dixon: Conversations with Herald R. Clark and other Related Correspondence, 1937–1946*, ed. Phillip Hone Clark (Provo, UT: Excel Graphics, 2001), 58.

52 Wallace, "Maynard Dixon: Painter and Poet of the Far West," 86; Linda Jones Gibbs, *Escape to Reality: The Western World of Maynard Dixon* (Provo, UT: Brigham Young University Museum of Art, 2000), 23, 25. During the strike "hot cargo" referred to freight unloaded by strikebreakers, which was refused by drivers and warehousemen sympathetic to the longshoremen's plight. See Taylor and Gold, "San Francisco and the General Strike," 405.

53 Wallace, "Maynard Dixon: Painter and Poet of the Far West," 80.

54 Gibbs, *Escape to Reality*, 25.

55 Ibid., 22.

56 Arthur Miller, "Brush Strokes," *Los Angeles Times*, newspaper clipping, reproduced in Philip Hone Clark, comp., *The Heart of Maynard Dixon: Conversations with Herald Clark and Other Related Correspondence, 1937–1946* (Prospect, VA: Theo's Art, 2001), 58.

57 *The Heart of Maynard Dixon*, 9.

58 Ibid., 10.

59 Ibid.

60 Ibid., 65.

61 Charlene Winters, "Escape to Reality," *BYU Magazine* (Winter 2000).

62 Gibbs, *Escape to Reality*, 25.

63 John McNaughton, e-mail correspondence with author, December 24, 2013.

64 See Sara Isrealsen-Hartley, "Artist John McNaughton Pulls Political, Religious Art from BYU Bookstore," *Deseret News*, April 27, 2010.

65 John McNaughton, "The Forgotten Man," http://jonmcnaughton.com/content/ZoomDetailPages/TheForgottenMan.html (accessed June 15, 2014).

Arthur Dove's *Carnival*:
Nature, Structure, and the Problem of Permanence

Jessica Murphy

From April 21 through June 1, 1935, Arthur Dove exhibited his newest work at Alfred Stieglitz's New York gallery, An American Place. The checklist for the exhibition comprised 17 oil paintings and 27 watercolors, a cross-section of Dove's customary subject matter: abstracted landscapes, animal studies, renderings of agricultural equipment, and depictions of rural landmarks in Geneva, New York, where the artist was living at that time.[1] One oil painting in the exhibition, however, did not fit easily into any of these categories. *Carnival* (Plate 10) (1934–35), showing a large tent and a Ferris wheel erected in a verdant landscape, is Dove's only canvas depicting such a subject.

When the painting went unsold at the 1935 exhibition, it may have remained temporarily at An American Place, for Stieglitz included it in a retrospective of Dove's work in 1939. After Dove's death in 1946, the artist's estate was handled by Edith Halpert at the Downtown Gallery in New York City. Through the Downtown Gallery, *Carnival* was occasionally loaned out to special exhibitions; in 1967, it was featured in two shows of Dove's work, one at the Geneva Historical Society and one at the Heckscher Museum in Huntington, New York. When the Montclair Art Museum (located in northern New Jersey) purchased *Carnival* from the Downtown Gallery in 1969, the painting found a permanent home. Since then, it has appeared in several exhibitions, usually thematic in nature,[2] but it was not included in more prominent recent retrospectives of Dove's art. Despite sustained scholarly interest in Dove's work over the past several decades, and the strong reputation of Montclair's American Art collection, *Carnival* has received very little attention as an individual work.

Since Dove's art, with its focus on harmonious form and organic processes, is typically rooted in the natural landscape, the traveling carnival—a temporary public spectacle with the potential for disorder and disruption—

seems like an unusual choice of subject. On the other hand, it meshes with several of Dove's ongoing artistic preoccupations. This analysis of *Carnival* draws upon Dove's diaries and correspondence of the mid-1930s, as well as related sketches and watercolors, and considers the artist's creative and personal motivations for selecting this subject. Despite its apparent break with Dove's usual subject matter, and its festive connotations, *Carnival* is not just a passing diversion. This painting is, in fact, a subtle interweaving of Dove's creative and personal concerns of 1934–35: expressive use of line and form, a balance of natural and man-made elements, seasonal events, and the artist's ambivalence about the duration and terms of his own time in Geneva, New York.

"No other choice"

Like most of Dove's work of the mid-1930s, *Carnival* is set in Geneva, and its foreground of rolling hills and its forest background, painted in shades of green ranging from celadon to olive to deep hunter, are typical of the landscape around upstate New York's Finger Lakes region. A simple red building with a gabled roof, similar to structures in many other works by Dove, anchors the left end of the composition. On the other hand, the scene contains elements that appear in no other oil painting in Dove's oeuvre: the foreground is layered with thin silvery lines delineating a carnival tent and a Ferris wheel, and the very center of the composition includes more ambiguous forms that could be additional amusements or rides.

In 1967 *Carnival* returned to its place of origin for an exhibition of Dove's work at the Geneva Historical Society. A Geneva resident who organized the exhibition later recalled a conversation with Dove's brother:

> Paul Dove, Arthur's brother (still living in Geneva) commented on this picture. He was delighted with it and recalled that carnivals were held out on the road where Arthur lived and he was fascinated by them. This, as well as many other Geneva locations, provided images for Arthur's paintings and water colours. Those familiar with the Geneva landscape, past and present, can recognize these in his pictures.[3]

Unlike his brother, Arthur Dove had left Geneva in 1901, when he enrolled at Cornell University; he had never planned to return.

When Dove's mother, Anna Chipps Dove, died in January 1933, Dove and Torr (who had married in 1932, following the death of Dove's first wife) traveled from New York's Long Island to Geneva to attend her funeral. Dove's father, William Dove, had died in 1921; Anna Dove left the family estate to their two sons, Arthur and Paul. Dove realized that he would have to reside in Geneva, at least temporarily, to settle the estate. The family's holdings

included a house on Geneva's South Main Street, a block of commercial real estate, farmland with two farmhouses, another small house near the farm, and brick and tile plants from the family's brick-making and construction business. Although reluctant to leave the New York City metropolitan area, Dove realized the financial benefits of this move. The Great Depression had worsened his tenuous fiscal situation; on his family's property, at least, he could live rent-free.

Writing to Stieglitz from Geneva the week of the funeral, Dove pondered the more positive aspects of a stay in his hometown: "Could work up there. It is good painting ground. Many lakes and if we can sell house we may all live on the farms—plenty of houses and room to be apart, barns, studio, etc."[4] On a return visit in April, he sounded resigned to the plan: "We are trying to mortgage the home to get enough to move with. —There is no other choice. There is also no other choice but to come here for this year anyway."[5] As the summer advanced, however, his tone turned darker: "There is something terrible about 'Up State' to me. I mean that part anyway. It is like walking on the bottom under water." And, by June: "The dread of going there is almost an obsession."[6] Nevertheless, he and Torr moved to Geneva on July 7, 1933. Rather than setting up their household in the family home on Main Street, they established themselves in a farmhouse without electrical power or running water on the family's farm property at the northern end of town.

Dove was immediately absorbed in the farm's everyday chores, from planting wheat and mowing hay to caring for the horses and hens. He hunted and fished to put food on the table as cheaply as possible, and he and Torr tended a vegetable garden. He was also caught up in the settling of the family estate, dealing with the complicated red tape of mortgages, back taxes on 80 acres of farmland, overdue tenant rents, and unpaid bills totaling $5,000. He found himself engaged in frequent disagreements with his brother over these matters. "It would be a Godsend to be born without relatives," he grumbled to Stieglitz in December 1933.[7]

Moreover, although Dove desired a certain amount of quiet in Geneva, he found himself an unwilling target of interest. His neighbors had been following his career in the press and were inquisitive about his return to the city (and his new marriage). Reporters from local newspapers frequently contacted him, hoping for interviews with Geneva's prodigal son. During that first summer in Geneva, even as they were attempting to adjust to their new circumstances, Dove and Torr also received several New York friends as guests. Dove described their home as "a live little farmhouse on the outskirts of what I should call a dead city. … It is fine here—in this house—but have a feeling we shall not be here long."[8] This theme of impermanence would arise repeatedly in his letters from Geneva.

"Living in exile"

Meanwhile, Dove carried on the necessary aspects of his artistic career, replying to Stieglitz's frequent updates about the daily business of An American Place. They often commiserated about Duncan Phillips, the Washington, DC–based collector who had been purchasing Dove's art from Stieglitz since 1926. Although Phillips was a major supporter of Dove's career, he was also a difficult personality and an unreliable benefactor who chose to pay in monthly installments (which he called "subsidies") for paintings he had already acquired or to borrow works from the gallery for unspecified lengths of time while he decided whether to purchase them. In their five years in Geneva, Dove and Torr only traveled to New York City once. The demands of the estate, in combination with their lack of financial resources, kept them tethered to the farm. Their first upstate winter was long and cold, and the farmhouse needed to be heated by three fireplaces that continually required Dove to gather and chop firewood. That February, Dove wrote to Stieglitz, "This is like living in exile."[9]

By spring of 1934, Dove's mood had lifted somewhat. In April he and Torr moved to another residence on the Dove farmland: "We have just moved to the larger farmhouse. And it is like living in a warehouse. After saying we didn't want to own anything, here we are with a lot of furniture."[10] Meanwhile, he had sold the Dove brickyard, divided the farm into saleable lots, and rented the family house on Main Street as apartments. That month he also shipped several cases of oil paintings and watercolors to Stieglitz for his annual spring show, which was well received. He was particularly gratified by a review written by critic Elizabeth McCausland for the *Springfield Sunday Union and Republican*. In a summary of Dove's style, McCausland wrote, "He has color, wit, a superb sense of fun, poetry, suavity, sensitiveness, tenderness." She elaborated on the difficulty of classifying Dove and his art:

> He is American, but he does not paint the "American scene." He is a child of Nature; but he is not a primitive. He anticipated the surrealists; but he does not call himself an "ist" of any sort. He has been an abstract painter for more years than one can offhand mention; but he has never subscribed to the gospel according to Picasso, simply because a man who is really himself does not have to ape another man.[11]

Dove was pleased by his prolific output of that first autumn and winter in Geneva, despite the constant business of the estate and the all-too-frequent interruptions of family quarrels, out-of-town visitors, well-meaning but intrusive neighbors, and enthusiastic members of the local press. As he wrote to Stieglitz in January 1934, "I have about 60 watercolors in spite of this stupid circus that surrounds us. It is not as bad as it started out being, but there is still room."[12] That remark would turn out to be curiously prescient.

"Breathing space"

As he entered his first full Geneva summer in 1934, Dove took stock of his newest home—the larger "North farmhouse" on the family's land—and his ambivalent feelings about this latest move and the moves that likely lay ahead for him and Torr:

> Reds is quite happy here but, as I, does not feel it permanent.—This is a larger house and there is breathing space.—The taxes where we were are paid. … Keeping moving—one sees different things—and gets ideas. "The rolling stone"—you *know* how much we want "moss" …[13]

By 1934 Dove had already been a "rolling stone" for more than a decade. During his marriage to Florence Dorsey, he alternated summers in Connecticut with winters in New York City; after the dissolution of their marriage, he and Torr lived on a houseboat from 1921 until their departure for Geneva in 1933, with the exception of a winter in Noroton, Connecticut, in 1928–29. During their residence on the boat, they moored at various locations along Long Island Sound until Dove took a position as caretaker of the Ketewomoke Yacht Club in Halesite, Long Island, in 1929. With their boat secured at Halesite harbor, the couple spent winters indoors, living in the upper floor of the club building.

In contrast to the cramped, damp houseboat and the temporary haven of the yacht club, the Geneva farmhouses offered Dove a sense of solidity and belonging. That same sense of permanence also gave rise to certain anxieties; Geneva was still his family's town, rather than his own, and he feared the limitations on experience and acquaintance that it might impose upon him. In 1934, however, several diversions added breadth and color to Dove's Geneva experience. One enjoyable escape was Dove's first flight in an airplane. A small airstrip, locally known as "Dove Airport," was located on the family property; on May 30, 1934, Dove and Torr were invited to take a brief flight. Torr noted in her diary, "Arthur & I flew two planes here in afternoon. I liked take off but not after we got up, a great feeling of tension & pressure, & almost deaf when I got out. Arthur liked it, made a drawing & did not feel as I about it."[14]

May also marked the arrival of a traveling carnival held in a lot adjoining the Dove farmland. Dove rented out space on his property for visitor parking, and thus enjoyed a close view as well as indirect participation in the festivities. This event has previously been identified as the source of Dove's *Carnival*, but it deserves closer and more detailed consideration.[15] It also inspired two related works on paper that have been overlooked in the scholarly literature on the artist, although they are documented in the correspondence and diaries for that year. On May 27, 1934, Torr wrote in her diary, "Carnival here in field. Paul here to dinner. We all watched carnival being set up in p.m. Arthur made water color & ink in early a.m. Fence & wires." On May 28, she continued,

"Arthur made nice water color of Carnival. … Carnival started." And on May 31, "Arthur made water color of big tree in orchard in a.m., one of ferris wheel in p.m."[16]

The watercolor and ink sketch of "fence & wires" is most likely a small work that surfaced in an auction at Christie's New York in September 1992, although its current location is unknown. As reproduced in the Christie's auction catalog, the drawing *Carnival* (measuring approximately 8 by 10 inches) shows a scene of preparation for the traveling fair. It is laid out in three horizontal zones: two carnival tents, with a cluster of bystanders near a trailer and two vehicles in the foreground; a pair of trees in the middle distance; and a train running along the horizon in the distance. The composition is dominated, however, by the towering vertical of a larger tent's central pole and several hanging ropes or cables that await the canvas they will support.[17]

Torr's mention of a May 31st watercolor may refer to a small work now in the collections of the Metropolitan Museum of Art (Figure 10.1). This tempera sketch is more abstract than the pen-and-ink drawing of the tent and carnival grounds. It includes just a few simplified, interlocking forms: a dark circle with spokes for the Ferris wheel, an overlapping, striated diagonal that suggests another amusement or ride, and a paler triangular shape with a rounded top that could be a tent. The palette of browns and greens, with lesser amounts of orange, white, and yellow, is elemental and earthy.

In a small city like Geneva, particularly during the Great Depression, an attraction like a traveling carnival provided an interlude of excitement and gaiety. Of course, like any transitory visitor from the outside world, the event also held the potential for danger and disruption.[18] Soon after its arrival, carnival attendees did cause a small commotion. As Torr wrote in her diary on May 30, "In evening we went to carnival, met Mildred Wheat & Paul, had our fortunes told. Back to house, a riot started, Paul telephoned for more police, two men arrested. To bed at 12."[19] The event was even worthy of mention in the *Geneva Daily Times*, which reported the following day,

> Reports of a disturbance in the Dove lot just outside the city in Exchange street, where a traveling carnival is now holding forth, sent Under Sheriff Walter Elling and Special Deputy Sheriff P. B. Oakley hurrying to the scene shortly after 10 o'clock last night. The officers found Special Deputy Sheriff Merton Collier, detailed to preserve order at the carnival, hemmed in by a cordon of youths and men, some of whom were apparently bent on making trouble for Collier.[20]

Two youths from the nearby town of Waterloo were arrested for disorderly conduct, and the remainder of the carnival's visit ran without incident. It had brought the Doves a small financial bonus, added some color and excitement to their week, and had provided a new source of visual inspiration for Dove's art.

10.1 Arthur Dove, *Study for "Carnival,"* c. 1935. Tempera and ink on paper, 3 x 4 in. (7.9 x 10.8 cm). Metropolitan Museum of Art, New York. Gift of William C. Dove. © Estate of Arthur G. Dove, courtesy Terry Dintenfass, Inc.

"Curiosity perhaps"

Dove's complaint about "the circus that surrounds us" was made humorously literal by the arrival of the May carnival. Genevans with a taste for amusement could attend similar events throughout the summer. On May 28, 1934, even as the first carnival was still taking place in "the Dove lot," Torr and her brother-in-law Paul Dove went "to a funny little circus in afternoon, a lovely little elephant, & 10 beautiful trained cocatoos [sic]."[21] Shortly thereafter, Geneva was visited by two circuses famous enough to merit local press coverage: Gorman Brothers, followed by Ringling Bros. and Barnum & Bailey. A preview in the *Geneva Daily Times* announced that Gorman Brothers would be arriving from Batavia, New York, and would set up in Geneva's "Baldwin lot."[22] Their installation would comprise a big top that reportedly seated 5,000 audience members, a menagerie, horse tents, a side show tent, and smaller "tops," and its attractions would include the cowboy actor Buzz Barton, Susie the Elephant Skin Girl, the Hodgini family of bareback riders, an elephant named Jap, and "The Six Sensational Lelands, Torelli's dogs, ponies and

monkeys, Ray Goody and his slide for life, The Ross Twins and many other equally well-known names."

The line-up for Ringling Bros. was similarly impressive and well publicized. The circus arrived from Syracuse on four railroad trains carrying a "traveling zoo" as well as human entertainers from aerialists to clowns. According to the article in the *Geneva Daily Times*, the "Greatest Show on Earth" would temporarily dominate the local landscape with its "acres of tents, and the big top seating 10,000 persons; the menagerie, the sideshow tops, the padroom and dressing tents, the auxiliary tents—all will be sharply defined against the skyline in massive silhouettes, and hundreds of men will swing side-walls and connections into place."[23] A small advertisement on the same page of the newspaper encouraged circus-goers to "Park nearest Ringlings' through Dove Airport, North Exchange." Torr noted in her diary that Arthur, Paul, and William Dove attended to the parking most of the day and evening of June 28, netting a total of $18 in fees.[24]

In addition to the monetary gains and visual source material they brought, the carnivals and circuses could have held some ironic personal significance for Dove. The artist himself may have felt like something of a public attraction during these months, drawing the lively scrutiny of his Geneva neighbors during his temporary residency. Despite his modest lifestyle and his quiet work habits, he must have been viewed as an ambassador of big-city culture. Despite his decision to live on the outskirts of town and his carefully spaced trips into Geneva proper, he drew more attention than he cared for. He was "surrounded" by the "circus" of family business and unwanted houseguests, but he was also something of a circus or a carnival in himself—at least, in the eyes of Geneva. At the very end of 1934, when calm had finally returned, Dove wrote to Stieglitz, "We are getting just a little of aloneness—and we love it. The people here seem to want to come here—curiosity perhaps."[25]

In the winter of 1934–35, as was his routine, Dove translated some of his summer watercolors and drawings into larger oil paintings. Torr first mentioned *Carnival* in her diary January 21, 1935: "Arthur painting on 'Carnival'—swell." He continued work on this canvas on January 22nd and 23rd. By the 25th, according to Torr's notes, he had moved on to other compositions: "Arthur drew 4 on canvas in p.m.—'Red Wagon,' 'Electric Orchard,' 'Corn Crib,' 'Sun & Ploughed Field.'"[26]

Torr's diary includes an interesting note regarding the title of this painting. She refers to the work as *Carnival* on January 21st and 22nd, as *Circus* on January 23, and as *Carnival* again on January 25th; in a second diary that she kept strictly as a list of works, the entry for January 23, 1935, reads, "Arthur painted on ~~Circus~~ Carnival." There is no way of knowing whether Torr's use of "Circus" was simply an error, or whether Dove was vacillating in his choice of title. However, the alternation between "carnival" and "circus" does suggest that Dove was working not only from his carnival sketches of late May but

might also have been incorporating his impressions of the two circuses that stopped in Geneva the following month.[27]

In Dove's finished painting, the impermanent constructions of the carnival/circus find their analogues within a more durable natural landscape: the pointed form of the tent echoes the outline of the red building, and the ribbed circle of the Ferris wheel amplifies the rounded forms of the trees behind it. The silver sky is painted in the same "aluminum" paint that Dove (frugal as always) had used for the farmhouse's kitchen in May 1934,[28] further blurring the distinction between the organic and the industrial. In the foreground, curving wedges could be the natural undulations of the grassy "Dove lot" or could be smaller tents (one black triangular form particularly suggests the opening of a tent). Some abstracted elements of the composition slip between Geneva's rural architecture and the carnival's temporary assemblages. For example, a horizontal zigzag form at the center of the composition could be an amusement ride like a rollercoaster, or a small bridge; it also resembles a form denoting the small local airport in one of Dove's watercolors of 1934.[29] Colored squares visible within (or through) the silvery outline of the large tent could indicate printed posters inside the tent or handbills pasted on a fence in the distance. Just as the formal elements of *Carnival* overlap, so too do the layers of Dove's experience and his impressions and evocations of the farm, the circus, and the landscape.

Yet within these overlaps, nature prevails, as it so often does in Dove's art. The greens and earth tones outweigh the shimmery outlines of the tent and the Ferris wheel, and the summer fields and trees will remain after the carnival troupe has packed up its apparatus and moved on to the next town on its itinerary. The carnival, after all, was a seasonal event. Viewed in that light, it is not so much of an anomaly in Dove's career, after all. As Anne Cohen DePietro has written, Dove returned again and again to cyclical patterns and subjects in his work: "the ebb and flow of tides, the movement of celestial bodies, the raging of storms and steady descent of blanketing snow."[30] Like the fall harvest or the spring births of baby farm animals, the carnival was integrated into his routine, was recorded in his diaries, and then receded into the past as it was succeeded by another wave of events.

"More use in the world"

In February 1935 Dove took stock of his recent work and wrote to Stieglitz, "These paintings are better than any in the last few years."[31] In March he shipped several crates of paintings and watercolors to New York for inclusion in his spring show at An American Place. *Carnival* was included in this shipment; like its real-life namesake, it traveled on to its next destination and its next audience. *Arthur G. Dove: Exhibition of Paintings (1934–35)* opened at

An American Place on April 21. Days after the opening, Dove reflected, "Am amazed of course, as much at being able to get work done as at the turn it has taken."[32]

Elizabeth McCausland's *Springfield Sunday Union and Republican* review of Dove's 1934 show was included as an essay in the 1935 exhibition brochure, setting the tone with its emphasis on Dove's "exuberant humor," his inventive use of materials, and his very personal brand of abstraction. *Carnival*, included as number 15 in the brochure's checklist, was one of many works in the exhibition that incorporated these qualities. Critical reception of the show was positive, but *Carnival*, despite (or perhaps because of) its apparently unusual subject matter, did not garner much individual attention. The only known review to have mentioned *Carnival* was Edward Alden Jewell's piece for the *New York Times*, in which he wrote,

> Occasionally Mr. Dove, who gives an unusually good account of himself this year, will set aside his more uncompromising abstract principles long enough to paint a "Carnival," in which the design becomes—a little in the Gauguin vein—instinct with design rhythms that may be called quasi-representational; but for the most part he adheres to his familiar style, producing such impressive syntheses as "Summer," "B[utton] Wood Tree" and "Holbrook's Bridge."[33]

This statement is puzzling, for what sets *Carnival* apart from the other, more "familiar" works in the exhibition was not its style, but its imagery. Many other paintings in the installation combined "instinct with design rhythms that may be called quasi-representational," but *Carnival*'s mechanized amusements may have seemed (superficially, at least) so out of place amongst the other canvases' sunrises, snowfalls, farm animals, and forests that Jewell failed to see any commonalities.

The summer of 1935 brought another cycle of traveling circuses to Geneva; in the diaries, Torr mentions a visit to an unspecified circus on May 28 and the arrival of a circus in "Baldwin's lot" on July 20. By 1936, Dove found himself continuing his own peripatetic existence with Torr. In January 1936, the couple moved from one half of the two-family "North farmhouse" to the other. By March Dove had sold the other farmhouse and a barn for $1,000 to pay taxes and wanted to finish the task of settling the estate: "The whole thing can go about so far and I will not give any more. Seem to have the reputation of being a 'good businessman' downtown. No compliment—just a contrast. Want to get where I can be of more use in the world."[34] In summer 1936, a circus came to town yet again, and both artists paused in their more mundane activities to capture its appearance. On June 3, Torr noted, "Circus in Crisi's field. Arthur made watercolor—black car—tents. I made drawing."[35]

Torr's painting *Circus* of 1936 (Plate 11) is an interesting companion and contrast to Dove's *Carnival*. Her imagery is far less abstracted: the scene's trailers, tents, and waving pennants are compressed into a shallow space but

are still readily identifiable. Yet the mood is similar to that of *Carnival*, with the fleeting pleasures of a summer concession depicted in a restrained palette of deep reds, browns, and greens (and the sky in silvery shades of gray) and an absence of any animal attractions, performers, or pleasure-seekers. Moreover, *Carnival* and *Circus* both differed from most depictions of such amusements in American art of the 1930s. Other members of the Stieglitz circle, including Charles Demuth and John Marin, focused on the performance aspects of the circus and the carnival. Demuth depicted acrobats and cyclists in the ring; Marin produced numerous complex scenes of elephants, horses with riders, ringleaders, and clowns entertaining large audiences inside the big top. The subject had popular appeal: even a relatively minor artist like Reynolds Beal could make a name for himself by producing scores of cheerful, candy-colored scenes of circus grounds and carnival attractions. However, Dove's interpretation, and its echo in Torr's work, does not address the carnival's element of spectacle, its sense of crowds and motion, its sensory jumble of sight and sound and smell, or its hints of the exotic and even the grotesque. In *Carnival*, Dove instead isolates and distills the most basic forms and patterns of the scene, integrating them into the larger context of the summer landscape, taking the same approach he would use to render a cow, a cluster of trees, or a piece of farm machinery.

In May 1937 Dove and Torr moved to their final location in Geneva, the third floor of a building on the downtown "Dove Block." The passage of time had increased Dove's tolerance for his hometown and its residents only slightly: "Think I'd better not try to like Geneva," he wrote. "It is swell from 3 a.m. to 6. —Then the people begin to appear."[36] He himself would finally disappear from Geneva in 1938, when he completed the final sale of the Dove estate and moved to Centerport, Long Island. There he and Torr lived until Dove's death in 1946. Their travels had finally ended. Dove never drew or painted another carnival subject, leaving his 1935 canvas a unique and unexpected work in his oeuvre.

Conclusion

Carnival's own history of travel and relocation was simpler than Dove's. And it would be inaccurate to say that *Carnival* has truly fallen into obscurity, since the Montclair Art Museum maintains a reputation as a center for studies of American Modernism, and *Carnival* was discussed and illustrated in the volume *Montclair Art Museum: Selected Works* (2012). Within broader Dove scholarship, however, it has been all but ignored. Perhaps this work is still seen, like an actual carnival or circus, as an unruly interloper into Dove's customary territory of landscapes and nature studies. As Elizabeth McCausland observed in her review of his 1934 exhibition, art that resists

easy classification tends not to garner wide acclaim.[37] *Carnival*, despite its underlying affinities with Dove's other work (not to mention its biographical underpinnings), has largely remained a sideshow attraction, relegated to the margins beyond the "big top" of Dove's more iconic works. This essay has sought to return it to a more prominent place—if not in the center ring, then at least within the main tent, against the broader context of his life and his oeuvre.

Notes

The author would like to thank the following individuals for their assistance and support: Gail Stavitsky, Renée Powley, and Kimberly Siino at the Montclair Art Museum, Rachel Mustalish and Thayer Tolles at the Metropolitan Museum of Art, Lisa Messinger, and Anne Cohen DePietro.

1 Titles for the watercolors were not included.

2 American Federation of Arts, *In Memoriam* (Washington, DC: American Federation of Arts, 1957). An American Place, May 24–July 19, 1981, Parrish Art Museum, Southampton, New York. Under the Big Top: The Circus in Art, May 4–June 23, 1991, Heckscher Museum, Huntington, New York. "The Elegant Auto: Design and Fashion in the 1930s," July 30–November 8, 1992, Portland Museum of Art, Maine. Carnival is illustrated in Helen A. Harrison, "A New Look at Stieglitz's Role," *New York Times*, June 7, 1981, 20; and Karin Lipson, "The Magic and Reality of Circus Life," *Newsday*, June 7, 1991, part II, 101. From December 1984 through February 1985, Carnival was on loan to Johnson & Johnson's corporate headquarters in New Brunswick, New Jersey. A typed list from the Downtown Gallery also includes exhibitions at the University of Minnesota circa 1937, the Philadelphia Art Alliance in May 1956, and the Dallas Museum for Contemporary Arts in October–November 1962; these venues could not be verified. Susan Fellin-Yeh research notes, object files, Montclair Art Museum Archives, Montclair, New Jersey. Hereafter cited as Object Files, MAM.

3 Richard L. Manzelmann to Susan Fillin-Yeh, undated letter, August–September 1975. Object files, MAM.

4 Arthur Dove to Alfred Stieglitz, January 29, 1933, Alfred Stieglitz/Georgia O'Keeffe Archive, Yale Collection of American Literature, Beinecke Rare Book and Manuscript Library, Yale University. Hereafter cited as Stieglitz Archive/Yale.

5 Dove to Stieglitz, April 9, 1933, Stieglitz Archive/Yale.

6 Dove to Stieglitz, probably May 18, 1933, Stieglitz Archive/Yale. Dove to Stieglitz, June 1933, Stieglitz Archive/Yale.

7 Dove to Stieglitz, December 8, 1933, Stieglitz Archive/Yale.

8 Dove to Stieglitz, September 18/25, 1933, Stieglitz Archive/Yale.

9 Dove to Stieglitz, February 2, 1934, Stieglitz Archive/Yale.

10 Dove to Stieglitz, May 1 or 2, 1934, Stieglitz Archive/Yale.

11 Elizabeth McCausland, "Dove's Oils, Water Colors Now at an American Place," originally published in the *Springfield Sunday Union and Republican*, April 22, 1934; reprinted in *Arthur G. Dove, Exhibition of Paintings (1934–1935)* (New York: An American Place, 1935).

12 Dove to Stieglitz, probably January 10, 1934, Stieglitz Archive/Yale.

13 Dove to Stieglitz, May 15, 1934, Stieglitz Archive/Yale.

14 Helen Torr, diary entry for May 30, 1934, Arthur and Helen Torr Dove Papers, 1905–75. Archives of American Art, Smithsonian Institution. Hereafter cited as Dove Papers/AAA. The drawing is unidentified. Dove to Stieglitz, early June, Stieglitz Archive/Yale: "It is just as mad here as you say it is in N.Y. We flew the other day for a few minutes."

15 Fillin-Yeh, Montclair. Mary Birmingham, entry in *Montclair Art Museum: Selected Works* (Montclair, NJ: Montclair Art Museum, 2002), 113.

16 Dove Papers/AAA.

17 This is mostly likely the work described by Elizabeth McCausland in her review of Dove's 1935 exhibition in the Springfield Sunday Union and Republican, May 5, 1935, E6, titled "Authentic American is Arthur G. Dove": "Only a divine fool … would want to make a railroad train bounce along its track as he does in the small watercolor from which the larger oil of a circus is taken."

18 Janet M. Davis, *The Circus Age: Culture and Society under the American Big Top* (Chapel Hill: University of North Carolina Press, 2002). Davis discusses the concept of "the carnivalesque," with reference to Bakhtin, considering the carnival as "a dialogical cultural process" between performers and audiences; an opportunity for community consolidation; a temporary suspension of social hierarchies; and a safety valve for illicit activities (25–8). For discussion of the circus in the visual arts of this period, see Susan Weber, Kenneth L. Ames, and Matthew Wittmann, eds., *The American Circus* (New York: Bard Graduate Center for Decorative Arts, Design History, Material Culture; New Haven and London: Yale University Press, 2012); and Donna Gustafson, "Images of the World Between: The Circus in 20th Century American Art," in *Images of from the World Between: The Circus in 20th Century American Art* (Cambridge, MA: MIT Press, 2001), 9–84.

19 Torr, diary entry for May 30, 1934, Dove Papers/AAA.

20 "Two Youths Are Arrested during Carnival Fight," *Geneva Daily Times*, May 31, 1934, 11.

21 Torr, diary entry for May 28, 193, Dove Papers/AAA.

22 "Gorman Brothers Circus Is in Geneva Today; To Give Two Performances," *Geneva Daily Times*, June 25, 1934, 7. Another 1934 description of the Gorman Circus reads, "The organization is billed as the largest independently owned circus on the road and travels in its own train of 65 cars"; "First Circus to Be Here May 2," *Reading Eagle* (Pennsylvania), April 23, 1934, 3.

23 "Horse to Be King When Big Circus Comes to Town," *Geneva Daily Times*, June 27, 1934, 3.

24 Torr, diary entry for June 28, 1934, Dove Papers/AAA.

25 Dove to Stieglitz, December 31, 1934, Stieglitz Archive/Yale. Local interest in, and admiration for, Dove would continue throughout his Geneva stay. On January 18, 1937, he wrote to Stieglitz, "Someone gave me one of those write-ups in Rochester paper. Butcher boy said, 'I'd a thought you was Jesus, if I hadn't knowed you'" (Stieglitz Archive/Yale).

26 Dove Papers/AAA.

27 On June 2, 1934, Torr wrote in her diary that "Arthur started oil p. of Circus." Dove Papers/AAA. This statement is difficult to interpret, since Dove did not typically work in oil during the summer.

28 "This room here is rather fine, the kitchen. The walls were gone to pieces so we used linseed oil and aluminum paint, over old paper, plaster, holes and all— Silver has covered many sins." Stieglitz to Dove, May 15, 1934, Stieglitz Archive/ Yale.

29 Airport, 1934, watercolor and graphite on paper, 5 x 7 inches. Collection of Edward G. Shufro. Reproduced in Debra Bricker Balken, *Arthur Dove: Watercolors* (New York: Alexandre Gallery, 2006), 25.

30 Anne Cohen DePietro, "Sense of Place in the Art of Arthur Dove," in Debra Bricker Balken, *Arthur Dove: Watercolors* (New York: Alexandre Gallery, 2006), 19.

31 Dove to Stieglitz, probably February 25, 1935, Stieglitz Archive/Yale.

32 Dove to Stieglitz, April 29, 1935, Stieglitz Archive/Yale.

33 Edward Alden Jewell, "From the Literal to the Abstract: A Delightful Exhibition of Bronzes by Degas—Andre Masson, Arthur Dove and Charles Shaw as Exponents of Abstraction," *New York Times*, May 5, 1935, X7.

34 Dove to Stieglitz, March 23, 1936, Stieglitz Archive/Yale.

35 Torr, diary entry for June 20, 1936: "I painted — Circus"; diary entry for June 22, 1936: "In afternoon finished 'Circus' tempera." Dove Papers/AAA. Also cited in Anne Cohen DePietro, *Out of the Shadows: Helen Torr: A Retrospective* (Huntington, NY: Heckscher Museum of Art, 2003), 34.

36 Dove to Stieglitz, June 1937, Stieglitz Archive/Yale.

37 "Dove's Oils, Water Colors Now at an American Place," Elizabeth McCausland, originally published in the *Springfield Sunday Union and Republican*, April 22, 1934; reprinted in *Arthur G. Dove, Exhibition of Paintings (1934–35)* (New York: An American Place), 1–4.

Palmer Hayden's John Henry Series: Inventing an American Hero

Lara Kuykendall

In its gallery on the third floor of the Macy's Department Store in Los Angeles's Baldwin Hills Crenshaw Plaza mall, the Museum of African American Art (MAAA) shows work by contemporary and historical black artists. Founded in 1976 by Dr. Samella Lewis, an art historian and printmaker, the museum is uniquely situated in a historically African American section of the city and maintains the largest single collection of works by Palmer Hayden.[1] Born in 1890, Hayden's painting career began during the New Negro Renaissance of the 1920s and spanned six decades. He is best remembered for *Fetiche et Fleurs* (1932–33), a still life that incorporates African objects, and works like *Midsummer Night in Harlem* (1936), which address racial stereotypes using a "consciously naïve" style.[2] Both of these paintings, along with 38 others, were given to the MAAA by the artist's widow, Miriam. The relatively small scale of the museum and its unique location make it a bit off the beaten path for many scholars and for the general public, but the institution deserves to be more widely recognized as the chief steward of Hayden's oeuvre and a continuing promoter of African American artistry.

Included in Miriam Hayden's bequest to the MAAA are 14 paintings that Palmer Hayden made in the 1940s related to the life, death, and enduring significance of the folkloric character John Henry. With his John Henry series, Hayden attempted to develop a pictorial epic that would elevate Henry to the status of national and historical hero. The politics of this goal were timely. During World War II, as American democracy waged war against international fascism, W.E.B. Du Bois, Alain Locke, and others redoubled their efforts toward raising the profile of black Americans' contributions to the national culture and ending persistent injustices like segregation. The ironic clash between the professed democratic goals of the war and the failure to implement real equality at home were not lost on civil rights intellectuals

of that era.[3] As Rayford W. Logan argued in 1944, the same year that Hayden began his John Henry series:

> We declare that our presence in this country for more than three hundred years, our toil, our honorable service in all our nation's wars, our demonstrated capacity for progress warrant our aspirations for eventual first-class citizenship and eventual full integration into the public life of the American people.[4]

The road to racial justice in the larger American culture was littered with obstacles, and as Logan noted, "the failure to give adequate publicity to white America of the feats of Negro heroes" contributed to the pervasive culture of racism and inequality. Hayden's aim to develop in art a character that would be respected widely as a hard-working, African American person reflects the tenor of such 1940s civil rights tactics. Hayden sought to translate a folksong into a series of history paintings, anchoring his images in facts, while also amplifying Henry's greatness, and had to navigate around the racial tensions inherent to the Henry legend and his own era. The resulting 14 paintings are a complicated and ambitious response to a national culture that marginalized, undervalued, and ignored African American contributions.

Visualizing a Folksong

John Henry ranks alongside Paul Bunyan and Pecos Bill as one of America's best-known folk figures. While the details of Henry's life vary and even the reality of his existence is debatable, the prevailing legend, established by popular stories and folk songs in the nineteenth century, casts Henry as an African American railroad worker whose skill and strength with a hammer led him to challenge a newly invented steam drill.[5] The race to see which was faster, the man or the machine, ended in a Pyrrhic victory for Henry; he won the contest, but the physical exertion cost him his life.[6] Hayden grew up with this legend, having been born in Widewater, Virginia, into a family that had been drawn to the area, like many others, by the construction of the railroad that ran along the Potomac River.[7] Hayden remembered hearing Henry songs sung by workers in his hometown when he was a boy and likely heard versions from his storytelling father and his banjo-playing brother.[8]

There is no canonical version of the John Henry ballad; lyrics vary, verses are interchangeable, and in different versions the order of events and certain details may change. As Alan Lomax explained, "John Henry is seldom sung by Negro folk singers as a connected narrative but occurs, rather, as a loose collection of stanzas, from which one may infer the story."[9] Hayden adapted some of the most familiar lyrics as his paintings' titles to ensure that his series would resonate with viewers no matter what version of the song they knew.[10] The sequential flexibility of the Henry story notwithstanding, Hayden's

series is anchored by chronology somewhat, which also makes it an effective introduction to the legend for those who are unfamiliar with the song. Hayden's John Henry series begins with a scene from Henry's childhood, *When John Henry Was a Baby*. In this work, a young Henry sits on his mother's knee, holds a toy hammer, and gestures toward a distant tunnel. This scene often appears in the first stanza of the ballad, when Henry tells his mother that his destiny is to work and die as a steel-driving man.[11] Six paintings show Henry's varied life experiences and can be rearranged without disrupting the trajectory of the tale. *John Henry Was the Best in the Land* and *His Hammer in the Wind* are all jubilant celebrations of Henry's well-known and much-appreciated prowess with the hammer. Henry's female companion visits the railroad tunnel to see Henry at work in *The Dress She Wore Was Blue* and entertains Henry and others during their leisure time by playing the banjo in *Where'd You Git Them Hightop Shoes*. In *A Man Ain't Nothin' but a Man*, Henry explains to his foreman that he can do hard labor and complete a tough job on his own, using his masculine strength and a hammer as his tools, rather than steam and technology. In *He Laid Down His Hammer and Cried*, Henry sits next to an unfinished railroad track and sheds tears over the enormity of his work and the gravity of his fate. The series climaxes with two images of Henry's fatal contest against the steam drill: *John Henry on the Right, Steam Drill on the Left* and *Died wid His Hammer in His Hand*. Hayden showed Henry's female companion and child heading into the tunnel to witness the site of Henry's demise in *Goin' Where Her Man Fell Dead* and painted Henry's funeral in *There Lies That Steel Drivin' Man*.

The most iconic image in the series, *His Hammer in His Hand* (Plate 12), acts as a pictorial refrain. In this work, Henry carries the tool of both his glory and his demise at the back of his neck. Gazing toward the left side of the composition, Henry surveys a hilly, wooded terrain punctuated by a winding river. He strides confidently along a stretch of railroad that begins in the tunnel in the background and widens into the foreground. Henry's smile expresses a sense of happiness and satisfaction, as he has completed his work and the railroad is finished and operable. *His Hammer in His Hand* tells the Henry story with impressive economy and is designed to resonate in a viewer's memory the way a song's chorus repeats in one's head long after a song ends. Phrases akin to "his hammer in his hand" recur throughout the ballad's lyrics, appearing when Henry first embarks on his career in the railroad industry, when he commits to the steel-driving contest, and after his death.[12] *His Hammer in His Hand* refines the legend of John Henry into one summary, optimistic picture showing Henry standing tall, strong, fulfilled, and independent. In some ways this image belies the intricacies of the series as a whole. Indeed, a close reading of Hayden's 14 John Henry paintings reveals complicated relationships between myth and fact, heroism and humanity, specificity and universality, the past and the present, and between black and

white Americans during both John Henry's and Palmer Hayden's eras. *His Hammer in His Hand* strikes a hopeful tone even as the series encodes some of the many challenges that Henry, as a black man and a folk legend, had to overcome in order to join the legion of national heroes that were canonized in the early twentieth century.

Historicizing Folklore

Though Hayden had known the John Henry story since his boyhood, he embarked upon his series of paintings somewhat late in his career. Hayden's life as a painter began after he moved to New York City in the early 1920s. He studied art at Columbia University and at the Commonwealth Art Colony in Boothbay Harbor, Maine. Most of Hayden's early paintings depict marine scenes and he won the inaugural and prestigious Harmon Foundation prize in 1926 for a work called *Boothbay Harbor* (c. 1925–26).[13] Subsequently, Hayden set off for Paris with financial support from the Harmon Foundation and his patron, textile heiress Alice M. Dike. In Paris, Hayden encountered many other African American artists including Aaron Douglas, Meta Warrick Fuller, Hale Woodruff, and the respected elder painter, Henry Ossawa Tanner. Hayden became a part of a coterie of promising young black creatives who benefitted from and were inspired by the fascination that the French had with African American culture. While abroad Hayden painted stylized scenes of contemporary black life like *Nous Quatre à Paris* (c. 1928–30) and at least one sketch of John Henry.[14] When he returned to New York in 1932, the Great Depression was underway, and by 1934 Hayden was working on the WPA, making paintings of New York Harbor. On his own time Hayden continued to explore themes of African American life in works like *The Janitor Who Paints* (c. 1937/1940).

After his tenure with the WPA ended, Hayden decided the time was right for an entire series of paintings depicting John Henry. Whereas previously John Henry's story had been spread largely by word-of-mouth, during the interwar "folk song revival" John and Alan Lomax, Zora Neale Hurston, and Carl Sandburg (among others) were recording the Henry songs and stories as part of their efforts to incorporate black vernacular culture into American folklore traditions.[15] Hayden wanted to contribute to this nationalistic endeavor and said he found himself compelled to paint "folk life, just as I remembered out of my experiences as a child and growing up in Virginia."[16] Hayden chose the Henry legend because, as he said, "I [had] been hearing that song all my life and I always loved it … . I wondered how much truth [was] in this song."[17]

As Hayden began his John Henry series in the 1940s, in order to discover how much "truth" existed in the folk legend, Hayden embarked on a course

of research with the help of his wife, Miriam.[18] Together they read a book by West Virginia University English professor Louis W. Chappell that sought to prove that Henry was an actual historical person who worked at Big Bend Tunnel, a stretch of the Chesapeake and Ohio Railroad near Talcott, West Virginia.[19] Chappell's text argued that Henry's occupation was to drill holes for the explosives that would blast through mountains to make way for railroad tracks. Using extensive archival research and oral histories of those who claimed to know Henry, Chappell dated the contest between Henry and the steam drill between 1870 and 1873. He dated the invention of the legend of John Henry (including the inception of work songs and ballads) to the 1870s as well.[20] After reading Chappell's book, Hayden corresponded with him about such details as the precise appearance of Henry's hammer and how his "woman" (which is the term that Chappell, Hayden, and most of the folk songs used to describe Henry's female companion) really looked.[21] Subsequently, Hayden traveled to West Virginia two times (in 1944 and 1945) to visit the tunnel, to interview Professor Chappell, and to, as Hayden said, "get some atmosphere."[22] Chappell's work on Henry was the most current that Hayden could access and the artist found it remarkably gratifying to find scholarly evidence that the hero he had known in his imagination since his boyhood was a bona fide historical figure.

Hayden was not the first visual artist to portray John Henry, but more than any of his predecessors and peers, Hayden went to great lengths to anchor his Henry epic in the historical facts that he learned from Chappell's book. Eben Given's illustration for a 1930 book of tall tales sets Henry against an urban industrial backdrop.[23] With smoke pouring out of chimneys behind him, it seems that Given misunderstood Henry's steel-driving occupation (which is clearly explained in the text alongside Given's image) as a reference to someone who works in a steel factory rather than on a railroad. In the 1930s and 1940s, J.J. Lankes, James Daugherty, and William Gropper portrayed Henry hammering railroad ties, not holes for explosives, and a folklore map that Gropper made in 1946 situates Henry in Alabama, three states away from West Virginia, where Hayden and Chappell believed he lived.[24] Fred Becker made a series of imaginative, jazz-infused surrealist woodcuts in the 1930s, one of which was included in the Museum of Modern Art's *Fantastic Art, Dada, Surrealism* exhibition in 1936.[25] For these artists, and many others, Henry was a fictional folkloric character, and the specificity of what he did and where he did it was immaterial or unknowable, and ultimately in conflict with the more specific story that Hayden came to believe.

In contrast to Given, Lankes, Daugherty, Gropper, and Becker, Hayden developed a more down-to-earth and multidimensional Henry character over the course of his 14 paintings. Hayden tried to balance the mythic greatness of Henry's legend with aspects of Henry's humanity. Hayden envisioned many different moments in Henry's life in order to show that he was extraordinarily

talented and dedicated to his work, but he could also laugh, dance, cry, build relationships, and (perhaps most importantly) was basically the same size as everyone else. In the brochure produced for an exhibition of Hayden's John Henry series at New York's Argent Galleries in 1947, Hayden cited the "facts" in Chappell's book as evidence of the "life and tragic death of a powerful and popular working man who belonged to my section of the country and to my own race." Hayden asserted emphatically that Henry was not simply "the Negro counterpart of the mythical Paul Bunyan, but did live and work in the Big Bend Tunnel in West Virginia" and that Henry was not "made up of the whole cloth."[26] It was imperative for Hayden that Henry be seen as a credible historical figure, and not as a black version of a fictitious white character invented to appeal to a minority. Hayden wanted to ensure that his African American hero could stand on his own reputation and occupy a place in the broader visual landscape of United States history.

Heroicizing History

Even as Hayden tried to demonstrate the factual elements of Henry's legend, he also said he sought to make "works which immortalize the Negro as a worthy contributor to the building" of America.[27] Immortalizing, aggrandizing, or canonizing Henry meant that Hayden needed to broaden Henry's significance and he did so using nationalistic and Christian visual references. Every painting in Hayden's John Henry series employs the patriotic colors red, white, and blue. Henry almost always wears some combination of those three hues, as do his mother, his "woman," and his foreman. Hayden also gave visual form to the associations between the life of his American hero and the life of Jesus, allusions inherent to the Henry stories and songs. *When John Henry Was a Baby* recalls Virgin and Child altarpieces. There are even winged creatures and sunflower haloes complementing Hayden's scene, and baby Henry holds his hammer the way Jesus often holds a cross, both props prefiguring their owners' martyrdom. In *He Laid Down His Hammer and Cried*, Henry's behavior recalls Jesus' response when he discovered that Lazarus had died, when the Bible states "Jesus wept." This emotional moment proved that Jesus was mortal. In both *Died wid His Hammer in His Hand* (Figure 11.1) and *His Hammer in His Hand*, Henry's outstretched arms evoke the image of a crucified Jesus, and the tunnel from which Henry emerges in the latter work stands in for the tomb from which Jesus was resurrected. As much as such allusions amplify Henry's status as a heroic martyr, they also underscore his ability to be consumed by emotion, and his humanity makes his death more tragic. For Hayden, the Christian overtones of Henry's legend also made him universally appealing and relatable to a wider American audience.

11.1 Palmer Hayden, *Died wid His Hammer in His Hand*, 1944–47. Oil on canvas, 29 x 38 in. Courtesy of the Museum of African American Art, Los Angeles, CA

Transcending Racial Oppression

The biggest challenges Hayden faced as he endeavored to create John Henry, the *American* hero, involved navigating the complicated politics of race within the legend, in his own style, and in 1940s America. In certain nuanced ways, Hayden's John Henry series attempts to overcome oppression even as the works acknowledge racism's persistent presence in American culture. For instance, in *John Henry on the Right, Steam Drill on the Left* (Figure 11.2), there is a clear division between Henry and his black assistant and the two white workers who operate the steam drill. The racial contrast is pronounced; segregation exists, but the competition is peaceful, and in the crowd of onlookers the races congenially intermingle. In images of the aftermath of that contest, *Died wid His Hammer in His Hand* and *There Lies That Steel Drivin' Man*, the congregations are also racially diverse as everyone in the area flocks to witness and pay their respects for the deceased, including his competitors from the previous image. In an image that precedes those of the competition and Henry's death, *John Henry Was the Best in the Land*, the hero impresses a population that is black and white, young and old, wealthy and

11.2 Palmer Hayden, *John Henry on the Right, Steam Drill on the Left*, 1944–47. Oil on canvas, 30 x 40 in. Courtesy of the Museum of African American Art, Los Angeles, CA

working class; all of the spectators are amazed at his performance. Chappell's book demonstrated how both black and white people from the Big Bend area participated in the development of Henry's legend in the nineteenth century.[28] In Hayden's John Henry paintings, we see moments of interracial collaboration, and an overall peaceful coexistence among the racially diverse characters. Without completely obliterating issues of racial separation and tension, Hayden's paintings model a way for twentieth-century viewers of all racial backgrounds to appreciate Henry as a universal American icon. As Stephen Tuck has demonstrated, American popular culture in the 1940s rarely offered positive images of black people to a white or interracial audience.[29] In this way, Hayden's series is an important step toward the desegregation of visual culture.

Throughout his career, when painting African and African American people, Hayden often employed a faux naive figural style, which causes some black characters to resemble racist stereotypes, and garnered mixed reactions from his contemporaries.[30] Alain Locke praised Hayden's works in this manner as "vigorously naïve racial interpretations," but James Porter thought Hayden was aiming for satire and denounced his style as "ill-advised if not altogether tasteless ... like one of those ludicrous billboards ...

[used] to advertise the blackface minstrels."[31] However, as Richard Powell has argued, in works like the John Henry series this also allowed Hayden "to infuse [his] art with the totemic allure of 'the folk.'"[32] Using lyrics from the folk song, including some phrases that are written in a subtle Southern dialect, as the paintings' titles and stereotypical facial features for many of the characters allowed Hayden to situate his scene in 1870s America and to reinforce the historical nineteenth-century roots of the Henry legend, which were crucial to Hayden's goal of establishing the factual nature of Henry's story.[33]

Hayden's use of caricature in the Henry series is inconsistent, which makes it even more difficult to ascertain the meaning of his artistic choices. Some figures' features are grotesquely exaggerated, whereas others are rendered sensitively. Henry himself undergoes a kind of visual evolution, and in such lighthearted episodes as *John Henry Was the Best in the Land* and *His Hammer in the Wind*, Henry performs his feats of strength, grins, laughs, and dances somewhat foolishly to the delight of onlookers. In the more serious images, including *His Hammer in His Hand* and *A Man Ain't Nothin' but a Man*, Henry appears far more naturalistic, and contrasts sharply with other African Americans within the series. The distance between Henry's features in *Died wid His Hammer in His Hand* and those of his assistants in that image and during the contest in *John Henry on the Right, Steam Drill on the Left* is marked; in the latter painting Henry's assistant guffaws with delight and bears the marks of minstrel-style caricature: round cheeks, large white teeth, and fat red lips. In *John Henry on the Right, Steam Drill on the Left* and *The Dress She Wore Was Blue*, Henry's features are hidden because he has turned away from the viewer to focus on his work. In *He Laid Down His Hammer and Cried*, Henry covers his face with a handkerchief, obscuring his features once again. In each of these cases the subtext of the image is that Henry's labor and significance as a soon-to-be martyred hero removes him from the realm of caricature. We cannot see him as a derogatory stereotype, because his worth transcends such a limited cultural and visual category.

Hayden's treatment of Henry is somewhat varied within the series, and Henry is most naturalistic at particularly heroic moments (contest, death, and afterlife), allowing Henry to shed his nineteenth-century, folkloric, stereotypical persona gradually and to resemble a more sensitive figural style that embodies a more respectful attitude toward African Americans. In Hayden's series, Henry subtly transforms from an antiquated folk hero to a modern icon of progress, a character that is relevant for twentieth-century viewers. This is an especially difficult evolution, as Henry was most often understood as a relic of the past who died to make way for modernity, but Hayden argued that the Henry story "dramatizes the beginning of the movement of the Negro from agricultural into industrial labor, and the practical use of machinery in place of hand labor in the development of industrial

America."[34] In this series, Hayden tried to give Henry credit as a transitional figure in this pivotal moment in American advancement. We watch Henry evolve from a child to a man. He comes to understand his troubled place in history, works and plays, earns the respect of his supervisor and his peers, dies admirably, and is mourned. The fatal contest allows Henry ultimately to break free from the pressures and tensions of his life and, in *His Hammer in His Hand*, he walks away independently, with the satisfaction of knowing that he fulfilled his sacrificial destiny. Henry's transformation from a folkloric to historical character and from a stereotypical to sensitive portrayal of a strong black worker is conceptually sophisticated but visually subtle. Scholars like John Ott and Phoebe Wolfskill have recently begun to understand Hayden's strategies for combating racism in art and culture as "savvy"[35] negotiations of "the difficulty and perhaps impossibility of constructing a completely 'New' Negro," and the John Henry series is an exemplary case study of Hayden's efforts in this vein.[36]

One of the most unusual elements of Hayden's version of the John Henry epic is his depiction of Henry's "woman" as a white redhead. This choice resulted from Chappell's research. In his book, and in correspondence with Hayden, Chappell insisted that Henry's female companion was of Scotch-Irish descent, with light skin and red hair. Hayden depicts her so in three paintings, but this level of interracial cooperation may not have been an easy choice for the artist. Interracial marriage was illegal in 30 states when Hayden began his series in 1944 and would have been illegal in Henry's 1870s era as well.[37] Although Hayden was part of an interracial couple himself—his wife Miriam was white and they had married in New York, one of the few states that had no antimiscegenation laws—in these images, Henry and his "woman" never interact. The only close relationship that Henry has with a white person is with his foreman. He appears alongside Henry in *A Man Ain't Nothin' but a Man* and presides over the memorial service after Henry's death in *There Lies That Steel Drivin' Man*. The foreman seems to have a real respect for Henry in these images, and the title *A Man Ain't Nothin' but a Man* reads as an evocation of fundamental human equality. But Henry and his "woman," the mother of his child, never embrace or even make eye contact. Furthermore, while we see the red-headed woman and her fair-skinned daughter walking hand in hand toward the scene of Henry's death in *Going' Where Her Man Fell Dead*, they do not appear at Henry's public funeral in *There Lies That Steel Drivin' Man*. Therefore, this controversial relationship, though Hayden and Chappell believed it was factual, is not consummated visually in Hayden's series. It is unresolved and unfulfilled, and it represents a very real limitation and serious threat to equality and social justice in the 1940s.

Joining the American Pantheon

Hayden's contributions to a self-consciously "American art" may seem somewhat belated in the context of the art world in the United States, as the American Scene movement with its focus on national traditions had already reached its apex in the 1930s. Yet, the construction of a new national history that was inclusive of African Americans remained central for black artists and intellectuals in the 1940s. The idea of a "black aesthetic," so pervasive in the heyday of the Harlem Renaissance of the 1920s and early 1930s, had developed into an impulse on the part of African American artists to emphasize the Americanness of their work in new ways.[38] Alain Locke, who had advocated for racially specific art in the 1920s, adapted his tactics in subsequent decades in favor of cultural integration.[39] As Wolfskill has argued, "by the 1930s, [Locke] had shifted his focus from racial uniqueness to the importance of black participation in a larger national culture."[40] For some the impetus for this new nationalism came from the ideals of the Communist Popular Front of the late 1930s, which abhorred racial discrimination.[41] For others celebrating Americanism was about promoting, expanding, and exercising the benefits of democracy and the aspirations of equal civil rights against a backdrop of right-wing oppression around the globe as World War II began.[42] John Henry was an ideal black hero because, as Lawrence Levine has explained, he "symbolized the strength, dignity, and courage many Negroes were able to manifest in spite of their confined situation."[43] Henry had experienced prejudice and overcame it to make a lasting mark on American culture and modernity. His life was an inspirational template for those still working toward equality in the 1940s.

W.E.B. Du Bois had been theorizing about the perils of African American "double consciousness," in which African Americans experience their blackness and their nationality as "two warring ideals in one dark body" since the turn of the twentieth century.[44] Mary Ann Calo has shown how art criticism of the interwar period often reinforced that separatism, marginalizing so-called Negro art and excluding it from the broader classification of "American art."[45] Even today, art historians often limit themselves to contextualizing work by African Americans in terms of race when the added dimension of nationality would yield far greater understanding. In his John Henry series, Hayden articulated both the black and the American sides of his hero. Going beyond simple articulation, Hayden further tried to reconcile the two to create a national hero who was also a proud, black historical figure. Doing so was a means of negating the cultural separatism that Hayden felt was nonsensical, while not erasing the uniqueness of black culture. Having been born in America to American parents, Hayden had always felt a profound connection to his nation.[46] He had served his country during World War I as part of the segregated US Army and later railed

against racial separatism, advocating integration as the only way to achieve meaningful social justice.[47] Of course, during the 1940s as he was making these paintings, integration and lasting social change were still distant goals and the sort of racial harmony and cooperation for which Hayden's heroic Henry strives was not yet realized.

In a 1927 publication, *Ebony and Topaz*, Guy B. Johnson implored painters, sculptors, poets, and playwrights to take up the subject of John Henry in their work, asserting that Henry "deserves a very high rank, not only in Negro folklore, but in American folklore in general."[48] Twenty years later it was Palmer Hayden, more than any other visual artist, who heeded and exceeded that call by attending to the historical and symbolic value of Henry's folk songs. Two final paintings summarize the goals and obstacles of Hayden's project. One, *Big Bend Tunnel*, shows the ghost of John Henry hovering above the tunnel opening as workers reflect upon his lingering mythical presence. The other, *It's Wrote on the Rock*, shows a tour guide explaining the reality of Henry's life to a tourist couple as they consult a documentary historical marker. By demonstrating on canvas that John Henry was a strong, capable African American man who actually worked in the American railroad industry in the nineteenth century, Palmer Hayden tried to show that although Henry was rooted in folklore, he was not simply the fictitious "black Paul Bunyan," but was a well-rounded historical figure in his own right. From the first time Hayden exhibited his John Henry series in 1947 until his death in 1973, he pursued a national forum and a national importance for these works. His series was the most thorough exploration of John Henry to date, and he sought to place the entire series in the collection of the Smithsonian Institution.[49] He also envisioned turning *His Hammer in His Hand* into a postage stamp for wide circulation.[50] But Hayden's series never achieved the national recognition that he desired. Despite his best efforts to negotiate the tensions between folklore and history and to cultivate a universally admirable African American hero, the intricacies of the series and the nuanced and problematic nature of Hayden's pictorial style made the works challenging for viewers and collectors. As Ott has explained, "critiques, which suggest that Hayden's work at times perpetuated the racisms of a dominant culture, have pushed him to the margins of African American art history."[51] Nevertheless, Hayden's series should be recognized as an evocation of national, regional, *and* racial pride, which is marked in complex ways by some of the anxieties and uncertainties that existed as African Americans worked toward achieving full recognition in American history and culture.

Notes

I would like to thank Charles C. Eldredge, David Cateforis, Marni Kessler, Natalie Phillips, and Ashley Elston for their helpful comments on this essay. Much of the research and writing was sponsored by the Georgia O'Keeffe Museum Research Center, where I was scholar-in-residence in 2010. Eumie Imm Stroukoff, Barbara Buhler Lynes, Fran Martone, Jobyl Boone, and Kelly Quinn deserve special thanks for their support during that productive period. Thanks to the Museum of African American Art, Los Angeles, for preserving and exhibiting Hayden's John Henry series regularly. The University of Kansas and Ball State University's Aspire New Faculty Start-up Award provided funding so that I could visit the MAAA to conduct research. Conferences of the New England American Studies Association in 2011 and the Midwest Art History Society in 2014 were rewarding laboratories for the ideas presented in this chapter, as well.

1 For a good introduction to the Museum of African American Art and Palmer Hayden's biography, see Allan M. Gordon, *Echoes of Our Past: The Narrative Artistry of Palmer C. Hayden* (Los Angeles: Museum of African American Art, 1988), passim.

2 Regenia A. Perry, *Free within Ourselves: African-American Artists in the Collection of the National Museum of American Art* (Washington, DC: National Museum of American Art, in association with Pomegranate Artbooks, 1992), 88.

3 Langston Hughes wrote eloquently about this paradox in his essay, "My America," in *What the Negro Wants*, ed. Rayford W. Logan (Chapel Hill: University of North Carolina Press, 1944), 299–307.

4 Logan, "The Negro Wants First-Class Citizenship," in *What the Negro Wants*, 8.

5 For the most recent scholarship on John Henry, see Scott Reynolds Nelson, *Steel Drivin' Man: John Henry, the Untold Story of an American Legend* (New York: Oxford University Press, 2006).

6 Archie Green, *Wobblies, Pile Butts, and Other Heroes* (Urbana and Chicago: University of Illinois Press, 1993), 52. Norm Cohen, *Long Steel Rail: The Railroad in American Folksong*, 2nd ed. (Urbana: University of Illinois Press, 2000), 64.

7 Hayden's given name was Peyton Cole Hedgeman. For additional biographical information, see Romare Bearden and Harry Henderson, *A History of African-American Artists: From 1792 to the Present* (New York: Pantheon Books, 1993), 157–67.

8 Work songs set the pace for such strenuous manual labor as laying railroad tracks and ballads use narrative lyrics and tunes that can be morose and dirge-like or "fast and chirpy." Nelson, *Steel Drivin' Man*, 30–31. Richard M. Dorson, "The Career of 'John Henry,'" in *Mother Wit from the Laughing Barrel: Readings in the Interpretation of Afro-American Folklore*, ed. Alan Dundes (Englewood Cliffs, NJ: Prentice Hall, 1973), 569. Nora Holt, "Painter Palmer Hayden Symbolizes John Henry," February 1, 1947. Unidentified newspaper clipping found in Palmer C. Hayden papers, 1920–70. Archives of American Art, Smithsonian

Institution (henceforth "Hayden papers, AAA-SI"). Series 4, Box 2, Folder 6, Document 13. Theresa Leininger-Miller, *New Negro Artists in Paris: African American Painters and Sculptors in the City of Light, 1922–1934* (New Brunswick, NJ: Rutgers University Press, 2001), 97.

9 Alan Lomax, *The Folk Songs of North America* (Garden City, NY: Doubleday & Company, 1960), 552.

10 Hayden's John Henry series relates to the legend broadly, as told in the many different work songs and stories, but the paintings' titles and content align specifically with the more elaborate narrative commonly recounted in the ballads. Hayden owned a copy of Louis W. Chappell's *John Henry: A Folk-Lore Study* (Jena, Germany: Frommannsche Verlag, W. Biedermann, 1933), which includes an archive of John Henry lyrics.

11 In a 1972 interview, Hayden recited or sang the following ballad lyrics: "John Henry was a li'l baby, Sittin' on his mama's knee, Said, 'De Big Bend Tunnel, Gonna cause the death of me.'" James Adams, "Palmer Hayden (1972 interview)," *Artist and Influence* 13 (1994): 97.

12 For example, "Johnie Henry was a hard-workin' man, He died with his hammer in his hand." Louise Rand Bascom, "Ballads and Songs of Western North Carolina," *Journal of American Folklore* 22, no. 84 (April–June 1909): 249.

13 Leininger-Miller, *New Negro Artists in Paris*, 72, 265. Samella S. Lewis, *African American Art and Artists*, 3rd ed. (Berkeley: University of California Press, 2003), 69. Bearden and Henderson, *A History of African-American Artists*, 161.

14 Leininger-Miller, *New Negro Artists in Paris*, 94, 97.

15 John A. Lomax and Alan Lomax, *American Ballads and Folksongs* (New York: Macmillan Company, 1934), 3–10. John A. Lomax and Alan Lomax, *Our Singing Country: Folksongs and Ballads* (New York: Macmillan Company, 1941), 258–61. Zora Neale Hurston, *Mules and Men* (Philadelphia: J.B. Lippincott Company, 1935), 80–81, 306, 309–32. Carl Sandburg, *The American Songbag* (New York: Harcourt, Brace & Company, 1927), 24–5. Steven Garabedian, "Reds, Whites, and the Blues: Lawrence Gellert, 'Negro Songs of Protest,' and the Left-Wing Folk-Song Revival of the 1930s and 1940s," *American Quarterly* 57, no. 1 (March 2005): 188.

16 Adams, "Palmer Hayden (1972 interview)," 103.

17 Ibid., 101.

18 Green, *Wobblies, Pile Butts, and Other Heroes*, 61–2. Adams, "Palmer Hayden (1972 interview)," 97.

19 Chappell, *John Henry: A Folk-Lore Study*, 92. Chappell's thesis conflicted somewhat with another study by Guy B. Johnson, which found evidence for the "real" John Henry less conclusive. Guy B. Johnson, *John Henry, Tracking Down a Negro Legend* (Chapel Hill: University of North Carolina Press, 1929). Contemporary opinions about the veracity of Henry's existence continue to vary.

20 Chappell, *John Henry: A Folk-Lore Study*, 39.

21 Chappell, letter to Hayden, April 8, 1944. Hayden papers, AAA-SI. Series 3, Box 2, Folder 5, Document 101.

22 Hayden kept diaries and made sketches during these trips, which are part of his papers at the Smithsonian's Archives of American Art. Adams, "Palmer Hayden (1972 interview)," 97.

23 Frank Shay, *Here's Audacity!* (New York: Macaulay Company, 1930), 245.

24 Lankes's illustrations appeared in Roark Bradford's *John Henry* (New York: Harper & Brothers, 1931). Daugherty illustrated his own text, *Their Weight in Wildcats: Tales of the Frontier* (Boston: Houghton Mifflin Company, 1936). Gropper's *America, Its Folklore* map was published widely by Associated American Artists in 1946 and the Library of Congress currently owns a copy.

25 Archie Green, "Fred Becker's John Henry," *John Edwards Memorial Foundation Quarterly* 15, no. 53 (1979): 31.

26 Palmer Hayden, *The Ballad of John Henry in Paintings by Palmer Hayden* (New York: Argent Galleries, 1947), n.p. Hayden papers, AAA-SI. Series 4, Box 2, Folder 7, Documents 3–4. It must have been frustrating for Hayden to read the *New York Times* review of his show, which ignored his insistence in the Argent brochure and referred to Henry as the "black Paul Bunyan." H.D., "By Groups and Singly," *New York Times*, January 26, 1947. In using the phrase, "made up of the whole cloth," Hayden is quoting Chappell. Chappell, *John Henry: A Folk-Lore Study*, 92.

27 As quoted in Gordon, *Echoes of Our Past,* 15.

28 Chappell, *John Henry: A Folk-Lore Study*, 39.

29 Stephen Tuck, "'You can sing and punch … but you can't be a soldier or a man': African American Struggles for a New Place in Popular Culture," in *Fog of War: The Second World War and the Civil Rights Movement*, ed. Kevin M. Kruse and Stephen Tuck (New York: Oxford University Press, 2012), 103–25.

30 For the most recent examination of the meaning of caricature in Hayden's art, see Phoebe Wolfskill, "Caricature and the New Negro in the Work of Archibald Motley Jr. and Palmer Hayden," *Art Bulletin* 91, no. 3 (September 2009): 348. See also, John Ott, "Labored Stereotypes: Palmer Hayden's the Janitor Who Paints," *American Art* 22, no. 1 (Spring 2008): 102–15.

31 Alain Locke, "Advance on the Art Front," *Opportunity* 17, no. 5 (May 1939): 136. James A. Porter, *Modern Negro Art* (New York: Arno Press, 1969, reprint of original 1943 edition), 110.

32 Richard J. Powell, "Re/Birth of a Nation," in *Rhapsodies in Black: Art of the Harlem Renaissance*, ed. David A. Bailey and Richard J. Powell (London: Hayward Gallery and Institute of International Visual Arts; Berkeley: University of California Press, 1997), 26.

33 Mary Ann Calo has also argued that a naive painting style embodied an authentic sort of primitivism that critics and patrons demanded of black artists. Primitivism also "suggested a genuine 'American' character" during this era of nationalism in United States art. See Calo, "African American Art and Critical Discourse between World Wars," *American Quarterly* 51, no. 3 (September 1999): 593–4.

34 Cohen, *Long Steel Rail: The Railroad in American Folksong*, 74. Hayden, *The Ballad of John Henry in Paintings by Palmer Hayden,* n.p. Hayden papers, AAA-SI. Series 4, Box 2, Folder 7, Documents 3–4.

35 Ott argues that Hayden was "a savvy professional aware of and engaged in ongoing debates about the efficacy and impact of various styles, modes, and subject matter on African American art," in "Labored Stereotypes: Palmer Hayden's the Janitor Who Paints," 113.

36 Wolfskill, "Caricature and the New Negro in the Work of Archibald Motley Jr. and Palmer Hayden," 344.

37 James R. Browning, "Anti-Miscegenation Laws in the United States," *Duke Bar Journal* 1, no. 1 (March 1951): 26–51.

38 Calo, "African American Art and Critical Discourse between World Wars," 580–83, 600.

39 Ibid., 604–8.

40 Wolfskill, "Caricature and the New Negro in the Work of Archibald Motley Jr. and Palmer Hayden," 349.

41 Hugo Gellert was inspired by the John Henry story to develop images of strong black workers for use in communist publications like the *New Masses* and the *Daily Worker* in the 1930s. Nelson, *Steel Drivin' Man*, 149–59.

42 Dudley Randall, "The Black Aesthetic in the Thirties, Forties, and Fifties," in *The Black Aesthetic*, ed. Addison Gayle, Jr. (Garden City, NY: Doubleday & Co., 1971), 224–9.

43 Lawrence W. Levine, *Black Culture and Black Consciousness: Afro-American Folk Thought from Slavery to Freedom* (New York: Oxford University Press, 1978), 400.

44 W.E.B. Du Bois, *The Souls of Black Folk* (New York: Vintage, 1990, reprint of the 1903 edition), 8.

45 Mary Ann Calo, *Distinction and Denial: Race, Nation, and the Critical Construction of the African American Artist, 1920–40* (Ann Arbor: University of Michigan Press, 2007), passim.

46 Adams, "Palmer Hayden (1972 interview)," 97–8, 104.

47 Palmer Hayden, "It's Hard but It's Fair," unpublished essay. Hayden papers, AAA-SI. Series 1, Box 1, Folder 2, Documents 32–3.

48 Guy B. Johnson, "John Henry: A Negro Legend," in *Ebony and Topaz: A Collecteana*, ed. Charles S. Johnson (Freeport, NY: Books for Libraries Press, 1971, reprint of original 1927 edition), 47–51.

49 Negotiations began during Hayden's last years and continued after his death. They crumbled due to cost and the need for conservation. Gordon, *Echoes of Our Past: The Narrative Artistry of Palmer C. Hayden*, 25.

50 A drawing for the stamp is in the Hayden papers, AAA-SI. Series 5.1, Box 2, Folder 8, Document 3.

51 Ott, "Labored Stereotypes: Palmer Hayden's the Janitor Who Paints," 102.

PART III
Art Outside of the Art Museum

The *Portrait of Mary McIntosh Sargent*:
Slavery and "Natural Slavery" in Federalist Era America

Kimberlee Cloutier-Blazzard

The Sargent House Museum in Gloucester, Massachusetts, was built in 1782 for Judith Sargent Murray (1751–1820), a philosopher, writer, and an early advocate of women's equality. The museum houses the writing closet in which Judith wrote her seminal essay, "On the Equality of the Sexes" (1790), the first such essay published on the subject. Judith was a friend of the first two US presidents and their first ladies, and elder sister to Winthrop Sargent, Jr. (1753–1820), brevet major under George Washington and the first governor of the Mississippi Territory. Though the Sargents were among our nation's founders, the museum remains virtually unknown outside of the North Shore of Massachusetts.

Among its collection of early American decorative arts and portraits, the Sargent House Museum displays portraits of Winthrop and his second wife, Mary McIntosh Williams Sargent (1764–1844), closely related to the Gilbert Stuart originals now displayed in the State Department's Diplomatic Reception Rooms. The pendant portrait of Mary (Plate 13), the centerpiece of this essay, is intriguing for several reasons: its ambiguous authorship, and its elucidation of individual freedoms and women's roles in eighteenth-century America. A discussion of the painting fits naturally into an anthology about marginalized American works of art as the portrait is largely overlooked due to both its location in an historic house museum and its perceived status as a "copy."

The Sargent Family

We know much about the Sargents' lives since Judith saved copies of every letter she wrote, compiling them into 20 bound letter books. Though common for politicians and public figures, this practice was singular for a woman of the

time. In her letters, Judith recounts the fine education lavished on her younger brothers Winthrop and Fitz William who began their classical education at home with tutors, later attending Boston Latin and Harvard. Meanwhile, Judith was taught only the rudiments of reading and writing, a common gender distinction at this time. However, it was perfectly clear to Judith from early on that she—and, by extension, all girls—was capable of attaining the same intellectual achievements as a boy, her only limitation coming from the societal stigma against allowing a girl a full education.[1] Judith not only recognized that this was a lopsided arrangement, but most importantly she verbalized her discontent in published works. An autodidact, Judith wrote dozens of articles, hundreds of poems, three plays, and thousands of letters. In 1798 she became the first American woman to self-publish a book, a compilation of her writings titled *The Gleaner*. Nevertheless, her literary fame was often disregarded, even by her own kin.[2]

While Judith struggled to find her voice in Gloucester, Winthrop earned brevet rank of major in the Continental Army where he was an aide-de-camp to George Washington.[3] After his military service, he joined the Ohio Company, was later elected as secretary of the Northwest Territory in 1787, and was appointed by President John Adams as the first governor of the Mississippi Territory in 1798.[4] Winthrop was also a member of the American Philosophical Society and the American Academy of Arts and Sciences.[5]

Winthrop married twice. The first marriage took place in 1789 to Rowena Tupper, a daughter of General Benjamin Tupper. Tragically, one year later Rowena died shortly after giving birth to a son. In 1798, less than two months after moving to Mississippi, Winthrop married Mary McIntosh Williams, the widowed daughter of a former British army officer and planter in the territory.[6] At the time she had four children by her first husband (Mary Gayoso, Anna, David, and James C. Williams), and during her marriage to Winthrop she gave birth to two more sons, William Fitz Winthrop (b. 1799) and George Washington Sargent (b. 1802). Thanks to an accumulation of vast plantation holdings, including the Grove and Bellemont plantations with their dozens of slaves, she was incredibly wealthy.

Judith Sargent often wrote to her brother Winthrop in Mississippi from her second home at Franklin Place in Boston. The families were close; all but one of Mary's children were educated in Boston under the auspices of Judith, who diligently sent home detailed word about their progress. She especially doted on Anna Williams, Mary's daughter by her first husband, who was the close companion of her only surviving child, Julia Maria. Judith's devoted attention to the girls had special significance. A pioneer, Judith helped found two female academies—one in Gloucester and one in Dorchester[7]—and she publicly advocated for equal education for girls, encouraging them to study all subjects and to gain economic self-sufficiency.

One wonders how Mary McIntosh felt about Judith's unorthodox approach to female education, one that ran counter to prevailing Southern notions of women's roles in society, based as they were on Aristotle's "natural slavery" arguments found in Book 1 of his *Politics*. Via the formidable authority of classical philosophy, codified within cultural authority,[8] women and slaves were classed similarly in their intellectually and socially inferior station.[9] The South's patriarchal slave society constrained both groups by physical, legal, and economic means that discouraged women to advocate for equal education, lest they exceed their proper station and risk losing the social privilege and power allotted them.[10] In the North, by contrast, women had more latitude in joining the polity and social discourse about freedoms— albeit in tempered forms such as short-lived public display at street festivals,[11] or within the domesticated rubric of "Republican Motherhood."[12] Thus, that Mary allowed her daughter Anna to live in the North under Judith's care argues that Mary trusted Judith's progressive methodology. We know Winthrop Sargent's reaction was less than sanguine; he felt that after a lengthy, expensive educational experiment in Boston, Anna lacked basic skills needed as a housewife.[13] For her part, Judith quipped, "Female avocations are not designed to fill the immortal mind."[14]

Gilbert Stuart and the Question of Authorship

Originally built between 1798–1803, Winthrop and Mary's Natchez, Mississippi, mansion was aptly christened "Gloster Place [*sic*]" by Winthrop in honor of his birthplace.[15] The mansion still stands.[16] In its heyday, the plantation house's decoration included an art collection that boasted great European masters such as Canaletto, Salvatore Rosa, Jusepe de Ribera, Francesco Bassi, and others.[17] Among the pieces once owned by Winthrop and Mary now on view at Sargent House are a mahogany breakfront and wine cooler in the common parlor, and a four-poster bed that presides upstairs, likely fashioned by François Seignouret of New Orleans. It was natural that an art connoisseur and man of refinement such as Winthrop would engage a preeminent American master—the painter Gilbert Stuart—to paint portraits of himself and his second wife.

Gilbert Stuart, a staunch Federalist, was at this time a famed New England painter from Rhode Island whose sitters included European kings, six American presidents, and prominent citizens. Moreover, Stuart personally knew the Sargents.[18] Many years prior to sitting for her own Stuart portrait in 1806, Judith mentions him in her letters such as that to her mother dated 1786, in which she documented a visit with Stuart and his family in Providence.[19] This personal relationship brings us to the authorship of the Sargent House "copies." Though the Sargent House portrait of Mary Sargent admittedly is

not a first-rate Stuart, it is most likely that one of his circle largely executed the work with Stuart's finishing touches completing it. Like the old masters of Europe, Gilbert Stuart commonly had his school draft images for clients. Based on the museum files, candidates from Stuart's circle include one of Stuart's studio hands, Stuart's daughter Jane, or even another, later copyist. A brief survey of the style and presentation of the portraits and the state of Stuart research will serve as an introduction to why the painting should be rediscovered *in part* as a Stuart.

The pendant portraits of Winthrop and Mary were most likely begun after Stuart's move to Boston in 1805,[20] and not in Philadelphia circa 1799–1801 as has been suggested.[21] For one, Judith and Julia Maria also had their portraits painted in 1806 by Gilbert Stuart, paid for by Winthrop.[22] For another, we know Winthrop visited Boston in 1807, and, according to Judith's firsthand account, the final finished portraits of Winthrop and Mary were completed in 1809, when Judith had them shipped from Boston to Mississippi and had a personal copy of Winthrop's made.[23]

Judith goes on to say in the same letter that she was sorry to be unable to obtain a copy of Mary's image. As there are only two known extant oil portraits of Mary, the evidence begins to clarify the question of which copies of the Stuart portraits the Sargent House Museum holds, and by whom they were painted.[24] We also have written family accounts of the provenance for the Sargent House works from Winthrop Sargent, Jr. (1887–1968), the Sargent descendant who placed them in the museum. According to Winthrop, Jr., these "draft" copies were "said to have been drafts of portraits of the governor and his wife done at his order to Gilbert Stuart."[25] They were given by Governor Winthrop Sargent to his younger brother Fitz William (1768–1822), then the pair came down through four namesakes.[26] He adds, "The two Portraits finally selected by Governor Sargent against his order to Gilbert Stuart, and that artist's own work, are now in the Metropolitan Museum of New York on loan from one of the Governor's descendants." Those latter works are the same portraits that now hang in the Diplomatic Reception Rooms.[27]

Did Stuart himself routinely paint "drafts?" The only other pendant works labeled as preliminary studies by Stuart, of which I am aware, are the Yates portraits.[28] The Yates pendants and their "drafts" have a similar discrepancy in the handling of glaze and paint buildup to that found between the Sargent House Museum and State Department works. Most recently, the Yates "drafts" have been attributed to an artist in Stuart's studio,[29] making the case for studio hands distinctly plausible in this instance.[30] A *terminus post-quem* of 1809 for the Sargent House works clearly disqualifies Stuart's daughter Jane (1812–88) as the artist, however, as has been theorized.[31]

The Hand behind the Stuart Drafts: James Frothingham (1786–1864)

The best candidate for the artist who painted Winthrop and Mary McIntosh, who fits neatly into the time line and the style of the works, is James Frothingham (1786–1864). I propose the pendant drafts were composed by him and completed with finishing touches by the master, Gilbert Stuart. In fact, Stuart expert Lawrence Park noticed the regularity of the copying of Stuart's paintings by studio hands, many still referred to as "Stuarts."[32] There is also the high regard that Stuart himself had for the young artist Frothingham. Stuart is rumored to have said, "Except myself, there is no man in Boston, but myself, can paint so good a head."[33]

The time line also works in our favor. As noted, Winthrop Sargent and Mary McIntosh traveled to Boston in the spring of 1807 to drop off their son William in Judith's charge.[34] Frothingham met and worked with Stuart precisely during this window of time, between 1805 and 1810.[35] I suggest it was in this period that Frothingham worked up the "proof" portraits for the Sargents, and later Gilbert Stuart "retouched" those and created the finer examples that were shipped to Natchez. The first drafts were gifted to Fitz William Sargent in Gloucester, but not before a final once-over by Stuart, particularly noticeable on the faces which are more sensitively rendered in delicate glazes than are evidenced by Frothingham in his other autograph works.[36]

The Sargent Portraits: The Question of Female Presentation

For the purpose of uncovering how Mary's portrait engages specific ideas about female presentation, it is illustrative to compare her portrait with the contemporary one of Judith by Stuart (Figure 12.1). Both women are shown seated in chairs in their three-quarter length portraits, as was traditional for English portraiture, which Stuart would have studied under Benjamin West in London. Both women exhibit reserve in their poses, hands clasped in their laps, both turning toward the viewer's right, their backdrops consisting of draped fabric and cloudy skies, in Mary's case, with a column pedestal exposed. They exude refinement, although in the Sargent House version of Mary there is a certain awkwardness about the hands. This treatment is not unusual in Stuart's oeuvre, however, as Gilbert Stuart typically painted hands in a cursory fashion.[37] Stuart's pupil Matthew Jouett remarked that Stuart rarely painted below the torso, and concentrated on faces.[38] Both women wear their hair in ringlets on their foreheads and wear lace draped around their heads and shoulders, and make eye contact with the viewer. But, this is where the close similarities end.

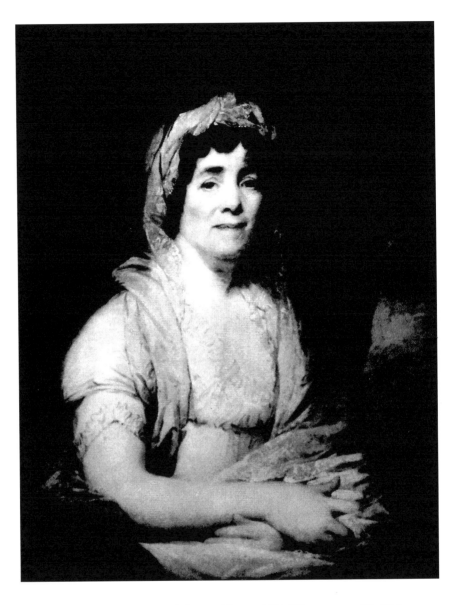

12.1 Gilbert Stuart, *Judith Sargent Murray*, 1806. Oil on canvas, 37 x 32 in.
Location unknown

Mary's arms are mostly covered with her rose-colored shawl, and her bodice displays an empire-style gown with double-ruched high lace collar. Judith, on the other hand, wears a longer lace veil that only covers one arm, leaving the other exposed in its short sleeves, her décolletage revealed by a plunging, lacy V-shaped neckline, particularly low-cut, and without the typical fine linen or muslin gauze to cover her bare skin. Interestingly, Judith had been represented in similarly risqué dress more than 30 years earlier in a portrait. At the age of 18, she was among the handful of women painted in modish, low-cut, and stayless *turquerie* by John Singleton Copley. According to contemporary fashion tropes, Judith's "déshabillé" appearance enhances her implied status as an author and philosopher, much like early portrait images of scholars in their studies often show them in a state of private negligee, such as banyans or kimonos, employed to evince freedom of thought. As art historian Isabel Breskin has demonstrated, women's fashion choices in the period could be linked to political motivations as well as ideas of gender position.[39] Though Breskin doesn't mention Judith's youthful *turquerie* portrait, it remains testament to Judith's flair for engagement with the world and openness to new modes for women. Furthermore, her representation in similar fashion so many years later indicates a consistent commitment to this style of fashion with all of its gendered associations.

In the case of Mary's dress, her reserved style perhaps reflects her more conservative regional politics when it came to the rights of women. To a greater degree than in the North, a love of reading and learning was discouraged among proper Southern women, and a "learned woman" was seen as unnatural, a rejection of her sex. Many women themselves observed that only outward ornaments earned positive male attention, so why, therefore, dote on the mind?[40] And, yet an overly conservative mode of dress was not necessarily flattering. It was said by James Fordyce in his widely read *Sermons to Young Women* (1766) that a woman could appear overly modest and too prudish in her dress and posture, risking the charge of affectation.[41] Indeed, in comparison to Judith, who is centered in the frame and seated at the front edge of her seat, Mary is pressed all the way to the deepest part of her chair on the left-hand side, seemingly reticent to emerge. In addition to costume, if body language is any indication, these are two very different women. In fact, no other portraits of women by Stuart show such a shift to the side of the frame such as Mary's.

Black Slavery in New England

Slavery is a topic that until quite recently was rarely discussed in histories of early New England. In fact, in pre-Revolutionary times slavery was common in Massachusetts. James R. Pringle's *History of Gloucester* recounts the period of Judith Sargent Murray's youth:

> At this period there was quite a number of negroes held here as slaves, nearly three hundred in number ... Some of the attics of the large houses were fitted up with slave pens for the accommodation of the blacks ... Slavery, however, did not flourish in northern soil and shortly after the Revolution the negroes disappeared.[42]

Pringle mentions one of those men, Judith's father's slave, Tobias Wornton, referred to as Bacchus.[43] Though legislation was long in coming, local slaves were freed by a 1783 Massachusetts Supreme Court ruling that slavery was unconstitutional,[44] and no slaves are recorded in Massachusetts censuses after 1790.[45] Unlike the South, in the North more universal notions of freedom began to eat away at the "natural slavery" argument, manumissions rose, and the gradual move toward emancipation began.[46]

According to a letter written by Judith in 1783, the same year as the state's Supreme Court ruling, Judith and her first husband John Stevens owned two "servants for life" whom they sold to separate privateers to relieve debt.[47] She describes "Two Negro Lads, which reserved as our last stake, not choosing to part with them, lest they might not be treated with affection, or even common justice."[48] As for Winthrop, we know that he wrote in his 1819 will that all his slaves should be sold off at his and Mary's deaths.[49] Manumission was common practice among Federalists of the period.[50] As Judith was an outspoken advocate for increasing the rights of women and freedom of conscience in the new Republic, one wonders about her opinion on the institution of slavery. And, as owner of a major slave-holding plantation, did Mary McIntosh share her views?

As a group who bore legal and social discrimination, and whose tenets of faith stated that salvation was open to all, contemporary Universalists like the Sargents widely reacted to slavery in a new way. Elhanan Winchester, an American Universalist, spoke out against slavery in Virginia and published an antislavery address in 1787 in England.[51] Another vigorous foe of slavery, Dr. Benjamin Rush,[52] a signer of the Declaration of Independence, provoked the first Universalist action on antislavery in 1790 when the Universalist Convention in Philadelphia adopted an antislavery resolution, the "pamphlet" given by Rev. John Murray to George Washington in Philadelphia.[53] In part it read,

> We believe it to be inconsistent with the union of the human race in a common Savior, and the obligations to mutual and universal love, which flow from that union, to hold any part of our fellow creatures in bondage. We therefore recommend a total refraining from the African trade and the adoption of prudent measures for the gradual abolition of the slavery of the negroes in our country, and for the instruction and education of their children in English literature, and in the principles of the Gospel.[54]

That said, others have written negatively of the widespread assumption that early and mid-nineteenth-century Universalism was at the forefront of antislavery and other reform movements.[55] Judith's biographer Sheila Skemp has said that Federalists in particular were keen to retain and strengthen the remaining barriers that divided the few from the many, men from women, whites from blacks.[56]

But, what did Judith leave us in writing on the question? We have Judith's strongly worded letter calling those in Gloucester who would refuse to hire Winthrop Junior's "negro" simply because of their "single objection … in their opinion, sufficient" as "very obstinant [sic], and very ignorant, as well as very proud."[57] After one of John Murray's open air sermons on the Philadelphia trip, Judith recounted to her parents, "One aged black man, in the midst of the discourse, softly exclaimed to a Bystander, 'Blessed God—is there then redemption for a poor slave, as well as for his more happy Master?'"[58] We also know that Judith's third play was titled *The African*, written in 1805[59] and performed in 1808 at Boston's Federal Street Theater. A critic panned it during rehearsal for unrecorded reasons, and unfortunately the manuscript remains missing, leaving us to wonder what the drama was about. Finally, Judith wrote one poem that references slavery, "Freedom":

> To Liberty the intellect was born,
> This flower so sensitive—in this rough soil,
> Will from the touch of slavery recoil …[60]

The use of "slavery" in this context brings up again Aristotle's concept of the "natural slavery" of women. The linked concepts of slavery and "natural slavery" bound in this classical text create dualities of master/slave, husband/wife and parent/child, where women are tantamount to slave/wife/child and the men as master/husband/parent.[61]

Although Judith did not write about the hard truths of institutionalized slavery, she did believe that its effects were pernicious to the slave owner. When confronted with the consistently bad behavior of Mary's sons in Boston, Judith—like many Northerners[62]—blamed plantation culture with its "uncontested dominion over the degraded African"[63] for fostering a "haughty and imperious mode of thinking."[64] Indeed, some plantation owners sent their young children north to Harvard, Princeton, and Yale to help them escape this phenomenon.[65]

Winthrop and Mary Sargent's Record on Slavery

While Winthrop Sargent was not an explicit abolitionist like his ally Andrew Ellicott,[66] his first established Mississippi legal code was to prohibit the importation of slaves from Spanish possessions.[67] Winthrop was also known to hire slaves, as in 1798 when he engaged a man named Cesar to work as a translator and intermediary with the Natchez Choctaws. Paid $30 a month, he earned the highest-known wage paid to a slave in Mississippi.[68] Sargent described Cesar's work as "highly important to National Dignity and Interests."[69] This was not a popular position; a grand jury in Mississippi's Adams County denounced the arrangement as disgraceful to "a free and independent people."[70] Sargent also was damned by a local constable for tolerating the slaves "drinking, profanation of Sundays, and weekend games of dice and chuck-penny."[71]

Though apparently Winthrop was moderate in his views, his own slaves were known to run away. Two were found in the woods west of the Mississippi River in 1802, nearly dead, but returned to him by Choctaw Indians.[72] There was also an advertisement for a runaway slave that appeared in Boston's *Columbian Centinel* on October 7, 1807. In it Winthrop remarkably says he believed that the "endeared" Sancho was perhaps not a runaway at all, but carried off.[73] In the end, Winthrop knew that slavery would not remain permanently in the new country. He addressed a group of militia officers as early as 1801: "That we deprive the [slaves] of the sacred boon of liberty is a crime they can never forgive. Mild and humane treatment may for a time continue them quiet, but can never fully reconcile them to their situation." The tenor of Winthrop's statement on slaves' unending desire for freedom echoes Aristotle's description of groups of people too noble for enslavement.

As for Mary, while we might assume that she would submit to the overwhelming culture of slave society to maintain her class, privilege, and powers by upholding the social order of the plantation system,[74] she did not. Unlike most Southern widows, after Winthrop's death in 1820 Mary sold Gloster Place rather than pass it on to her male heirs, as tradition would dictate.[75] She moved north with the children to Philadelphia where at that time over 99 percent of blacks were free.[76] Perhaps Mary's time with Judith affected Mary's principles, and allowed her the confidence to make those bold moves.

Conclusion

The Gilbert Stuart portrait of Mary McIntosh Sargent in the Sargent House Museum in Gloucester is rendered marginal due to its historic house museum location, as well as its tenuous place within the artist's oeuvre. Perhaps the

most pressing reason for rediscovering the work is for its illumination of the role of slavery as institution in the North following the Revolution, as well as the public presentation of the perceived roles of women in society: slavery and "natural slavery" visualized through the medium of portraiture.

Notes

1 Judith Sargent Murray, "On the Equality of the Sexes," *Massachusetts Magazine,* March–April 1790. http://nationalhumanitiescenter.org/pds/livingrev/equality/text5/sargent.pdf (accessed July 14, 2014).

2 This included her cousin, the writer Lucius Manlius Sargent, who wrote, "Her buckwheat cakes and her symbals (molasses cookies) were incomparable. She wrote poetry by the acre, but not to compare with the symbals." Lawrence Park, *Gilbert Stuart: An Illustrated Descriptive List of his Works,* vol. II (New York: William Edwin Rudge, 1926), 542.

3 E. Conger and Alexandra W. Rollins, eds., *Treasures of State: Fine and Decorative Arts in the Diplomatic Reception Rooms of the U.S. Department of State* (New York: Harry N. Abrams, Inc. 1991), 333.

4 In Winthrop's portrait, he wears the Society of Cincinnatus badge. https://diplomaticrooms.state.gov/Pages/Item.aspx?item=41 (accessed June 24, 2013).

5 He wrote essays on natural wonders of the Northwest, as well as manmade antiquities such as an Indian mound near Cincinnati. William Kloss, "Governor Winthrop Sargent," http://1997-2001.state.gov/www/about_state/diprooms/d73.55.html (accessed July 2, 2014).

6 Patti Carr Black, *Art in Mississippi, 1720–1980* (Seattle: Marquand Books, Inc., 1998), 30.

7 Headmistress Judith Saunders was Judith's cousin. Murray first helped Saunders form a school in Gloucester, then one in 1802 in Dorchester, MA, known as the Saunders and Beach Academy. www.dorchesteratheneum.org/page.php?id=1009 (accessed July 15, 2014).

8 Catherine Kerrison, *Claiming the Pen: Women and Intellectual Life in the Early American South* (Ithaca, NY: Cornell University Press, 2006), 29.

9 Holt N. Parker, "Aristotle's Unanswered Questions: Women and Slaves in *Politics* 1252a–1260b," *EuGeStA* no. 2 (2012), 72, http://eugesta.recherche.univ-lille3.fr/revue/pdf/2012/Parker-2_2012.pdf (accessed July 21, 2014). Holt writes that the two roles are fettered to each other: woman and slave.

10 Kerrison, 25.

11 Susan Branson, *These Fiery Frenchified Dames: Women and Political Culture in Early National Philadelphia* (Philadelphia: University of Pennsylvania Press, 2001), 1 and n. 3.

12 Kerrison, 156.

13 Sheila Skemp, *First Lady of Letters: Judith Sargent Murray and the Struggle for Female Independence* (Philadelphia: University of Pennsylvania Press, 2009), 356.

14 Skemp, 357, n. 59.

15 Joseph Frazer Smith, *Plantation Houses and Mansions of the Old South* (Mineola, NH: Dover Publications, 1993), 114–15.

16 http://misspreservation.com/101-mississippi-places-to-see-before-you-die/gloucester-natchez/.

17 Frazer Smith, 115.

18 Bonnie Hurd Smith, *Letters of Loss and Love* (Salem, MA: Hurd Smith Communications, 2009), 468.

19 Ibid., 173.

20 Notes from Accession File #8, "Addenda #8," by Elizabeth B. Hough, Chairman of the Museum Committee, February 17, 1987: "painted in Washington in 1805 … . Our paintings Numbers 8 and 9 are copies of the originals said to have been done by Jane Stuart, Gilbert Stuart's daughter. There is also another copy of the Governor in the state capital of Mississippi, Jackson, more recently commissioned." Sargent House Museum Archives, Gloucester, MA. Hereafter cited as SHMA.

21 Conger and Rollins, 406.

22 Skemp, 329.

23 Judith would not ship them before having a copy of Winthrop's made by an itinerant New York artist. The young artist also made one for himself for his public figures' gallery. Judith Sargent Murray, letter to her brother, March 18, 1809, Letter Book XV, SHMA.

24 Lawrence Park writes, "A copy [of Winthrop's portrait] was made at the order of Mrs. William Butler Duncan and is now in the possession of descendants of Governor Winthrop Sargent." Park, *Gilbert Stuart*, 664. And, of Mary's portrait, "A copy was made at the order of Mrs. William Butler Duncan and is now in possession of the descendants of Mrs. Winthrop Sargent." Park, *Gilbert Stuart*, 665. It is unclear where these copies are currently.

25 Letter from Winthrop Sargent, Jr., to Sargent-Murray-Gilman-Hough House Association, October 19, 1943, Miscellaneous Files, SHMA.

26 Fitz William's son Winthrop Sargent (1792–1874), then his grandson Winthrop Sargent (1822–96), his great-grandson Winthrop Sargent (1853–1932), and finally his great-great-grandson, the Winthrop Sargent (1887–1968), who donated them.

27 The paintings were handed down by descendants of George Washington Sargent (1802–64) until they were eventually sold a number of times, then lent and placed on view before eventually being purchased by the State Department. These works are both 33 ½ x 27 inches, and "Lent by Mrs. Stephen A. Wilson." *Guidebook to Diplomatic Reception Rooms* (Washington, DC: Department of State, 1975), 66. Elizabeth Hough, chairman of the Museum Committee in "Addenda #8" (1986), Files 8 & 9, SHMA.

28 Timothy Cahill, "Unraveling a Mystery: With Analysis and Connoisseurship, Experts Delve into a Gilbert Stuart Copy, *Art Conservator* 4, no. 2 (Fall 2009): 4–13. Found: www.williamstownart.org/artconservator/images/AC4.2.pdf (accessed May 12, 2014).

29 According to Tom Branchick, director of the Williamstown Art Conservation Center, "We think we have a sound attribution for the copies. John Vanderlyn, who trained with Stuart and copied 'the master.'" Personal e-mail correspondence, May 12, 2014.

30 Incidentally, the State Department portraits of Winthrop and Mary both measure 33 1/2 x 27 inches, whereas the Sargent House Museum's are smaller, each 30 x 25 inches. It would be interesting to discover if other Stuart "draft" portraits maintained similar shifts in size. The National Gallery of Art image of Catherine Brass Yates measures 30 x 25 inches unframed.

31 See note 29. Hough does not state the origin of the Jane Stuart attribution.

32 "We know that Winstanley, Rembrandt Peale, Vanderlyn, Frothingham, Chapman, Wall, Fraser, Jane Stuart herself, and others made a fair living by copying this head, as well as Stuart's other portraits of Washington and without doubt many of the so-called 'Stuarts' are from among these." Park, *Gilbert Stuart*, 53.

33 William Dunlap, *A History of the Rise and Progress of the Arts of Design in the United States* (Boston: C.F. Goodspeed & Co., 1918), 368. And, also, "That young man's coloring reminds one of Titian's." Dunlap, *A History*.

34 Skemp, 349.

35 Their close relationship caused Frothingham's biographer William Dunlap to remark that we must call Frothingham Stuart's pupil. Dunlap, *A History*, 368.

36 Winthrop Sargent, Jr., wrote in 1954, "As to their provenance—they were drafts which Stuart was accustomed to have his school make for the consideration of his client. The two in the Metropolitan were the two that the Governor chose and the two in the Judith Sargent House he gave to his brother Fitzwilliam Sargent." Letter to "Sargent Bradlee, Esq., Beverly Farms" from Winthrop Sargent, Jr., September 18, 1954, Accession Files, numbers 8 and 9, SHMA.

37 www.worcesterart.org/Collection/Early_American/Artists/stuart/biography/ (accessed June 24, 2013).

38 Notwithstanding this knowledge, the final private owner of the Mary McIntosh portrait felt it should be excluded from Stuart's oeuvre as "indicated by the six fingers on Mary," an unwarranted charge. Letter to "Sargent Bradlee, Esq., Beverly Farms" from Winthrop Sargent, Jr., September 18, 1954, Accession Files (numbers 8 and 9), SHMA.

39 Isabel Breskin, "On the Periphery of a Greater World": John Singleton Copley's "Turquerie" Portraits, *Winterthur Portfolio* 36, no. 2/3 (Summer–Autumn 2001): 111–12.

40 Kerrison, 160.

41 James Fordyce, Sermon XIII, *Sermons to Young Women*, vol. 2 (New York: I. Riley, 1809), 121.

42 James Pringle (Lynn, MA: G.H. & W.A. Nichols, 1892), 86–7.

43 Wornton was, in fact, a veteran of the Continental Army who fought at the Battle of Bunker Hill while still a slave. For information on Wornton, see James O. and Lois E. Hornton, *In Hope of Liberty* (New York: Oxford University Press, 1997), 92. Wornton's granddaughter was the celebrated authoress Nancy Gardner Prince (1799–c.1856). Prince's memoir (*Narrative of the Life and Travels of Mrs. Nancy Prince* [1850]) recounts that Wornton was a staunch Congregationalist, attending service each morning and taking care of her and her siblings in the afternoons while her mother worked to support the family. It's interesting to imagine the relationship that Judith's abolitionist cousins Henrietta and Catherine may have had with Prince's work. The cousins were both very close to Judith, and spent many hours with her both in Boston and in Hampstead, New Hampshire, begging the question of whether Judith had a strong effect on their moral compasses. See Carolyn L. Karcher, *The First Woman in the Republic: A Cultural Biography of Lydia Maria Child* (Durham, NC: Duke University Press Books, 1998), 199 and passim. Henrietta is also mentioned in *The Letters of William Lloyd Garrison: Let the Oppressed Go Free, 1861–1867*, Walter Merrill, ed. (Cambridge, MA: Belknap Press of Harvard University Press, 1979), where Garrison refers to her as "our dear and venerated friend."

44 http://boston1775.blogspot.com/2006/06/end-of-slavery-in-massachusetts.html (accessed July 23, 2014).

45 A. Leon Higginbotham, *In the Matter of Color: Race and the American Legal Process* (Oxford, UK: Oxford University Press, 1980), 91.

46 Kerrison, 141.

47 Judith Sargent Stevens to Madame Walker, October 8, 1783, SHMA.

48 Ibid. Thanks to Lise Breen for bringing this letter to my attention.

49 Codicil to Winthrop Sargent Will, written November 21, 1819. Cited in Skemp, 471, n. 18.

50 Kennedy, 105.

51 www.uua.org/re/tapestry/adults/river/workshop12/workshopplan/ leaderresources/178742.shtml (accessed October 5, 2013).

52 A well-regarded Universalist-sympathizer, Rush formed the first antislavery society in America, the Pennsylvania Society for Promoting the Abolition of Slavery and the Relief of Free Negroes Unlawfully Held in Bondage, and was its first president.

53 http://founders.archives.gov/documents/Washington/05–06–02–0103 (accessed July 21, 2014).

54 George Huntston Williams, *American Universalism*, 4th ed. (Boston: Skinner House Books, 2002), 45.

55 "Universalists as a whole … were no more in the forefront of the anti-slavery movement than other denominations." Ibid., 45. Like George Williams, Ann Lee Bressler has noted that "Several recent studies of antebellum attitudes toward slavery have shown clearly that Universalists, along with numerous other groups that stood apart from the strident evangelicalism of the age, were

generally opposed to abolitionism and were at pains to distance themselves from the position of the Garrisonian agitators." *The Universalist Movement in America: 1770–1880* (New York: Oxford University Press, 2001), 85–6.

56 Skemp, 96–7.

57 Judith Sargent Murray, letter 408 to Winthrop Sargent, Jr., May 18, 1785. Found in Sharon M. Harris, *Selected Writings of Judith Sargent Murray* (New York: Oxford University Press, 1995), 94–5.

58 Judith Sargent Murray writing about John Murray's preaching to Winthrop Sargent and Judith Saunders Sargent (her parents), July 31, 1790. "Judith Sargent Murray Quotes," http://.jsmsociety.com/Quotes.html (accessed July 21, 2014).

59 "Judith Sargent Murray Biography," http://jsmsociety.com/Biography.html (accessed October 5, 2013).

60 Tammy Mills, "'Lines Written in my Closet': Volume One of Judith Sargent Murray's Poetry Manuscripts," (PhD diss., Georgia State University, 2006): 361, http://scholarworks.gsu.edu/english_diss/11/, accessed July 21, 2014.

61 Judith's poem continually references the idea that "Children by Nature spurn parental rule." Mills, 361.

62 Skemp, 354, and note 50. From Chandos Michael Brown, *Benjamin Silliman: A Life in the Young Republic* (Princeton: Princeton University Press, 1989), 143; Richard Bushman, "A Poet, a Planter, and a Nation of Farmers," *Journal of the Early Republic* 19 (1999): 13.

63 Found in Skemp, 353, and note 50. JSM letter to Mrs. Tenney, May 20,1806, Letter Book 13: [156].

64 Found in Skemp, 353, and note 50. JSM letter to Mrs. Webber, October 6, 1807, Letter Book 14: 85.

65 Joanne Pope Melish, *Disowning Slavery: Gradual Emancipation and "Race" in New England, 1780–1860* (Ithaca, NY: Cornell University Press, 1998), xiii–xiv.

66 Andrew Ellicott was an abolitionist Quaker, surveyor, mathematician; US boundary commissioner, Mississippi Territory.

67 Through the Federalist-Quaker coalition, Mississippi may have gone against slavery when joining the Union if Ellicott and Sargent had been able to have Thomas Jefferson's support. To the contrary, Winthrop was fired from his post after Jefferson's election to the presidency in 1800. Roger G. Kennedy, *Burr, Hamilton, and Jefferson: A Study in Character* (New York: Oxford University Press, 2000), 315.

68 Letter to John Minor from Winthrop Sargent, April 3, 1800, SHMA. http://archive.org/stream/mississippiterri01missuoft/mississippiterri01missuoft_djvu.txt (accessed June 4, 2014). Daniel H. Usner, Jr., "Frontier Exchange and Cotton Production: The Slave Economy in Mississippi, 1798–1836," in *From Slavery to Emancipation in the Atlantic World*, ed. Sylvia R. Frey and Betty Wood (London: Frank Cass Publishers, 1999), 28 and 36 n. 11.

69 Adam Rothman, *Slave Country: American Expansion and the Origins of the Deep South* (Cambridge, MA: Harvard University Press, 2007), 59.

70 Rothman, 59.

71 Terry Alford, excerpt of "Prince among Slaves," in *A Place Called Mississippi: Collected Narratives*, ed. Marion Barnwell (Jackson: University Press of Mississippi, 1997), 385.

72 Rothman, 60, and note 97, "Letter from Darnell to Sargent, April 22, 1802, Reel 6, Winthrop Sargent Papers, LC."

73 He continues by describing how faithful, accomplished, and dear he is to the family and other servants.

He writes if Sancho did runaway, however, and voluntarily came home, he would be welcomed with open arms without punishment. Then, in a rapid shift in tone, Winthrop writes that if Sancho is indeed a fugitive, he is offering $50 to the person who returns him—and "no expense will be spared to punish those who might be harboring him." http://catalogue.swanngalleries.com/asp/fullCatalogue.asp?salelot=2308++++++31+&refno=++671750&saletype= (accessed June 4, 2014).

74 Kerrison, 189.

75 Ibid.

76 Ira Berlin, *Generations of Captivity: A History of African-American Slaves* (Cambridge, MA: Harvard University Press, 2003), 276–8.

An Oblique View of New Orleans's St. Louis Cathedral

Sara Picard

In 1842 *La Cathedrale* presented a dynamically new perspective of New Orleans's famous colonial monument, the St. Louis Cathedral (Figure 13.1). While images of the celebrated edifice generally represent it from the front, in a stable, symmetrical composition, French expatriate artist-lithographer Jules Lion (1806–66) depicted the cathedral at an oblique angle from a block down the street in an often-reproduced lithograph drawn from a daguerreotype. This sidelong orientation, as well as the visual details and velvety texture, have made *La Cathedrale* an attractive illustration in histories of Louisiana life and American photography.[1] Details of the print have been used for ornament, such as an embossed cartouche in bookbinding or endpaper decoration.[2] It is also widely visible in general literature such as tourist brochures and websites, including Wikipedia's page for the public commons it faces, now called Jackson Square.[3] Despite this popularity, the print has never received a critical reading.

La Cathedrale suffers invisibility in art historical discourse because of its peripheral geography and middlebrow medium. The South has long been neglected, eclipsed by the Northeast, perhaps too complicated to fit easily into the American art narrative.[4] Regional art histories neglect *La Cathedrale*, focusing instead on painting, sculpture, and decorative arts.[5] Louisiana's food and music receive more attention than its visual culture and its architectural history is overdetermined by vernacular and residential structures. These studies miss the exceptional and incisive contribution this print makes to American visual culture.

Exhuming *La Cathedrale* from its local vault at the Louisiana State Museum allows for its study in a larger context of art history and social history that illuminates the technological innovation and transatlantic connections. One of Lion's daguerreotypes, a technology he introduced to the South from Paris, was likely the source for this lithographic illustration. In media and

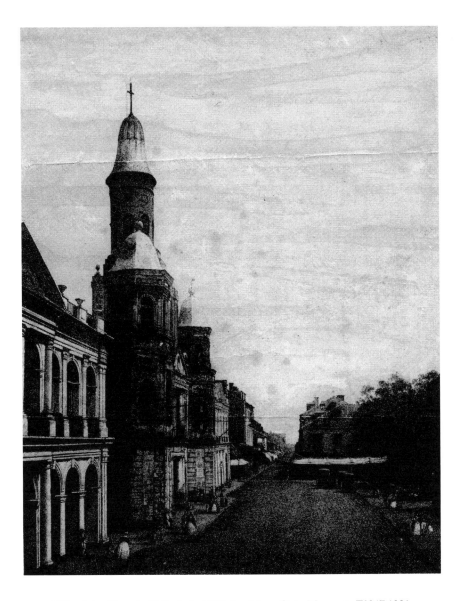

13.1 Jules Lion, *La Cathedrale*, 1842. Louisiana State Museum, T0347.1991.
Courtesy of the Collections of the Louisiana State Museum

theme, *La Cathedrale* illuminates French-American exchanges of art and ideas. In addition, the print's dynamic perspective parallels the waning French influence and growing ethnic diversity that preceded larger social and structural problems in antebellum Louisiana.

The Artist's Background

Born in Paris in 1806, Jules Lion likely trained as an informal apprentice in one of the growing number of lithographic print shops. Still a teenager, Lion showed lithographs in four Parisian Salons and published a few in the French Romantic journal *l'Artiste*. Before he came to America, Lion had already created works of American subjects including portraits of Andrew Jackson and Martin van Buren. From his arrival in Louisiana in 1837 to his death in 1866, Lion produced more than 200 lithographs, most of them portraits of prominent Louisiana statesmen and businessmen.

In 1839 Lion traveled back home to Paris the same summer Louis Jacques Mandé Daguerre first presented his amazing new machine to the public. In his last hours in Paris that summer, Lion hustled to opticians' shops alongside other "amateurs panting for daguerreotype apparatus" so he could bring the technology with him back to Louisiana on the transatlantic voyage.[6] He must have tinkered with the process privately while he maintained his portraiture business publicly. Traveler George Vail had little faith in the Southern daguerreotypists he encountered, writing home to Samuel Morse that, "few if any experiments have been made there. Where they have been[,] it has been done by some scientific gent who attacked it as a matter of curiosity with crude instruments."[7] Just days after Vail left New Orleans, Lion presented the first Southern exhibition of daguerreotypes at the St. Charles Museum. His advertisement in the *Bee* for this presentation promised "the likeness of the most remarkable monuments and landscapes existing in New Orleans," and received positive reviews for his "serious study" and "marvelous precision."[8] While we have hundreds of his lithographs, none of Lion's daguerreotypes are extant and none of the three extant daguerreotype views of the city date to the period in which he worked.[9]

La Cathedrale

Captured from the southwest, the scene in *La Cathedrale* centers on Chartres Street's open drive and side walkways more than the old church. Lion's asymmetrical view marginalizes the cathedral's facade, tower, and cross. Two-story row houses at the far corner of St. Ann Street face the viewer and Chartres Street recedes in dramatic one-point perspective. Early morning

light from the southeast rakes across the scene as the sun rises out of the Mississippi River, which is beyond the composition frame to the right, past unseen trees, the public square, and the levee. Lion's oblique angle creates an open composition with the wide banquettes and a bright street, but it is also claustrophobic, as the Cathedral's great height towers over the diminutive passersby and the street narrows, obscured by dark shadows, as it moves down river deeper into the French Quarter.

La Cathedrale is anomalous in Lion's oeuvre as one of only two known architectural renderings among his hundreds of portraits, but it is one of his most reproduced works and one of the most popular images of the old St. Louis Cathedral. It demonstrates two of Lion's great, yet under sung achievements that were likely influenced by his French roots: he was the first in the South to present the daguerreotype publicly and he was the first American artist to use the daguerreotype in conjunction with printmaking.

Scholars have suggested that one of Lion's lost daguerreotypes was the likely source for his lithographic illustration of the cathedral because of its "unmistakable precision of detail, tone, and rendition of perspective."[10] Indeed, a reporter praised the daguerreotypes displayed in Lion's 1840 exhibition for "l'illusion [de la] perspective ... des vues de certaines rues/the illusionistic perspective ... of specific streets." Images of the cathedral and its adjacent edifices were isolated for "témoigner de l'étonnante précision des details/demonstrating amazing precision of detail."[11] In the lithographic illustration, Lion carefully delineated architectural features, such as the bricks and cornices, denticulation in the tower's entablature, and lightning rod next to the cross on top, suggesting that he used a mechanical image as his source for drawing on stone.[12] Lion's oeuvre shows he was consistently concerned with delineating details in which he displays his sitter's distinctive hair and facial features such as wrinkles and moles.

Drawn from a daguerreotype, *La Cathedrale* harnesses the nascent heliographic technology's potential as a vehicle for mass reproduction of images through printmaking. French trade journal *Le Lithographe* suggested, "the marvelous way to complete this process would be the ability to engrave, or better yet to lithograph, with the aid of the Daguerréotype."[13] Mere weeks after Daguerre's presentation, lithographs drawn from daguerreotypes appeared. One early project, *Album de Daguerréotype Reproduit*, was published with lithographs on silver-toned paper, probably to suggest a daguerreotype plate.[14]

While Lion's practice followed French prototypes, he was an American pioneer. He introduced the American South to the daguerreotype alongside ideas on how to use it for the mass production of images. He became the first in America to draw a lithograph directly from a daguerreotype, a process that Philip P. Haas, John Plumbe, Jr., and Matthew Brady, among others, exploited later for their projects of celebrity portraiture and sentimental imagery.[15]

13.2 Louis Xavier Magny, *Ancienne Cathédral de la Nouvelle Orleans*, c. 1848. Louisiana State Museum, Gift of Henry Krotzer 1956.250. Courtesy of the Collections of the Louisiana State Museum

The Cathedral and Cultural Identity

Lion's *La Cathedrale* was the first (and only) drawing he completed for a French-style *"grand ouvrage"* of views, monuments, and remarkable sites of the state of Louisiana, called *Voyages Pittoresques en Louisiane*. While helping him solicit subscribers, one newspaper complemented the drawing for its harmony, detail, and lighting, but also its *"vétusté respectable*/respectable dilapidation." This "respectable dilapidation" describes the state of the old structure and echoes the romantic concerns of the larger print project.[16]

Just as the title *Voyages Pittoresques en Louisiane* uses the language of French travel visual culture, *La Cathedrale* projects French ideas about nationalism onto potential Louisiana subscribers. French *voyages pittoresques* tapped into "a deep and widespread involvement in *exploring France*," intended to blend scientific pursuits with romantic ideals, such as Baron Taylor and Charles Nodier's *Voyages pittoresques et romantiques dans l'ancienne France*. This imagery could support historical conservation and educate successive generations. An article in the *Journal des Artistes* celebrated depictions of Parisian scenes at the 1827 Salon saying that they "exploit with increasing success [Paris's] picturesque and historic sites, her ruined monuments on

the point of disappearing."[17] Lion's replication of French *voyages* would provide an imagined tour of Louisiana sights, beginning with Louisiana's most important monument, creating a transformative experience captured by daguerreotype and translated into the ubiquitous parlor print.

New Orleans's St. Louis Cathedral, continuously rebuilt on the same site since the eighteenth century, remains an iconic Louisiana landmark. From eighteenth-century map views to contemporary wedding photography, frontal depictions have been the convention, exemplified by Louis Xavier Magny's lithograph from about 1848, in which the cathedral is flanked on the left by the Cabildo, home of the Spanish colonial government, and on the right by the Presbytere, built on the site of residence for Capuchin monks (Figure 13.2). These symmetrical views articulate the monument's cultural significance and stability. Lion's departure from this convention is another aspect that distinguishes *La Cathedrale*, reverberating with social history.

La Cathedrale records charming French Louisiana as it was fading away. By 1842, New Orleans was in the midst of citywide construction; the city's physical landscape and cultural identity was in flux; and the old cathedral was left a relic of the colonial regime. While the rest of the city seemed to be under constant improvement with some projects lingering from the previous financial boom and others issued to accommodate a city swelling with new residents, Creoles lamented the "respectable dilapidation" of their beloved cathedral. A contributor for the bilingual newspaper the *Bee* wrote in 1838,

> The church of St. Louis, or as it is commonly known among the American portion of the population, the Cathedral is … in a state of impending ruin. The arches and ceiling of this imposing edifice, are in a state of lamentable decay, and so dilapidated by time, that the entire roof threatens to topple headlong.

Lion's lithograph of the cathedral displays cracks and missing chunks in the facade and the tower roofs. According to the *Bee* article, the "temple" had received no repairs in decades and "now stands a monument of an antiquated but dignified and majestic style of architecture."[18]

Despite its neglect, the church of St. Louis remained geographically and metaphorically central to Creole life. Called "patrician[s] of this land" in the popular city guide *Norman's New Orleans and Environs*, Creoles descended from French and/or Spanish colonists and were quite attached to their old church.[19] Jacques Tanesse's *Plan of the City* from 1817 displays the cathedral in the top central position of framed architectural vignettes as well as at the geographic heart of the map, and Charles Manouvrier's map from about 1841 shows a similar hierarchical format. A romantic poem by Armand Lanusse published in the *Bee* in August 1839, just before Lion returned from his summer in Paris, lyrically celebrates the edifice. "*Salut à toi, salut, antique Cathédrale*/Honoring you, ancient Cathedral," the poem begins. After rejoicing the baptisms,

marriages, and peace celebrated under the its nave, Lanusse envisions the Cathedral as the *"tombeau des anciens fils de notre Louisiane*/tomb of the ancient sons of our Louisiana" whose names are *"perpétuer ici, le souvenir constant*/here eternally in steadfast memory."[20] Lanusse expressed the elegiac emotions many *Bee* readers felt about their beloved church. The earlier mentioned item from the *Bee* clearly distinguishes the Creole name, "the church of St. Louis," from how "it is commonly known among the American portion of the population, the Cathedral," in an acerbic statement of ownership.[21]

For Latin Creoles, St. Louis Cathedral was a testament to the days when the French residents dominated as the largest, most affluent, and most powerful of the city's population. By the time Lion arrived, times had changed. Louisiana became American territory in 1803 and achieved statehood in 1812. The proliferation of the steamboat on the Mississippi made New Orleans a boomtown, one of the world's busiest ports, attracting entrepreneurs from the North. While the Creole was "patrician of this land," there were increasingly more of what Norman's city guide called the "enterprising, calculating, hardy Yankee."[22]

The region's economic role nationally was ascendant, but the old population was in decline. As "enterprising and hardy Yankees" started arriving in droves from the upper South, mid-Atlantic, and New England, a battle evolved between the newcomers and the long timers, each group, in the words of historian Joseph Tregle, "thought of themselves as engaged in a struggle for the very soul of the community."[23] Battle lines emerged through geographical patterns. Americans accumulated upriver in Faubourg St. Marie and the upper quarter (between Canal and Conti), while Creoles were numerous downriver in the lower quarter and suburbs. At first the Creoles wielded their patrician power to their advantage. The Gallic majority in the city council sabotaged the wharf system that supported St. Marie and hoarded financial support for paving, lighting, and municipal improvements away from the American quarter. However, the Creoles soon lost ground. As Tregle explains, they "lagged almost hopelessly behind in education and political experience, and they could summon no one from their ranks competent enough to assure their continued hegemony."[24]

In 1836, the year before Lion's arrival to Louisiana, these competing neighborhoods compelled the state to divide the city into three distinct municipalities, each with its own council but a shared mayor and police force. The first municipality was in the middle bounded by two parallel borders from the river toward the lake. It contained the old city center (French Quarter) and an emerging neighborhood "back-of-town" called Faubourg Tremé, largely inhabited by Latin Creoles. The second municipality was across Canal Street, upriver from the old city center and referred to as the "American section" including Faubourg St. Marie. The third municipality was the least affluent. It began at Esplanade and continued downriver from the old

city taking in Faubourg Marigny, also populated by Latin Creoles as well as recent immigrants.[25] Canal Street was a cultural divide, separating the French-speaking first municipality and the English-speaking second municipality, while Esplanade was the economic and social boundary between the bourgeoisie in the old city and working-class residents downriver.

In Lion's print *La Cathedrale*, the viewer looks from the American section toward the Creole parts of town. The print's oblique perspective of a Creole monument suggests the city's sloping demographics, changing political economy, and the "Americanization" of New Orleans. By the mid-1840s, the American section benefited from a barrage of building that made it transcend the old Creole city center. The lower French Quarter lay in neglect. E.H. Durrell felt the cathedral marked the space between the "new" and the "old," the clean and thriving American center up river and the "decayed town of Europe," where Creoles were intellectually stagnant, deficient in business, and afraid of change.[26] Oakley Hall, the "Manhattaner in New Orleans," compared the area below Jackson Square to St. Giles, one of the worst slums in Britain at this time, "where poverty and vice runs races with want and passion."[27]

After five years in New Orleans, Lion's relationship to the city was complicated. He was neither Creole, nor Yankee, but "foreign French," a group that was politically aligned with the Creoles at the same time it scorned their provincialism.[28] While he moved around a lot, most of Lion's residences and studios up to this time were on the border between Creole and American neighborhoods and his exhibitions of the daguerreotype were in Faubourg St. Marie. The diminutive figures in *La Cathedrale* likely visualize Lion's attitudes about the local Creoles; they were small and quaint bumpkins analogous to the rustic staffage in French *voyage* prints of ancient ruins. Noël-Marie Paymal Lerebours's print of the Colosseum from his 1842 *Excursions Daguerriennes* shows a country herdsman and a woman balancing a jug on her head with the ancient arena crumbling in the background.[29] The carefree Creole strollers in *La Cathedrale*, alongside scruffy dogs and barefoot loiterers, were the urban equivalent to Italy's peasant underclass with their previous glory dissolving beside them. The old Creole monument was both a relic of the olden days symbolizing Creole decay and a landmark between the future and the past. *La Cathedrale* marginalizes its subject just like the old Creole population in the new New Orleans society. Patches of horse manure on the street in front of the cathedral may reference the Creole state of affairs.

Popular Prints vs. "Fine Arts" Taste

Despite its unflattering undertones, *La Cathedrale* faired well in its review by one of the local newspapers. Beyond its capture of "respectable dilapidation," the print was seen as formally effective in light and detail. The reporter

remarked that viewers would be unable to resist temptations to subscribe to *Voyage Pittoresque en Louisiane* after seeing this "*image parfaite*/perfect image."[30] The print must have been widely distributed because there is one copy in the Louisiana History Museum and two in the Historic New Orleans Collection.[31] There are likely to be more in other collections.

Unfortunately, Lion's series of *Voyages Pittoresques en Louisiane* never materialized and Lion only produced *La Cathedrale*, despite reports that the number of subscribers was growing.[32] Even though Creoles expressed intense affection for the St. Louis Cathedral, New Orleans art collectors and patrons had no interest in art that celebrated their region of the country, whether rural or urban. Many of the images that New Orleans residents read about in papers and visited in galleries ran parallel to national interests. Biblical and religious scenes rivaled celebrity portraiture in popularity. Most of New Orleans's art exhibitions were in the second municipality, organized by and catering to the Anglo American residents and tastes.

Local tastes were not inclined toward regional landscape either. What became known as the Hudson River School was blossoming in the North while Southern images of "moss draped oaks, sleepy bayous, swamps teeming with wildlife, lakes dotted with cypress knees, waving green ribbons of sugar cane alongside fields dotted with cotton, venerable houses mixed in with cajun [*sic*] cottages and sharecropper's cabins" did not emerge until later in the nineteenth century.[33] What William Gerdts called "bayou landscape" was driven by nostalgia for the mythic Old South after Reconstruction.[34] Antebellum galleries attracted visitors with bird's-eye views of the city, dioramas, and even the landscape of Paris carved in wood.[35] These images of vast geographical spaces were feats of mastery and visual bravura; the limited frame and close study of a few dilapidated buildings in *La Cathedrale* could hardly compete.

Although it was not successful in the way he had hoped, Lion's lithograph of the cathedral received a wide audience as source material for the cover of *Frank Leslie's Illustrated Newspaper* published out of New York (Figure 13.3). The paper appropriated Lion's 1842 depiction of the old cathedral to illustrate the inauguration of the Andrew Jackson monument at Jackson Square in 1856.[36] However, by 1856, Lion's image was outdated. The reporter described the "palatial" Pontalba Buildings on either side of the square, saying the balconies were filled with ladies, but the illustration retained the old two-story row houses of the 1840s, with no balconies of ladies.[37] It wasn't until the late 1840s when the row houses were converted into high-style four-story brick structures with ornamental cast iron columns.[38] By 1850, a practically new cathedral was well underway to catch up. When the Jackson Monument was installed, the cathedral had been rebuilt with almost all new architectural elements including pointed spires, and the Cabildo and Presbytère had been augmented with mansard roofs and dormers, improvements absent in the image gracing *Frank Leslie's*.

FRANK LESLIE'S
ILLUSTRATED
NEWSPAPER

| No. 12.—VOL. I.] | NEW YORK, SATURDAY, MARCH, 1, 1856. | [PRICE TEN CENTS. |

SHALL WE REFER THE CENTRAL AMERICAN QUESTION TO ARBITRATION?

ENGLAND proposes a settlement of the Central American Question by a reference to the arbitration of a third power. This will not suit us at all. We should fare badly in a decision by any one of the European governments. They have all too many prejudices, and too many interests at stake in the award, not to render its character certain beforehand. It would be like trying a case in a court where the jury is packed, where the judge is bribed, and where the mockery of a trial is merely a compliance with the forms of conventional decency. It is not likely that we will place ourselves in the position of the luckless suitor who carries his cause before such a tribunal. Holding the option of Brennus, we shall not allow our adversary to kick the scales.

So far as special pleading is concerned, it must be admitted that Lord Clarendon has the best of the discussion thus far. Our simple-minded and good natured representative, Mr. Clayton, was clearly overreached in the negotiations which led to the treaty that bears his name. He had to deal with a man practised in the subtleties and casuistry of European diplomacy, and whose well-placed and oily flatteries threw him off his guard. Of the intent and understanding of the treaty, so far as our representative was concerned, there cannot, however, be the slightest doubt. Mr. Clayton would have been false to the interests of his country, false to the well-understood principle which has become the canon of our political creed—the Monroe doctrine—if he had for a moment contemplated or admitted the construction since put upon this document by the English cabinet. We have had no object in our entering into any such treaty at all, unless its principle was intended to be retrospective. Nothing can be more absurd than to suppose that this country would voluntarily, and without necessity, impose limits to her own action, whilst she guaranteed to Great Britain pretensions (for rights they cannot be called), which were dangerous to her interests. That the terms of the treaty admit of a different interpretation, is to be attributed to the unskilfulness and incapacity of Mr. Clayton. Such a construction was the object to be especially guarded against, for it involved all that was really at stake. That the looseness of the text of the treaty should be taken advantage of by the English cabinet, was hardly to be expected, considering the well-understood purpose of it. But as, unfortunately, bad faith can sometimes be sustained by special pleading, and as the blunder that has been committed is our own, we must now guard against any possible future misconception of the views which have influenced our policy on this question. To admit of a reference to arbitration, would be to acknowledge that we have been either acting without an object in the framing of this treaty, or that having done so, we are now seeking to put a forced construction upon it, in order to deprive Great Britain of certain

INAUGURATION OF THE JACKSON STATUE, NEW ORLEANS.—THE PROCESSION PASSING INTO JACKSON SQUARE, OPPOSITE THE OLD CATHEDRAL.

13.3 *Frank Leslie's Illustrated Newspaper* (March 1, 1856). Louisiana State Museum.
Courtesy of the Collections of the Louisiana State Museum

Conclusion

The 1850s brought a new look to Jackson Square along with new social and cultural conditions that left the Creoles increasingly underrepresented. More Anglo Americans infiltrated politics and the financial markets. In 1852, the three separate municipalities were consolidated under the Americans bolstered by support from increasing numbers of recent Irish and German immigrants. Some powerful Americans married into old Creole families, and Creole resistance crumpled. Representations of New Orleans were dominated by panoramic views that embed the cathedral in urban density, instead highlighting the Mississippi River and its industrial value, such as John Bachman's *Nouvelle Orleans Vue pris d'Algiers* and John William Hill's *New Orleans from the Lower Cotton Press*, both from the 1850s. Lion's livelihood also suffered. Unable to keep up with technical improvements with the daguerreotype, he moved from the heart of the business district deeper into the Latin Creole Quarter and eventually out of the Quarter to the border of Faubourgs Tremé and Marigny.

As the inaugural image for his *Voyage Pittoresque en Louisiane*, Lion had hoped *La Cathedrale* would kick off a celebration of his adopted state. In the larger project's failure, the image suffered obscurity. Its contribution has remained unnoticed because of the dominance of the so-called fine arts and American art history's regionalism. Having been mass reproduced, the image has not been given ample consideration even though it was more widely accessible than a one-of-a-kind. Its popularity speaks just as much about trends in American values and visual culture as elite artworks. Regionally, the North overshadows Southern culture, and Louisiana, with its Latin rather than Anglo colonial history, is marginalized more than the rest of the South. Nineteenth-century Northern art production and scholarship remains dominant and American art history has been written from a Northern perspective. Yet, the work demands attention for these reasons. *La Cathedrale*'s complicated reception by Anglo Americans as well as Creoles may have rendered it invisible, but it echoes the unpopular narrative of Anglo American domination of New Orleans. Through Southern art, we learn about the shaping of American identity in its diversity. The European influences demonstrate the synthesis of visual practices across the Atlantic world, asking for a reevaluation of what makes American art "American."[39]

Notes

1 For example, Christina Vella, *Intimate Enemies: The Two Worlds of Baroness de Pontalba* (Baton Rouge: Louisiana State University Press, 1977), after 172, where the illustration has been speciously signed by A[drien] Persac; Shirley Elizabeth Thompson, *Exiles at Home: The Struggles to Become American in Creole New Orleans*

(Cambridge: Harvard University Press, 2009), after 109; and Peter Bacon Hales, *Silver Cities: Photographing American Urbanization, 1839–1939* (Albuquerque: University of New Mexico Press, 2005), 99.

2 Deborah Willis, *Reflections in Black: A History of Black Photographers, 1840 to the Present* (New York: Norton, 2000); and *In Search of Julien Hudson: Free Artist of Color in Pre–Civil War New Orleans*, with essays by Williams Keyse Rudolph and Patricia Brady (New Orleans: Historic New Orleans Collection, 2010).

3 "Jackson Square (New Orleans)," Wikipedia. Accessed June 9, 2014, http://en.wikipedia.org/wiki/Jackson_Square_%28New_Orleans%29.

4 Maurie D. McInnis, "Little of Artistic Merit? The Problem and Promise of Southern Art History," *American Art* 19, no. 2 (Summer 2005): 11–18.

5 See Jay Michael Sartisky, Richard Gruber, and John Kemp, eds., *A Unique Slant of Light: The Bicentennial History of Art in Louisiana* (New Orleans: Louisiana Endowment of the Humanities, 2012).

6 Beaumont Newhall, *The History of Photography: From 1839 to the Present Day* (New York: Museum of Modern Art, 1964), 18.

7 Letter, in Papers of Samuel F.B. Morse, Manuscript Division, Library of Congress, as quoted in Margaret Denton Smith and Mary Louise Tucker, *Photography in New Orleans: The Early Years, 1840–1865* (Baton Rouge: Louisiana State University Press, 1982), 17.

8 *Louisiana Courier*, March 10, 1840. *New Orleans Bee*, March 11, 1840.

9 Patricia Brady, "Jules Lion, F.M.C.: Lithographer Extraordinaire," in *Printmaking in New Orleans*, ed. Jessie J. Poesch (Jackson: University Press of Mississippi, 2006), 168.

10 Smith and Tucker, 20.

11 *Louisiana Courier*, March 14, 1840; copied from Jules Lion's artists file at the Historical Center of the Louisiana State Museum. Hereafter cited as LSM.

12 Interestingly, Samuel F.B. Morse reported on the daguerreotype from Paris to the New York *Observer* saying, "The exquisite minuteness of the delineation cannot be conceived. No painting or engraving ever approached it," quoted in Smith and Tucker, *Photography in New Orleans*, 15. Morse's observations comment on the desire for detail in visual reproduction.

13 A.T., "Le Daguerréotype," *Le Lithographs, Journal Artistes et des Imprimeurs* (1839), 298, as cited and translated in Jeff Rosen, "Lithographie: An Art of Imitation" in *Intersections: Lithography, Photography, and the Traditions of Printmaking*, ed. Kathleen Stewart Howe (Albuquerque: University of New Mexico Press, 1998), 27.

14 See Beaumont Newhall and Robert Doty, "The Value of Photography to the Artist, 1839," *Bulletin of the George Eastman House of Photography* 11, no. 6 (1962): 25–28. For an example see Janet E. Buerger, *French Daguerreotypes* (Chicago: University of Chicago Press, 1989), Figure 19 and Plate 1.

15 Clifford Krainik claims that Haas's portrait of Adams was the first, but if Lion used one of his daguerreotypes for his print of the cathedral, this work antedates Haas's by one year. See Krainik, "National Vision, Local Enterprise: John

Plumbe, Jr., and the Advent of Photography in Washington, D.C.," *Washington History* 9, no. 2 (Winter 1998): 14.

16 *Louisiana Courier*, June 18, 1842, LSM.

17 *Journal des Artistes*, April 27, 1828, 261, as quoted in Nicholas Green, *The Spectacle of Nature: Landscape and Bourgeois Culture in Nineteenth-Century France* (Manchester: Manchester University Press, 1990), 101.

18 *Bee*, January 10, 1838. The first church on the site was built in 1718 under the French. Lion captured the third, built in 1789 by the Spanish, and it was raised to cathedral rank in 1793. The article erroneously says the cathedral had received no repairs in 60 years, but it was not quite 50.

19 Benjamin Moore Norman, *Norman's New Orleans and Environs* (New Orleans: B.M. Norman, 1845), 74.

20 Armand Lanusse, "*La Cathedrale Saint-Louis*," *Bee*, August 8, 1839.

21 *Bee*, January 10, 1838.

22 Norman, *Norman's New Orleans*, 74.

23 Joseph Tregle, "Creoles and Americans," in *Creole New Orleans: Race and Americanization*, ed. Arnold R. Hirsch and Joseph Logsdon (Baton Rouge: Louisiana State University Press, 1992), 141, 153–4.

24 Tregle, "Creoles and Americans," 156.

25 For an interesting perspective, see James E. Winston, "Note on the Economic History of New Orleans, 1803–1836," *Mississippi Valley Historical Review* 11, no. 2 (September 1924): 224–5.

26 H. Didimus [E.H. Durrell], *New Orleans as I Found It* (New York: Harper & Bros., 1845), 79.

27 A. Oakley Hall, *Manhattaner in New Orleans* (New York: Redfield, 1851), 102.

28 Joseph G. Tregle, Jr., "Early New Orleans Society: A Reappraisal," *Journal of Southern History* 18, no. 1 (February 1952): 31; Tregle, "Creoles and Americans," 153.

29 Andrew Szegedy-Maszak, "A Perfect Ruin: Nineteenth-Century Views of the Colosseum," *Arion* 2, no. 1 (Winter 1992): 118–19. Like Lion's daguerreotypes, none of the original daguerreotypes for *Excursions Daguerriennes* are extant. Newhall, *History of Photography*, 19.

30 *Louisiana Courier*, June 18, 1842.

31 The Historic New Orleans Collection accession nos. 1959.3 and 1940.1. The first is erroneously signed "A Persac."

32 *Louisiana Courier*, June 18, 1842.

33 Anglo-American Museum, *The Louisiana Landscape, 1800–1969* (Baton Rouge: Louisiana State University, 1969), 16, as quoted in Estill Curtis Pennington, *Downriver: Currents of Style in Louisiana Painting, 1800–1950* (Gretna: Pelican Publishing Company, 1991), 65.

34 William H. Gerdts, "Louisiana Art: Regionally Unique; Southern Exemplar," in *Complementary Visions of Louisiana Art: The Laura Simon Nelson Collection at the Historic New Orleans Collection*, ed. Patricia Brady, Louise C. Hoffman, and Lynn D. Adams (New Orleans: Historic New Orleans Collection, 1996), 21.

35 *Bee*, December 24, 1840; January 4, 1843; for Paris in wood, October 8, 1842.

36 *Frank Leslie's Illustrated Newspaper*, March 1, 1856. See also Patricia Brady, "Seeing Is Not Believing," *Historic New Orleans Collection Quarterly* 18, no. 1 (Winter 2000): 7.

37 For the veracity of *Frank Leslie's* images, see Andrea G. Pearson, "*Frank Leslie's Illustrated Newspaper* and *Harper's Weekly*: Innovation and Imitation in Nineteenth-Century American Pictorial Reporting," *Journal of Popular Culture* 23, no. 4 (1990): 81–111.

38 *Plan and Program for the Preservation of the Vieux Carre* (New Orleans: Urban Renewal Demonstration Project, 1968), 17.

39 McInnis, "Little of Artistic Merit," 11–18.

Complex Negotiations:
Beadwork, Gender, and Modernism in Horace Poolaw's Portrait of Two Kiowa Women

Laura Smith

Horace Poolaw was one of the first professional American Indian photographers of the early twentieth century. Born in Mountain View, Oklahoma, in 1906, Poolaw observed and documented his community's twentieth-century efforts toward sovereignty and economic security. Yet his photographs were relatively unknown and unanalyzed until recently. This is largely due to the long-standing scholarly neglect of American Indian art. Indigenous artists have rarely been included in American art historical surveys or exhibitions; they are conventionally assigned to a separate art category. The story of American modernism has generally followed Euro American male artists who, beginning in the mid-nineteenth century, challenged classical modes of visual representation and either embraced or rejected modernization. Much scholarship has shown the gendered and racial exclusiveness of the Western modernist core. If non-Western artists are included in this history, they are identified as modernist only if they share the attributes of the Western avant-garde. In these writings, modernism is a central, static force to which female and non-Western artists are peripherally positioned.[1] At the margins of the Western art circle, they can only react to it or act upon it.

In light of this invisibility, one of the most unique and valuable subjects that Poolaw photographed between 1926 and 1980 was that of American Indian women. In a 2002 lecture on Poolaw at Smith College, folklorist and poet Rayna Green (Cherokee) discussed how his work challenges conventional ways of seeing and knowing Indian women.[2] Green has written extensively on popular European representations of Indians. In particular, *The Pocahontas Perplex* examines the development of the symbolic Indian princess, such as Pocahontas.[3] In contrast to those white, fabricated Indian princesses who

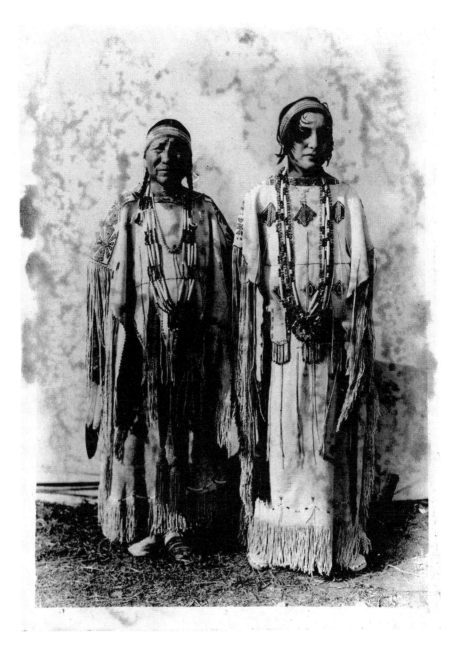

14.1 Horace Poolaw, *Cynthia and Hannah Keahbone*, c. 1930. Vintage print. Author's collection. Courtesy Horace Poolaw Family. Original negative stored at Nash Library, University of Science and Arts of Oklahoma, Chickasha, OK

are forever trapped in a preindustrial past, Poolaw's female subjects stand distinctly in the moment in which they lived. This paper examines Poolaw's (Kiowa) portrait *Sindy [Sayn-Day-Mah] and Hannah Keahbone* (c. 1930) (Figure 14.1). The mother and daughter stand in front of a tipi at a public event near the Oklahoma City Farmers Public Market.[4] They wear modern Kiowa women's most prestigious clothing, beaded buckskin dresses. Sindy Keahbone (1870–1950) was an excellent beadworker, but the dress she wears in this photograph was made by Old Lady Smoky. Hannah's (1913–75) dress was made by Mrs. Kicking Bird.[5] Despite the prevailing federal Indian policies of assimilation, the Keahbone's determination to proclaim and perpetuate a high regard for their cultural heritage and female artistry is noticeable. The tipi backdrop further promotes a contemporary vision of Kiowa female authority. A close study of this photograph reveals the way that Poolaw's photography advances our understanding of American women's modernist art production.

Recognition for Poolaw's Photography

Many people have come to know Poolaw's work as a result of the 1989 conservation and research effort initiated at Stanford University, under the direction of his daughter Linda Poolaw (Kiowa/Delaware) and Stanford's then assistant dean of Undergraduate Studies, Charles Junkerman. This project contributed invaluable documentation on Poolaw's photographs, and resulted in an exhibition that traveled the country beginning in 1991.[6]

Poolaw never totally supported himself or his family with his photography. The family isn't sure of the amount of money his work brought in, but it wasn't much. He didn't print many of his negatives because of the expense. Poolaw was mostly self-taught but sought out technical advice from local studio photographers such as George Long. Under Long's tutelage in the 1920s, Poolaw learned the mechanics of studio photography and began taking his own photographs at local fairs, expositions, and Wild West shows. He printed some of his photographs on postcard stock to sell at local fairs. Both Indians and non-Indians purchased them. Besides the postcards, Poolaw also made 5 by 7 inch prints and larger, hand-colored photographic portraits, a few of which do survive. Most of Poolaw's early images are portraits of family, friends, and noted leaders in the Kiowa community. Today a few Poolaw postcards and prints have ended up in museum collections including the Anadarko Heritage Museum in Oklahoma. More Poolaw postcards and prints can be found at the Oklahoma Historical Society in Oklahoma City, the Ft. Sill Museum and the Museum of the Great Plains in Lawton, Oklahoma, the Stockade Museum in Medicine Lodge, Kansas, and the National Anthropological Archives and the National Museum of the American Indian in Washington, DC.

Each of these venues, however, contains only a small number of Poolaw's works. Some of them are prints made from the same negative, so it has not been possible to grasp the real breadth of his interests and endeavors. Most of the photos are carefully preserved and stored in archives, away from public view. They are all certainly available by request, but most people wouldn't know to ask for them. A hidden location is additionally true for the vast number of Poolaw's negatives. After Poolaw's death in 1984, the family kept them stored in boxes in their homes. Since 2010, the University of Science and Arts of Oklahoma's (USAO) Nash Library in Chickasha, Oklahoma, has stored the Poolaw negatives that are known to exist.[7] This is where the negative for the Keahbone portrait can be found.[8]

The Poolaw family has a long-standing and personal connection to USAO. Linda Poolaw is a 1974 graduate, and in 1995, the university honored her for her outstanding accomplishments in tribal leadership, public health, and the arts. The USAO Art Gallery also hosted an exhibition of Horace Poolaw's work in 1998. Now coed, USAO began as an industrial institute for girls in 1908 and evolved into the Oklahoma College for Women four years later. It was one of only five other US educational institutions of its kind at the time.[9] While founded as a college for white (or nonblack) women, a notable early twentieth-century American Indian graduate is the internationally recognized Chickasaw storyteller and performer Te Ata (1895–1995). One of the earliest faculty members was Choctaw historian Anna Lewis (1885–1961). The present context for Poolaw's negative collection is another reason to privilege a discussion on a few of his female subjects. A few of Poolaw's photographs have been integrated into American Indian art historical surveys, but little extended attention has been devoted to his representations of women.

Beadwork as a Signifier of Modernism

Scholars such as Marcia Bol, Barbara Hail, and Jacki Thompson Rand (Choctaw) provide justifications for considering American Indian women's modernism on its own terms. They have noted the ways in which Plains women's beadwork practices dramatically changed beginning in the reservation period.[10] They have also demonstrated that this art form mediated the transformations in the artists' lifestyles and identities due to colonialism. Through their writings it becomes apparent that while Plains Indian beadwork continues to be exhibited or studied as a traditional or historical art, the beaded buckskin dresses worn by the Kiowa women in Poolaw's Keahbone portrait are more astutely understood as modernist expressions.

Kiowa beadworkers transformed aspects of their past to respond to their contemporary needs and/or desire. Poolaw's Keahbone portrait documents

this transformation; it reflects a variety of concurrent dialogues on modernity, beadwork, and Kiowa female identity in the 1920s and 1930s. My perspective on Poolaw's portrait is informed by other writers whom have used the lens of transculturation to consider American Indian modernism in terms of multifarious, open-ended negotiations of media, technique, beliefs, and power relations. In line with historian Philip Deloria (Dakota), among others, I present the Indian world framed by Poolaw as a mutable, relational space where Kiowa mothers and daughters, middle-class white women, suffragettes, flappers, Hollywood film actors, field matrons, ethnologists, and Indian agents contested and accommodated new and old lifeways.[11]

Beadwork and Native Women's Authority

Among many North American indigenous communities, women who were skilled in the quillwork and beadwork arts held revered social positions. One of the oldest forms of American Indian decorative arts was quill embroidery, used to ornament important garments and other items such as bags and pipe stems. Bone or shell beads, animal teeth and hair, and painted designs were other common embellishments. Fine clothing and possessions often expressed the wearers' esteem, achievements, and kinship relations. It was a prominent practice among western and northern North American tribes where the porcupine most commonly resided. As the porcupine was not native to the northern Plains where there was an elaborate quillwork tradition, groups traded for the quills. Beads made of glass arrived with the first Europeans and supplemented earlier ornamental practices. The glass beads offered a brighter array of colors and did not require extensive preparation for use as did quills. It's not known exactly when the first beads made their way to the Plains.[12] By the nineteenth century, however, Plains Indian beadwork was a prominent art form.

The dramatic influx of glass beads to the Kiowa reservation in the 1880s influenced a change in the exclusive use of elk teeth as decorative elements to convey female affluence. The stress of the reservation period spurred many Plains Indian women to create some of the most elaborate beadwork ever seen.[13] Articles of clothing, which had contributed to the expression of family identity in the past, were now fully ornamented with complex patterns of beads and cultural symbols. Bol and Hail have linked the intensification of Plains beadwork production on clothing to the need to affirm family and cultural self-images in the face of much social disruption. Kiowa women not only began beading dresses more profusely but also other items that expressed personal and family identity such as their cradleboards.[14] Through the 1920s, master beadworker and cultural historian Vanessa Jennings (Kiowa-Apache / Gila River Pima) has related that "after so many years of some missionaries

forbidding Kiowas and others to dress in traditional clothing, putting on those dresses ... was a way to defy those orders and affirm your right to dress, and express your pride in being, Kiowa or Indian."[15] Decorative emphasis on earlier dresses had largely been confined to the garments' edges. Trims included linear beaded designs, fringes, and paint. By the 1880s, geometric and abstracted floral and leaf motifs appeared on the blouse, apron, and skirt areas, such as those on Hannah's dress. Hail has argued that eastern tribes such as the Delaware who moved into Oklahoma Territory in the nineteenth century at least partly inspired these new designs. Individual ingenuity spurred the introduction of other Kiowa motifs such as the oak leaf. Tahdo (Medicine Sage) reportedly invented the design. It gained popularity in the 1920s after she won awards for her work at some Albuquerque craft shows.[16]

Under the auspices of the assimilation program begun in the 1880s, federal reformers established various institutions bent on eradicating indigenous lifeways and worldviews. The forces of Christianity and capitalism accompanied by American colonialism directed Native women to take on white middle-class female domestic duties and raise productive workers. Further, they were to reject the 'heathen' values (and practices) of tribalism. Yet as late as 1926, Kiowa Agency Superintendent John A. Buntin expressed despair that Kiowa women continued to pursue bead-working enterprises. In a letter to the Commissioner of Indian Affairs, Buntin wrote,

> I herewith inclose [sic] you a communication received from Mrs. Susie C. Peters relative to having a Christmas bazaar in Anadarko and Carnegie, Oklahoma. At the bazaar she would exhibit Indian work, a part of which would be sold There is only one objection to the bazaar and that is the fact that it centers the attention of the Indians to a considerable extent on bead work, trinkets and things of less value than the care of children, sanitary conditions, cooking, sewing, laundry work, prevention of the spread of contagious diseases, etc.[17]

In other words, Buntin felt that beadwork impeded an Indian woman's progress toward his conception of modernity. Kiowa women's beading persistence infused the practice with subversive power.

Just the year before, Kiowa Agency field matron Susie Peters had written Buntin that until she encouraged bead-working in the Indian women's farm clubs she organized, the Kiowa women would not show up for meetings.[18] Women's clubs provided training and promoted interest in domestic and agricultural tasks. Some Kiowa women complied with federal reform initiatives; they learned to can and sew. But they also insisted the clubs accommodate beadwork. Compelled by dire economic circumstances, Kiowa women began to turn their labor to commercial beadwork production after 1880. Peters worked with them to expand their markets in the 1920s.

She organized exhibits of their beadwork at local fairs.[19] In this way, Peters didn't strictly follow federal directives. She encouraged the Kiowa to maintain their heritage and supported female entrepreneurship.

Poolaw's portrait of Sindy Keahbone and her daughter Hannah wearing beaded clothing affirm Rand's thesis that Kiowa women retained a high level of political autonomy in the early twentieth century, regardless of the United States' colonial system.[20] Before the reservation period, women's craftsmanship was vital to a family's health, comfort, and prestige. The community particularly rewarded female ingenuity in tipi and clothing production.[21] Jennings indicates that a Kiowa woman showed her status by the way she set up her camp, as well as the way she dressed herself and her family. Linda Poolaw remembers that even in the mid-twentieth century people held great respect for women who maintained an orderly household (like their camps) and were highly skilled in beadwork.[22]

The Keahbones further conveyed their modern prestige by donning the most esteemed material of the time. The Kiowas had used animal hides to create clothing up through the nineteenth century. But by the 1820s, John Ewers indicates that important Kiowa women preferred dresses made of trade cloth and ornamented with elk teeth.[23] After 1890, they were more commonly wearing beaded and painted buckskin outfits for important occasions. By the reservation period buckskin had become difficult to obtain and this enhanced its value.

Contemporary Fashion and Native Women's Modernity

Not all of the standards for female behavior and self-presentation lay in the past, nor in federal mandates for Indian women's "progress." Contemporary fashions and film stars of the 1920s inspired some young Kiowa women to alter their clothing, hair, and lifestyles.[24] While Sindy conservatively wears her hair in the standard long braids, Hannah somewhat coyly engages the photographer behind the short locks of the popular, flapper-style bob. Reportedly, Hannah was a rebel. Vanessa Jennings remembers that she defied temperance laws and the field matrons from the Anadarko Indian Agency. She wore makeup and, as described by Jennings,

> was known to have a small metal flask held in place by the tight roll of her stockings just above her knees. She was bold and beautiful. The rules for women and their physical appearance at this time [were] harshly regulated by the field matrons at the Anadarko Indian Agency. You were supposed to be dressed like a super-modest white woman and NO makeup.[25]

Among many American women in this period, the adoption of the bob hairstyle signified a rejection of Victorian demureness and confining modes of appearance and behavior.

Modern women found short hair easier to maintain. They also preferred corsetless dresses for freer movement. This flapper fashion responded to the interwar-period woman's push for social and political liberation. The film star Clara Bow popularized the new, unrestrained American female type. According to film scholar Sara Ross,

> This modern girl [Clara Bow] was sexually aggressive. She would smoke, drink and neck her way through films, wearing revealing clothing and making suggestive remarks while attending wild parties and dancing to ... jazz bands or driving roadsters at dangerous speeds.[26]

Jennings recalls that "every woman in America wanted to be Clara Bow." Similar to Bow's portrait on the July 1927 cover of *Motion Picture Classic*, Hannah loosely tied her tousled, bobbed hair back with a headband (Figure 14.2). Each woman in Poolaw's photograph greets the viewer with a sultry, half-smile by raising the right corner of their mouth. Hannah's saucy gaze allies her with Bow, that female transgressor of white, middle-class polite society. This rebellion against Victorian mores was also documented among American Indian girls attending federal off-reservation boarding schools in this period. Ethnohistorian K. Tsianina Lomawaima (Creek) has examined the ways that clothing and hairstyle clearly marked the terrain of power in the Indian boarding schools, especially in the girls' dormitories. Lomawaima demonstrates that despite military regimentation in dress and domestic training at the Chilocco Indian Agricultural School in Oklahoma, students often found creative ways to undermine federal educational directives. For the girls, some of these acts included bobbing their hair.[27] In addition to rejecting white womanhood conventions, Hannah Keahbone's appearance challenges standards for Kiowa female respectability, represented by her mother's expressive restraint. Most other elder women in Poolaw's portraits from this period follow Sindy's example.

Not simply responding to federal authorities, twentieth-century Kiowa mothers and daughters often negotiated the terms for female identity among themselves. Of the few published accounts of Kiowa women's conversations in this period, most record a contentious divide between the generations. In her 1927 book *Kiowa Tales*, ethnologist Elsie Clews Parsons noted the tensions between some Kiowa adults and their children. They argued about modes of dress and social conduct. In the introduction, Parsons describes an "incredibly great" gap "between the Kiowa generations."[28] Focused on her informants Sendema and her daughter Katie, Parsons illustrated their differences through clothing. Katie, who Parsons describes as "a widow and out of hand," is reported by the ethnologist to "disdain" her valuable buckskin dress.

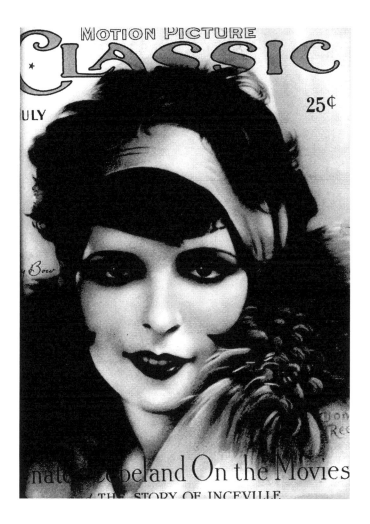

14.2 *Motion Picture Classic*, cover, July 1927

She was looking forward to buying a fur coat. By contrast, Parsons writes that Sendema "lovingly" folded hers in cloth before packing it away in a trunk.[29] Parsons conveyed her concern about the younger generation of Kiowa who "are either ignorant of the tribal past or ashamed of it."[30] She claimed the elders with whom she worked also shared her worries. In choosing to begin her book with stories of ambivalent youth, Parsons effectively suggested the future of Kiowa culture was doomed. Another ethnologist working among the Kiowa in the 1930s, Alice Marriott, wrote about elder Kiowa women's concerns over contemporary fashions, particularly the shortening of skirts. Only "bad" women or white women chose to wear short dresses.[31]

Poolaw's portrait of the Keahbones frames what surely must have been a more nuanced conversation. Despite her bad-girl bob, Hannah Keahbone dons a beaded buckskin dress, not a fur coat or knee-high dress. A daughter stands resolutely with her similarly dressed mother against the backdrop of a tipi. The Keahbones are ultimately united by intergenerational signs of Kiowa female authority and self-affirmation.

Conclusion

The complexity of Poolaw's portrait of the Keahbone's in their beaded dresses reflects the reality of the contemporary context of colonization. Yet, the photo also generates a sense of the creative life force that is a Kiowa female legacy. The women appear uniquely engaged with their present, as well as their heritage. Women adorned their own bodies, and those of their families, with political and social symbols particularly relevant to their present lives. They also transformed aspects of the past, such as gender roles or expressions of status, to sustain Kiowa culture and identity. The flux or modernism of early twentieth-century Kiowa culture and art was not an oppositional, essentially foreign, or deadly force. It was part of the ongoing process of life whereby Kiowas made choices to direct their present and future. The reservation period was one of many periods of change.

The varied faces of the women in Poolaw's portrait preserve Kiowa memory for the community; they have further substantial value in advancing the global consciousness of twentieth-century American Indian female vitality. While much work is now being done to exhume Poolaw's important contributions to the history of photography, quite often works by non-Western and female artists continue to be hidden away even when recovery projects are successful. The perception that American Indian art does not "fit in" with Western male aesthetic sensibilities regularly contributes to their exclusion from most major art history surveys, art museum collections and exhibitions, university curriculums, and art journals.[32] In relation to several museums who recently renovated their galleries of Native art, *ARTNews* journal contributor Kyle MacMillan noted that "the challenge [for these museums] is how to situate Native American art in a broader historical context." The question that is not asked is which or whose historical context. American Indian and women's arts are not the problem. It's the history.[33] In constructing a story that draws from notions of culture and identity that are unfixed and perpetually in flux, this essay opens up the closets and provides a method toward a more inclusive vision of twentieth-century American art and experience.

Notes

1 For example, see Truman T. Lowe, "The Emergence of Native Modernism," and Gail Tremblay, "Different Paths, Tracks Worth Following," in *Native Modernism: The Art of George Morrison and Allan Houser*, ed. Truman Lowe (Smithsonian National Museum of the American Indian in association with University of Washington Press, 2004); Bill Anthes, *Native Moderns: American Indian Painting, 1940–1960* (Durham, NC: Duke University Press, 2006); David Penney and Lisa Roberts, "America's Pueblo Painters: Encounters on the Borderlands," in *Native American Art in the Twentieth Century*, ed. W. Jackson Rushing (London: Routledge, 1999); W. Jackson Rushing, "Essence and Existence in Allan Houser's Modernism," *Third Text* 39 (Summer 1997): 87–94, and "Modern By Tradition: The Studio Style of Native American Painting," in *Modern By Tradition: American Indian Painting in the Studio Style* (Santa Fe: Museum of New Mexico Press, 1995); Gerhard Hoffman, "Frames of Reference: Native American Art in the Context of Modern and Postmodern Art," *Arts of the North American Indian: Native Traditions in Evolution*, ed. Edwin L. Wade (New York: Hudson Hills in association with Philbrook Art Center, Tulsa, 1986).

2 Rayna Green, along with Linda Poolaw, visiting lecture, "War Bonnets, Tin Lizzies, and Patent Leather Pumps: Native American Photography in Transition," Smith College, February 7, 2002.

3 Rayna D. Green, "The Pocahontas Perplex: The Image of Indian Women in American Culture," *Massachusetts Review* 16 (1975): 698–714.

4 The Keahbones appear in a series of photos that Poolaw took of a group of Kiowas dressed in full regalia near the farmer's public market in Oklahoma City. Based on documentation in the 1979 brochure of Poolaw's exhibition at the Southern Plains Indian Museum in Anadarko, some Kiowas may have participated in the opening ceremonies for this market in 1928. Newspaper accounts of the opening do not make note of any Indian activities that would help clarify their involvement. *Photography by Horace Poolaw*, exhibition brochure, US Department of the Interior, Indian Arts and Crafts Board, Southern Plains Indian Museum and Crafts Center, Anadarko, Oklahoma, May 27–June 27, 1979.

5 Vanessa Jennings interview with author, September 2012.

6 See Linda Poolaw, *War Bonnets, Tin Lizzies, and Patent Leather Pumps: Kiowa Culture in Transition, 1925–1955* (Stanford, CA: Stanford University, 1990). Some of the venues for the Poolaw traveling exhibit cosponsored by Stanford and the Eastman Kodak Company before 1995 were the Natural History Museum of Los Angeles County, February–April 1992; the Smithsonian's National Museum of American History in 1992; the Heard Museum in Phoenix, AZ, October 1993–January 1994; the Gilcrease Museum in Tulsa, OK, July–September 1993; the Kiowa Tribal Museum and Resource Center in Carnegie, OK, June–August 1994; and the Loveland Gallery, Loveland, CO, October–December 1994. Scholar Nancy Marie Mithlo and photographer Tom Jones have continued this important preservation and research work on Horace Poolaw's images. Nancy Marie Mithlo, "'A Native Intelligence': The Poolaw Photography Project 2008," http://nancymariemithlo.com/Research/2008_Poolaw_Photo_Project/index.html. My work on the subject of

modernity, modernism, and Horace Poolaw's photographs is further developed in my 2008 dissertation "Obscuring the Distinctions, Revealing the Divergent Visions: Modernity and Indians in the Early Works of Kiowa Photographer Horace Poolaw, 1925–1945" (PhD diss., Indiana University, 2008). A revised version of this research to be published by the University of Nebraska Press is forthcoming.

7 The Poolaw family controls the copyright to all of Horace Poolaw's materials. They have estimated that there are around 2,000 negatives in total.

8 The vintage print of the Keahbones reproduced in this essay is owned by the author. In my own efforts to research and preserve Poolaw's works, I purchased this print from a used book dealer in 2005. Recognizing that art in personal collections provides only limited access to scholars, I hope that this essay broadens the availability of this important image.

9 Anna Lewis, "The Oklahoma College for Women," *Chronicles of Oklahoma* 27 (Summer 1949): 179–86. USAO's significance in shaping public education for women led to its listing as an historic district on the National Registrar of Historic Places in 2001.

10 Barbara Hail, ed., *Gifts of Pride and Love: Kiowa and Comanche Cradles* (Bristol, RI: Haffenreffer Museum of Anthropology, Brown University, 2000), 22, 25; Marcia Bol, "Lakota Women's Artistic Strategies in Support of the Social System," *American Indian Culture and Research Journal* 9, no. 1 (1985): 33–51; Jacki Thompson Rand, *Kiowa Humanity and the Invasion of the State* (Lincoln: University of Nebraska Press, 2008), 131–50.

11 Phil Deloria, *Indians in Unexpected Places* (Lawrence: University of Kansas Press, 2004). See also Elizabeth Hutchinson, "Modern Native American Art: Angel DeCora's Transcultural Aesthetics," *Art Bulletin* 83, no. 4 (December 2001): 740–56, and *The Indian Craze: Primitivism, Modernism, and Transculturation in American Art, 1890–1915* (Durham, NC: Duke University Press, 2009); Jennifer McLerran, *A New Deal for Indian Art: Indian Arts and Federal Policy, 1933–1943* (Tucson: University of Arizona Press, 2009); Ruth Phillips, "Morrisseau's 'Entrance': Negotiating Primitivism, Modernism, and Anishnaabe Tradition," in *Norval Morrisseau, Shaman Artist*, ed. Greg A. Hill (Ottawa: National Gallery of Canada, 2006). Transculturation or neoculturation was coined by Fernando Ortiz in 1947 to account for the "creation of new cultural phenomena" through a union of cultures. *Cuban Counterpoint: Tobacco and Sugar* (New York: Alfred A. Knopt, 1947), 103.

12 Barabara Hail, *Hau, Kóla!: The Plains Indian Collection of the Haffenreffer Museum of Anthropology* (Providence, RI: Haffenreffer Museum of Anthropology, 1980), 51.

13 David Penney, *Art of the American Indian Frontier: The Chandler-Pohrt Collection* (Seattle: University of Washington Press, 1997), 48–54. The Kiowa did little quillwork. William C. Meadows, *Kiowa Military Societies: Ethnohistory and Ritual* (Norman: University of Oklahoma Press, 2010), 424, n. 85.

14 Hail, *Hau, Kóla!*, 22 and 25; Bol, "Lakota Women's Artistic Strategies," 33–51.

15 Vanessa Jennings interview with the author, October 8, 2005.

16 Hail, *Hau, Kóla!*, 28–9, 87.

17 Letter from John A. Buntin, Kiowa Agency Superintendent to the Commissioner of Indian Affairs, October 2, 1926, Record Group 75, Kiowa CCF 1907–1939, Associations and Clubs, National Archives, Washington, DC.

18 Letter from Susie Peters to John A. Buntin, Kiowa Agency Superintendent, March 19, 1925, ibid.

19 Rosemary Ellison, "Introduction," *Contemporary Southern Plains Indian Painting*, exh. brochure (Anadarko: Oklahoma Indian Arts and Crafts Board Cooperative and the Southern Plains Indian Museum and Crafts Center, 1972), 14–15; "Woman Responsible for Kiowa Indian Artists Relates How They Began in 1917: Art Is 'Second Nature' to Them," *Anadarko Daily News*, August 21, 1938, 4.

20 Rand, *Kiowa Humanity and the Invasion of the State*, 150.

21 Women built and owned their tipi homes. Bernard Mishkin's study of class among Kiowa women in 1940 affirmed that their creative industries were key to their stature in the community. *Rank and Warfare among the Plains Indians* (1940; reprint, Lincoln: University of Nebraska Press, 1992), 55.

22 Vanessa Jennings interview with the author, October 8, 2005. Linda Poolaw, "Bringing Back Hope," *All Roads Are Good: Native Voices on Life and Culture* (Washington, DC: Smithsonian Institution and the National Museum of the American Indian, 1994), 216. Ethnologist Elsie Clews Parsons recorded similar rules for Kiowa female behavior and self-presentation during her 1927 fieldwork, in *Kiowa Tales* (New York: American Folklore Society, 1929), x.

23 John C. Ewers, "Climate, Acculturation, and Costume: A History of Women's Clothing among the Indians of the Southern Plains," *Plains Anthropologist* 25, no. 87 (February 1980): 78.

24 Horace's nephew Newton Poolaw (b. 1918) remembered Kiowas occasionally going to movie theaters in Mountain View in this period. Newton Poolaw interview with the author, October 17, 2005.

25 Vanessa Jennings interview with the author, September 2012.

26 Sara Ross, "'Good Little Bad Girls': Controversy and the Flapper Comedienne," *Film History* 13, no. 4 (2001): 409.

27 K. Tsianina Lomawaima, "Domesticity in the Federal Indian Schools: The Power of Authority Over Mind and Body," *American Ethnologist* 20, no. 2 (May 1993): 232. Not so far away from Chilocco, Haskell Indian School student Irene Stewart (Navajo) reported on the widespread adoption of makeup and the bob by Indian girls in the 1920s. Despite anxieties about looking like a boy, Stewart and some of her friends upheld the benefits of the short hairstyle in terms of the ease of its care, a more youthful appearance, and a sign of wealth. Irene Stewart, *A Voice in Her Tribe: A Navajo Woman's Own Story* (Socorro, NM: Ballena Press, 1980), 29–30.

28 Parsons, *Kiowa Tales*, x.

29 Ibid., ix.

30 Ibid., xi.

31 Alice Marriott, *The Ten Grandmothers* (Norman: University of Oklahoma Press, 1945), 272.

32 Two notable recent examples of international exhibits where the Western modernist canon was reified include the Victoria and Albert Museum's *Modernism: Designing a New World, 1914–1939*, Christopher Wilk, ed. (London: V&A Publications, 2006), which opened in London and arrived in 2007 at the Corcoran Gallery of Art in Washington, DC, and the 2013 exhibition at the Museum of Modern Art in New York City, *Inventing Abstraction: 1910–1925: How A Radical Idea Changed Modern Art*, Leah Dickerman, ed. (New York: Museum of Modern Art, 2012).

33 Kyle MacMillan, "Bring Out the Masterpieces," *ARTnews*, February 2011, 47.

La Fille au Reflet de l'Homme:
A Portrait of Pegeen Guggenheim

Elizabeth Kuebler-Wolf and Connie Cutler

Nestled in the bucolic setting of Peru, Indiana, is a small gem of an art collection housed at the Peru High School. Consisting of both Chinese porcelain and modernist painting and printmaking, the Peru collection is an unusual find in a public high school. In collaboration with Peru High School teacher Wayne Taylor, G. David Thompson (1899–1965), a Peru High School graduate who became a successful steel executive and banker, donated a wide range of modernist and Chinese art to the high school over a period spanning nearly 20 years (1946–65) with the idea that art students would benefit from direct exposure to original works of art. The Peru High School collection stands out as a coherent and deliberate formation: the unique product of a friendship between a philanthropic, public-minded collector of art and an art teacher, both of whom believed in the necessity of careful study of real art objects.

Among the works in the collection is a fine portrait by Jean Hélion of Pegeen Guggenheim (1925–67) (Plate 14), daughter of Peggy Guggenheim, and an artist in her own right. The portrait dates to 1944, just prior to Pegeen Guggenheim's marriage to Jean Hélion. Although other portraits of Guggenheim by Hélion have been published (one is available for purchase as a lithograph from the Guggenheim in Italy), this portrait has been unavailable for study outside of Peru, and like both its subject and painter, largely overlooked. Since Pegeen Guggenheim's death, only one study of her life has been published; Hélion similarly has faded into semi-obscurity in the last 25 years.[1] Only in the past few years with the initiative the Peru School Superintendent and the Peru Community School Board to create a dedicated gallery space has the painting been on public display in Indiana.

G. David Thompson and the Peru High School Collection

G. David Thompson was a prolific collector of modern art. He built an impressive personal collection, which the Guggenheim Museum exhibited in a solo show, One Hundred Paintings from The G. David Thompson Collection, in 1961. In the preface to a catalog of the show of Thompson explained,

> It has been my experience that in purchasing works of art the buyer is inevitably the one who gains. The seller receives payment but once. The purchaser however collects a daily spiritual dividend that goes hand in hand with ownership of great art. The joy of possessing it contains a special uplifting ingredient that permits the possessor to live in an aura reserved for the Saints.[2]

In the One Hundred Paintings show, Thompson's astute eye as a collector of contemporary art is evident. While there are canonical artists such as Van Gogh, Degas, and Picasso in the collection, Thompson also collected works by more cutting-edge artists such as Alberto Giacometti and Jean Dubuffet. Thompson would always be a bold collector, purchasing the financially risky works of Arte Povera artists like Alberto Burri. But he balanced these more risky works with solid "investment" pieces like Picasso's Femme Assise, Robe Bleue (1939).[3] Thompson's choice to collect avant-garde art has been explained by art historian John Richardson as "born out of resentment—resentment of stuffy Pittsburg society, which supposedly scorned him."[4] Richardson explains, "To get back at the old guard, Dave set about trouncing them in the field of modern art—the one field where the old guard would not have noticed or cared whether they had been trounced or not."[5]

Thompson's fingerprints are on some important museum collections. For example, he gifted Willem deKooning's Woman IV (1953) and Henry Moore's Reclining Figure (1957) to the Carnegie Museum of Art, and in 1959 the Museum of Modern Art in New York received Picasso's Two Nudes (1906), as a gift in honor of Albert Barr, and Antoni Tàpies's Painting (1957).[6] Beyond the gifts Thompson made to various museums, his name shows up in provenance records multiple times for a myriad of collections including the Tate Gallery in London and the Museum of Contemporary Art in Los Angeles.[7] None of Thompson's big-price-tag or riskily avant-garde paintings were meant for the Peru collection, however.

For the Peru collection, Thompson judiciously chose pieces that represented more conservative modern art, or were more modestly priced, such as prints rather than paintings. Modern works in the Peru collection include a minor Picasso print, and paintings by Maurice Prendergast, Jean Metzinger, Arthur Bowen Davies, and Max Pechstein. Another significant part of the collection is Chinese ceramics. Everything in the collection was made available for students to study, paint, draw, and copy. The Peru collection was intended as a teaching tool in that it would provide students at Peru the chance to look

closely at works of art in person rather than in reproduction. In this regard, Thompson collaborated with art teacher Wayne Taylor, who began teaching at Peru in 1943. Working with Taylor, Thompson supplied the school with original art to benefit the students at Peru as well as the local community until Thompson's death in 1965.[8] "These works were donated with the understanding that they be displayed and used for public appreciation and education," noted Taylor's successor at Peru High School.[9]

Despite the outstanding works of art that characterize the Thompson collection, it has rarely been on display outside of the high school and even at the high school the full collection has never before been on display. Because the collection of Chinese ceramics is so impressive, Dr. Yutaka Mino, curator of Oriental Art at the Indianapolis Museum of Art (IMA), arranged for the IMA to display the 54-piece collection from 1979 to 1986, and the IMA still has four pieces on loan. But that was not the case with other works in the collection. After years in storage, this unusual collection is now on display in a dedicated gallery space, the Peru High School Fine Art Gallery.

The Portrait of Pegeen Guggenheim: A Modernist Pedigree

Jean Hélion's portrait of Pegeen Guggenheim was a good choice for the Peru High School art collection. Painted at a pivotal point in Hélion's career, with a subject who lived at the center of international modernism, the portrait represents the best of both worlds for an art school collection: not too valuable to be put out in the classroom, but significant as an example of one way to approach painting, with close connections to the international art world. Viewed in person, the painting clues students into ways in which pigment can be applied abstractly, boldly, and painterly in a semiabstract composition that is still legible as a portrait, and in which a semiabstract composition can convey rich meaning. In *La Fille au Reflet de l'Homme*, the girl stands on a wet pavement, a tear on her cheek, while at her right, a man walks away from her, and the viewer, down the pavement. The curb that separates them is cracked and broken. We see the man's overcoat, pants, and shoes; only in the wet pavement do we see the back of his head and his hat, reflected on the mirrored surface of the water, faceless and facing away from us.

Other Hélion portraits of Guggenheim from this period, notably the lithograph *Fille au Mannequin* (Guggenheim Venice) contain similar allusions to broken pathways, impassable gulfs, and men or women in the shadows, in mirrors, faceless, encased, and estranged. The title is a play on words and meanings; in English it can be translated as "the girl in man's reflection," "the girl in man's image," or "the girl reflected in man." Each translation suggests a rich vein of gender dynamics in this couple's marriage and artistic life. It may also allude to the broken relationship between Guggenheim and her

father, Lawrence Vail, or her broken relationship with her stepfather, Max Ernst. The portrait is evocative of loss, trauma, and difficult relationships with men. For students in Indiana, the portrait of Guggenheim provides a good example of how an artist can reconcile the abstract with the recognizable, evoke emotion, and stand on its own as a composition of balanced shapes, colors, and contrasts.

Peegan Guggenheim: A Life

Jean Hélion met Pegeen Guggenheim just as he was making what would become a radical move in the art world of his day, especially for the surrealist and abstract art world of Peggy Guggenheim. After the war, Hélion turned away from abstraction-creation (a movement that embraced formalism, rejecting the vogue for surrealism in the 1930s) to a narrative and symbolic realism that he pursued until the end of his life.[10] His paintings of Pegeen Guggenheim mark a midpoint in this turn, when he was still using abstract forms and unnatural colors to construct his paintings. But as his portraits of Guggenheim show, he was resolving those abstract forms and colors into meaning beyond art for art's sake. Guggenheim, in turn, painted her life with Hélion, their marriage, and their children, in her exuberant, "naive" style.

From birth, Pegeen Jezebel Vail Guggenheim was surrounded by an inauspicious constellation of grownups and would struggle to be taken seriously. Famously, Peggy Guggenheim Vail went into labor with Pegeen after Lawrence Vail, Peggy Guggenheim's notoriously violent husband, dumped a plate of hot beans in her lap. Pegeen was given the middle name Jezebel, perhaps as part of her parents' seemingly desperate attempts to prove they were sexually uninhibited, bohemian, and shocking. In the avant-garde circle in which they traveled, giving their daughter a name saturated with derogatory, sexualized associations may have been amusing; whether this weighed on Pegeen later in life is an open question.[11]

Enduring a variety of her mother's lovers, guests, and hangers-on, Pegeen would never have a stable home-base during her entire childhood. Deprived not only of a single residence to call home, Pegeen's childhood was also filled with a parade of adults who could not, it seems, stop from acting like naughty children. From her early days at Pramousquier, which Pegeen's grandmother called "Promiscuous" because of the behavior exhibited there, to the summer spent at Haywood Hall where Emily Coleman, Djuna Barnes, Peggy Guggenheim, and John Holms spent a summer flirting and bed hopping, Pegeen was raised in an environment where sex was constantly, almost literally, on the table.[12]

Pegeen's own father was culpable in her sexual precocity. Anton Gill's biography of Peggy Guggenheim explains that by the time Pegeen was 17,

"Laurence (whose relationship with his own sister was always too close) seems to have been flirting again with the idea of incest, taking baths with his daughters and trying to interest them in the size of his penis."[13] Gill rather cavalierly claims that Vail "never took matters farther than this"; however, the effect of this kind of behavior on a teenage girl should not be dismissed so easily.[14] At the very least Vail should not be let off the hook for exposing himself to his teenage daughter. Many of Pegeen's paintings deal with issues of sexuality, vulnerability, and family life, her mature work returning over and over to overly cheerful childhood scenes.

What a relief it must have been for Pegeen to meet Jean Hélion in 1943, when her mother showed Hélion's work in her gallery.[15] A hero of the French resistance, a well-established and respected abstract artist, and just barely old enough to be her father, yet entirely unlike her own biological father or stepfather, Max Ernst, each of whom misbehaved sexually with and around Pegeen; Hélion must have been like a pole star for a young woman utterly unmoored in her own life. He was serious and philosophical, and it is evident from paintings done by each artist during their courtship and marriage that Hélion took Pegeen seriously as an artist and as a person, treatment she may never have enjoyed before they met.[16]

A Portrait of the Young Woman as an Artist

During their time together, Hélion and Guggenheim's work reveals an ongoing artistic and intimate personal dialogue. Hélion moved toward a palette of brighter colors, certainly evidenced in his portrait in the Peru collection. As they grew closer and then married, Hélion started a series of images of couples in the rain, the man holding an umbrella to protect his female companion, perhaps a commentary on their relationship.[17] Helion painted at least 12 images of couples under umbrellas during their marriage.[18] Guggenheim had painted a couple under an umbrella as early as 1940 (*Untitled*, c. 1940). Just as Hélion incorporated umbrellas into his paintings of couples in the years of their marriage, both umbrellas and Hélion's signature shock of hair and striped pants repeatedly appear in hers. Each artist responds to the other while remaining within the pursuit of their own styles.

Guggenheim's work has mostly been noted for its strong use of colors, repeated motifs of happy scenes, and naive or reduced forms and figures. A good example of her work from the era of her marriage to Hélion is *My Wedding* (1946) (Plate 15). Painted in strong, exuberantly contrasting colors with an emphasis on primary colors, *My Wedding* is a joyous-seeming composition. On a dark-blue background, Hélion's signature shock of hair and striped pants and Guggeheim's massed yellow topknot, and their relative size compared to the rest of the figures, mark the wedding couple.

Simplified shapes, flattened perspective, and childlike outlines are typical of Guggenheim's style, which may have been influenced by her early exposure to the art of surrealism and encouragement she received as a child artist from figures such as Yves Tanguy.

In his work, it is clear that Hélion saw Guggenheim as an artist, not only as a troubled wild-child as she is portrayed in biographies of her mother.[19] Two paintings by Hélion from 1954 show Guggenheim in her studio, sitting at her desk in various attitudes. In each portrait, Guggenheim's work hangs conspicuously on the wall, or sits on an easel in full view. Paintbrushes figure prominently in each painting. Still, one feels that all is not well. The first, *Pegeen á l'Atelier* from February 1954 (Figure 15.1), shows Pegeen seated at her desk, resting her elbows on a stack of books, looking deep in thought. Her brushes and paint pots sit on the desk, ready, but no easel is in sight. In the later 1954 *Pegeen á l'Atelier*, her hands, the painter's most important tool, rest uncomfortably in her lap, curled up like arthritic claws. They look unable to handle the paintbrushes that sit in a cup on the floor, unused, while an unfinished painting sits waiting on the easel.

15.1 Jean Hélion, *Pegeen á l'Atelier*, 1954. Oil on canvas, 21 1/2 x 25 5/8 in. Musée National d'Histoire et d'Art du Luxembourg

Hélion's paintings of Pegeen in the studio show an artist who is thinking, wrestling, even faltering at her work. These paintings treat her as a real, serious artist, not a dabbler or "naive" hobbyist. Throughout his career Hélion returned to the theme of the artist in the studio; in his later self-portraits he constantly refers to his abstract-creationist origins with paintings inside paintings. He is self-reflexive. But in his portraits of Pegeen as an artist, he is also affirming her singular identity. Even if she is facing some artistic struggle, she is not simply "wife of" an artist, "daughter of" a collector, "mother of" his children, but a serious artist grappling with questions of art.

While Hélion was moving further toward realism, his relationship with Guggenheim matured and then withered under the stress of her mental illness. One story from an observer of the couple in 1951 in Venice suggests that they were intensely immersed in each other's work, and though somewhat callously, notes the mental instability from which Guggenheim suffered.

> Pegeen had slit the veins of her wrists, for the noblest of reasons: namely, because of an argument about painting. Her husband, it seems, had accused her of painting 'gingerbread' Surrealist figures. One wonders if, in revenge, she had taunted him with his umbrellas blown up to the size of trophies of war … . No matter. Pegeen's life was saved, and she went back to the Cafe Flore, where she was joined by the Modiglianesque Helion.[20]

Although they were separated by 1955, Guggenheim continued to live with Hélion as she went to psychoanalysis. During this time, Hélion continued his portraits of Guggenheim, evoking her changing moods and emotions. As he noted, this resulted in "a score of successive studies, each of which … reveals her differences from day to day."[21] At least 33 portrait studies of Guggenheim from 1955 survive; in each Hélion presents multiple views of his subject, intent on capturing her rapidly shifting moods. For example, *Pegeen, Autres Pegeens* (1955, private collection) shows three views of Guggenheim, her hair cropped to the chin, looking strained and tired. As Hélion somberly noted in *Récits et Commentaires*, "there is no situation, however painful it is, that cannot be converted to happiness [a successful outcome] in paint."[22]

Hélion and Guggenheim's marriage would not survive, but Guggenheim continued to paint in her "naive" style and Hélion continued to pursue his realist course after they parted ways. She painted prolifically of marriage, childbirth, and family life, continuing to use bright colors and "gingerbread" surrealist forms. In 1958 she married Ralph Rumney, a member of the Situationist International group. Rumney, whose ephemeral work with Situationist International could not have been more different from Hélion's grounded, painterly realism, would be remain married to Guggenheim until her death, possibly by suicide, in 1967. After Guggenheim, Hélion would marry his former sister-in-law (Pegeen's brother's ex-wife) and continue painting in a realist manner until the end of his life.

Conclusion

Although destined for a rather limited audience, Hélion's *La Fille au Reflet de l'Homme* provides an entry into the life of a complex artistic couple who lived and worked at the very epicenter of international modernism in its heyday. Long forgotten, the painting marks a chapter and an artist contributing to international modernism who has been somewhat overlooked. As a point of entry into a fascinating American and transnational life in which many important midcentury art world figures intersect, this painting merits both further research and a wider audience.

Notes

1 Pegeen Guggenheim's work is on display in a permanent gallery at Guggenheim Venice. It has only been published in Benjamin Lanot and Benjamin Hélion, *Pegeen Vail Guggenheim: A Life Through Art* (Paris: Sisso Editions, 2010), which is extensively illustrated. Hélion's work is in New York's Museum of Modern Art, the Art Institute of Chicago, the Tate London, and other European museums. His art is discussed in Fred Licht, ed., *Homage to Jean Hélion: Recent Works* (Venice: Guggenheim Foundation, 1986); and Jean Hélion, *Jean Hélion* (London: Paul Holberton, 2004).

2 David G. Thompson, preface, in *One Hundred Paintings from the G. David Thompson Collection* (Venice: Solomon R. Guggenheim Museum, 1961), n.p.

3 Picasso's *Femme Assise, Robe Bleue*, most recently sold at auction at Christie's for $29 million in December 2011 (sale 7974, lot 49). See record at www.christies. com/lotfinder/paintings/pablo-picasso-femme-assise-robe-bleue-5459987-details. aspx, accessed June 19, 2014.

4 John Richardson, *The Sorcerer's Apprentice: Picasso, Provence, and Douglas Cooper* (Chicago: University of Chicago Press, 1999), 223–4.

5 Ibid., 224.

6 The Alberto Giacometti Foundation collection is anchored by 55 sculptures and paintings once owned by Thompson; other museums with works donated by Thompson include the Kunsthaus Zürich, the Kunstmuseum Basel, and the Kunstmuseum Winterthur. The Fogg Museum at Harvard University was given Alberto Burri's *Legno e rosso 3* (1956) in memory of Thompson's son.

7 For example, the Norton Simon Museum, the Art Institute of Chicago, the Hirshhorn Museum, the Museum of Modern Art, and the Metropolitan Museum of Art.

8 Paul Engle, "An Historic Account of the Origin of the Thompson Collection in Peru, Indiana, and Its Educational Uses," *Marilyn Zurmuehelen Working Papers in Art Education* 4, no. 1 (1985): 25–9.

9 Ibid., 27.

10 Justine Dana Price, "Abstraction, Expression, Kitsch: American Painting in a Critical Context, 1936–1951" (PhD diss., University of Texas, 2007), 234.

11 See Lanot and Hélion, *Pegeen Vail Guggenheim.*

12 For the Hayward House interlude, see Elizabeth Podnieks, ed., *Emily Coleman, Rough Draft: The Modernist Diaries of Emily Coleman, 1929–1937* (Newark: University of Delaware, 2011).

13 Anton Gill, *Art/Lover: A Biography of Peggy Guggenheim* (New York: Harper Collins, 2002), 229–30.

14 Ibid.

15 Price, "Abstraction, Expression, Kitsch," 242.

16 Pegeen's work was exhibited by her mother on several occasions, but her solo shows outside her mother's purview all postdate her meeting Hélion. Raymond Quineau *Pegeen, peintures, gouaches, dessins : du 7 juin au 21 juin 1949* (Paris: Galerie artiste et artisan, 1949); *Pegeen : mostra personale, disegni a colori e guazzi* (Venice: Galleria del Cavallino, 28 agosto–10 settembre, 1948).

17 In *Récits et Commentaires: Mémoire de la chamber jaune, À perte de vue; Choses revues*, Hélion rejects the idea that his umbrellas have meaning, explaining that umbrellas are simply an interesting object, containing the potential for a variety of shapes. But on the same page, he also says that an abstract motif can become a sign (in a semiotic sense) of reality. Jean Hélion, *Récits et Commentaires: Mémoire de la chamber jaune, À perte de vue; Choses revues* (Paris: École Nationale Supérieur des Beaux-Arts, 2004), 82–3. "L'idée de parapluie, c'était seulement celle de contraste, de legerete, de plis plat, par rapport au vaulume do son corps. C'est-a-dire, que le parapluie était pour moi un terme abstrait, un mélange d'angles, des angles doux qui s'affaisaaient les uns sure les autres et qui changeaiet de forme dès que la main bougeait la crosse ... [mais] Un abstrait devenu figurative, c'est-à-dire un homme plein de signs dont il reconnâit tout a coup l'existence dans la monde." [Translation mine.]

18 These can be seen in the online catalog *raisonée* of Helion's work at www.helion-cat-rais.com/moteur/recherche2.php, accessed September 21, 2014.

19 Gill, *Art/Lover,* and Mary Dearborn, *Mistress of Modernism: The Life of Peggy Guggenheim* (New York: Houghton Mifflin, 2004) both discuss Pegeen's behavior, understandably, but give scant attention to her artistic life.

20 Michel Georges-Michel, *From Renoir to Picasso: Artists in Action* (Boston: Houghton Mifflin, 1957).

21 Jean Hélion, *Récits et Commentaires,* 72. "Il en est resulté une vigntaine d'études successives que ne se ressemblet que par le détail, tellement il y avait de différénces entre elle un jour et elle le jour suivant." [Translation mine.]

22 Jean Hélion, *Récits et Commentaires,* 113, " il n'y a pas de situation, si pénible s'oit-elle, qui'l ne puisse convertir en bonheur de peindre." [Translation mine.]

Silent Protest and the Art of Paper Folding: The *Golden Venture* Paper Sculptures at the Museum of Chinese in America

Sandra Cheng

A journey of a thousand miles begins with a single step.

Lao-Tzu

Housed in the Museum of Chinese in America (MoCA) is the Fly to Freedom collection of paper art that was produced using traditional folk methods of Chinese paper folding. The 123 paper works were created by detainees of the *Golden Venture*, a freighter used to smuggle undocumented immigrants into the United States. On the evening of June 6, 1993, the ship ran aground off the Rockaways in New York City and nearly three hundred migrants, gaunt from a four-month ordeal at sea, poured out of the cramped windowless hold of the vessel. Several drowned that night, a few escaped, but the majority was detained by the US Immigration and Naturalization Service (INS), some for nearly four years. A large group of men were assigned to a detention center in York, Pennsylvania, where they produced over ten thousand paper sculptures that helped fuel a grassroots movement to secure their freedom.

The detainees produced paper sculptures of ships, fruit, and animals, but perhaps the most emblematic was the eagle, an American symbol of freedom and strength. Advocates referred to the paper eagles as "freedom birds," reflecting the detainees' quest for release from the detention centers. The museum has a poignant example of an eagle sculpture that is highlighted on its website (Plate 16). Constructed out of paper and papier-mâché, the bald eagle is perched atop two crossed branches with inscriptions "Fly to the Freedom," "Made in York," and "飛向自由," which specifically referred to their incarceration in Pennsylvania and the desire for liberty.[1] In 1996, MoCA included this eagle sculpture in an exhibition, *Fly to Freedom: The Art of the Golden Venture Refugees*, located in the institution's earlier location at

70 Mulberry Street in New York City's Chinatown.[2] The exhibition became a traveling show that helped raise awareness of the detainees' plight, many of whom were still incarcerated in York three years after the ship's grounding.

Today, the eagle and other *Golden Venture* sculptures are stored in the museum's archives and rarely put on display. Their inaccessibility is a metaphor for the ephemerality of folded paper art, an art form that is difficult to preserve and not the customary subject of art historical scholarship. The absence from display also speaks to the lack of artistic status of the makers, imprisoned refugees from coastal China who were far removed from the art world. The *Golden Venture* makers are not often viewed as artistic identities in comparison to celebrated artists who explore the impermanence of paper constructions such as Thomas Demand or Huang Yong Ping.[3] Huang, the founder of the radical avant-garde collective Xiamen Dada, hailed from Fujian, the same Chinese province that most of the *Golden Venture* passengers called home, but unlike the refugees he was a well-connected entity within the contemporary art scene. This essay proposes that the *Golden Venture* collection at the newly refashioned MoCA helps art historians consider the interconnected roles of politics, identity, and advocacy in relation to artistic production by immigrants. These next pages examine the cultural and artistic issues of transmission of the *Golden Venture* paper sculptures, the communal and individual agency of the disenfranchised, and the importance of gift giving across cultures of this group who were caught in the political red tape of shifting immigration policy. Left to languish in detention centers with an unknown timetable, the *Golden Venture* refugees turned to a folk technique to express their deepest fears, anxieties, and hopes.

Political Puppets, Accidental Artists

After the *Golden Venture* crashed into the Rockaways, the passengers were ordered to jump overboard to reach the shoreline because they were told that if they were caught before reaching land, they would not be able to apply for political asylum. Many could not swim, precipitating a spectacular rescue effort by the Coast Guard and local law enforcement. Sending a strong statement of deterrence to those seeking to illegally enter the United States, President William Jefferson Clinton made a bold move to have the Chinese refugees detained.[4] In earlier cases, if illegal immigrants were caught, it was customary for migrants to apply for political asylum and be released on bond, thereby avoiding jail time. The *Golden Venture* refugees, however, were the largest group of illegal aliens to reach American shores at once, and they did so in the most dramatic manner with television crews documenting the rescue of frightened and malnourished passengers. President Clinton made an example of the *Golden Venture* passengers, a reflection of the hardening US

policies concerning illegal immigration.[5] Captured were 262 men along with 24 women and 14 children; another 6 managed to slip away during the chaos of the rescue.[6] INS was unprepared to accommodate the large number of detainees and transferred the refugees to sites across the country, some as far as Bakersfield, California.[7] Within days, one wing of the medium security jail, York County Prison in Pennsylvania, was converted into a detention center for INS, becoming the largest holding space for the refugees. The prison was a startling welcome for the bewildered men, who had already endured a tortuous voyage to America.[8]

The *Golden Venture* was a 150-foot, worn-out freighter that picked up passengers in Bangkok and again in Mombasa where the ship's hold was filled to overcapacity, a hold that was the size of a two-car garage with one toilet. To gain passage, each person paid a fraction of a $30,000-plus fee to "snakeheads," the human smugglers for whom they planned to work to repay the remaining debt after arrival. For many the trip to America began long before they boarded the *Golden Venture*. To reach Bangkok and ocean passage to the United States, many left China on foot, crossing the mountains in the west into Myanmar and walking their way across tropical terrain to Thailand. On board the *Golden Venture*, they slept, ate, and passed the time on the floor atop tiny spaces allotted to each. The passengers described their overcrowded voyage as a "hell" filled with brutalities from their handlers, who meted out punishment and raped some of the women, as well as the gnawing lack of food.[9] After the shocking end to a traumatic voyage, the men were confined to jail cells in York, rendering them ineffectual and unable to repay their debt to the snakeheads nor to assist their families back home.

The detainees applied for political asylum, citing numerous reasons for leaving that ranged from persecution under China's one-child policy and forced sterilizations to fear of reprisals from involvement with the pro-democracy movement that was violently suppressed at Tiananmen Square in 1989. Without doubt, the majority attempted to illegally enter the United States because of the lack of economic opportunities back home. Almost all the York refugees were from the Fujian province, part of a new wave of Chinese immigration that began in the 1980s that was attracted to the potential for financial success in America.[10] To pass the time as they sought asylum, many of the *Golden Venture* detainees turned to the folk art of paper folding and produced sculpture from torn pieces of paper recycled from magazines and newspapers.

Zhezhi was the traditional art of paper folding that most Chinese learned as children when they mastered basic folds to make paper hats and boats. The *Golden Venture* refugees would have been familiar with paper folding done for amusement or funeral practices. Around the holidays, people often constructed paper fruit out of money for good luck. Paper folding was also an important part of funerary practice, which included the burning of paper

objects to commemorate the dead.[11] At funerals, people folded joss paper, or hell money, into the shape of gold ingots and burned these offerings to provide for the deceased in the afterlife. Traditional Chinese paper folds were fragile and fell apart easily. The detainees, however, developed a sturdier form of *zhezhi* that used glue. To this day, their practice is often referred to as *"Golden Venture* paperfolding" since their art works exposed an overlooked Chinese folk practice to a wide Western public.

Attorneys with little immigration experience helped the detainees process their asylum cases. At the behest of Jeff Lobach, president of the York County Bar Association, many attorneys and legal assistants signed up to take the cases pro bono and took crash courses to learn the basics of immigration law. The detainees had no resources; most arrived with possessions that could fit into a small grocery shopping bag. The attorneys visited the prison to build the asylum cases, providing a service that the detainees had no means to repay. As small tokens of thanks, some of the Chinese men began folding paper sculptures and giving them to the attorneys.[12] They taught each other the folding techniques and soon the practice of constructing paper sculpture for gifts spread to nearly all the men. The detainees, terrified of imminent deportation and frustrated with incarceration, turned idle hands into an expression of appreciation and found a means to reciprocate the attorneys' gift of service. Bound by a culture with highly ritualized gift-giving practices, the Chinese men invented a way to partially satisfy the norms of reciprocation and "saving face" necessitated by receiving pro bono counsel.[13] The *Golden Venture* detainees became artistic makers not only to create tokens of gratitude for the lawyers, but to fulfill the requirements of gift exchange that were intrinsic to their cultural identity.

Collaborative Paper Folding: Techniques and Themes

What initially began as gifts for attorneys turned into an extensive workshop production of paper art. As stories leaked about the detainees' request for asylum, disapproval mounted against their incarceration, which many felt was unjust and inhumane. Some were fleeing from religious persecution, others told horrible tales of forced sterilization (the women detained at other sites reported forced abortions). All feared deportation to China where they would certainly face imprisonment, torture, punitive fines, and possibly death.[14] Supporters soon gathered outside the prison to demonstrate their solidarity with the detainees. A grassroots organization, the People of the Golden Vision, began to meet every Sunday for a weekly vigil. Protesting under the umbrella of social justice, people came together for different reasons. Most were conservative, pro-life advocates who opposed the Chinese government's measures of enforcing a one-child policy; others were politically left-leaning

and viewed the detainees' plight as a human rights issue. The first prayer vigil was held in August, two months after the men arrived in York, and continued until the last man was released.[15] Lobach's wife, Cindy, began distributing a one-page newsletter about the detainees that helped solicit support for their cause.[16] The newsletter included English translations of letters from the Chinese men, reports of detainees held at other sites, requests for supplies or money, and fundraising activities. The support group eventually swelled to 600 members.

Cindy Lobach was the first to suggest the sale of art to help raise awareness and to build funds for their advocacy. The refugees used materials at their disposal, including Styrofoam cups, toilet paper, newspapers, and magazines. At first the paper sculptures were simple, small-scale pineapples and birds that the men gave to prison officials, attorneys, and legal aides. Prison officials encouraged the activity since it lifted the men's spirits. The prison chaplain secured the detainees the right to use scissors under strict supervision. Many of the early works fell apart; therefore, the chaplain persuaded authorities to give the detainees access to glue to help keep the sculptures intact.[17]

Each sculpture was composed of a thousand or more pieces of folded paper. Small paper pieces were folded into triangular forms and nested into each other. The detainees often worked in groups, a factor that was dictated by the prison system. The men were separated by "pods," bi-level units of 16 to 32 cells, which functioned as microcosms of artistic production. A main designer would carefully plan the pattern and his assistants would fold paper, grouping heaps of paper units according to color. Each pod gained a reputation for a genre of paper folding. Bill Westerman, the curator of the *Fly to Freedom* exhibition noted, "One pod was known for baskets, another for trees, another for towers."[18]

Many detainees chose to produce eagles, not only because they were the American national bird but for the association with liberty. The detainees had modified the traditional paper-folding technique with the addition of papier-mâché, which they prepared by soaking toilet paper in glue and water. The combination of folded paper and papier-mâché allowed the makers to mold the works into highly realistic representational forms. The "freedom birds" required a combination of techniques, including thousands of folded papers for the wings and tail and papier-mâché for the head, feet, and body, which were colored with marker. The sculptors applied a glaze of white glue, smoothed over with a plastic spoon. The eagles varied in size from approximately 1 foot to more than 3 feet. Papier-mâché was used to build up bases from cardboard armatures to allow for even larger installation pieces, such as one with two eagles in a tree. At times the pods would compete with each other, striving to outdo the other groups, or pods would experiment and

develop new motifs or processes that the men would share by holding their works up to cell windows.

The eagle by Cheng Kwai Sung is a typical example of a freedom bird. What strikes one immediately is the kaleidoscope of color on the wings. The nestled pieces of paper units and the wear and tear of the creased edges produce an uneven surface that evokes the texture of ruffled feathers. The hollow beneath the wings gives the illusion of flight, as if the eagle is about to fly. The head is constructed of papier-mâché and painted white in stark contrast to the colorful wings. The black oblong-shaped eyes are ringed with yellow to make them appear fierce. The pointed beak is heavily incised and curves into a slight hook, giving the eagle a determined expression. The eagle sits alight crossed branches painted white and decorated with floral motifs and writing in Chinese and English. The inscriptions are what make this eagle the most symbolic of the museum's freedom birds because of direct reference to freedom and the prison in York. Aside from eagles, numerous themes were appropriated from American culture, including the Statue of Liberty and Disney characters. Religious themes were represented too with several statues of Christ on the cross. More bittersweet objects included caged eagles, replicas of the *Golden Venture* ship, or the occasional paper cakes that marked the passing of time. MoCA's collection has two birthday cakes that "celebrate" the second anniversary of the ship's grounding.

"Art from Behind Bars": Chinese Immigrants as Outsider Artists

The paper sculptures raise the knotty question of classification in art history and the art market. The works can fall under diverse categories including folk art, outsider art, and self-taught art.[19] Though the sculpture derived from Chinese paper craft traditions, the men were not associated with artisanal practices in China. Most of the men were manual laborers who did not participate in revived Chinese craft traditions, especially the production of paper offerings.[20] On a certain level, the art production at York fits within the rubric used to define outsider art.[21] Self-taught, incarcerated, and desperate, the detainees fit the profile of most outsider artists whose biographies tend to emphasize personal trauma and the lack of formal artistic training. However, the detainees problematize the notion that outsider artists create art independently. The *Golden Venture* refugees may have worked in social isolation because they were behind bars but there existed a strong sociability between the men, which fostered competition and inventiveness. Despite the differences between the detainees and outsider artists, the emphasis on their peripheral status—prisoner, illegal alien, and outsider—helped fuel the sale of their works.

With the intent to raise funds and garner publicity, Cindy Lobach arranged for the artworks to be sold at auction. Despite the detainees' doubts, the first auction took place in March 1994 and Lobach sold all 100 paper objects that she brought to the local YWCA for sale. Production increased manifold after the prisoners received some of the proceeds from the sales. The detainees became more motivated, some worked for hours on end between 10 am and 10 pm or later. Reports of visits to the prison described cells filled with art.[22] Lobach marveled, "It didn't take them long to pick up on the capitalist system."[23] The exhibitions stressed the handcrafted quality of the works, the use of rudimentary materials like Elmer's Glue, and the prisoner status of the artists. The announcement for a March 1995 auction at Grace United Methodist Church in Hanover, Pennsylvania, featured the image of an eagle with the headline "Art from Behind Bars."[24]

Lobach intentionally sold the works at low cost in order to make it possible for a wide range of people to support the refugees. As she made arrangements for more auctions, word spread of the detainees' artwork. Her house became a veritable gallery and she fielded purchase requests at all hours of the day. By July 1994, four benefit auctions had been held for the refugees and $15,000 had been raised. The auctions attracted the attention of gallery dealers and museums in the Philadelphia area and beyond. The following year, the paper sculptures were exhibited in an upscale gallery on Madison Avenue.[25] One hundred pieces were priced between $135 and $450 to raise money for the detainees' legal defense.

The excitement over the paper sculptures from folk art dealers and advocates of the budding field of outsider art (the first annual Outsider Art Fair happened in 1993) made it an opportune time for the works to be well received. There was even an attempt to give the refugees' paper-folding technique its own name. The magazine *Folk Art*, a publication of the Museum of American Folk Arts in New York City, published an article that identified the technique as *Qian Shi*, which meant "a thousand papers."[26] The label *Qian Shi* was fabricated because one of the detainees' attorneys felt "this unique paper sculpture needed a name to help identify it" and consulted a historian to generate a label.[27] This type of branding reflects a desire to frame the *Golden Venture* art within a genre, generally folk art, when, in effect, the paper sculptures problematize attempts to classify it. Unlike outsider art that privileges the work of the mentally ill or folk art that highlights the gravitas of a folkloric tradition, the *Golden Venture* sculptures were produced in response to a situation imposed on the refugees. Most of the men were carpenters, electricians, and construction workers, not artists driven to carry forth a time-honored tradition. They learned the techniques in prison and they sculpted in response to whatever stimuli they encountered from behind prison walls. Their period of art production was a reactionary one that would not continue once the men were released.[28]

As their imprisonment dragged on, some of the men became increasingly dejected and stopped making art. One detainee, Lin Ping, recalled how he stopped folding papers after six months. Overcome with worry for the wife and children he left behind and his inability to repay the $10,000 his family borrowed to fund his passage on the *Golden Venture*, Lin stated, "I don't have any interest in it anymore."[29] One by one the asylum cases were rejected and more were deported. Others gave up their asylum cases, preferring to return to a hostile reception in China than to remain imprisoned.

In the three-and-a-half years they spent at York County jail, the detainees produced more than 10,000 sculptures and raised more than $100,000. The prolific production was indicative of the industriousness of the men. They were willing to enter the country illegally and make incalculable sacrifices necessary to repay the snakeheads for providing passage to America. Leaving behind families and working like indentured servants for years, the men expected to repay their debt and to save enough to start their own businesses. The entrepreneurial drive is indicative of what the Chinese equated with "making it" on Gold Mountain, the colloquial Chinese name for America as the place of freedom and prosperity.

Freedom Birds and Maya Lin's Museum of Chinese in America

In spring of 1996, the third year of incarceration for the detainees at York, MoCA's *Fly to Freedom* exhibition caught the eye of Bob Herbert of the *New York Times*.[30] Herbert's editorial called attention to the detainees' plight as a travesty of an ill-defined immigration policy. The confinement, as Herbert noted, led to the production of artworks infused with dreams of freedom and frustrations over the lengthy incarceration. Herbert ended his opinion piece solemnly, "Depressed, the men in the York County Jail have stopped making their paper constructions." As the men despaired, their artwork continued to be exhibited and sold.

The release of the remaining passengers occurred in February 1997, after a congressman from York intervened and presented President Clinton with two paper sculptures. Attorneys for the detainees credit *New York Times* coverage and the congressman's involvement as a turning point for the refugees.[31] Republican William Goodling met with Clinton and presented him with two paper sculptures, a freedom bird and a tree, to which the president remarked, "They're beautiful," and decided the next day to release the men. The last 39 *Golden Venture* detainees left York County Prison on February 26, 1997, almost four years after their doomed voyage. In the end, their release was bittersweet because Clinton did not grant asylum but placed them on parole, thereby condemning the men to a legal limbo that made them vulnerable to deportation.[32]

Many paper sculptures entered MoCA's collection after the pivotal 1996 *Fly to Freedom* exhibit but the works are no longer on display. Since then, the museum was transformed from its homespun origins as the New York Chinatown History Project, established to preserve the community's local history, to a national-level cultural institution. Maya Lin renovated a nineteenth-century factory building on the edge of Chinatown to house MoCA's galleries and offices, a process that expanded exponentially the display space from the cramped one-room exhibition area in an old school building on Mulberry Street. She intentionally highlighted spatial juxtapositions between the past and present by designing what she called a "bridge" between old and new, creating a space that encouraged visitors to contemplate the experience of the Chinese diaspora in the Americas on multiple levels.[33]

The factory building, a former machine shop, has two facades, one that faces the Chinese community and the other looks to American modernity represented by New York's Soho neighborhood. The main entrance is located on Centre Street, the side that faces Chinatown, reinforcing the museum's connection to the Chinese community. A floor-to-ceiling window on the Soho side allows one to peer into a reproduction of a nineteenth-century Chinese general store, the gathering space of the community, thus highlighting the interchange between past and present. The core of the building is a hollow light well that Lin unearthed and left raw, retaining the original skylight and red brick walls (Figure 16.1). This courtyard serves as the symbolic core of the building, reminiscent of the internal courtyards found in traditional Chinese residential architecture. The walls are punctured with portals that offer glimpses into the permanent exhibition on Chinese American experience, *With a Single Step: Stories in the Making of America*. Lin's juxtapositions of old and new, East and West, help engineer a confrontation with the museum space that is infused with nostalgia and questions of identity.[34]

The new MoCA building is itself a work of art. Lin constructed an atmospheric space out of soothing muted colors and subtle historic details, forming a space that encourages reflection. The core exhibit is carefully orchestrated around objects from MoCA's collection, which unfortunately excludes the paper sculptures. The *Golden Venture* art remains in storage but its story is important to the continuing narrative of Chinese experience and modern immigration. One can only hope MoCA will make the sculptures accessible, because the art is an eloquent expression of a critical global issue. President Clinton's unprecedented decision to imprison the *Golden Venture* passengers in 1993 paved the way for the troubling treatment of immigrants today. Currently, approximately 430,000 people are detained each year for immigration issues in the United States.[35] Without sustainable immigration reform, situations like the *Golden Venture* beached on a New York shoreline or hundreds of migrant children detained in warehouses will become more common, and increasingly difficult to ignore.

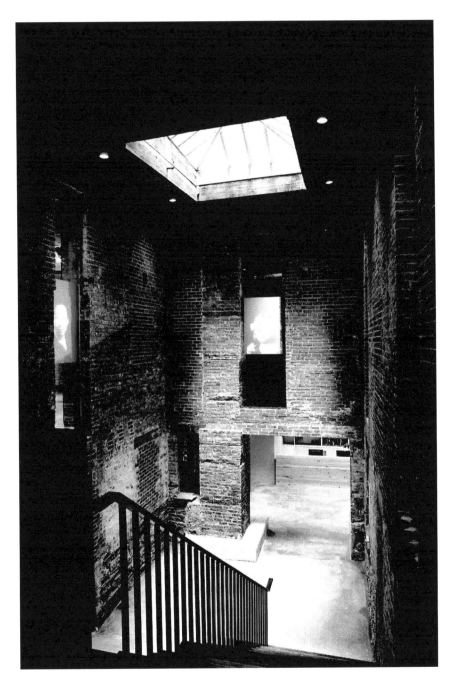

16.1 Photograph of courtyard in the Museum of Chinese in America.
Designed by Maya Lin, 2009. Courtesy of Maya Lin Studio/
Museum of Chinese in America, New York

Notes

1 "飛向自由" is Chinese for "Fly to the Freedom." According to the Museum of Chinese in America's inventory, this eagle sculpture was produced by Cheng Kwai Sung and inscribed by Shi Jian Li, acc. no. L1996.001.49.

2 The booklet that accompanied the traveling exhibition is William Westerman and Shushan Chin, *Fly to Freedom: The Art of the Golden Venture Refugees* (New York: Museum of the Chinese in the Americas, 2001).

3 On Demand, see the recent exhibition catalog, *Thomas Demand* (New York: Museum of Modern Art, 2005). On Huang, see Huang Yong Ping and Philippe Vergne, *House of Oracles: A Huang Yong Ping Retrospective* (Minneapolis, MN: Walker Art Center, 2005).

4 For a comprehensive account of the *Golden Venture* in relation to modern Chinese immigration, see Patrick Radden Keefe, *The Snakehead* (New York: Doubleday, 2009).

5 A good overview of immigration policies and the political asylum process is Carol Bohmer and Amy Shuman, *Rejecting Refugees: Political Asylum in the 21st Century* (New York: Routledge, 2008), especially chapter 1, "No More Huddled Masses."

6 Ten passengers did not survive and were given a Buddhist ceremony funded by New York City's Chinatown community. "A Buddhist Ceremony Is Held for Victims of Golden Venture Grounding," *New York Times*, June 23, 1993 (accessed July 15, 2014 http://www.nytimes.com/1993/06/23/nyregion/a-buddhist-ceremony-is-held-for-victims-of-golden-venture-grounding.html). Six bodies remained unidentified in the morgue for 10 months, and were buried together.

7 In 1995, several women from the *Golden Venture* were imprisoned in Bakersfield, California, and went on a hunger strike in an attempt to publicize their incarceration and imminent deportation. Kenneth B. Noble, "Golden Venture Refugees on Hunger Strike in California to Protest Detention," *New York Times*, December 2, 1995 (accessed July 14, 2014, http://www.nytimes.com/1995/12/02/us/golden-venture-refugees-on-hunger-strike-in-california-to-protestdetention.html).

8 A smaller group of men was sent to a facility in Winchester, Virginia; the women ended up in New Orleans, Louisiana or Bakersfield, California, and juveniles were placed in foster care.

9 An early *New York Times* article described the ship conditions, Robert D. McFadden, "Smuggled to New York: The Overview," *New York Times*, June 7, 1993 (accessed July 15, 2014, http://www.nytimes.com/1993/06/07/nyregion/smuggled-new-york-overview-7-die-crowded-immigrant-ship-grounds-off-queens.html). Several of the survivors recalled the conditions on the *Golden Venture* in a documentary by Peter Cohn, *Golden Venture*, DVD, directed by Peter Cohn (2006; Harriman, NY: Hillcrest Films).

10 On immigration from Fujian province, see Zai Liang and Wenzhen Ye, "From Fujian to New York: Understanding the New Chinese Immigration," in *Global Human Smuggling. Comparative Perspectives*, ed. D. Kyle and R. Koslowski (Baltimore: Johns Hopkins University Press, 2011), 204–30; and Peter Kwong, "China's Human Traffickers," *The Nation*, October 17, 1994, 422–5.

11 On Chinese funerary practice, see Janet Lee Scott, *For Gods, Ghosts, and Ancestors: The Chinese Tradition of Paper Offerings* (Seattle: University of Washington Press, 2007). It is interesting to note that the traditions of paper sculpture for funerary and celebratory events were being revived at this time in the Fukien province, where most of the *Golden Venture* passengers were from. Publications that offer comparative perspectives on modern funerary traditions in Fukien and parts of Taiwan with Fukienese associations are Kenneth Dean, "Funerals in Fujian," *Cahiers d'Extrême-Asie* 4 (1988): 19–78; and Ellen Johnston Laing and Helen Hui-Ling Liu, *Up in Flames: The Ephemeral Art of Pasted-Paper Sculpture in Taiwan* (Stanford: Stanford University Press, 2004).

12 Westerman, *Fly to Freedom*, 24.

13 On contemporary Chinese gift giving and its relation to traditional practice, see Chen Zhou and Han Guang, "Gift Giving Culture in China and Its Cultural Values," *Intercultural Communication Studies* XVI, no. 2 (2007): 81–93. See also Yunxiang Yan, *The Flow of Gifts: Reciprocity and Social Networks in a Chinese Village* (Stanford: Stanford University Press, 1996).

14 Two of the refugees profiled in the *Golden Venture* documentary reported how they were imprisoned, tortured, and fined large sums following deportation, Cohn, *Golden Venture*.

15 Joan Maruskin, a United Methodist minister, planned the first vigil and recalled, "It was very strange. We had guys with rifles pointed at people praying." The vigils were held nightly for almost a year and then weekly for the remainder of the refugees' imprisonment. Mike Argento, "Golden Venture 20 Years Later Today: Many Lives Remain in Limbo," *York Daily Record*, June 6, 2013 (accessed July 15, 2014, http://www.ydr.com/ci_23362804/golden-venture-20-years-later-many-lives-remain).

16 The newsletter appeared to have been published from September 1993 through February 1997, the month the York detainees were released.

17 Dale Gregory, "Qian Zhi, Treasures from the Golden Venture," *Folk Art* (1996): 49.

18 Westerman, *Fly to Freedom*, 25.

19 These distinctions are beyond the scope of this essay but important to acknowledge to better understand the reception of the art works. Charles Russell refers to and moves beyond this "term warfare" in his analysis of non-mainstream art, "Finding a Place for the Self-Taught in the Art World(s)," in *Self-taught Art: The Culture and Aesthetics of American Vernacular Art* (Jackson: University Press of Mississippi, 2001), 3–34.

20 On paper craftsmanship for worship and funerary practice, see Scott, *For Gods, Ghosts and Ancestors*, 159–200; and Roderick Cave, *Chinese Paper Offerings* (New York: Oxford University Press, 1998).

21 The literature on outsider art is extensive but tends to focus on the study of individual artists. Good historical overviews of the movement are Roger Cardinal, *Outsider Art* (London: Studio Vista, 1972); and Vera L. Zolberg and Joni Maya Cherbo, eds., *Outsider Art: Contesting Boundaries in Contemporary Culture* (Cambridge: Cambridge University Press, 1997).

22 Westerman, *Fly to Freedom*, 45–6.

23 Gregory, "Qian Zhi," 49.

24 *People of the Golden Vision Newsletter*, March 2, 1995.

25 The exhibit was held at the Frank J. Miele Gallery. Mitchell Owens, "A Folk Art Defense Fund, Built of Paper," *New York Times,* August 10, 1995 (accessed July 10, 2014, http://www.nytimes.com/1995/08/10/garden/currents-a-folk-art-defense-fund-built-of-paper.html).

26 The museum is now called the American Folk Art Museum. Gregory, "Qian Zhi," 46–52. Several of the paper sculptures illustrated in the article belonged to Frank Miele's gallery.

27 The article also perpetuated a mythic beginning to the unusual paper fold, which the author ascribed to an anonymous detainee who was transferred to another prison; Westerman noted how this story circulated widely though in truth many of the refugees had experience with paper folding, *Fly to Freedom*, 23.

28 Although, it should be noted that five detainees were granted permanent residency for "extraordinary artistic ability."

29 Ashley Dunn, "Golden Venture's Tarnished Hopes; Most of Ship's Human Cargo, a Year Later, Is Still Confined," *New York Times*, June 5, 1994 (accessed July 14, 2014, http://www.nytimes.com/1994/06/05/nyregion/golden-venture-s-tarnished-hopes-most-ship-s-human-cargo-year-later-still.html).

30 The museum's name was slightly modified when it reopened in the new space. Bob Herbert, "In America; Freedom Birds," *New York Times*, April 15, 1996 (accessed July 13, 2014, http://www.nytimes.com/1996/04/15/opinion/in-america-freedom-birds.html).

31 Celia W. Dugger, "Chinese Immigrants from Stranded Ship Are to Be Released," *New York Times*, February 15, 1997 (accessed July 14, 2014, http://www.nytimes.com/1997/02/15/nyregion/chinese-immigrants-from-stranded-ship-are-to-be-released.html).

32 The men are allowed to live, work, and pay taxes but they do not have permanent residence, and several have received notices of deportation that have been repeatedly appealed. Patrick Radden Keefe, "A Path Out of Purgatory," *New Yorker*, June 6, 2013 (accessed July 11, 2014, http://www.newyorker.com/news/daily-comment/a-path-out-of-purgatory).

33 Maya Lin's design elements of the building are evident in her opening statement on the grand opening ceremony on September 22, 2009, and in her online tour of the museum; the tour video is available on the museum's website (accessed July 8, 2014, http://www.mocanyc.org/visit/). A thoughtful analysis of the building and response to the museum's detractors is Jeff Yang, "The Living Museum," *San Francisco Chronicle*, October 1, 2009 (accessed July 14, 2014, http://www.sfgate.com/entertainment/article/The-Living-Museum-2529554.php).

34 On immigration, identity, and nostalgia, see Andreea Deciu Ritivoi, *Yesterday's Self: Nostalgia and the Immigrant Identity* (Lanham, MD: Rowman & Littlefield, 2002).

35 Radden Keefe points out that the cost of federal immigration enforcement is $18 billion, more than the budget of all other major federal law enforcement agencies combined. See "A Path Out of Purgatory."

Appendix A: Museum Information

Note: This information has largely been collected from the websites of the museums.

Name/Location

- date founded
- size of permanent collection
- brief description of collection
- Web address
- other

Northeast

Sargent House, Gloucester, MA

- 1917
- around 1900
- American decorative arts and furniture; collections of American family portraits
- http://sargenthouse.org/

Danforth Art, Framingham, MA

- 1975
- more than 3,500 works
- American art with a regional focus
- www.danforthart.org/
- community museum and art education center

Memorial Art Gallery, University of Rochester, Rochester, NY

- 1913
- more than 12,000 works
- encyclopedic collection
- http://mag.rochester.edu/
- university art gallery

Museum of Chinese in America, New York, NY

- 1980
- not available
- preserving and presenting the history, heritage, culture, and diverse experiences of people of Chinese descent in the United States
- www.mocanyc.org/

Montclair Art Museum, Montclair, NJ

- 1914
- more than 12,000 works
- European American and Native American art
- http://montclair-art.com/
- regional art museum

Smithsonian American Art Museum, Washington, DC

- 1829
- not available
- "home to one of the largest and most inclusive collections of American art in the world"
- http://americanart.si.edu/

Midwest

Mitchell Museum at Cedarhurst Center for the Arts, Mount Vernon, IL

- 1973
- approximately 560
- late 19th- and early 20th-century American paintings, sculpture, and decorative arts
- www.cedarhurst.org/
- personal collection of John R. and Eleanor R. Mitchell

Peru Community Schools Art Gallery, Peru High School, Peru, IL

- 2013
- 138
- European and American modern art and Chinese ceramics
- no website
- works donated by G. David Thompson between 1945 and 1965

Joslyn Art Museum, Omaha, NE

- 1931
- more than 11,000 woks
- Western American art
- www.joslyn.org/

South

Speed Art Museum, Louisville, KY

- 1925
- not available
- encyclopedic collection
- www.speedmuseum.org/home.html
- currently closed

Louisiana State Museum, New Orleans, LA

- 1906
- 450,000
- artifacts and works of art related to the history and diverse cultures of Louisiana
- www.crt.state.la.us/louisiana-state-museum/

Nash Library, University of Science and Arts of Oklahoma, Chickasha, OK

- not applicable
- https://library.usao.edu/home/

Southwest

Colorado Springs Fine Arts Center, Colorado Springs, CO

- 1936
- 23,000
- American, Latin American, and American Indian
- www.csfineartscenter.org/museum.asp

Brigham Young University Museum of Art, Provo, UT

- 1993
- more than 17,000
- encyclopedic
- http://moa.byu.edu/
- university museum

West

De Young Fine Arts Museum, San Francisco, CA

- 1875
- 27,000 works
- American art
- https://deyoung.famsf.org/

Museum of African American Art, Macy's Department Store, Los Angeles, CA

- 1976
- not available
- African American art
- www.maaala.org/
- located in Macy's Department Store

Bibliography

Archives

Alfred Stieglitz/Georgia O'Keeffe Archive. Beinecke Rare Book and Manuscript Library. Yale University. New Haven, CT.

Ann-Eliza Club Records. Rhode Island Historical Society. Providence, RI.

Arthur and Helen Torr Dove Papers. Archives of American Art. Smithsonian Institution. Washington, DC.

Edward Bannister Box. The Providence Art Club Archives. Providence, RI.

Edward Mitchell Bannister Papers. Archives of American Art. Smithsonian Institution. Washington, DC.

Edwin Blashfield Papers. New York Historical Society. New York, NY.

Farm Security Administration Archives. Library of Congress. Washington, DC.

Jules Lion Artist File. Historical Center of the Louisiana State Museum. New Orleans, LA.

Maynard Dixon Papers. Archives of American Art. Washington, DC.

Memorial Art Gallery Archives. Rochester, NY.

Susan Fillin-Yeh Research Notes. Montclair Art Museum Archives. Montclair, New Jersey.

Palmer C. Hayden Papers. Archives of American Art. Smithsonian Institution. Washington, DC.

Sargent House Museum Archives. Gloucester, MA.

Mississippi Territorial Archives. http://archive.org/stream/mississippiterri01missuoft/mississippiterri01missuoft_djvu.txt.

National Archives. http://founders.archives.gov/documents/Washington/05–06–02–0103.

Records of the Bureau of Indian Affairs. National Archives. Washington, DC.

Works Cited

"A Buddhist Ceremony Is Held for Victims of Golden Venture Grounding." *New York Times*, June 23, 1993.

"A Prosperous Painter." *Harper's Bazaar* 14, no. 17 (April 23, 1881): 2.

"A Roman Studio," *Decorator and Furnisher* (December 1884): 86–7.

Aberth, Susan. *Leonora Carrington: Surrealism, Alchemy and Art*. London: Lund Humphries, 2004.

Ackerman, Gerald. *American Orientalism*. Paris: ACR Edition Internationale, 1994.

Adams, Ansel. "Maynard Dixon: An Artist, a Friend." In *Maynard Dixon: Images of the Native American*. San Francisco: California Academy of Science, 1981.

———. "Free Man in a Free Country: The West of Maynard Dixon." *American West* 6 (November 1969): 41–7.

Adams, Henry. "Despite Its Twist on Tradition, Portrait of Painter Thomas Eakins Is Blemished." Review of William S. McFeely, *Portrait: The Life of Thomas Eakins*. *Chicago Tribune*, November 26, 2006, Living/Books.

———. *Eakins Revealed*. Oxford: Oxford University Press, 2005.

Adams, James. "Palmer Hayden (1972 interview)." *Artist and Influence* 13 (1994): 91–105.

Adler, Kathleen, Erica E. Hirshler, and H. Barbara Weinberg, et al. *Americans in Paris, 1860–1900*. London: National Gallery, 2006.

Alford, Terry. "Prince among Slaves." In *A Place Called Mississippi: Collected Narratives*. Marion Barnwell, ed. Jackson: University Press of Mississippi, 1997.

"American Art News." *Art Interchange* 4, no. 7 (March 31, 1880): 59.

"American Artists at War in Paris." *New York Times*. December 1, 1907.

American Federation of Arts. *In Memoriam*. Washington, DC: American Federation of Arts, 1957.

"American Painters—Winslow Homer and F.A. Bridgman." *Art Journal* n.s., no. 4 (1878): 225–9.

Anthes, Bill. *Native Moderns: American Indian Painting, 1940–1960*. Durham, NC: Duke University Press, 2006.

Argento, Mike. "Golden Venture 20 Years Later Today: Many Lives Remain in Limbo." *York Daily Record*, June 6, 2013.

Armstrong, D. Maitland. "Report of D. Maitland Armstrong, Superintendent of the Art Gallery." *Reports of the United States Commissioners to the Paris Universal Exposition, 1878*. Vol. 1. Washington, DC: Government Printing Office, 1880.*Arthur G. Dove, Exhibition of Paintings (1934–1935)*. New York: An American Place, 1935.

Balken, Debra Bricker. *Arthur Dove: Watercolors*. New York: Alexandre Gallery, 2006.

Bann, Stephen. "Art History and Museums." In *The Subjects of Art History*. Mark Cheetham, ed. Cambridge, UK: Cambridge University Press, 1998.

Bannister, Edward. *Edward Mitchell Bannister, 1828–1901, Providence Artist: An Exhibition Organized by the Museum of Art, Rhode Island School of Design for the Museum of African Art, Frederick Douglass Institute, Washington*. Washington, DC: Museum of African Art, 1966.

Bannister Gallery (Rhode Island College) and Rhode Island Black Heritage Society. *4 From Providence: Bannister, Prophet, Alston, Jennings: Black Artists in the Rhode Island Social Landscape*. Providence: Rhode Island College, 1978.

Barker, Emma, ed. *Contemporary Cultures of Display*. New Haven and London: Yale University Press, 1999.

Bascom, Louise Rand. "Ballads and Songs of Western North Carolina." *Journal of American Folklore* 22, no. 84 (April–June 1909): 247–9.

Batkin, Jonathan. *Colorado Springs Fine Arts Center: A History and Selections from the Permanent Collections*. Colorado Springs: Colorado Springs Fine Arts Center, 1986.

Bearden, Romare, and Harry Henderson. *A History of African-American Artists: From 1792 to the Present*. New York: Pantheon, 1993.

Beaulieu, Jill, and Mary Roberts, eds., *Orientalism's Interlocutors: Painting, Architecture, Photography. Objects/Histories*. Durham, NC: Duke University Press, 2002.

Bell, Adrienne Baxter. "Utopian Pastiche: The Still Life Paintings of Charles Caryl Coleman," In *A Seamless Web: Transatlantic Art in the Nineteenth Century*. Cheryll May and Marian Wardle, eds. Newcastle upon Tyne: Cambridge Scholars Publishing, 2014.

Bell, J.L. "Boston 1775." http://boston1775.blogspot.com/2006/06/end-of-slavery-in-massachusetts.html.

Benjamin, Roger. *Orientalist Aesthetics: Art, Colonialism, and French North Africa, 1880–1930*. Berkeley: University of California Press, 2003.

Berger, Roni. *Immigrant Women Tell Their Stories*. New York: Routledge, 2011.

Bergerat, Emile. "Salon de 1877 (10e article)." *Journal Officiel de la Republique Française* 9, no. 171 (June 24, 1877): 4747–8.

Berlin, Ira. *Generations of Captivity: A History of African-American Slaves*. Cambridge, MA: Harvard University Press, 2003.

Black, Patti Carr. *Art in Mississippi, 1720–1980.* Seattle: Marquand Books, Inc., 1998.

Bloemink, Barbara. *The Life and Art of Florine Stettheimer*. New Haven: Yale University Press, 1995.

Böchlin, Arnold. *Böcklin*. Thomas Bourke, trans. Munich: F. Bruckmann, 1975.

Bohmer, Carol, and Amy Shuman. *Rejecting Refugees: Political Asylum in the 21st Century*. New York: Routledge, 2008.

Boime, Albert. *The Academy and French Painting in the Nineteenth Century.* London: Phaidon, 1971.

———. "Thomas Couture and the Evolution of Painting in Nineteenth Century France." *College Art Bulletin* 51 (1969): 48–56.

Bol, Marcia. "Lakota Women's Artistic Strategies in Support of the Social System." *American Indian Culture and Research Journal* 9:1 (1985): 33–51.

Bowdoin, W.G. "A Versatile Figure in Art." *Art Interchange* 42, no. 2 (April 1899): 86–8.

Braddock, Alan. *Thomas Eakins and the Cultures of Modernity*. Berkeley, University of California Press, 2007.

Bradford, Roark. *John Henry*. New York: Harper & Brothers, 1931.

Brady, Patricia. "Jules Lion, F.M.C.: Lithographer Extraordinaire." In *Printmaking in New Orleans*. Jessie J. Poesch, ed. Jackson: University Press of Mississippi, 2006.

———. "Seeing Is Not Believing." *Historic New Orleans Collection Quarterly* 18, no. 1 (Winter 2000): 7.

Branson, Susan. *These Fiery Frenchified Dames: Women and Political Culture in Early National Philadelphia*. Philadelphia: University of Pennsylvania Press, 2001.

Brauer, Fae. *Rivals and Conspirators: The Paris Salons and the Modern Art Centre.* Newcastle upon Tyne: Cambridge Scholars Publishing, 2013.

Breskin, Isabel. "'On the Periphery of a Greater World': John Singleton Copley's 'Turquerie' Portraits," *Winterthur Portfolio* 36, no. 2/3 (Summer–Autumn 2001): 97–123.

Bressler, Ann Lee. *The Universalist Movement in America: 1770–1880*. Oxford, UK: Oxford University Press, 2001.

Brettell, Richard. "The 'First' Exhibition of Impressionist Painters." In *The New Painting: Impressionism, 1874–1886*. Charles S. Moffett, ed. San Francisco: Fine Arts Museums of San Francisco, 1986.

Bridgman, F.A. *L'Anarchie dans l'art*. Paris: Société Française d'Editions d'Art, L. Henry May, 1898.

———. "Working Under Great Masters, II: Gérôme, The Painter." *Youth's Companion* 3500 (June 21, 1894): 290.

Brown, Chandos Michael. *Benjamin Silliman: A Life in the Young Republic*. Princeton, NJ: Princeton University Press, 1989.

Brown, William Wells. *The Black Man, His Antecedents, His Genius, and His Achievements*. 2nd ed. New York: T. Hamilton, 1863.

Browning, James. "Anti-Miscegenation Laws in the United States." *Duke Bar Journal* 1, no. 1 (March 1951): 26–51.

Buerger, Janet. *French Daguerreotypes*. Chicago: University of Chicago Press, 1989.

Burns, Sarah. *Inventing the Modern Artist: Art and Culture in Gilded Age America*. New Haven and London: Yale University Press, 1996.

Burnside, Wesley. *Maynard Dixon, Artist of the West*. Provo, UT: Brigham Young University Press, 1974.

Bushman, Richard. "A Poet, a Planter, and a Nation of Farmers." *Journal of the Early Republic* 19 (1999): 1–14.

Byrn, Lillian Kendrick. "Frederick A. Bridgman," *Taylor-Trotwood Magazine* 4, no. 5 (February 1907): 489–92.

Cahill, Timothy. "Unraveling a Mystery: With Analysis and Connoisseurship, Experts Delve into a Gilbert Stuart Copy. *Art Conservator* 4, no. 2 (Fall 2009): 4–13, www.williamstownart.org/artconservator/images/AC4.2.pdf, accessed 5/12/2014.

Calo, Mary Ann. *Distinction and Denial: Race, Nation, and the Critical Construction of the African American Artist, 1920–40*. Ann Arbor: University of Michigan Press, 2007.

———. "African American Art and Critical Discourse between World Wars." *American Quarterly* 51, no. 3 (September 1999): 580–621.

Cardinal, Roger. *Outsider Art*. New York: Praeger Publishers, 1972.

Carrier, David. *Museum Skepticism: A History of the Display of Art in Public Galleries*. Durham, NC: Duke University, 2006.

Carter, Karen and Susan Waller, eds. *Foreign Artists and Communities in Modern Paris, 1870-1914: Strangers in Paradise*. Farnham: Ashgate, 2015.

Cave, Roderick. *Chinese Paper Offerings*. New York: Oxford University Press, 1998.

Champier, Victor. *L'année artistique: année 1878*. Paris: A. Quantin, Imprimeur-Éditeur, 1879.

Chang, Gordon. "Chinese Painting Comes to America: Zhang Shuqi and the Diplomacy of Art." In *East-West Interchanges in American Art: A Long and Tumultuous Relationship*. Washington, DC: Smithsonian Institution Scholarly Press, 2012.

———, ed. *Asian American Art, 1850–1970*. Stanford, CA: Stanford University Press, 2008.

Chappell, Louis. *John Henry: A Folk-Lore Study*. Jena, Germany: Frommannsche Verlag, W. Biedermann, 1933.

Chase, W.M. "Mr. Bridgman's Pictures." *New York Times*. April 18, 1890.

Chave, Anna. "Minimalism and Biography." In *Reclaiming Female Agency: Feminist Art History after Postmodernism*. Norma Broude and Mary Garrard, eds. Berkeley: University of California Press, 2005.

———. "O'Keeffe and the Masculine Gaze." In *Reading American Art*. Marianne Doezema and Elizabeth Milroy, eds. New Haven: Yale University Press, 1998.

Chestnut, R. Andrew. *Devoted to Death: Santa Muerte, the Skeleton Saint*. Oxford: Oxford University Press, 2012.

Clark, Phillip Hone, ed. *The Heart of Maynard Dixon: Conversations with Herald R. Clark and Other Related Correspondence, 1937–1946*. Provo, UT: Excel Graphics, 2001.

Cohen, Norm. *Long Steel Rail: The Railroad in American Folksong*. 2nd ed. Urbana: University of Illinois Press, 2000.

Cohn, Peter. *Golden Venture*. DVD. Directed by Peter Cohn. 2006. Harriman, NY: Hillcrest Films.

Coke, Van Deren, and Ed Garman. *Raymond Jonson: A Retrospective Exhibition*. Albuquerque: University of New Mexico Press, 1964.

Conger, E., and Alexandra W. Rollins, eds. *Treasures of State: Fine and Decorative Arts in the Diplomatic Reception Rooms of the US Department of State*. New York: Harry N. Abrams, Inc. 1991.

Cook, Roger. *The Tree of Life: Symbolism of the Centre*. London: Thames & Hudson, 1974.

Cooke, Lynne. "Orthodoxies Undermined." In *"Great and Mighty Things": Outsider Art from the Jill and Sheldon Bonovitz Collection*. Ann Percy and Cara Zimmerman, eds. Philadelphia: Philadelphia Museum of Art, 2013.

Corn, Wanda. "Coming of Age: Historical Scholarship in American Art." *Art Bulletin* 70, no. 2, (June 1988): 188–207.

"Culture and Progress." *Scribner's Monthly* 17, no. 5 (March 1879): 757–62.

Cuno, James ed. *Whose Muse? Art Museums and the Public Trust*. Princeton, NJ: Princeton University Press, 2004.

Cvetkovich, Ann, and Douglas Kellner, eds. *Articulating the Global and the Local: Globalization and Cultural Studies*. Boulder, CO: Westview Press, 1997.

Daugherty, James. *Their Weight in Wildcats: Tales of the Frontier*. Boston: Houghton Mifflin Company, 1936.

Davis, Janet. *The Circus Age: Culture and Society under the American Big Top*. Chapel Hill: University of North Carolina Press, 2002.

De Beauvoir, Simone. *The Second Sex*. 1949. Reprint. H. M. Parshley, trans. New York: Knopf, 1952.

De Mille, Agnes. *Martha*. New York: Random House, 1956.

Dean, Kenneth. "Funerals in Fujian." *Cahiers d'Extrême-Asie* 4 (1988): 19–78.

Dearborn, Mary. *Mistress of Modernism: The Life of Peggy Guggenheim*. New York: Houghton Mifflin, 2004.

Deloria, Phil. *Indians in Unexpected Places*. Lawrence: University of Kansas Press, 2004.

DePietro, Anne Cohen. *Out of the Shadows: Helen Torr: A Retrospective*. Huntington, New York: Heckscher Museum of Art, 2003.

Descubes, A. "Le Salon de 1877," *Gazette des lettres des science & des arts* 19 (June 1, 1877): 248–52.

Dickerman, Leah. *Inventing Abstraction: 1910–1925: How a Radical Idea Changed Modern Art*. New York: Museum of Modern Art, 2012.

Didimus, H. [E.H. Durrell]. *New Orleans as I Found It*. New York: Harper & Bros., 1845.

Dijkstra, Bram. *Idols of Perversity: Fantasies of Feminine Evil in Fin-de-Siècle Culture*. New York: Oxford Univeristy Press, 1986.Dixon, Maynard. *Rim-Rock and Sage: The Collected Poems of Maynard Dixon*. San Francisco: California Historical Society, 1977.

"Dixon Portrays the Waterfront Strike." *Art Digest* 11 (October 15, 1936), 14.

Dorson, Richard. "The Career of 'John Henry." In *Mother Wit from the Laughing Barrel: Readings in the Interpretation of Afro-American Folklore*. Alan Dundes, ed. Englewood Cliffs, NJ: Prentice Hall, 1973.

Doss, Erica. "Between Modernity and 'The Real Thing': Maynard Dixon's Mural for the Bureau of Indian Affairs." *American Art* 18, no. 3 (Fall 2004): 8–31.

Du Bois, W.E.B. *The Souls of Black Folk*. 1903. Reprint. New York: Vintage, 1990.

Dugger, Celia. "Chinese Immigrants from Stranded Ship Are to Be Released." *New York Times,* February 15, 1997.

Duncan, Carol. *Civilizing Rituals—Inside Public Art Museums*. London and New York: Routledge, 1995.

Dunlap, William. *A History of the Rise and Progress of the Arts of Design in the United States*. Boston: C.F. Goodspeed & Co., 1918.

Dunn, Ashley. "Golden Venture's Tarnished Hopes; Most of Ship's Human Cargo, a Year Later, Is Still Confined." *New York Times,* June 5, 1994.

Edwards, Holly, et al. *Noble Dreams, Wicked Pleasures: Orientalism in American Art, 1870–1930.* Princeton, NJ: Princeton University Press, 2000.

Elkins, James. "Naïfs, Faux-naïfs, Faux-faux naïfs, Would-be Faux-naïfs: There Is No Such Thing as Outsider Art." In *Inner Worlds Outside.* John Thompson, ed. Dublin: Irish Museum of Modern Art, 2006.

Ellison, Rosemary. Introduction. In *Contemporary Southern Plains Indian Painting.* Anadarko, OK: Oklahoma Indian Arts and Crafts Board Cooperative and the Southern Plains Indian Museum and Crafts Center, 1972.

Engle, Paul. "An Historic Account of the Origin of the Thompson Collection in Peru, Indiana, and Its Educational Uses." *Marilyn Zurmuehelen Working Papers in Art Education* 4, no. 1 (1985): 25–9.

Esten, John. *Thomas Eakins: The Absolute Male.* New York: Universe Publishing, 2002.

Ewers, John. "Climate, Acculturation, and Costume: A History of Women's Clothing among the Indians of the Southern Plains." *Plains Anthropologist* 25, no. 87 (February 1980): 63–82.

Fairbrother, Trevor. *The Bostonians: Painters of an Elegant Age, 1870–1930.* Boston: Museum of Fine Arts, 1986.

Ferrars, George. "Burial of an Egyptian Mummy." *Art Interchange* 6, no. 6 (March 17, 1881): 58.

Fillin-Yeh, Susan. "Mary Birmingham." In *Montclair Art Museum: Selected Works.* Montclair, NJ: Montclair Art Museum, 2002.

Fine, Gary Allen. *Everyday Genius: Self-Taught Art and the Culture of Authenticity.* Chicago: University of Chicago Press, 2004.

Fink, Lois Marie. *American Art at the Nineteenth-Century Paris Salons.* Washington, DC: National Museum of American Art, Smithsonian Institution, 1990.

"First Circus to Be Here May 2." *Reading Eagle* (Pennsylvania). April 23, 1934.

Folts, Franklin. *Paintings and Drawings by Philip Leslie Hale, 1865–1931.* Boston: Vose Galleries of Boston, 1966.

Fordyce, James. "Sermon XIII." In *Sermons to Young Women.* Vol. 2. New York: I. Riley, 1809.

Fort, Ilene Susan, Tere Arcq, and Terri Geis, eds. *In Wonderland: The Surrealist Adventures of Women Artists in Mexico and the United States.* Los Angeles: Los Angeles County Museum of Art, 2012.

———. "Frederick Arthur Bridgman and the American Fascination with the Exotic Near East." PhD diss., City University of New York, 1990.

Foucault, Michel. "Of Other Spaces: Utopias and Heterotopias." 1967 lecture. http://foucault.info/documents/heterotopia/foucault.heterotopia.en.html, accessed September 1, 2014.

"Frederick Arthur Bridgman." *Art Amateur* 40, no. 4 (March 1899): 76–77.

Frederickson, Kristen and Sarah E. Webb, eds. *Singular Women: Writing the Artist.* Berkeley: University of California Press, 2003.

Frelinghuysen, Alice Cooney, et al. *In Pursuit of Beauty: Americans and the Aesthetic Movement.* New York: Metropolitan Museum of Art, 1987.

"Gallery Exhibit Showcases Works by Tota, Williams." *Brighton-Pittsford Post,* February 1990.

Gammell, R.H. Ives. *The Boston Painters, 1900–1930.* Orleans, MA: Parnassus Imprints, 1986.

Garabedian, Steven. "Reds, Whites, and the Blues: Lawrence Gellert, 'Negro Songs of Protest,' and the Left-Wing Folk-Song Revival of the 1930s and 1940s." *American Quarterly* 57, no. 1 (March 2005): 179–206.

Garman, Ed. *The Art of Raymond Jonson, Painter*. Albuquerque: University of New Mexico Press, 1976.

Georges-Michel, Michel. *From Renoir to Picasso: Artists in Action*. Boston: Houghton Mifflin, 1957.

Gerdts, William. "Louisiana Art: Regionally Unique; Southern Exemplar." In *Complementary Visions of Louisiana Art: The Laura Simon Nelson Collection at the Historic New Orleans Collection*. Patricia Brady, Louise C. Hoffman, and Lynn D. Adams, eds. New Orleans: Historic New Orleans Collection, 1996.

Gibbs, Linda Jones. *Escape to Reality: The Western World of Maynard Dixon*. Provo, UT: Brigham Young University Museum of Art, 2000.

"Gilbert Stuart." Worcester Art Museum. www.worcesterart.org/Collection/Early_American/Artists/stuart/biography/, accessed June 24, 2013.

Gill, Anton. *Art/Lover: A Biography of Peggy Guggenheim*. New York: Harper Collins, 2002.

"'Gloucester', Natchez." Preservation in Mississippi. http://misspreservation.com/101-mississippi-places-to-see-before-you-die/gloucester-natchez/, accessed August 11, 2015.

Goodrich, Lloyd. *Thomas Eakins*. 2 vols. Cambridge: Harvard University Press, 1982.

———. *Thomas Eakins: His Life and Work*. New York: Whitney Museum of American Art, 1933.

Gopnik, Adam. "Eakins in the Wilderness." *New Yorker,* December 26, 1994, 78–91.

Gordon, Allan. *Echoes of Our Past: The Narrative Artistry of Palmer C. Hayden*. Los Angeles: Museum of African American Art, 1988.

Gordon, Linda. *Dorothea Lange: A Life beyond Limits*. London: W.W. Norton, 2009.

"Gorman Brothers Circus Is in Geneva Today; To Give Two Performances." *Geneva Daily Times,* June 25, 1934.

Gourvennec, J.C.P. *Un Journal Américain à Paris: James Gordon Bennett et le New York Herald, 1887–1918*. Paris: Musée d'Orsay, 1990.

Graf, Alfred Byrd. *Hortica*. East Rutherford, NJ: Roehrs Company, Publishers, 1992.

Grant, Susan. "Whistler's Mother Was Not Alone: French Government Acquisitions of American Paintings, 1871–1900." *Archives of American Art Journal* 32, no. 2 (1992): 2–15.

Green, Archie. *Wobblies, Pile Butts, and Other Heroes*. Urbana and Chicago: University of Illinois Press, 1993.

———. "Fred Becker's John Henry." *John Edwards Memorial Foundation Quarterly* 15, no. 53 (1979): 30–31.

Green, Nicholas. *The Spectacle of Nature: Landscape and Bourgeois Culture in Nineteenth-Century France*. Manchester, UK: Manchester University Press, 1990.

Green, Rayna. "The Pocahontas Perplex: The Image of Indian Women in American Culture." *Massachusetts Review* 16 (1975): 698–714.

Gregory, Dale. "Qian Zhi, Treasures from the Golden Venture." *Folk Art* (1996): 48–54.

Grigsby, Darcy. *Colossal: Engineering the Suez Canal, Statue of Liberty, Eiffel Tower, and Panama Canal: Transcontinental Ambition in France and the United States during the Long Nineteenth Century*. Pittsburgh, PA: Periscope, 2012.

Grimberg, Salomon. "Frida Kahlo: The Self as an End." In *Mirror Images: Women, Surrealism, and Self-Representation*. Whitney Chadwick, ed. Cambridge: MIT Press, 1998.

Gustafson, Donna. "Images from the World Between: The Circus in Twentieth-Century American Art." In *Images from the World Between: The Circus in Twentieth-Century American Art*. Cambridge: MIT Press, 2001.

Guth, Christine. "Japonisme." In *The Cult of Beauty: The Victorian Avant-Garde, 1860–1900*. London: V & A Publishing, 2011.

Hagerty, Donald. *Desert Dreams: The Art and Life of Maynard Dixon*. Salt Lake City, UT: Gibbs Smith, 1998.

Hail, Barbara. *Hau, Kóla!: The Plains Indian Collection of the Haffenreffer Museum of Anthropology*. Providence, RI: Haffenreffer Museum of Anthropology, 1980.

———, ed. *Gifts of Pride and Love: Kiowa and Comanche Cradles*. Providence, RI: Haffenreffer Museum of Anthropology, 2000.

Hale, Nancy. *The Life in the Studio*. Boston: Little, Brown and Company, 1957.

Hales, Peter Bacon. *Silver Cities: Photographing American Urbanization, 1839–1939*. Albuquerque: University of New Mexico Press, 2005.

Hall, A. Oakley. *Manhattaner in New Orleans*. New York: Redfield, 1851.

Hamerton, Philip Gilbert. "English and American Painting at Paris in 1878, II." *International Review* (May 1879): 547–66.

Harris, Sharon. *Selected Writings of Judith Sargent Murray*. New York, NY: Oxford University Press, 1995.

Harris, W.T. "The Dialectic Unity in Emerson's Prose." *Journal of Speculative Philosophy* 18, no. 2 (1884): 195–202.

Harrison, Helen. "A New Look at Stieglitz's Role." *New York Times*, June 7, 1981.

Hart-Davis, Rupert, ed. *The Letters of Oscar Wilde*. London: Rupert Hart-Davis, Ltd., 1962.

Hartel, Jr., Herbert. "Raymond Jonson and the Chicago Little Theatre, 1912–1917: The Influence of the Simple Stage Aesthetic on an American Modernist Painter." *Journal of the Illinois State Historical Society* 104, no. 3 (Fall 2011): 199–222.

———. "'The Land of Sunshine and Color and Tragedy': The Early Paintings of Raymond Jonson and the Lure of the Southwest." *Journal of the American Studies Association of Texas* 36 (2005): 69–91.

———. *The Art and Life of Raymond Jonson: Concerning the Spiritual in American Abstract Art*. PhD diss., Graduate School and University Center of the City University of New York, 2002.

Hartigan, Lynda Roscoe. "Edward Mitchell Bannister." In *Sharing Traditions: 5 Black Artists in 19th Century America*. Washington, DC: Smithsonian Institution Press, 1985.

Hatt, Michael. "'Making a Man of Him': Masculinity and the Black Body in Mid-Nineteenth Century American Sculpture." *Oxford Art Journal* 15, no. 1 (1992): 21–35.

———, and Charlotte Klonk. *Art History: A Critical Introduction to Its Methods*. New York: Manchester University Press, 2006.

H.D. "By Groups and Singly." *New York Times*, January 26, 1947.

Heckscher Museum. *Under the Big Top: The Circus in Art*. Huntington, NY: Heckscher Museum, 1991.

Hegel, G.W.F. *Introductory Lecture on Aesthetics*. Michael Inwood, ed. Bernard Bosanquet, trans. London: Penguin Books, 1993.

Hélion, Jean. *Jean Hélion*. London: Paul Holberton, 2004.

———. *Récits et Commentaires: Mémoire de la chamber jaune, À perte de vue; Choses revues*. Paris: École Nationale Supérieur des Beaux-Arts, 2004.

Hendrix, John Shannon. *Aesthetics and the Philosophy of Spirit: From Plotinus to Schelling and Hegel*. New York: Peter Lang Publishing, 2005.

Herbert, Bob. "Freedom Birds." *New York Times,* April 15, 1996.

Heyman, Therese Thau. *Celebrating the Collection: The Work of Dorothea Lange*. Oakland, CA: Oakland Museum, 1978.

Higginbotham, A. Leon. *In the Matter of Color: Race and the American Legal Process* (Oxford: Oxford University Press, 1980.

Higonnet, Patrice. *Paris: Capital of the World.* Cambridge, MA: Belknap Press of Harvard University Press, 2002.Hoffman, Eugène "Exposition Bridgman." *Journal des Artistes* 17, no. 3 (January 16, 1898): 2150.

Hoffman, Gerhard. "Frames of Reference: Native American Art in the Context of Modern and Postmodern Art." In *Arts of the North American Indian: Native Traditions in Evolution*. Edwin L. Wade, ed. New York: Hudson Hills, 1986.

Holland, Juanita, ed. *Narratives of African American Art and Identity: The David C. Driskell Collection*. College Park: University of Maryland Press, 1998.

Holland, Juanita Marie, and Corrine Jennings. *Edward Mitchell Bannister, 1828–1901.* New York: Kenkeleba House and Whitney Museum of Art, 1992.

Holland, Juanita Marie, and Kenneth Rodgers. *Edward Mitchell Bannister: American Landscape Artist.*, Durham, NC: North Carolina Central University Art Museum, 1997.

Hooper, Lucy. "American Art in Paris." *Art Journal* n.s., no. 4 (1878): 89–91.

———. "The Paris Salon of 1877, III." *Art Journal* n.s. 3 (September 1877): 282–3.

Hopper-Greenhill, Eilean. *Museums and the Shaping of Knowledge*. London: Routledge, 1992.

Hornton, James, and Lois Hornton. *In Hope of Liberty: Culture, Community and Protest among Northern Free Blacks, 1700–1860*. New York: Oxford University Press, 1997.

Horosko, Marian. *Martha Graham: The Evolution of Her Dance Theory and Training, 1926–1991.* Chicago: A Cappella Books, 1991.

Horowitz, Helen Lefkowitz. *Rereading Sex: Battles Over Sexual Knowledge and Suppression in Nineteenth-Century America*. New York: Knopf, 2002.

"Horse to Be King When Big Circus Comes to Town." *Geneva Daily Times*, June 27, 1934.

Hurston, Zora Neale. *Mules and Men*. Philadelphia: J.B. Lippincott Company, 1935.

Hutchinson, Elizabeth. *The Indian Craze: Primitivism, Modernism, and Transculturation in American Art, 1890–1915*. Durham, NC: Duke University Press, 2009.

———. "Modern Native American Art: Angel DeCora's Transcultural Aesthetics." *Art Bulletin* 83, no. 4 (December 2001): 740–56.

Isrealsen-Hartley, Sara. "Artist John McNaughton Pulls Political, Religious Art from BYU Bookstore." *Deseret News,* April 27, 2010.

"Jackson Square (New Orleans)." Wikipedia. http://en.wikipedia.org/wiki/Jackson_Square_%28New_Orleans%29, accessed June 9, 2014.

James, Henry. *The Italian Hours*. 1909. Reprint. New York: Grove Press, 1959.

Jaques, Susan. *A Love for the Beautiful: Discovering America's Hidden Art Museums*. Guilford, CT: Globe Pequot Press, 2011.

Jensen, Robert. *Marketing Modernism in Fin-de-Siècle Europe.* Princeton: Princeton University Press, 1994.

Jewell, Edward Alden. "From the Literal to the Abstract: A Delightful Exhibition of Bronzes by Degas—Andre Masson, Arthur Dove and Charles Shaw as Exponents of Abstraction." *New York Times*, May 5, 1935.

Johns, Elizabeth. "Histories of American Art: The Changing Quest." *Art Journal* 44, no. 4 (Winter 1984): 338–44.

———. *Thomas Eakins: The Heroism of Modern Life*. Princeton, NJ: Princeton University Press, 1983.

Johnson, Guy. *John Henry, Tracking Down a Negro Legend*. Chapel Hill: University of North Carolina Press, 1929.

———. "John Henry: A Negro Legend." In *Ebony and Topaz: A Collecteana*. Charles S. Johnson, ed. 1927. Reprint. Freeport, NY: Books for Libraries Press, 1971.

Jones, Amelia. *Body Art: Performing the Subject*. Minneapolis: University of Minnesota Press, 1998.

Judith Sargent Murray Society. "Judith Sargent Murray Biography." http://www. jsmsociety.com, accessed October 5, 2013.

———. "Judith Sargent Murray Quotes." http://www.jsmsociety.com, accessed July 21, 2014.

Karabell, Zachary. *Parting the Desert: The Creation of the Suez Canal*. New York: A.A. Knopf, 2003.

Karcher, Carolyn. *The First Woman in the Republic: A Cultural Biography of Lydia Maria Child*. Durham, NC: Duke University Press Books, 1998.

Karlstrom, Paul, ed. *On the Edge of America: California Modernist Art, 1900–1950*. Berkeley: University of California Press, 1999.

Keefe, Patrick Radden. *The Snakehead*. New York: Doubleday, 2009.

———. "A Path Out of Purgatory." *New Yorker*, June 6, 2013.

Kennedy, Roger. *Burr, Hamilton, and Jefferson: A Study in Character*. New York: Oxford University Press, 2000.

Kerrison, Catherine. *Claiming the Pen: Women and Intellectual Life in the Early American South*. Ithaca, NY: Cornell University Press, 2006.

Kloss, William. "Governor Winthrop Sargent." US Department of State Archive. http://1997-2001.state.gov/www/about_state/diprooms/d73.55.html, accessed July 2, 2014.

Krainik, Clifford. "National Vision, Local Enterprise: John Plumbe, Jr., and the Advent of Photography in Washington, D.C.," *Washington History* 9, no. 2 (Fall/Winter 1997): 4–27.

Kwong, Peter. "China's Human Traffickers." *Nation*. October 17, 1994, 422–5.

Lafont-Courturier, Hélène. *Gérôme & Goupil: Art and Enterprise*. Paris: Réunion des musées nationaux, 2000.

Laing, Ellen Johnston, and Helen Hui-Ling Liu. *Up in Flames: The Ephemeral Art of Pasted-Paper Sculpture in Taiwan*. Stanford, CA: Stanford University Press, 2004.

Landgren, Marchal. *American Pupils of Thomas Couture*. Baltimore: University of Maryland Art Gallery, 1970.

Lange, Dorothea. *The Thunderbird Remembered: Maynard Dixon, the Man and the Artist / Sketched from Memory by His Wife, Dorothea Lange, His Last Wife Edith Hamlin, and His Two Sons Daniel & John*. Los Angeles: University of Washington Press, 1994.

———. *The Making of a Documentary Photographer*. Interview by Suzanne B. Riess. Berkeley: Regional Oral History Office, Bancroft Library, University of California, 1968.

Lanot, Benjamin, and Benjamin Hélion. *Pegeen Vail Guggenheim: A Life Through Art*. Paris: Sisso Editions, 2010.

"Leader Resource 1: Slavery and Antislavery." Unitarian Universalist Association. www.uua.org/re/tapestry/adults/river/workshop12/workshopplan/ leaderresources/178742.shtml, accessed October 5, 2013.

Lee, Anthony. "Crooning Kings and Dancing Queens: San Francisco's Chinatown and the Forbidden City Theatre." In *Reading California: Art, Image, and Identity, 1900–2000*. Los Angeles: Los Angeles County Museum of Art, 2000.

Lefort, Paul. "Les Écoles étrangères de peinture." *Gazette des Beaux-Arts* ser. 2, 8, no. 4 (October 1878): 470–85.

Leininger-Miller, Theresa. *New Negro Artists in Paris: African American Painters and Sculptors in the City of Light, 1922–1934*. New Brunswick, NJ: Rutgers University Press, 2001.

Levine, Lawrence. "The Historian and the Icon: Photography and the History of the American People in the 1930s and 1940s." In *Modern Art and Society: An Anthology of Social and Multicultural Readings*. Maurice Berger, ed. New York: IconEditions, 1994.

———. *Black Culture and Black Consciousness: Afro-American Folk Thought from Slavery to Freedom*. New York: Oxford University Press, 1978.

Lewis, Anna. "The Oklahoma College for Women." *Chronicles of Oklahoma* 27 (Summer 1949): 179–86.

Lewis, Samella. *African American Art and Artists*. 3rd ed. Berkeley: University of California Press, 2003.

Liang, Zai, and Wenzhen Ye. "From Fujian to New York: Understanding the New Chinese Immigration." In *Global Human Smuggling: Comparative Perspectives*. D. Kyle and R. Koslowski, eds. Baltimore: Johns Hopkins University Press, 2011.

Licht, Fred, ed. *Homage to Jean Hélion: Recent Works*. Venice: Guggenheim Foundation, 1986.

Lipson, Karin. "The Magic and Reality of Circus Life." *Newsday*, June 7, 1991, part II, 101.

Locke, Alain. "Advance on the Art Front." *Opportunity* 17, no. 5 (May 1939): 132–6.

Loftis, Anne. *Witness to the Struggle: Imaging the 1930s California Labor Movement*. Reno: University of Nevada Press, 1998.

Logan, Rayford, ed. *What the Negro Wants*. Chapel Hill: University of North Carolina Press, 1944.

Lomax, Alan. *The Folk Songs of North America*. Garden City, NY: Doubleday & Company, 1960.

Lomax, John, and Alan Lomax *Our Singing Country: Folksongs and Ballads*. New York: Macmillan Company, 1941.

———. *American Ballads and Folksongs*. New York: Macmillan Company, 1934.

Lomawaima, K. Tsianina. "Domesticity in the Federal Indian Schools: The Power of Authority Over Mind and Body." *American Ethnologist* 20, no. 2 (May 1993): 227–40.

Lord, Beth. "Foucault's Museum: Difference, Representation, and Genealogy." *Museum and Society* 4, no. 1 (March 2006): 1–14.

Lowe, Truman, ed. *Native Modernism: The Art of George Morrison and Allan Houser*. Washington, DC: Smithsonian National Museum of the American Indian, 2004.

Lynd, Robert, and Helen Lynd. *Middletown in Transition: A Study in Cultural Conflicts*. New York: Hartcourt, Brace, 1937.

MacMillan, Kyle. "Bring Out the Masterpieces." *ARTnews*, February 2011, 47.

Mantz, Paul. "Exposition Universelle: Les Écoles Étrangères, IX. Etats-Unis, Suisse, Danemark, Swéde, et Norvége." *Les Temps*, November 6, 1878.

Marcoci, Roxana. *Thomas Demand*. New York: Museum of Modern Art, 2005.

Marrinan, Michael. *Painting Politics for Louis-Philippe: Art and Ideology in Orléanist France, 1830–1848*. New Haven and London: Yale University Press, 1988.

Marriott, Alice. *The Ten Grandmothers*. Norman: University of Oklahoma Press, 1945.

Marter, Joan, ed. *The Grove Encyclopedia of American Art*. Oxford, UK: Oxford University Press, 2011.

McCauley, Elizabeth. *Raymond Jonson: The Early Years*. Albuquerque: Jonson Gallery of the Art Museum of the University of New Mexico, 1980.

McCauley Lee, Eric, and Rima Canaan. *The Fred Jones Jr. Museum of Art at the University of Oklahoma: Selected Works*. Norman: University of Oklahoma Press, 2004.

McCausland, Elizabeth. "Authentic American Is Arthur G. Dove." *Springfield Sunday Union and Republican*, May 5, 1935.

———. "Dove's Oils, Water Colors Now at an American Place." *Springfield Sunday Union and Republican*, April 22, 1934.

McClellan, Andrew, ed. *Art and Its Publics: Museum Studies at the Millennium*. Oxford: Blackwell, 2003.

McFadden, Robert. "Smuggled to New York: The Overview." *New York Times*, June 7, 1993.

McFelly, William. *Portrait: The Life of Thomas Eakins*. New York: W.W. Norton & Company, 2006.

McInnis, Maurie. "Little of Artistic Merit? The Problem and Promise of Southern Art History." *American Art* 19, no. 2 (Summer 2005): 11–18.

McIntosh, DeCourcy. "Goupil's Album: Marketing Salon Painting in the Late Nineteenth Century." In *Twenty-First-Century Perspectives on Nineteenth-Century Art: Essays in Honor of Gabriel P. Weisberg*. Petra ten-Doesschate and Laurinda S. Dixon, eds. Newark: University of Delaware Press, 2008.

McLerran, Jennifer. *A New Deal for Indian Art: Indian Arts and Federal Policy 1933–1943*. Tucson: University of Arizona Press, 2009.

Meadows, William. *Kiowa Military Societies: Ethnohistory and Ritual*. Norman: University of Oklahoma Press, 2010.

Melish, Joanne Pope. *Disowning Slavery: Gradual Emancipation and "Race" in New England, 1780–1860*. Ithaca, NY: Cornell University Press, 1998.

Meltzer, Milton. *Dorothea Lange: A Photographer's Life*. New York: Farrar, Straus, Giroux, 1978.

Merrill, Walter, ed. *The Letters of William Lloyd Garrison: Let the Oppressed Go Free, 1861–1867*. Cambridge, MA: Belknap Press of Harvard University Press, 1979.

Meynell, Wilfred. *A Glimpse of the East: 200 + 30 Sketches and Studies by F.A. Bridgman in Egypt and Algeria*. London: Fine Art Society, 1887.

Miller, Angela. *The Empire of the Eye: Landscape Representation and American Cultural Politics, 1825–1875*. New York: Cornell University Press, 1993.

———, et al. *American Encounters: Art, History, and Cultural Identity*. Upper Saddle, NJ: Pearson, 2008.

Millet, F.D. "Mr. Bridgman's Pictures." *New York Times*, April 17, 1890.

Mills, Tammy. "'Lines Written in my Closet': *Volume One of Judith Sargent Murray's Poetry Manuscripts*." 2006. PhD diss., Georgia State University, 2006. http://scholarworks.gsu.edu/english_diss/11/, accessed July 21, 2014.

Mithlo, Nancy Marie. "'A Native Intelligence': The Poolaw Photography Project 2008." http://nancymariemithlo.com/Research/2008_Poolaw_Photo_Project/index.html, accessed January 20, 2015.

Montzeuma [Montague Marks]. "My Note Book." *Art Amateur* 2, no. 5 (April 1880): 91.

Morris, Anthony. "The Censored Paintings of Paul Cadmus." PhD diss., Case Western Reserve University, 2010.

Morton, Mary. "Gérôme en Amérique." In *Jean-Léon Gérôme (1824–1904): l'histoire et spectacle*. Paris: Musée d'Orsay and Skira, 2009.

Munroe, Alexandra, et al. *The Third Mind: American Artists Contemplate Asia, 1860–1989*. New York: Guggenheim Museum, 2009.

Murray, Judith Sargent. "On the Equality of the Sexes." *Massachusetts Magazine* (March–April 1790). http://nationalhumanitiescenter.org/pds/livingrev/equality/text5/sargent.pdf, accessed 7/14/2014.

National Cyclopaedia of American Biography. Vol. 21, p. 233. New York: James T. White and Company, 1931.

Nelson, Scott Reynolds. *Steel Drivin' Man: John Henry, the Untold Story of an American Legend*. New York: Oxford University Press, 2006.

Netsky, Ron. "Two Artists: Naive by Design," *Democrat and Chronicle*, February 11, 1990.

Newhall, Beaumont. *The History of Photography: From 1839 to the Present Day*. New York: Museum of Modern Art, 1964.

———, and Robert Doty. "The Value of Photography to the Artist, 1839." *Bulletin of the George Eastman House of Photography* 11, no. 6 (1962): 25–8.

Newman, Benjamin Tupper. "Two Americans in Paris: 1885." *Archives of American Art Journal* 12, no. 4 (1972): 23–4.

Noble, Kenneth. "Golden Venture Refugees on Hunger Strike in California to Protest Detention." *New York Times,* December 2, 1995.

Norman, Benjamin Moore. *Norman's New Orleans and Environs*. New Orleans: B.M. Norman, 1845.

Novak, Barbara. *Nature and Culture: American Landscape and Painting, 1825–1875*. 1980. Reprint, New York: Oxford University Press, 2007.

O.F. "Petites Expositions: Tableaux et Études de M. Bridgman." *La Chronique des arts et de la curiosité* 2 (January 8, 1898): 10.

O'Keeffe, Georgia. *Georgia O'Keeffe*. New York: Viking Press, 1976.

Ortiz, Fernando. *Cuban Counterpoint: Tobacco and Sugar*. New York: Alfred A. Knopf, 1947.

Ott, John. "Labored Stereotypes: Palmer Hayden's the Janitor Who Paints." *American Art* 22, no. 1 (Spring 2008): 102–15.

Outremer. "Art Echoes from Paris, II." *Aldine* 9, no. 4 (July 01, 1879): 114–18.

———. "Art Echoes from Paris, I," *Aldine*, 9, no. 3 (May 1, 1878): 94–7.

Owens, Mitchell. "A Folk Art Defense Fund, Built of Paper." *New York Times,* August 10, 1995.

Park, Lawrence. *Gilbert Stuart: An Illustrated Descriptive List of his Works*. Vol. II. New York: William Edwin Rudge, 1926.

Parker, Holt. "Aristotle's Unanswered Questions: Women and Slaves in *Politics* 1252a–1260b." *EuGeStA* no. 2 (2012): 71–112. http://eugesta.recherche.univ-lille3.fr/revue/pdf/2012/Parker-2_2012.pdf, accessed July 21, 2014.

Parrish Art Museum. *An American Place*. Southampton, NY: Parrish Art Museum, 1981.

Parsons, Elsie Clews. *Kiowa Tales*. New York: American Folklore Society, 1929.

Patel, Samir. "America's Chinatowns: Dozens of Digs and Collections Are Revealing the Culture, Diversity, and Challenges of the First Chinese American." *Archaeology*, May/June 2014, 39.

Patterson, Jennifer Danielle. "Beyond Orientalism: Nineteenth-Century Egyptomania and Frederick Arthur Bridgman's 'The Funeral of a Mummy.'" MA thesis, University of Louisville, 2002.

Patton, Sharon. "Edward Mitchell Bannister (1826/7–1901)." In *African-American Art*. Oxford, UK: Oxford University Press, 1998.

Pearson, Andrea. "*Frank Leslie's Illustrated Newspaper* and *Harper's Weekly*: Innovation and Imitation in Nineteenth-Century American Pictorial Reporting." *Journal of Popular Culture* 23, no. 4 (1990): 81–111.

Pegeen: mostra personale, disegni a colori e guazzi. Venice: Galleria del Cavallino, 28 agosto–10 settembre, 1948.

Penney, David. *Art of the American Indian Frontier: The Chandler-Pohrt Collection*. Seattle: University of Washington Press, 1997.

———, and Lisa Roberts. "America's Pueblo Painters: Encounters on the Borderlands." In *Native American Art in the Twentieth Century*. W. Jackson Rushing, ed. London: Routledge, 1999.

Pennington, Estill Curtis. *Downriver: Currents of Style in Louisiana Painting, 1800–1950.* Gretna: Pelican Publishing Company, 1991.

People of the Golden Vision Newsletter. March 2, 1995.

Perry, Regenia. *Free within Ourselves: African-American Artists in the Collection of the National Museum of American Art.* Washington, DC: National Museum of American Art, 1992.

Phelan, Peggy. *Mourning Sex: Performing Public Memories.* London: Routledge, 1997.

Phillips, Ruth. "Morrisseau's 'Entrance': Negotiating Primitivism, Modernism, and Anishnaabe Tradition." In *Norval Morrisseau, Shaman Artist.* Greg A. Hill, ed. Ottawa: National Gallery of Canada, 2006.

Photography by Horace Poolaw. Exhibition brochure. Anadarko, OK: US Department of the Interior, Indian Arts and Crafts Board, Southern Plains Indian Museum and Crafts Center, May 27–June 27, 1979.

"Pictures of Algiers." *New York Times*, April 14, 1890.

Ping, Huang Yong, and Philippe Vergne. *House of Oracles: A Huang Yong Ping Retrospective.* Minneapolis, MN: Walker Art Center, 2005.

Plan and Program for the Preservation of the Vieux Carre. New Orleans, LA: Urban Renewal Demonstration Project, 1968.

Pochmann, Henry. *German Culture in America: Philosophical and Literary Influences, 1600–1900.* Madison: University of Wisconsin Press, 1957.

———. *New England Transcendentalism and St. Louis Hegelianism: Phases in the History of American Idealism.* Philadelphia: Carl Schurz Memorial Foundation, 1948.

Podnieks, Elizabeth, ed. *Emily Coleman, Rough Draft: The Modernist Diaries of Emily Coleman, 1929–1937.* Newark: University of Delaware, 2011.

Pointon, Marcia, ed. *Art apart: Art Institutions and Ideology across England and North America.* Manchester, UK: Manchester University Press, 1994.

Pontello, Jacqueline. "Southwest No Longer Stigma." *Southwest Art* 19 (December 1989): 23–4.

Poolaw, Linda. "Bringing Back Hope." In *All Roads Are Good: Native Voices on Life and Culture.* Washington, DC: Smithsonian Institution and the National Museum of the American Indian, 1994.

———. *War Bonnets, Tin Lizzies, and Patent Leather Pumps: Kiowa Culture in Transition, 1925–1955.* Stanford, CA: Stanford University, 1990.

Porter, James. *Modern Negro Art.* 1943. Reprint, New York: Arno Press, 1969.

Portland Art Museum. *The Elegant Auto: Design and Fashion in the 1930s.* Portland, ME: Portland Museum of Art, 1992.

Powell, Richard. "Re/Birth of a Nation." In *Rhapsodies in Black: Art of the Harlem Renaissance.* David A. Bailey and Richard J. Powell, eds. London: Hayward Gallery and the Institute of International Visual Arts, 1997.

Powell, Richard, et al. *To Conserve a Legacy: American Art from Historically Black Colleges and Universities.* Andover, MA: Addison Gallery of American Art, 1999.

Preziosi, Donald, ed. *The Art of Art History: A Critical Anthology.* New York: Oxford University Press, 2009.

Price, Justine Dana. "Abstraction, Expression, Kitsch: American Painting in a Critical Context, 1936–1951." PhD diss., University of Texas at Austin, 2007.

Prince, Sue Ann, ed. *The Old Guard and the Avant-Garde: Modernism in Chicago, 1910–1940.* Chicago: University of Chicago Press, 1990.

Pringle, James. *History of Gloucester.* Lynn, MA: G. H. & W. A. Nichols, 1892.

Proth, Mario. *Voyage au pays de peintres Salon de 1877.* Paris: Henri Vatan Librairie, 1877.

Quineau, Raymond. *Pegeen, peintures, gouaches, dessins: du 7 juin au 21 juin 1949.* Paris: Galerie artiste et artisan, 1949.

Rand, Jacki Thompson. *Kiowa Humanity and the Invasion of the State*. Lincoln: University of Nebraska Press, 2008.

Randall, Dudley. "The Black Aesthetic in the Thirties, Forties, and Fifties." In *The Black Aesthetic*. Addison Gayle, Jr., ed. Garden City, NY: Doubleday & Co., 1971.

Rank and Warfare among the Plains Indians. 1940. Reprint, Lincoln: University of Nebraska Press, 1992.

Reilly, Maura, and Linda Nochlin, eds. *Global Feminisms: New Directions in Contemporary Art*. New York: Merrill, 2007.

Richardson, John. *The Sorcerer's Apprentice: Picasso, Provence, and Douglas Cooper*. Chicago: University of Chicago Press, 1999.

Ritivoi, Andreea Deciu. *Yesterday's Self: Nostalgia and the Immigrant Identity*. Lanham, MD: Rowman & Littlefield, 2002.

Robinson, Edith. "The Portrait by Hunt." *Outing, an Illustrated Monthly Magazine of Recreation* 21, no. 2 (November 1892): 128–33.

Rorem, Ned. *Lies: A Diary, 1986–1999*. Washington, DC: Counterpoint, 2000.

Rosen, Jeff. "Lithographie: An Art of Imitation." In *Intersections: Lithography, Photography, and the Traditions of Printmaking*. Kathleen Stewart Howe, ed. Albuquerque: University of New Mexico Press, 1998.

Roskill, Mark. *What Is Art History?* London: Thames and Hudson, 1976.

Ross, Sara. "'Good Little Bad Girls': Controversy and the Flapper Comedienne." *Film History* 13, no. 4 (2001): 409–26.

Rothman, Adam. *Slave Country: American Expansion and the Origins of the Deep South*. Cambridge, MA: Harvard University Press, 2007.

Rushing, W. Jackson. "Essence and Existence in Allan Houser's Modernism. *Third Text* 39 (Summer 1997): 87–94.

———. "Modern By Tradition: The Studio Style of Native American Painting." In *Modern By Tradition: American Indian Painting in the Studio Style*. Santa Fe: Museum of New Mexico Press, 1995.

Russell, Charles. "Finding a Place for the Self-Taught in the Art World(s)." In *Self-taught Art: The Culture and Aesthetics of American Vernacular Art*. Jackson: University Press of Mississippi, 2001.

St. Gaudens, Augustus. "The Bridgman Exhibition." *New York Times*, April 20, 1890.

Salamone, Frank. *Italians in Rochester, New York, 1900–1940*. Lewiston, NY: Edwin Mellen Press, 2000.

Saltz, Jerry. "Jerry Saltz on the Outsider Art Fair—And Why There's No Such Thing as 'Outsider' Art." *Vulture.com*, February 1, 2013.

Sandburg, Carl. *The American Songbag*. New York: Harcourt, Brace & Company, 1927.

Sartisky, Jay Michael, Richard Gruber, and John Kemp, eds. *A Unique Slant of Light: The Bicentennial History of Art in Louisiana*. New Orleans: Louisiana Endowment of the Humanities, 2012.

"Saunders and Beach Academy." Dorchester Atheneum [*sic*]. http://www.dorchesteratheneum.org/page.php?id=1009, accessed July 21, 2014.

Schedler, Sylvan. *Eakins*. Boston: Little, Brown and Company, 1967.

Schelling, F.W.J. *The Philosophy of Art*. Douglas W. Scott, ed. and trans. Reprint, Minneapolis: University of Minnesota Press, 1989.

Schjeldahl, Peter. "The Surgeon." *New Yorker,* October 22, 2001, 79.

Scott, Janet Lee. *For Gods, Ghosts, and Ancestors: The Chinese Tradition of Paper Offerings*. Seattle: University of Washington Press, 2007.

Selvin, David. *A Terrible Anger: The 1934 Waterfront and General Strikes in San Francisco*. Detroit: Wayne State University Press, 1996.

Sewell, Darrell, et al. *Thomas Eakins*. Philadelphia: Philadelphia Museum of Art, 2001.

Sharp, Kevin, Sharon Bradham, Adam Thomas, Julie Novarese Pierotti, and Amy Roadarmel. *Cedarhurst: The Museum and Its Collection*. Mount Vernon, IL: Cedarhurst Center of the Arts, 2008.

Shaw, Gwendolyn DuBois. "Landscapes of Labor: Race Religion and Rhode Island in the Painting of Edward Mitchell Bannister." In *Post-Bellum, Pre-Harlem: African American Literature and Culture, 1877–1919*. Barbara McCaskill and Caroline Gebhard, eds. New York: New York University Press, 2006.

Shay, Frank. *Here's Audacity!* New York: Macaulay Company, 1930.

Sheldon, George William. *Recent Ideals of American Art: One Hundred and Seventy-five Oil Paintings and Water Colors in the Galleries of Private Collectors, Reproduced in Paris on Copper Plates by the Goupil Photogravure and Typogravure Processes*. New York and London, 1888.

Sherman, Danie, and Irit Rogoff, eds. *Museum Culture: Histories, Discourses, Spectacles*. Minneapolis: University of Minnesota Press, 1994.

Shinn, Earl. "F-A. Bridgman." In *The Great Modern Painters: English, French, German, etc.* Paris: Goupil & Co., 1884–86.

Shlaes, Amity. *The Forgotten Man: A New History of the Great Depression*. New York: Harper Collins, 2007.

Siegel, Marcia. *The Shapes of Change: Images of American Dance*. Boston: Houghton Mifflin Co., 1979.

Simpson, Marc. "Sargent and His Critics." In *Uncanny Spectacle: The Public Career of the Young John Singer Sargent*. New Haven and London: Yale University Press, 1997.

Sims, Lowery, and Jonathan P. Binstock. "Edward Mitchell Bannister." In *African American Art: 200 Years*. New York: Michael Rosenfeld Gallery, 2008.

Skemp, Sheila. *First Lady of Letters: Judith Sargent Murray and the Struggle for Female Independence*. Philadelphia: University of Pennsylvania Press, 2009.

Skrbis, Zlatko, Gavin Kendall, and Ian Woodward. "Locating Cosmopolitanism: Between Humanist Ideal and Grounded Social Category." *Theory, Culture & Society* 21, no. 6 (2004): 115–36.

Smith, Bonnie Hurd. *Letters of Loss and Love*. Salem, MA: Hurd Smith Communications, 2009.

Smith, Joseph Frazer. *Plantation Houses and Mansions of the Old South*. Mineola, NH: Dover Publications, 1993.

Smith, Laura. "Obscuring the Distinctions, Revealing the Divergent Visions: Modernity and Indians in the Early Works of Kiowa Photographer Horace Poolaw, 1925–1945." PhD diss., Indiana University, 2008.

Smith, Margaret Denton, and Mary Louise Tucker. *Photography in New Orleans: The Early Years, 1840–1865*. Baton Rouge: Louisiana State University Press, 1982.

Smith, Roberta. "No More on the Outside Looking In." *New York Times*, April 11, 2013.

Solomon-Godeau, Abigail. "Going Native." *Art in America* 77, no. 7 (July 1989): 119–61.

Soria, Regina. *Dictionary of Nineteenth-Century American Artists in Italy, 1760–1914*. East Brunswick, NJ: Associated University Presses, Inc., 1982.

———. *Elihu Vedder: American Visionary Artist in Rome (1836–1923)*. Rutherford, NJ: Fairleigh Dickinson University Press, 1970.

———. "Washington Allston's Lectures on Art: The First American Art Treatise." *Journal of Aesthetics and Art Criticism* 18, no. 3 (March 1960): 329–44.

Sprague, Marshall. "Colorado Springs Fine Arts Center: Its Formative Years." In *Colorado Springs Fine Arts Center: A History and Selections from the Permanent Collections*. Colorado Springs: Colorado Springs Fine Arts Center, 1986.

Stark, Louise. "The Origin of the Penitente 'Death Cart.'" *Journal of American Folklore* 84, no. 333 (July–September 1971): 304–10.

Starr, Kevin. *Endangered Dreams: The Great Depression in California*. New York: Oxford University Press, 1996.

Steele, S.J. Thomas. *Santos and Saints: The Religious Folk Art of Hispanic New Mexico*. Santa Fe, NM: Ancient City Press, 1994.

Stewart, Irene. *A Voice in Her Tribe: A Navajo Woman's Own Story*. Socorro, NM: Ballena Press, 1980.

Story, William Wetmore. "The Fine Arts," *Reports of the United Commissioners to the Paris Universal Exposition, 1878*. Vol. 2, 111–12. Washington, DC: Government Printing Office, 1880.

Stott, William. "Introduction to a Never-Published Book of Dorothea Lange's Best Photographs of Depression America." *Exposure* 22 no. 3 (Fall 1984): 22–30.

Strahan, Edward [Earl Shinn]. "Frederick A. Bridgman." *Harper's Monthly* 63, no. 377 (October 1881): 694–705.

———. "The Art Gallery: Frederick A. Bridgman." *Art Amateur* 4, no. 4 (March 1881): 67, 70–71.

———. "Exhibition of the Philadelphia Society of Artists." *Art Amateur* 4, no. 1 (December 1880): 4–7.

———, ed. *The Chefs-d'oeuvre d'art of the International Exhibition, 1878*. Philadelphia: Gebbie & Barrie Publishers, 1878.

Stretch, Bonnie Barrett. "A Modernist Surprise," *ARTnews* 88 (November 1989): 45–6.

Sumner, William Graham. *The Forgotten Man: And Other Essays*. New Haven: Yale University Press, 1919.

Swan Auction Galleries. "Sale 2308, Lot 31: 'A Good Likeness of Sancho a Negro'." http://catalogue.swanngalleries.com/asp/fullCatalogue.asp?salelot=2308++++++31+ &refno=++671750&saletype=, accessed June 4, 2014.

Szegedy-Maszak, Andrew. "A Perfect Ruin: Nineteenth-Century Views of the Colosseum." *Arion* 2, no. 1 (Winter 1992): 115–34.

Taft, Robert. *Artists and Illustrators of the Old West, 1850–1900*. New York: Charles Scribner's Sons, 1969.

Talbot, Hayden. "Frederic A. Bridgman and Some of His Paintings." *New York Times*, April 24, 1904.

Taylor, Paul, and Norman Leon Gold. "San Francisco and the General Strike." *Survey Graphic* 23, no. 9 (September 1934): 404–11.

Teall, Gardner. "As in a Steel Sword: True Refinement in Art." *Hearst's Magazine* 37, no. 2 (March 1920): 40, 69.

"The F.A. Bridgman Pictures at the American Art Gallery." *Brooklyn Daily Eagle*, February 3, 1881.

Thompson, David. Preface. In *One Hundred Paintings from the G. David Thompson Collection*. Venice: Solomon R. Guggenheim Museum, 1961.

Thompson, Shirley Elizabeth. *Exiles at Home: The Struggles to Become American in Creole New Orleans*. Cambridge, MA: Harvard University Press, 2009.

Thuillier, Jacques, et al. *Georges de La Tour*. Paris: Réunion des Musées Nationaux, 1972.

Tregle, Joseph. "Creoles and Americans." In *Creole New Orleans: Race and Americanization*. Arnold R. Hirsch and Joseph Logsdon, eds. Baton Rouge: Louisiana State University Press, 1992.

———, and Joseph G. Tregle, Jr. "Early New Orleans Society: A Reappraisal." *Journal of Southern History* 18, no. 1 (February 1952): 20–36.

Tropman, John. *American Values and Social Welfare: Cultural Contradictions in the Welfare State*. Englewood Cliffs, NJ: Prentice Hall, 1989.

Tsinhnahjinnie, Hulleah, and Veronica Passalacqua. *Our People, Our Land, Our Images: International Indigenous Photographers*. Berkeley: Heyday Books, 2006.

Tuchman, Maurice. Introduction. In *Parallel Visions: Modern Artists and Outsider Art*. Maurice Tuchman and Carol S. Eliel, eds. Los Angeles: Los Angeles County Museum of Art, 1992.

Tuck, Stephen. "'You can sing and punch … but you can't be a soldier or a man': African American Struggles for a New Place in Popular Culture." In *Fog of War: The Second World War and the Civil Rights Movement*. Kevin M. Kruse and Stephen Tuck, eds. New York: Oxford University Press, 2012.

Twain, Mark. *The Innocents Abroad: Or, the New Pilgrim's Progress: Being Some Account of the Steamship Quaker's City's Pleasure Excursion to Europe and the Holy Land: With Descriptions of Countries, Nations, Incidents, and Adventures as They Appeared to the Author*. Hartford, CT: American Publishing Company, 1869.

"Two Youths Are Arrested during Carnival Fight." *Geneva Daily Times*, May 31, 1934.

Udall, Sharyn. *Modernist Painting in New Mexico, 1913–1935*. Albuquerque: University of New Mexico Press, 1984.

Usner, Daniel, Jr. "Frontier Exchange and Cotton Production: The Slave Economy in Mississippi, 1798–1836." In *From Slavery to Emancipation in the Atlantic World*. Sylvia R. Frey and Betty Wood, eds. London: Frank Cass Publishers, 1999.

Van Rensselaer, Mrs. Schuyler (Marianna Griswold). "Frederick Arthur Bridgman." *Frank Leslie's Popular Monthly* 29, no. 6 (June 1890): 2–11.

———. "The Philadelphia Exhibition, I." *American Architect and Building News* 8, no. 259 (December 11, 1880): 279–81.

———. "Spring Exhibitions and Picture-Sales in New York, II." *American Architect and Building News* 7, no. 228 (May 8, 1880): 201–2.

Vella, Christina. *Intimate Enemies: The Two Worlds of Baroness de Pontalba*. Baton Rouge: Louisiana State University Press, 1977.

Viborel, Frédéric. "Le peintre Frédéric A. Bridgman." *La revue des lettres et des arts*, May 1, 1909, 310–13.

Wallace, Grant. "Maynard Dixon: Painter and Poet of the Far West." In *California Art Research* 8. Gene Hailey, ed. San Francisco: Works Progress Administration [Project 2874], 1937.

Wallach, Alan. *Exhibiting Contradiction: Essays on the Art Museum in the United States*. Amherst: University of Massachusetts Press, 1998.

Ward, Barbara McLean. "Society of the Cincinnati Badge and Ribbon Owned by Secretary of State Timothy Pickering." US Department of State Archive. https:// diplomaticrooms.state.gov/Pages/Item.aspx?item=41, accessed June 24, 2013.

Watson, Sheila, ed. *Museums and Their Communities*. London: Routledge, 2007.

Weber, Susan, Kenneth L. Ames, and Matthew Wittmann, eds. *The American Circus*. New Haven: Yale University Press, 2012.

Weigle, Marta. *Brothers of Light, Brothers of Blood*. Albuquerque: University of New Mexico Press, 1976.

Weinberg, H. Barbara. *The Lure of Paris: Nineteenth-Century American Painters and Their French Teachers*. New York: Abbeville Press Publishers, 1991.

———. *The American Pupils of Jean-Léon Gérôme*. Fort Worth, TX: Amon Carter Museum, 1984.

———. "Nineteenth-Century American Painters at the École Des Beaux-Arts." *American Art Journal* 13, no. 4 (1981): 66–84.

Welch, Patricia Bjaaland. *Chinese Art: A Guide to Motifs and Visual Imagery*. Boston: Tuttle Publishing, 2012.

Welleck, Renee. "Emerson and German Philosophy." *New England Quarterly* 16, no. 1 (March 1943): 60–61.

———. "The Minor Transcendentalists and German Philosophy." *New England Quarterly* 15, no. 4 (December 1942): 652–80.

Werbel, Amy. *Thomas Eakins: Art, Medicine and Sexuality in Nineteenth-Century Philadelphia*. New Haven: Yale University Press, 2007.

Westerman, William and Shushan Chin. *Fly to Freedom: The Art of the Golden Venture Refugees*. New York: Museum of the Chinese in the Americas, 2001.

Whitaker, Jan. *The Department Store: History, Design, Display*. London: Thames and Hudson, 2011.

Whittaker, George. "Reminiscences of Providence Artists." *Providence Magazine: The Board of Trade Journal* (March 1914): 137–9.

Wiesinger, Véronique. "La politique d'acquisition de l'État français sous la Troisième République en matière d'art étranger contemporain: l›exemple américain (1870–1940)." *Bulletin de la Société de l'Histoire de l'Art français* (1993): 263–99.

Wilk, Christopher, ed. *Modernism: Designing a New World, 1914–1939*. London: V&A Publications, 2006.

Wilkinson, C.P. Seabrook. "Emerson and the Eminent Painter." *New England Quarterly* 71, no. 1 (March 1998): 120–26.

Williams, George Huntston. *American Universalism*. 4th ed. Boston: Skinner House Books, 2002.

Willis, Deborah. *Reflections in Black: A History of Black Photographers, 1840 to the Present*. New York: Norton, 2000.

———, with Williams Keyse Rudolph and Patricia Brady. *In Search of Julien Hudson: Free Artist of Color in Pre-Civil War New Orleans*. New Orleans: Historic New Orleans Collection, 2010.

Wilmerding, John. *Thomas Eakins*. London: National Portrait Gallery, 1993.

Wilson, MaLin. *Raymond Jonson: Cityscapes*. Albuquerque: Jonson Gallery of the Art Museum of the University of New Mexico, 1989.

Winston, James. "Note on the Economic History of New Orleans, 1803–1836." *Mississippi Valley Historical Review* 11, no. 2 (September 1924): 224–5.

Winters, Charlene. "Escape to Reality." *BYU Magazine* (Winter 2000), n.p.

Wolff, Albert. "Le Salon de 1877." *Figaro*, May 4, 1877.

Wolfskill, Phoebe. "Caricature and the New Negro in the Work of Archibald Motley Jr. and Palmer Hayden." *Art Bulletin* 91, no. 3 (September 2009): 343–65.

"Woman Responsible for Kiowa Indian Artists Relates How They Began in 1917: Art Is 'Second Nature' to Them." *Anadarko Daily News*, August 21, 1938.

Wroth, William. *Images of Penance, Images of Mercy: Southwestern Santos in the Late Nineteenth Century*. Norman: University of Oklahoma Press, 1991.

Yan, Yunxiang. *The Flow of Gifts: Reciprocity and Social Networks in a Chinese Village*. Stanford, CA: Stanford University Press, 1996.

Yang, Jeff. "The Living Museum." *San Francisco Chronicle*, October 1, 2009.

Yasin, Ann Marie. "Displaying the Sacred Past: Ancient Christian Inscriptions in Early Modern Rome." *International Journal of the Classical Tradition* 7, no. 1 (Summer 2000): 39–57.

Yellen, Samuel. *American Labor Struggles*. New York: S.A. Russell, 1936.

Yoder, R.A. "Emerson's Dialectic." *Criticism* 11, no. 4 (Fall 1969): 313–28.

Zhuo, Chen, and Han Guang. "Gift Giving Culture in China and Its Cultural Values." *Intercultural Communication Studies* XVI, no. 2 (2007): 81–93.

Zolberg, Vera, and Joni Maya Cherbo, eds. *Outsider Art: Contesting Boundaries in Contemporary Culture*. Cambridge, UK: Cambridge University Press, 1997.

Index

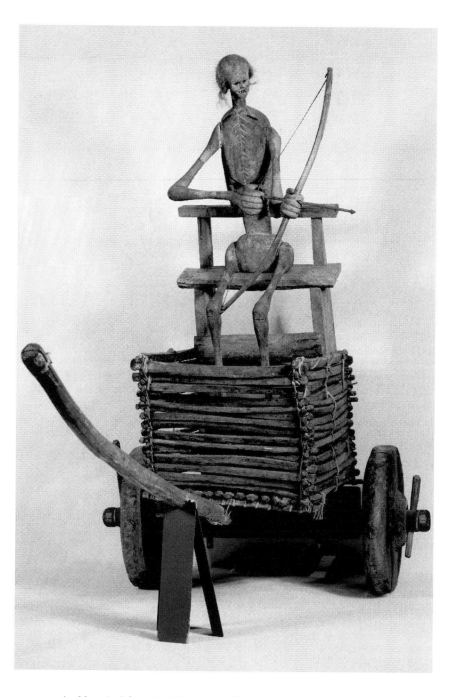

1 Nasario López, *La Muerte en su Carreta*, late nineteenth-century.
Gesso, leather, cottonwood, and pine, 51 x 24 x 32 in.
Collection of Colorado Springs Fine Arts Center, Colorado Springs, CO

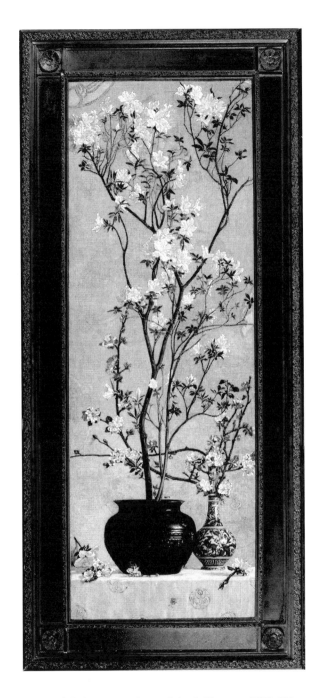

2 Charles Caryl Coleman, *Azaleas and Apple Blossoms*, 1879. Oil on canvas, 71 1/4 x 25 in. (181 x 63.5 cm), inscribed "Roma" and dated "1879." De Young Museum, San Francisco, CA

3 Philip Leslie Hale, *Deianira, Wife of Heracles, Being Carried Off by the Centaur Nessus*, c. 1897. Oil on canvas, 58 3/4 x 71 1/4 in.
Danforth Art, Framingham, MA

4 Raymond Jonson, *Composition Five — The Wind*, 1925. Oil on canvas, 33 x 44 in.
Joslyn Art Museum, Omaha, NE

5 Josephine Tota, *Untitled (Life Story)*, c. 1980s. Egg tempera on Masonite, 16 x 20 1/8 in.
Memorial Art Gallery of University of Rochester, Rochester, NY

6 Edward Mitchell Bannister, *Approaching Storm*, 1886. Oil on canvas, 102 x 152.4 cm. Smithsonian American Art Museum, Washington, DC

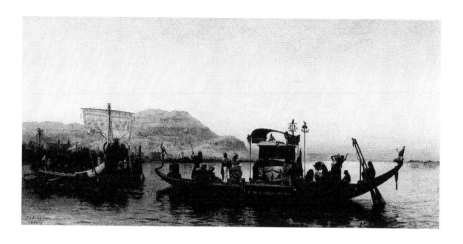

7 Frederick Arthur Bridgman, *The Funeral of a Mummy on the Nile*,
1876–77. Oil on canvas, 45 x 91 3/8 in.
Collection of the Speed Art Museum, Louisville, KY

8 Thomas Eakins, *Portrait of Samuel Murray*, 1889. Oil on canvas, 24 x 20 in.
Cedarhurst Center for the Arts, Mount Vernon, IL

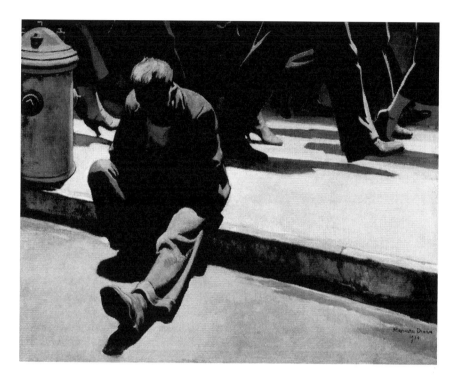

9 Maynard Dixon, *The Forgotten Man*, 1934. Oil on canvas, 40 x 50 1/8 in.
Brigham Young University Museum of Art, Provo, UT

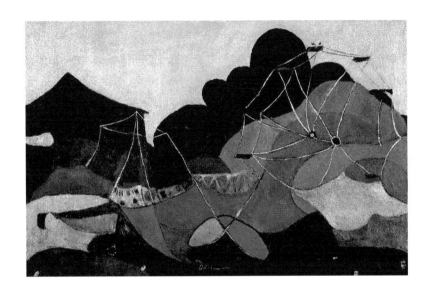

10　Arthur Dove, *Carnival*, 1935. Oil and metallic paint on canvas,
22 x 34 in. (55.9 x 86.4 cm).
Montclair Art Museum, Montclair, NJ

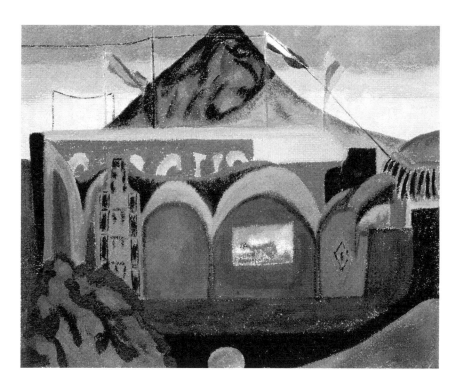

11 Helen Torr, *Circus*, 1935. Gouache on paper, 8 1/2 x 10 1/2 in. (21.6 x 26.7 cm).
© The Lane Collection. Courtesy, Museum of Fine Arts, Boston, MA

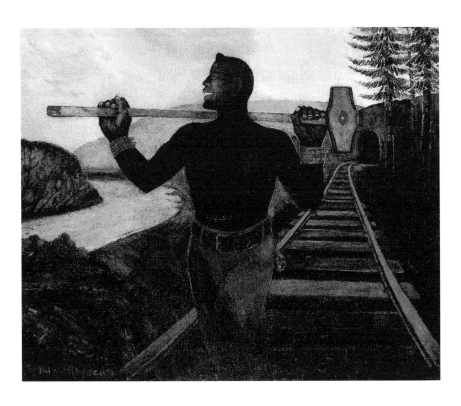

12 Palmer Hayden, *His Hammer in His Hand*, c. 1947. Oil on canvas, 27 x 33 in.
Courtesy of the Museum of African American Art, Los Angeles, CA

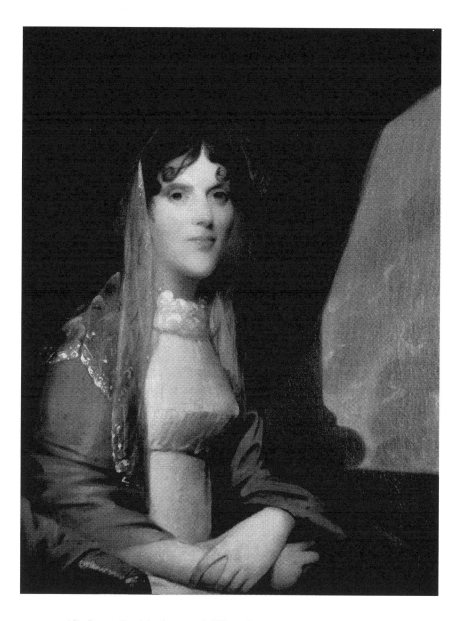

13 James Frothingham and Gilbert Stuart, *Mary McIntosh Sargent*,
c. 1807. Oil on canvas, 30 x 25 in.
Sargent House Museum, Gloucester, MA

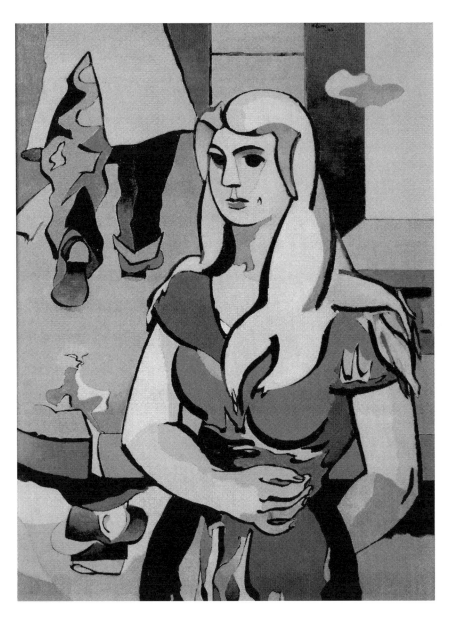

14 Jean Hélion, *La Fille au Reflet de l'Homme*, 1944. Oil on canvas, 34 1/2 x 45 in.
Peru Community Schools Fine Art Gallery, Peru High School, Peru, IN.
© 2015 Artists Rights Society (ARS), New York / ADAGP, Paris

15 Pegeen Guggenheim, *My Wedding*, 1946. Oil on canvas, 76.1 x 91 cm.
Peggy Guggenheim Collection, Venice.
Solomon R. Guggenheim Foundation, New York

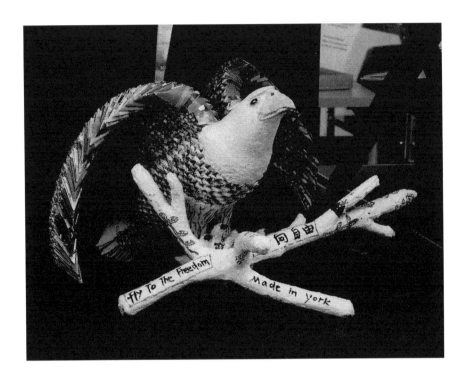

16 Cheng Kwai Sung, with inscriptions by Shi Jian Li, *Eagle*, 1993–96.
Folded paper, papier-mâché, glue, and marker, 8 x 12.5 x 10 in.
Museum of Chinese in America Fly to Freedom Collection, New York

Made in the USA
Middletown, DE
10 February 2022

60910983R00177